SELF-TAUGHT ARTISTS

OF THE 20TH CENTURY

AN AMERICAN ANTHOLOGY

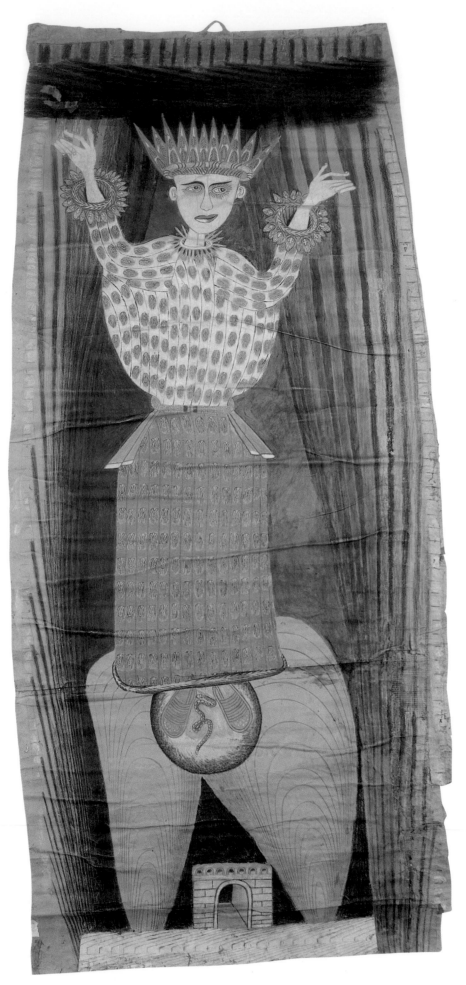

UNTITLED / **Martin Ramirez** / **c. 1950** / Graphite, tempera, and crayon on paper / 110 × 51″ /
Collection of Jim Nutt and Gladys Nilsson

SELF-
TAUGHT
ARTISTS
OF THE 20TH CENTURY

AN AMERICAN ANTHOLOGY

FOREWORD BY
Gerard C. Wertkin DIRECTOR, MUSEUM OF AMERICAN FOLK ART

Elsa Longhauser CURATOR

Harald Szeemann CURATOR

Lee Kogan PROJECT COORDINATOR

Museum of American Folk Art NEW YORK

CHRONICLE BOOKS
SAN FRANCISCO

Printed in Hong Kong

Library of Congress Cataloging-in-Publication Data available.
ISBN 0-8118-2098-X (hc) / 0-8118-2099-8 (pb)

Book and cover design: Carole Goodman
Composition and design assistance: Peter Kesselman

Cover photographs:
WATERFALLS / **Morris Hirshfield** / **1940** / Oil on canvas / 20 × 28" / Private collection /
© Estate of Morris Hirshfield / Licensed by VAGA, New York

CANDLELIGHT IN ACAPULCO ICE FOLLIES 1964 / **Justin McCarthy** / **n.d.** / Oil on Masonite /
32 × 35 ¾" / Museum of American Folk Art, New York / Gift of Elias Getz / 1981.7.4

TIGER AND BEAR / **William L. Hawkins** / **1989** / Enamel, paper, duct tape, and sand on board / 42 × 48" /
High Museum of Art, Atlanta / T. Marshall Hahn Jr. Collection / 1997.84

Back cover photographs:
UNTITLED (H BOMB) / **Eugene Von Bruenchenhein** / **1954** / Oil on paperboard / 21 × 26" / Milwaukee Art Museum /
Gift of Friends of Art

HIPPOCEROS / **Edgar Alexander McKillop** / **c. 1928–1929** / Black walnut, glass eyes, leather tongue, bone teeth, tusks, plastic nostrils,
and Victrola works / 58¼" wide / Abby Aldrich Rockefeller Folk Art Center, Williamsburg, Virginia / 61.701.15

UNTITLED (CALVERINIA) / **Henry Darger** / **n.d.** / Watercolor and collage on paper / 7 × 8" / Collection of Nathan Lerner
Living Trust / 14 F-B

Distributed in Canada by
Raincoast Books
8680 Cambie Street
Vancouver, B.C. V6P 6M9

10 9 8 7 6 5 4 3 2 1

Chronicle Books
85 Second Street
San Francisco, California 94105

Web Site: www.chronbooks.com

"Self-Taught Artists of the 20th Century: An American Anthology" is presented with the generous support of the Lila Wallace–Reader's Digest Fund, The Henry Luce Foundation, Inc., and the Dolfinger-McMahon Foundation.

TOUR ITINERARY

PHILADELPHIA MUSEUM OF ART
Philadelphia, Pennsylvania
March 10 to May 17, 1998

HIGH MUSEUM OF ART
Atlanta, Georgia
July 14 to September 20, 1998

AMON CARTER MUSEUM and
THE MODERN ART MUSEUM OF FORT WORTH
Fort Worth, Texas
October 31, 1998, to January 24, 1999

MEMORIAL ART GALLERY OF THE UNIVERSITY OF
ROCHESTER
Rochester, New York
February 20 to April 18, 1999

WEXNER CENTER FOR THE ARTS, THE OHIO STATE
UNIVERSITY
Columbus, Ohio
May 15 to August 15, 1999

MUSEUM OF AMERICAN FOLK ART
New York, New York
September 19 to December 11, 1999

TABLE OF
CONTENTS

FORE
WORD

GERARD C. WERTKIN

"Self-Taught Artists of the 20th Century: An American Anthology" brings together the work of thirty-two gifted American artists. Selected by Elsa Longhauser and Harald Szeemann, co-curators, with the collaboration of Lee Kogan, project coordinator, the paintings, sculpture, installations, and other works of art that are presented in this catalog, and in the exhibition that it documents, span the entire twentieth century. All were created outside the structures of the artworld—but not necessarily outside the broader cultural mainstream, as Maurice Berger perceptively notes in his essay for this volume. Each artist speaks with a distinctive expressive vocabulary—some drawing upon received traditions and ideas that are firmly rooted in the culture of community, others upon inner visions and voices that are heard only privately, and still others upon the events and questions of the day, great and small. The artists represented here are too individualistic to be understood as constituting or fostering a "movement," "school," or "style" in American art; indeed, their work continues to confound attempts at classification or placement within the history of art, notwithstanding its self-evident power to elicit responses of wonder and awe.

Founded in 1961, the Museum of American Folk Art has been committed to the study and exhibition of the creative expression of contemporary self-taught artists since the mid-1960s, when it extended the scope of its historically based mission to include their work. Prodded by Herbert Waide Hemphill Jr., a founding trustee and the first curator of the institution, the Museum began to include in its schedule exhibitions that challenged the notion that folk expression—even broadly defined—ceased to be a factor in American culture after the nineteenth century. During this period, as art historian and curator Lynda Roscoe Hartigan observed in *Made with Passion,* the Museum of American Folk Art "became the principal arena for regularly staging one-person, thematic and genre-specific exhibitions," and "its exhibition program . . . signaled a major change in the field."

Previously, the Museum had been concerned almost exclusively with eighteenth- and nineteenth-century folk sculpture and painting, categories that had been codified by curator Holger Cahill in two pioneering exhibitions at The Newark Museum: "American Primitives: An Exhibit of the Paintings of Nineteenth Century Folk Artists" in 1930–1931 and "American Folk Sculpture: The Work of Eighteenth and Nineteenth Century Craftsmen" in 1931–1932. Now, however, with the broader perspective that Hemphill encouraged, the Museum could embrace a more eclectic and wide-ranging program, which was supported by Mary Childs Black, the Museum's director from 1964 to 1970. In its first decade of operation, the Museum showed photographs of contemporary roadside signs, William Edmondson's carvings, the art of tattoo, and the paintings of Louisiana artists Bruce Brice, Clementine Hunter, and Sister Gertrude Morgan, and mounted other exhibitions that featured twentieth-century materials. Hemphill's landmark 1970 presentation, "Twentieth-Century Folk Art and Artists," marked a significant turning point, not only in the history of the Museum but in the field.

That the Museum was able to adopt this enlarged purview was, at least in part, the result of advances in the understanding of American folk art itself. Cahill's Newark exhibitions, in keeping with the thinking of the day, tended to characterize folk art as anonymous, as if the individual hand of the artist were beside the point. In the following decades, however, scores of eighteenth- and nineteenth-century artists were identified, along with

the differing vocational or avocational contexts in which they worked; the nature and extent of their training; the influence of local, regional, and ethnic traditions on their creativity; and the varied sources, levels of personal virtuosity, and technical skills that they brought to the artistic endeavor. It was now possible to discern visual, contextual, methodological, thematic, and other continuities, if not direct lines of transmittal, between the earlier artists and those who worked in the twentieth century. It should be acknowledged that these continuities were often accidental, rather than related to the essence of the art or its production, but they nonetheless provided an argument for extending the field into the present. Not only did this represent a break from the model that had been established by Cahill, but it placed even greater distance between American usage and the original, European understanding of folk art as the tradition-bound household arts of peasant communities—an idea that had had little influence on the development of the field in the United States, although it continued to resonate within the disciplines of folklore, folklife studies, and cultural anthropology.

Differing usage and discipline-based approaches to folk art in the United States have resulted in a highly charged and often rancorous debate, which has been all the more frustrating because the different sides rarely are concerned with the same classes of cultural production. This has resulted in parallel discussion, rather than meaningful discourse. Moreover, the growing international interest among collectors, curators, and critics in the work of twentieth-century self-taught artists—a notable feature of the 1990s—has further complicated the discussion. Increasingly, distinctions are being drawn between

folk art, on the one hand, and such categories as outsider art, visionary art, or intuitive art, on the other. Rather than clarifying matters, however, the distinctions too often are drawn at the expense of the older term: "folk art" is defined according to more specific, more limiting European criteria, but it is also stigmatized as static, shallow, and derivative. Authenticity and aesthetic strength are claimed to reside solely in the artworks of persons living at the margins of society, especially those afflicted with mental illness. While it is undoubtedly true that passion and power may be found in abundance among "outsiders," these virtues are no less in evidence among artists who draw from the wellsprings of community. In fact, when the surface

A FRIEND IN NEED IS A FRIEND INDEED / Henry Church Jr. / 1885 / Stone and iron / approx. 40 × 84 × 16" / Collection of Frances O. Babinsky

is scratched, the full complexity of each artist and of his or her work becomes apparent. Facile and narrow labels that reduce the creative spirit to a single dimension are of little significance in the long run, especially when they obscure the multiplicity of intentions, ideas, meanings, influences, connections, and references inherent to every work of art. (Lamentably, even the terminology that was chosen for this exhibition and catalog—"self-taught"—fails

for this reason.) The artwork represented here is essential to an understanding of the American experience in its fullness. What has been needed is the more measured, more balanced approach that is taken here.

Interestingly, although the Museum rejected the limitations of Holger Cahill's early configuration of the field of American folk art, its extended mission was well within the demonstrated areas of his interest. Having followed his Newark exhibitions with the influential "American Folk Art: The Art of the Common Man in America, 1750–1900" at The Museum of Modern Art in 1932, Cahill served as curator of the American section of "Masters of Popular Painting: Modern Primitives of Europe and America" at the same institution in 1938. In the introduction to the catalog for that exhibition, Alfred H. Barr Jr., then director of The Museum of Modern Art, characterized the presentation as the third in a series of exhibitions on "*the major divisions or movements in modern art* [emphasis mine]," the others being abstraction and surrealism. Among the American artists chosen by Cahill were the nineteenth-century painter Edward Hicks, and John Kane, Joseph Pickett, and Horace Pippin. Implicitly recognizing that their paintings could be (and, in fact, had been) contextualized as folk art, Barr rejected this approach in favor of one permitting, he asserted, more appropriate emphasis on the artists' individual talents and distinctiveness. But despite the ambitious claims that Barr and Cahill advanced on behalf of these "masters of popular painting" (ironically, using an adjective from the French—*populaire*—that may also be translated as "folk"), The Museum of Modern Art, and the modernist world with it, would later surrender their interest in the field, at least for much of the second half of the century. Modernism had opened the door to an appreciation of folk art in the 1920s and the 1930s, but the fascination was short-lived. The work of twentieth-century American self-taught artists would become the exclusive province of a lively network of collectors and dealers, tied more often than not to an interest in folk art and strongly influenced by Hemphill, his exhibitions at the Museum of American Folk Art and other institutions, his collecting patterns, and the book that he and Julia Weissman published in 1974, *Twentieth-Century American Folk Art and Artists*.

Robert Bishop, who served as director of the Museum of American Folk Art from 1977 to 1991 after a remarkably varied career in the performing and visual arts, was an active participant in this network and a tastemaker in his own right. Even before taking over the helm of the Museum, he had demonstrated a strong commitment to twentieth-century folk art through his important discoveries in the field and through his personal collecting interests. Under his stewardship, the Museum continued to explore contemporary creativity, while preserving its long-standing interest in eighteenth- and nineteenth-century folk art. It was during his tenure as director that the Museum's permanent collection grew to include hundreds of twentieth-century paintings and objects in a variety of media.

At the same time, the world outside the

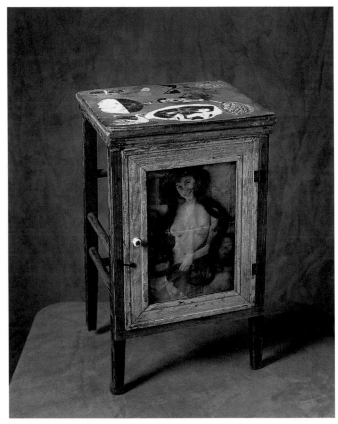

UNTITLED / Steve Ashby / n.d. / Oil house paint on wood with hinges, serrated rubber pad, upholstery tacks, picture frame, magazine photo collage, glass, ribbon, human hair, hook, ceramic knob, and metal rod with wooden washers / 23 ³/₄ x 14 ¹/₄ x 13" / Collection of Robert A. Roth

Museum of American Folk Art was clearly waking to the importance of the field. "Transmitters: The Isolate Artist in America," organized by Elsa Longhauser at the Philadelphia College of Art in 1981, was widely appreciated as a landmark, as was Jane Livingston and John Beardsley's "Black Folk Art in America, 1930–1980" at The Corcoran Gallery of Art in Washington, D.C., the following year. The acquisition of major portions of the col-

lection of Herbert Waide Hemphill Jr. by the Smithsonian Institution's National Museum of American Art in 1986 caused a sensation. Lynda Roscoe Hartigan's *Made with Passion*, the catalog of the resulting exhibition, provided the first detailed history of the field and was of inestimable importance in legitimizing this area of study. Several influential regional exhibitions occurred during this period as well.

While the 1980s were eventful, the 1990s witnessed an explosion of interest unlike anything previously experienced, with the principal art museums of the country adding the work of self-taught artists to their collections and exhibition schedules. To be sure, this was in part a response to the nation's multicultural agenda; nonetheless, it was a real and significant change. The Milwaukee Art Museum, for example, which had had a strong commitment to the field over many years through the interest of its director, Russell Bowman, acquired the pioneering folk art collection of Michael Hall and Julie Hall, which consisted primarily of twentieth-century paintings and sculpture. The Los Angeles County Museum of Art presented "Parallel Visions: Modern Artists and Outsider Art," organized by Maurice Tuchman and Carol S. Eliel, in 1992; the New Orleans Museum of Art organized "Passionate Visions of the American South" in 1993, with Alice Rae Yelen as curator; and "A World of Their Own: 20th-Century American Folk Art," with Joseph Jacobs as curator, was presented by The Newark Museum in 1995. Also in 1995, a promising new institution, the American Visionary Art Museum, with a mission specifically addressing these issues, was founded in Baltimore through the efforts of Rebecca Hoffberger. For its part, the Museum of American Folk Art emphasized incisive single-artist presentations during the last decade of the century. It either organized or hosted exhibitions of the work of Henry Darger, Thornton Dial Sr., Minnie Evans, William Hawkins, Achilles Rizzoli, and Ellis Ruley, while including many others in group or thematic presentations, all under the discerning eye and thoughtful care of the Museum's curator, Stacy C. Hollander. In 1997, I announced the formation of The Contemporary Center, an institutional division of the Museum of American Folk Art, to be devoted solely to twentieth-century (and, by extension, twenty-first-century) artists. Spearheaded by Museum patrons Didi Barrett and Samuel Farber, The Contemporary Center has a broad-based and

international mission.

It was in affirmation of these developments that "Self-Taught Artists of the 20th Century: An American Anthology" was organized. Intended as a critical consideration of a full century of astonishing artistic creativity, the exhibition had its origins in a series of conversations that I had with Selwyn Garraway, then Program Associate of the Lila Wallace–Reader's Digest Fund, soon after I became director of the Museum of American Folk Art in late 1991. His belief in the project, and the generous support of the Lila Wallace–Reader's Digest Fund, permitted planning for the exhibition to be undertaken. Joining these early discussions was Claudia Polley, whose creative participation helped shape the project. Implementation of the exhibition and publication was made possible by a thoughtful grant from The Henry Luce Foundation. I should like to express my deep gratitude to Henry Luce III, Chairman; John Wesley Cook, President; and Ellen Holtzman, Program Associate for the Arts. Additional, very kind support for this catalog was provided by the Dolfinger-McMahon Foundation and Jill and Sheldon M. Bonovitz of Philadelphia, which I am pleased to acknowledge with thanks.

Elsa Longhauser long ago established a well-deserved reputation for insightful, rigorous exhibitions on the cutting edge of world culture, many of which considered the work of self-taught artists. I have previously referred to her significant "Transmitters: The Isolate Artist in America." She has also presented exhibitions of the Gugging artists, Adolf Wölfli, Martin Ramirez, and others at Moore College of Art and Design, where she has served, since 1983, as director of the Goldie Paley Gallery and the Levy Gallery for the Arts in Philadelphia. I was delighted when she accepted my invitation to serve as guest curator of "Self-Taught Artists of the 20th Century: An American Anthology," and pleased when she suggested that the eminent Swiss "exhibition-maker," Harald Szeemann, share the appointment with her. Szeemann, an independent curator at Kunsthaus Zurich, was director of Kunsthalle Bern from 1961 to 1969. Internationally recognized for the scope, power, and prescience of his many exhibitions, he directed documenta 5 in Kassel in 1972, which brought the paintings of Adolf Wölfli to a world audience, and was co-organizer of the Venice Biennale in 1980. Art brut has figured importantly in his work. Longhauser and Szeemann were an immensely imposing team as they

traveled in pursuit of the exhibition's objectives. "Self-Taught Artists of the 20th Century: An American Anthology" was shaped through several years of intensive, thoughtful, and critical inquiry. The ideas developed, honed, and shared by the co-curators over countless hours of travel throughout the country gave the exhibition its aesthetic strength and breadth of vision. My gratitude to them is without bounds.

Working closely with Longhauser and Szeemann was Lee Kogan, director of the Folk Art Institute, the educational arm of the Museum of American Folk Art. As project coordinator, she embraced the exhibition and catalog with whole-hearted commitment. She collaborated with the co-curators on all aspects of the project, acted as staff liaison, prepared the bibliography for this volume, and brought her own insights and deep knowledge of the field to the curatorial process. She has my profound appreciation.

The editing of a manuscript that involved so many contributors, each with a distinctive voice and approach to the subject, required special sensitivity and skill. Ben Boyington assumed this challenging role; I am indebted to him for his outstanding efforts.

As always, the members of the professional staff of the Museum of American Folk Art gave of themselves without reserve. This was an exceptionally complex and demanding project to organize. Without the care and dedication of the Museum's staff, it would have been impossible to accomplish the goals of the exhibition and book. My heartfelt thanks go to Stacy C. Hollander, curator, for overseeing the internal administration of the project with great professional aplomb and attention to detail; Ann-Marie Reilly, registrar, for her creative and constructive approach to problem-solving; Rosemary Gabriel, director of publications, and Tanya Heinrich, production editor, for their unflagging commitment to this catalog and meticulous concern for its excellence; Judith Gluck Steinberg, assistant registrar, for her assiduous efforts in arranging the exhibition tour; Joan Sandler, director of education and collaborative programs, Janey Fire, photographic services, Eugene Sheehy and Rita Keckeissen, volunteer librarians, Katya Ullmann, library assistant, for their significant contributions; and Riccardo Salmona, deputy director, and Susan Flamm, public relations director, for their critically important counsel and advice

during every step in the development of the project. Research, editorial, and general support were provided by Dallas Brennan, William Brooks Jr., Abby Donovan, Stephen Feeney, and Teresa Parker, along with Deborah Ash, Nichola Groom, Barbara Klinger, Sherrill Kraus, Drunell Levinson, Paige Robinson, Philip Scher, and Anne Stringer. Theirs was a dedicated team effort, and I am delighted to acknowledge their contributions with thanks.

The word "anthology," which has been applied to this volume and the exhibition that it documents, is apt. The artists whose work is presented here are a diverse and talented lot. The same may be said of the catalog writers, who bring a variety of disciplines and approaches to their essays. A debt of gratitude is owed Maurice Berger, Arthur C. Danto, Gerald L. Davis, Emily Barton, Nan Bress, Norman Brosterman, Marshall Curry, Derrel De Passe, William A. Fagaly, Kenneth J. Gergen, Norman J. Girardot, Michael D. Hall, Marvin Heiferman, Robert Hobbs, Jon Ippolito, Jane Kallir, Mason Klein, Lee Kogan, Jack L. Lindsey, John L. Moore, Joachim Neugroschel, Teresa Parker, Carter Ratcliff, John W. Roberts, Ellen Handler Spitz, Judith E. Stein, Wendy Steiner, Robert Storr, Victor and Carol Millsom Studer, Ann Temkin, and Jay Tobler.

At Chronicle Books, which has published this volume in association with the Museum of American Folk Art, thanks are due to Christine Carswell and Adam Bluestein of the editorial department, copy editor Judith Dunham, and Carole Goodman for her excellent book design. This collaboration was one of the special pleasures of the project.

Finally, deep and abiding appreciation is due to the lenders to "Self-Taught Artists of the 20th Century: An American Anthology." Their staunch commitment to the exhibition was of paramount importance to the realization of its goals. Although it may be a decade or more before historians have enough distance to assess the twentieth century, it is clear that it has been a time of dramatic if not tumultuous change. If the century is to be understood in its fullness, privileged voices are not the only ones that may be heard. I hope that this volume and the exhibition that it documents, by fostering appreciation for the work of artists who too often have not been heard despite their eloquence, may be a major contribution to that understanding.

INTRO
DUCTION

ELSA LONGHAUSER

This exhibition sur- veys the accomplishment of American artists who have worked outside the confines of art schools, galleries, and museums. Although this position often has been viewed as limited (in education or resources, for example), we have found it to be one of freedom—freedom from institutional convention and expectation. The exhibition spans the twentieth century. It comprises paintings, drawings, sculpture, constructions, and installations by thirty-two artists of varying backgrounds who come from urban and rural locales throughout the United States. Some of the artists made their art for decades, others for only a few years, but each created a significant body of work that has the resonance all art must possess to excite and sustain interest over time.

The earliest work in the exhibition is a traditional still-life painting by Henry Church, in which a perfect bowl of fruit is centrally placed amidst a sedate Victorian interior. Tranquillity, however, soon turns to chaos in a second painting as two monkeys enter the room and disrupt the careful arrangement. As Church's first painting gives way to his second, we enter the territory of the exhibition. The artworks have an inventiveness of conception and execution, and a wry humor that does not flag even when the subject matter is contemplative and serious. Edgar Alexander McKillop carves a monumental wooden *Hippoceros* that has a Victrola built into its back; when the record plays, the animal's tongue moves in and out in time to the music. Steve Ashby's whirligigs are populated by collaged and constructed characters who perform graphic sexual acts when the wind blows through them. Leroy Person's incised and assembled wooden thrones, though wobbly and crooked, nonetheless have an uncanny elegance. On a paper megaphone used for street preaching, Sister Gertrude Morgan paints a portrait of herself, in an airplane with Jesus, and entitles it *Jesus Is My Co-Pilot*.

In preparation for the exhibition, traditional curatorial research was conducted in museums, galleries, and private collections. We consulted an ever-growing network of artists, collectors, curators, and scholars—many outside the field—so that a range of perspectives was consistently factored into the curatorial framework. In addition to choosing work by such well-known artists as Martin Ramirez, Henry Darger, William Edmondson, Bill Traylor, Grandma Moses, Joseph Yoakum, and Elijah Pierce, we were pleased to include several artists—Henry Church Jr., Edgar Alexander McKillop, A.G. Rizzoli, Steve Ashby, Emery Blagdon, Leroy Person, and Ken Grimes—whose work is either little or completely unknown.

The traditional resources yielded valuable information, but the very nature of this work took us well beyond the usual artworld venues. We traveled little-known roads, from major cities to rural towns. Even though we were familiar with an artist's work before our visit, each trip yielded unexpected revelations. In Birmingham, Alabama, for instance, Lonnie Holley spoke eloquently about the philosophy of his evolving two-acre garden, a tangled and beautiful mass of nature, assembled junk sculpture, and sandstone carvings. In Rocky Mount, North Carolina, we had to rummage through a tiny storage room at the back of a church to locate and photograph the marvelous cache of Leroy Person's carved sculpture, tables, and chairs. When we first saw Emery Blagdon's healing machines, they were stored in a warehouse in North Platte, Nebraska. A farmer by profession, Blagdon retired in his mid-forties, after receiving an inheritance from his uncle, and spent the next thirty years making more than a thousand wire constructions and circuitlike paintings, which he

assembled in his shed and lit with colored Christmas bulbs. Blagdon believed that this miraculous kingdom of twisted wire and twinkling light would cure a variety of physical ailments and complaints. Henry Darger's room, in Chicago, yielded yet another poignant moment, as the reality of Darger's modest circumstances was set against the grandeur of his lifework.

The thirty-two artists in this exhibition were selected because their work was rich in those qualities that characterize any serious work of art: inherent expressive power; the transformation of an idea, emotion, vision, or communal values into a personal and symbolic vocabulary of form; visual impact; technical virtuosity; and enduring resonance. The selection emerged at the end of a long process. We looked at the work many times, over and over again.

The catalog of the exhibition is a compendium of voices—many new to the field—that represent the different ways one can consider this work. We invited three distinguished scholars to write major essays and discuss the artworks from their particular points of view. Art historian Maurice Berger provides a sociopolitical analysis of the field, emphasizing the pitfalls of codifying this

UNTITLED (AFRICAN THRONE) / Leroy Person / n.d. / Carved and assembled wood / 35 × 26 ½ × 23" / The Robert Lynch Collection of The Daisy Thorpe Gallery at North Carolina Wesleyan College

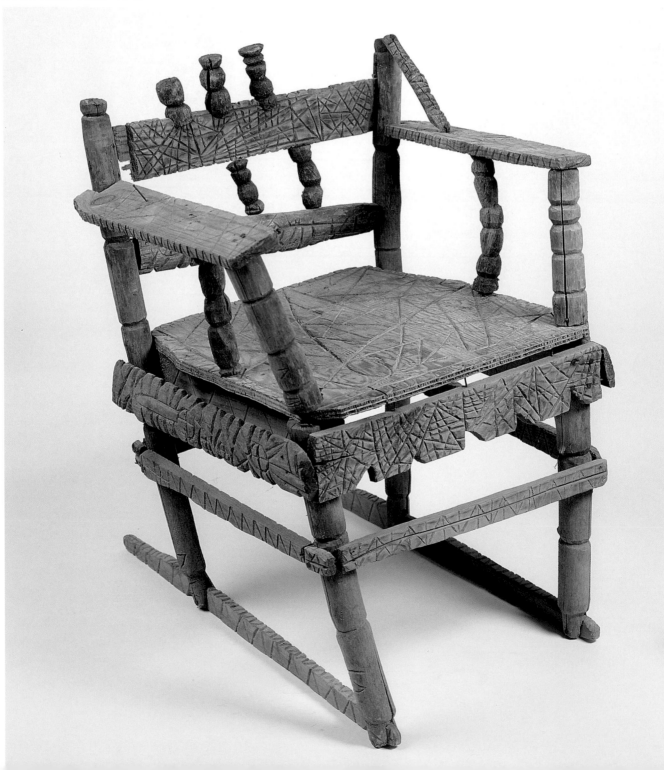

work under a single rubric; art critic and philosopher Arthur Danto writes about the evolving interplay between art of the artworld and of the non-artworld; and folklorist Gerald Davis argues for a consideration of the work as an expression of a mature communal aesthetic standard. We invited twenty-nine additional writers from a broad range of disciplines to contribute biographical and interpretive texts on each artist. This list of authors is made up of art historians, critics, and curators; scholars of cultural studies and psychology, theology, English literature, and folklore; a psychoanalyst, an architect, and a linguist, as well as other artists.

The work of self-taught artists does not fit comfortably within the art-historical canon. Finding the right title for this exhibition underscored the limitation of language to describe the work adequately without sounding hackneyed, overly lyrical, or ambiguous. "Self-taught" is an imprecise term; it does not define a movement or a style. "God don't want much style," William Edmondson said. God told Edmondson to make art, and he did because he could, because he was an artist. This exhibition considers these artists on their own terms. It acknowledges the range and breadth of their talent, and rejoices in their creations.

———

My thanks to all those whose diligence and commitment helped this project evolve from concept to reality. Gerard Wertkin has been an unfailing source of encouragement throughout. As exhibition coordinator, Lee Kogan, director of the Folk Art Institute at the Museum of American Folk Art, has been integral to the curatorial process. The staff of the museum have been energetic teammates. Artist and scholar Michael Hall worked with me to develop a framework for my early research. Dallas Brennan's assistance with the organization of the exhibition and catalog was invaluable; her successor, Abby Donovan, assiduously attended to the details in advance of the exhibition's debut.

The catalog essayists have done an exemplary job in examining the work of self-taught artists. The range of their individual voices and respective points of view give breadth to this important critical anthology. Mason Klein's editorial assistance was especially invaluable.

Many museum directors, curators, and scholars provided advice and wisdom. They include Maurice Berger, Russell Bowman, Lynda Roscoe Hartigan, Joseph Jacobs, Steven Loring Jones, Mason Klein, Jack Lindsey, Roger Manley, Elka Spoerri, Ann Temkin, and Jay Tobler. To these colleagues, my heartfelt thanks.

The numerous collectors we visited were unstinting in their graciousness and enthusiasm. My special thanks to Everett Adelman; Judith Alexander; William Harrison, Matthew, and Paul Arnett; Didi and David Barrett; Anne Hill and Monty Blanchard; Jill and Sheldon Bonovitz; Dan Dryden, Don Christensen, Trace Rosel, and Eleanor Sandresky; Sam and Betsey Farber; Estelle Friedman; Robert Greenberg and Corvova Lee; Albert and Jane Hunecke; Kiyoko Lerner; Richard Levine; William Louis-Dreyfus; Jim Nutt and Gladys Nilsson; David T. Owsley; Siri von Reis; Lisa and David Roberts; Robert Roth; Selig D. Sacks; and Judy Saslow.

At the Philadelphia Museum of Art every detail involved in the exhibition's inaugural presentation was handled with careful consideration and aplomb. My thanks to all those who helped make our curatorial vision concrete: Anne d'Harnoncourt, director; Ann Temkin, curator of twentieth-century art; Jack Lindsey, curator of American decorative arts; Suzanne Wells, special exhibitions coordinator; Alice Beamesderfer, special assistant to the director for projects; Jack Schlechter, installation designer; Irene Taurins, chief registrar; Elie-Anne Chevrier, registrar; Karen Binswanger, research assistant; Martha Masiello, senior installation technician; and the many assistants in each of these departments who worked on this project as well.

I am grateful, as well, to all the lenders for their generosity and to the following gallery directors for their cooperation: Shari Cavin and Randall Morris, Eugene Epstein, Janet Fleisher and John Ollman, Skot Foreman, Bonnie Grossman, Carl Hammer, Tim and Pamela Hill, Carroll Janis, Jane Kallir, Phyllis Kind and Ron Jagger, Frank Maresca and Roger Ricco, Robert Reeves, and Luise Ross and Robert Manley.

Harald Szeemann has been a great partner in this endeavor. His encyclopedic mind and capacity for embracing life in all its variations have made this an incomparable adventure.

ACKNOWLEDGMENTS

A project of this scope and complexity could not have been accomplished without the assistance and cooperation of many individuals. The Museum of American Folk Art acknowledges with gratitude the following colleagues for their expertise and help in facilitating loans for the exhibition and photography for the catalog:

Catherine H. Grosfils, Visual Resources Editorial Librarian, Barbara R. Luck, Curator, Paintings and Drawings, and Anne Motley, Registrar, Abby Aldrich Rockefeller Folk Art Center, Colonial Williamsburg Foundation; Ann Whaley, Assistant Registrar, Ackland Art Museum, The University of North Carolina at Chapel Hill; Medha Patel, Coordinator of Photographic Services, Rights and Reproductions, Carnegie Museum of Art; Howard T. Agriesti, Museum Photographer, Bruce Christman, Chief Conservator, and David Steinberg, former Assistant Curator of American Art, The Cleveland Museum of Art; John Owens, Head of Exhibition Programs, and Brian Young, Assistant Registrar, Columbus Museum of Art; Mary Haas, Registrar of Photo Services, The Fine Arts Museums of San Francisco, M.H. de Young Memorial Museum; Linda Skolarus, Access Services Coordinator, and Mia Temple, Researcher, Henry Ford Museum & Greenfield Village; Joanne Cubbs, former Curator of Folk Art, and Kimberly R. Schell, Assistant to the Registrar, High Museum of Art; Raechelle Smith, Director of Exhibitions, Kansas City Art Institute; Ellen T. Clark, Assistant Director for Programming, Emil Donoval, Registrar, Bridget Haggerty, Marketing Coordinator, and Ruth Kohler, Director, John Michael Kohler Arts Center; Everett Mayo Adelman, Associate Professor of Art and Curator, The Robert Lynch Collection of The Daisy Thorpe Gallery at North Carolina Wesleyan College; Deanna Cross, Photo Slide Library Senior Coordinator, Lowery Sims, Curator, 20th Century Art, and Trine Vanderwall, Associate Loans Coordinator, The Metropolitan Museum of Art; Margaret Andera, Curatorial Assistant, Russell Bowman, Director, and Judith Palmese, Registrar's Assistant, Milwaukee Art Museum; John Alexander, Associate Permissions Officer, Mikki Carpenter, Director, Department of Photographic Services and Permissions, and Avril Peck, Permissions Officer, The Museum of Modern Art; Annie Brose, Photo Services Technician, and Lynda Roscoe Hartigan, Deputy Chief Curator, National Museum of American Art, Smithsonian Institution; Kathleen Ryan, Rights and Reproductions, and Ann Temkin, Curator, 20th Century Art, Philadelphia Museum of Art; Tina Garfinkel, Head Registrar, and Jennifer Small, Assistant Registrar, San Francisco Museum of Modern Art; Ann Prival, Rights Administrator, Visual Artists and Galleries Association, Inc.; Ellin Burke, Associate Registrar, Permanent Collection, and Anita Duquette, Manager, Rights and Reproductions, Whitney Museum of American Art.

The Museum acknowledges the following gallery directors and staff for their generosity in sharing knowledge and time, and for providing photography for study purposes and publication in the catalog:

Bonnie Grossman and Wendy Morris, The Ames Gallery, Berkeley, California; Shari Cavin and Randall Morris, Cavin-Morris Gallery, New York; Eugene Epstein, Epstein/Powell, New York; John Ollman, Fleisher/Ollman Gallery, Philadelphia; Jane Kallir and Alithia Dutschke, The Galerie St. Etienne, New York; Carl Hammer and

Karen Smith, Carl Hammer Gallery, Chicago; Pamela and Tim Hill, Hill Gallery, Birmingham, Michigan; Timothy Keny, Keny Galleries, Columbus, Ohio; Phyllis Kind and Ron Jagger, Phyllis Kind Gallery, New York; Frank Maresca and Roger Ricco, Ricco/Maresca Gallery, New York; Luise Ross and Robert Manley, Luise Ross Gallery, New York; Judy A. Saslow, Judy A. Saslow Gallery, Chicago; Joan T. Washburn, Joan T. Washburn Gallery, New York; Marcia Weber, Art Objects, Inc., Montgomery, Alabama.

The following individuals deserve special recognition for their efforts in providing access to private collections and for sharing their insights into the artists selected for the exhibition:

Judith Alexander, Ben Apfelbaum, Paul Arnett, William S. Arnett, Frances and Jane Babinsky, Don Cristensen, Ann M. De Simone, Dan Dryden, Ken Fadeley, William A. Fagaly, Patricia I. Faux, H.W. Fraley, M.D., Estelle E. Friedman, Kelly Galligan, Larry Hackley, Michael D. Hall, Albert and Jane Hunecke, Nancy Karlins-Thoman, David Kassel, Nathan and Kiyoko Lerner, Alastair B. Martin, Charlotte Mullavey, Gladys Nilsson, Nigel Noble, Jim Nutt, David T. Owsley, Cynthia Peterson, Curator, The Anthony Petullo Collection of Self-Taught & Outsider Art, Claudia Polley, Robert Reeves, Trace Rosel, Chuck and Jan Rosenak, Robert A. Roth, Eleanor Sandresky, Bob Seng, Ute Stebich, Jay Tobler, and Lanford Wilson.

UNTITLED (BLACK JESUS) / Bill Traylor / 1939–1942 / Gouache and pencil on cardboard / 13 ¾ × 10" / The Metropolitan Museum of Art / Promised gift of Charles E. and Eugenia C. Shannon, 1995 / L.1995.38.10

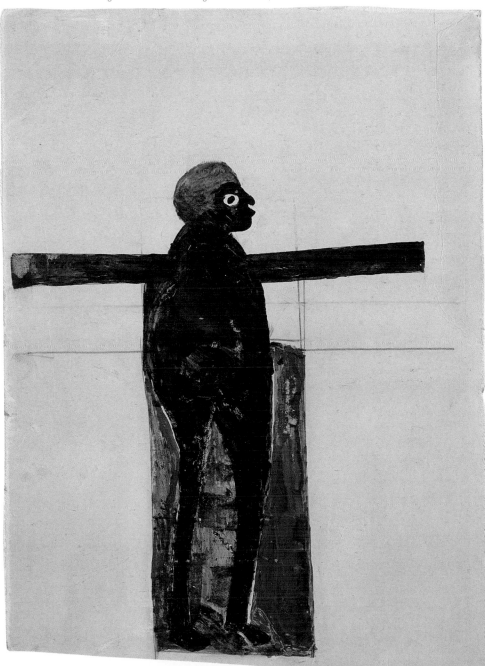

THE

ARTWORLD AND ITS OUTSIDERS

ARTHUR C. DANTO

In order to define art correctly it is necessary first of all to cease to consider it as a means to pleasure, and to consider it as one of the conditions of human life.

—Leo Tolstoy, *What Is Art?*

Philosophers in recent years have begun to refer to a commonplace and possibly indispensable body of explanatory principles as "folk psychology." We practice folk psychology, according to this usage, whenever we try to understand anyone's behavior with reference to their beliefs and desires—whenever, for example, someone's flipping a switch is explained through his wanting the lights to go on and his belief that flipping the switch is a means to that end. Of course, such an explanation may be wrong—someone may only have wanted to see if the switch worked, or, if from a very distant culture, wanted to see what would happen if one moved that thing in the wall. But this would only mean that we had misdescribed his beliefs and wants, not that there was something as hopelessly primitive as the sneering use of "folk psychology" implies in the entire practice of explaining their behavior through beliefs and desires.

A century ago, "folk psychology" would certainly have been understood to mean the psychology of the folk, understood as backward peoples, living close to nature in largely tradition-bound cultures, with very different and definitely more primitive ways of thinking about their world than civilized and evolved people like ourselves think about the world. When the French anthropologist Claude Lévi-Strauss wrote his book *La pensée sauvage* (*The Savage Mind*, 1966), it was understood from the title that it would describe the way primitive minds thought and how the patterns of primitive thinking would differ from our—presumed superior—patterns. These implications are certainly preserved in the recent philosophical usage. They insinuate that, however civilized and knowing we may be, the way in which we understand and explain one another's behavior remains primitive and retarded relative to a scientifically creditable mode of explanation, and that we are primitive through the fact that we continue to think this way. These philosophers believe (if we may use this discredited term) that in time to come, a sophisticated neuroscience will eliminate these practices in roughly the same way that primitive or savage—or folk—mentalities wither as they are replaced with more sophisticated mentalities. This may be lamentable, but it is the price of progress. In time to come, we will stop referring to mental states at all in the explanation of human conduct, much as we no longer explain the barrenness of women as due to the baleful influence upon them of local witches.

The contrast between folk psychology and a visionary neuroscience is not merely a contrast between two ways of representing human reality. The concept of "advanced" implies a measure of progress, as if the two methods of explanation and perception constituted lower and higher stages in a progression of knowledge, though it would generally be admitted that we are not yet at the implied higher stage. I shall return to folk psychology, but first I want to describe a parallel conception in art. It has been rather a while since the concept of progress has had great currency in the arts, but as historian and philosopher of science Thomas Kuhn observed in his influential text, *The Structure of Scientific Revolutions* (1962), "For many centuries painting was regarded as the cumulative discipline." The history of painting was progressive in part because—to revert to folk psychology—it was widely accepted that the goal of pictorial art could be defined through the conquest of visual appearances, and that there was a pictorial technology,

mastery of which was a condition for being a visual artist. The history of that technology was marked by breakthroughs, which included perspective, foreshortening, chiaroscuro, and the like, allowing, in Kuhn's phrase, for "successively more perfect representations of nature." Folk art, had it been noticed at all, deserved the title "art" only because it appeared to aspire to the same goal as painting or sculpture everywhere, but it would have been counted as folk primarily because its practice situated it at a regressed stage of the progress that had been taken to such heights in the great art centers of Europe. It was what the folk would have been capable of, folk culture being regarded as a relatively underdeveloped form of life, low on the same scale on which European culture was high. And the assumption would have been that the artists of such cultures would, given their goals, have painted like Florentines or Englishmen if only they knew how to—the way the Aztecs would certainly have adopted the wheel had they known about it, or the way Fijians today eagerly appropriate electronics, running shoes, and powerboats.

This did not in fact always happen in art, often because there were reasons, connected with the forms of life in which pictures figured, that might even have been incompatible with advanced technologies of pictorial representation. In China—a primitive civilization only from the most condescendingly parochial point of view—it was immediately recognized that perspective was precisely the right way to show objects receding in space when the Jesuit missionary Father Guiseppe Castiglione (1688–1766)—himself an artist—demonstrated how to do this. But the Chinese literati who acknowledged the advantage of mathematical perspective rightly felt that that was not the point of art in their cultural life, and that its objective preferability was therefore irrelevant to their artistic practices. What the Chinese recognized was that a distinction could be drawn between the role of art in a culture and that culture's means of picture-making. For example, Chinese painters typically alluded to earlier works in making their own pictures, a practice that would have become awkward if the earlier works belonged to a more primitive stage, as they would have had perspective been adopted. It just happened, the Chinese might have gone on to say, that Western culture was such that the role pictures played in it was inseparable from their optical truth—a connection that did not exist

in their culture. In a similar way, folk artists might very well have acknowledged the objective discoveries that defined the progress, without feeling that they could benefit from them. Pictures, for them, might have other roles to play, so that the technologies of progressive accuracy in visual representation were inconsistent with the function pictures performed in the life of their cultures. It is even thinkable that the Aztecs might have reflected on what the cultural costs of adopting the wheel might have been, and decided it was not for them.

It would only, by the way, be relative to a scheme of artistic training which went with these technologies that folk artists would be regarded as "untrained" or poorly trained. There might be all sorts of spiritual training connected with being an artist in cultures in which someone became an artist very much as others became priests or shamans. But it took a long time before Westerners could accept this, as the continued use of such terms as "primitive" in connection with the arts of (to us) exotic cultures shows—or, for that matter, the term "folk" itself, which clearly carries the connotation of backwardness that those who deprecate the practices of folk psychology appeal to in drawing their contrasts. The idea of multiculturalism is an effort to rectify these condescensions, by relativizing the arts to the various forms of life to which they might originally have belonged, and between which no ranking order is considered legitimate (the idea of "quality," for example, has come to be regarded by some as illegitimate even within a given culture).

Commendable as such relativism is, it tends to be blind to its own cultural parochialism, in that it seeks to assimilate all art, irrespective of its various functions in various forms of life, to the institutional practices of an exhibiting culture, where we are supposed to look at all art in the same spirit of aesthetic detachedness with which we are alleged to look at our own. The museum is a very powerful solvent of cultural differences, and is monocultural in its cultural pluralism—exhibiting all sorts of art but presenting it in much the same ways: mounted in display cases or hung on walls. It is in any case precisely because certain examples of folk art came to be regarded as capable of holding their aesthetic own with the best of Western art that they have been transported from museums of natural history—where they served as examples of what other cultures were capable of—to museums of fine art,

where they stand to Western art in no different a relationship than that in which "schools" of Western art stand to one another. The acknowledgment of different schools—the Italian school, the French, the Spanish, and the Dutch schools—defined the structure of the art museum from its inception, beginning with the Louvre. Multiculturalists, then, want the art of various cultures also to be recognized as belonging to different schools—but this is tantamount to insisting that art, irrespective of its cultural provenance, all be addressed in the terms of one culture, namely our own. It is modernism that has made this possible.

It would always have been true that there was more to advanced Western painting than increasing competence in depicting perceptual phenomena. But until the advent of modernism, that order of competence was a precondition for anything further an artist might attempt. The relationship between folk art and (let us say) fine art underwent a revolution in the later decades of the nineteenth century, when the concept of a cumulative advance in representational adequacy dissolved and art history was no longer seen as the progress sixteenth-century writers and thinkers like Giorgio Vasari had assumed was its structure. What provoked the conceptual split between art and naturalistic representation is an unexplained problem in the cultural history of Europe, but the precise historical moment at which aesthetic attention began to be paid to folk art, in the 1860s, coincided with what is often regarded as the first moment of modernist painting, the creation of Manet's *Olympia* in 1865, and the destinies of modern art and folk art have been inseparably linked since. They have been as linked, in truth, as postmodern art has been with outsider art, into which the concept of folk art has somewhat uncomfortably evolved, though "folk" and "outsider" convey very different sets of associations.

The French painter and critic Gustave Courbet described Manet's provocative nude as follows: "it's flat, it isn't modeled; it's like the Queen of Hearts. . . ." And this witticism opened room for someone to say of the figure on a playing card that it was like Manet's *Olympia*. Whether or not playing card figures serve as fair examples of folk art, it is striking that Manet, through flattening his figures, began a systematic deconstruction of representational strategies that made the history of modernism look like the history of art run in

reverse. Part of this could have been the result of photography—after all, the great realist Paul Delaroche had declared in 1839 that with Daguerre's invention, painting was dead. And this was true at least with regard to the goal that had defined painting through the centuries, since all the skills that made someone an artist could now be built into a mechanism, which anyone could in principle operate, without having to learn to draw or paint photographically, as one might now be able to describe Delaroche's technique.

This meant that something other than exact representation would have to define painting, and it began to occur to artists that other cultures might have better answers to their questions than their own history provided, since the technology of pictorial progress no longer seemed pertinent to the meaning of painting. Van Gogh modeled himself on Hokusai; Gauguin preempted forms from Breton carvers and finally turned his back definitively on a culture he declared rotten. These were relatively early signals of a certain loss of cultural confidence that sent artists to less "evolved" cultures, not in the spirit of anthropological investigation, but to learn what in them might be emulated in seeking greater artistic authenticity. "We have the habit of thinking that the power to create expressive plastic form is one of the greatest of human achievements," wrote British art critic Roger Fry in his powerful 1920 essay "Negro Sculpture." And he went on to say, "I have to admit that these things are great sculpture—greater, I think, than anything we produced even in the Middle Ages. Certainly they have the special qualities of sculpture in a higher degree." Those who think of art as something peripheral to our society might ponder the deep transformations in Western self-appraisal that accompanied, if it was not caused by, the loss of faith in the preeminence of the art that had defined its superiority. One can discern in such aesthetic transformations prefigurations of political transformations to come—the breaking up of the great colonial empires and, collaterally, the opening up of the museum doors to forms of art that could no longer justifiably be excluded in terms of artistic "backwardness."

In "The Innocent Eye, American Folk Sculpture" (*Two Hundred Years of American Sculpture*, Whitney Museum of American Art, 1976), Tom Armstrong draws attention to a 1928 work by a paradigmatic modern artist, Alexander Calder: a boxwood figure of a horse that, "carved and assembled

in three parts, expresses the essential character of the animal in an abstracted manner, with emphasis upon the attitude of the legs and the extended neck and head." Armstrong compares Calder's *The Horse*, now in The Museum of Modern Art in New York, with a work done around the same time by "folk" artist Edgar Alexander McKillop: *Hippoceros*, now in the collection of the Abby Aldrich Rockefeller Folk Art Center. The basis of the comparison is that McKillop's figure "expresses the artist's similar ability to select and emphasize those elements which contribute most to his personal statement." This, Armstrong writes, "encourages the application of similar judgments about the work," and shows that "Folk art should be considered within the same hierarchy of criteria that we apply when making judgments about contemporary art." Armstrong is applying the same order of aesthetic initiative we find in Fry's essay (published at about the same time Calder made his horse), from the perspective of which it really makes no special difference, aesthetically speaking, whether the object of our scrutiny is a piece of "negro sculpture," of modern sculpture,

basis now for distinguishing folk art from fine art or modern art from "negro art." From this perspective, Calder and McKillop merely have "parallel visions," to preempt the title of the 1992 exhibition of "outsider art" organized by the Los Angeles County Museum of Art.

Armstrong could have used Fry's "expressive plastic form" to characterize both his artists. "The masterworks of American folk art in the nineteenth century," Armstrong wrote, "are now appreciated in terms of twentieth-century art which consciously recognizes many of the same aesthetic criteria intuitively realized by American folk sculptors of the past." The old slope of progressive representational adequacy, which set folk art at a significantly lower rank than the art (say) of Sir John Millais, has been replaced with a different slope, on which Calder and McKillop occupy the same position and (perhaps) Sir John Millais has a long way to go to pull abreast of either. Such was the transformation in attitudes toward art wrought by modernism. Modernism, with its emphasis upon form, took a step in the direction of dissolving the

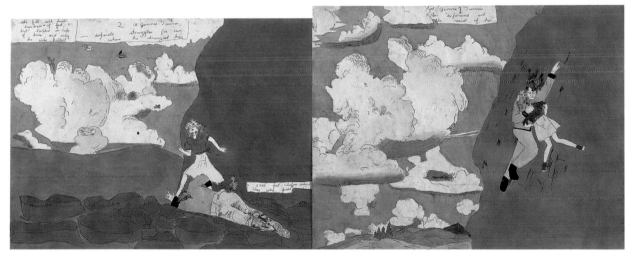

UNTITLED (2000 FEET BELOW/RED MOUNTAIN) DOUBLE-SIDED, RECTO/VERSO / Henry Darger / n.d. / Watercolor, ink, and pencil on pieced paper / 17¾ × 47¼" / Collection of Robert M. Greenberg

or of folk sculpture. This attitude would hardly have been available to anyone a century earlier, unless to an art lover who happened to be a disciple of Jeremy Bentham, whose view it was that "Quantities of pleasure being equal, pushpin is as good as poetry." There may have been some for whom, by hedonic criteria, the Queen of Hearts was as good as Manet's *Olympia*, but Armstrong, like Fry, has gone beyond considerations of pleasure to considerations of selection and emphasis, and the contributions these make to an artist's personal statement. From this perspective there is really scant

differences between museums of modern art and museums of folk art.

Armstrong's discussion of Calder's piece occurs just after a discussion of two sets of utilitarian objects from the folk art domain, to which *The Horse* has unquestionable formal affinities. The first is a set of weathervanes, in the shape of a hen and some roosters, from around 1885; the second is a crane decoy by an unknown artist, from 1907. These objects have the look they have because of their intended use: the crane decoy looks cranelike enough to fool cranes, and the weathervanes are

flat, to catch the wind. The decoy has no surplus, one supposes, of symbolic meaning, unlike the weathervanes, which resemble hens and roosters because of symbolic associations, doubtless to the barns on which they would be mounted, enabling the farmer or his wife to read the wind's direction as they step outside the farmhouse. But there are certainly weathervanes in the form of horses, and it is altogether within the realm of possibility that a weathervane might have been made by some name-less folk carver that exactly resembled Calder's *Horse*. But this makes room for the kind of thought experiment I have so often used in my philosophi-cal discussions of art, in which we imagine two objects, perceptually as alike as is required for pur-poses of the case, hence exactly alike if need be. We then recognize that despite their perceptual similarities, there are great differences between them—as great as the difference between Andy Warhol's *Brillo Box* and its lookalike counterparts in supermarkets, one being a work of art and the other not. And the question then is how to explain the difference if it is not perceptual.

In truth, it would not have been inconsistent with Calder's artistic agenda in the 1920s for he himself to have made a weathervane. In 1925 he made a sundial using the form of a cockerel, and in 1927 he was making moving toys for the Gould Manufacturing Company. During that same period, he made the familiar animals and wire figures with which he put on circus performances in his studio. *The Horse* was acquired by The Museum of Modern Art as part of the Lillie P. Bliss Bequest in 1943. The newly acquired work would doubtless have been welcomed as an early piece by an important mod-ernist artist, and hence part of the history of mod-ernism. Calder was now making the abstract, unpowered, moving sculptures—the mobiles—which had become so recognizable a part of the modernist canon. The important point is that in 1928 mod-ernism had reached a point where it was possible for someone whose work, or at least some of it, might easily have been seen as folk art to be counted an artist, even an important artist.

So now let us suppose that in 1943 a weathervane is found, one that looks as much like *The Horse* as our example requires, and is donated to the Abby Aldrich Rockefeller Folk Art Center. It would not have been donated to The Museum of Modern Art, unless the latter had developed a department of folk art, and it would then have been accepted by the kind of criteria Armstrong invokes in his discussion of McKillop: "Folk art should be considered within the same hierarchy of criteria which we apply when making judgments about contemporary art." But at just that moment of his-tory, it would be doubtful that the department of folk art would have accepted McKillop's piece, mainly because in 1943 modern art had not evolved to a point where work that looked like that had entered the modernist canon. Jean Dubuffet had only, for example, begun to take up art again in 1942, and his concept of art brut belongs to the postwar years.

The history of modernism was, we might say, selectively enfranchising. Modernists had begun in the 1920s or even earlier to admire and to collect folk art, and to see in the pieces of folk art, placed as decorative items in the fishing shacks in which painters at Ogunquit, Maine, spent their summers, something more than conveyers of local color. We could imagine the same items, serving the same emblematic and decorative functions, placed in such shacks two or three decades earlier, when they would have been seen merely as part of the identifying background, like steering wheels and painted floats and lobster traps and maybe mounted fish. To have begun to see such folk art as art, and indeed as offering the possibilities of an escape from academic formalism and from impres-sionism, similar to what van Gogh had seen in Japanese art or Gauguin in the art of other exotic cultures, required a deep transformation of per-ception that would have been available only to those who participated in the structures of the art-world of the 1920s. The first citation of the expres-sion "folk art" listed in the *Oxford English Dictionary* was in 1921, though doubtless it was already estab-lished in artworld conversations before that time. The first exhibition of American folk art to be held at the Whitney Studio Club was in 1924. By 1928, when Calder put *The Horse* together, it had clearly become a possibility to go further than finding possibilities for modern art in folk art: it became possible for modern artists to make objects that could have been made by folk artists.

It is a mistake, I think, to speak here of par-allel visions. In one of Wittgenstein's best philo-sophical examples, a tribe is found that uses what in fact are the symbols of calculus as decorative ele-ments on their tents and in their embroideries. Imagine, even, that they have been doing this for

time immemorial. It would certainly be a mistake to say that they had anticipated Newton and Leibniz in hitting upon the notation of calculus centuries before them, or to juxtapose a photograph of one of their teepees with a page from a calculus text, and speak of these as parallel visions. Parallelism implies having no point in common, but nonetheless resembling one another to the degree that two straight lines are images of one another. Whatever the markings on the teepee are or mean, they cannot mean sums, integrals, derivatives, functions, and the like. You cannot just have calculus: calculus builds on trigonometry, on analytical geometry, on the whole history of mathematics. It would be out of the question to imagine the aborigines with calculus without the concepts of rates of change of rates of change. But similarly, were we to find a tribe whose textiles were like Mondrian's paintings, with eccentric black grids filled in with the primary colors, it would be wrong to speak of its weavers as having a vision parallel to that of Mondrian. To have a concept of primary colors would require theories not available before the work of John Dalton (1766–1844) and Hermann von Helmholtz (1821–1894); and the geometry again requires a certain attitude only someone in the platonic tradition would possess. There is no greater illusion in art than the view that similarity of object entails similarity of vision. And this would be as much true of the two "parallel" horses, Calder's and that of my imagined nameless carver from the slopes of Mount Katahdin. Calder arrived at his horse, almost certainly, from having participated in a set of conversations that defined the artworld of the 1920s. No one knows the history of my imagined "parallel horse," but we can imagine the artist giving as his reason for making the horse as he did that "Folks in these parts have always made horses this way, damned if I know why!"

I introduced the concept of an artworld in 1964, taking the expression from journalism and giving it a philosophical application. I did so in order to deal philosophically with the appropriations from reality that were being made by the pop artists in that time, for the question was made vivid for me as to why, say, the *Brillo Box* of Andy Warhol was an artwork while the Brillo boxes of the supermarket were not (it would be absurd to speak of Warhol and the carton makers as having "parallel visions"!). And I felt that in order to see Warhol's box as art required participation in the discourses of the artworld, mastery of some of its theories, and knowl-

edge of its relevant history. To belong to the artworld is to participate in an institutionalized conversation as to what art is and what it ought to be, and it is the nature of conversations that they are constantly under transformation by their participants, so that if someone drops out of the conversation at a given time, they can reenter it at a later time only by recognizing that the conversation will have evolved in unanticipated ways. At a certain stage in the conversations, objects of folk art—or some of them, namely those that embody some of the aesthetic features that the artworld acknowledges—can be seen as art. At a later stage, artworld artists can actually make such objects. At that point, the difference between the objects may in fact be as indiscernible as that between Calder's *Horse* and my imagined folk art horse. At that point, the differences may be so minimal that theorists begin to speak of parallel visions!

But the reasons that go into the explanation of each of the indiscernible works vary, and the reasons for appreciating them do so as well. And creativity follows the stream of the conversation. We can imagine Calder going on from moving toys to the mobiles and the stabiles. But we would not imagine a similar future for the folk artists, who are likely to turn out variations of the same horse indefinitely mainly because there is no institutional reason to do something else. Not unless the folk artist, as contrasted with his art, gets taken up into the artworld, and becomes participant in its conversations and modifies his own work in the light of them. Which could not have happened, given his lack of relevant training, in the artworld of the 1890s or the 1790s!

When Dubuffet's writings on art brut first appeared in 1976, the discourses of the artworld had taken a number of sinuous turns, each leaving behind deposits in the form of artworks made and artworks enfranchised. In particular, surrealism had entered and for a time even dominated the conversation, with its ideas of the creative unconscious and the sense that individuals who lived close to the unconscious—children and the insane, for example—produced work that was more authentically surrealist than anything the trained artist might come up with. Whole new domains of art were enfranchised in this way. Such art, Dubuffet wrote, "springing from pure invention and in no way based, as cultural art constantly is, on chameleon- or parrot-like processes," is evidence for a certain

natural artistic bent, innate in human beings, which will express itself spontaneously when there are no cultural inhibitions. Dubuffet began to make works "parallel" to those produced by children, or by patients in psychiatric wards, but again, these would hardly provide evidence for parallel visions but precisely for what Dubuffet stigmatized—a "chameleon- or parrot-like process." The theory of art brut entered into the explanation of his art as well as its reception. But of course it hardly accounted for the art it helped enfranchise, the art

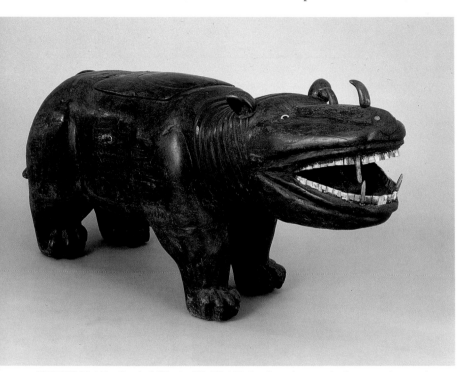

HIPPOCEROS / Edgar Alexander McKillop / c. 1928–1929 / Black walnut, glass eyes, leather tongue, bone teeth, tusks, plastic nostrils, and Victrola works / 58¼" wide / Abby Aldrich Rockefeller Folk Art Center, Williamsburg, Virginia / 61.701.15

made by children and the like! (Dubuffet was a very sophisticated and urbane artist, hardly a producer of art brut save in the matter of style.) It required artists, especially those in New York in the late 1940s, to find a way to the unconscious through automaticity—to what Robert Motherwell designated "the original creative principle"—to produce the kind of art that illustrated Dubuffet's concept of "pure invention." It did not look at all like the art of the psychotic, though it took a very short time indeed for the drip and the splatter to find their way into the repertoire of the kindergarten teacher, and for real children to begin to execute abstract expressionist paintings in miniature.

I do not know just when Dubuffet's own examples of art brut made their entry into The Museum of Modern Art's exhibition space. But when the criteria for admissibility opened up to

their acceptance, they opened up as well for the acceptance into MoMA's imagined folk art collection of a work like McKillop's jocular *Hippoceros*. There would even have been the possibility for an artworld artist, ignorant of the latter work, to produce an effigy as much like it as my imagined folk art horse would be like Calder's *Horse!* And it might enter the collections of The Museum of Modern Art not as folk art but—as art. The art of the artworld and that of the non-artworld enfranchised by the artworld's evolving discourses really do work in parallel. The artworld recognizes what resembles the work its artists produce, and in postmodernism the enfranchised objects are almost always of a kind the artworld artists could themselves have produced. In an exhibition called "Bearing Witness: African-American Vernacular Art of the South," held concurrently with the Outsider Art Fair of 1997, everything, though made by "outsider" artists far from the precincts of the artworld, could easily have been made by artworld artists instead, for whatever reasons prevailed in the artworld when they were made. There were some marvelous paintings by Mary T. Smith that could have been painted by Dubuffet himself. It is, I must emphasize, not that Dubuffet's art and discourse enter into the explanation of Mary T. Smith's art (though they could have). They enter, rather, into the perception of her art *as* art. And of course there are, in 1997, works made by artworld artists that are unlikely to have been made by outsider artists. The drawings that Mel Bochner did in 1991 for Wittgenstein's *On Certainty* would not, as drawn marks, have taxed an outsider artist. But such an artist would hardly have been interested in illustrating a philosophical text: his or her drawings would resemble Bochner's the way Wittgenstein's tent decorations resemble a sheet of equations from a textbook on calculus. Similarly, I can imagine a scrawl made by anyone that might resemble one of Cy Twombly's drawings. But I could not imagine the vernacular scrawler being considered an artist or his scrawl being considered art. The decision process is very delicate, and the argumentation of a kind that takes place daily in the artworld.

It must at this point be noted that we have insidiously moved from the descriptive adjective "folk" to the descriptive "outsider." There are a great many compounds formed with "folk": "folk wisdom," "folk saying," "folk medicine," "folktale," "folklore"—and of course "folk psychology." All of

these connote practices of, well, folk—a group of persons forming a traditional society and living intimately with their environment. There is an unquestioned sense that in pursuing what the folk know and do, we are approaching something fundamental—which is, after all, what the term "primitive" itself connotes. The "primitives" of a logical or mathematical system are those propositions used as the axiomatic base of the system, from which everything else is to be proven or on which everything else is based; and the primitive terms are those undefined terms through which everything else is to be understood. What the folk know and do is something very often felt to be what civilization has lost, and which would bring with it a certain health were it recovered. There is the further sense that we who are not part of the folk are rootless. These are ideas that in modern terms derive from Jean-Jacques Rousseau, and from Chateaubriand's idea of the noble savage—though they have antecedents in ancient literature as well.

The relative recentness of the term "outsider art" may be marked by the paucity of other compounds, though perhaps it has some connection with the term "alternative," so that "outsider medicine" might very well carry the meaning that "alternative medicine" does, and "alternative lifestyles" might very well be the lifestyles of outsiders. My sense is that this word, too, is of romantic derivation, and connects with the glamour of the outlaw (the art of prisoners, for example, falls within the range of "outsider art"). Certain visual and literary artists who have been outlaws—François Villon, Caravaggio, Li Po—seem, in virtue of their nonconformity, to have a special authenticity. It is this idea of a "special authenticity"—a special cognition—I think, that recommended the "outsider" to the surrealists or to Dubuffet. And there is finally the contrast between the outsider and the conformist, which is registered in the contrasts that defined Chinese thought, between the philosophies of Lao-tzu and of Confucius, but which itself is almost a distinction in folklore between conformity and nonconformity, between the straight and the not straight. It is in any case easy to see how there should have evolved a connection between the complex of attitudes roughly designated by the term "multiculturalism" and the various modes of outsiderhood in art. "It is now widely recognized," wrote an editorializer in *New Art Examiner* in September 1994, "that the community of artists engaged in the politics of identity—women, people of color, lesbians, gays, and others—have created a favorable atmosphere in which to consider the work of self-taught artists. . . . As multiculturalism has rendered the notion of a static, cultural mainstream forever problematic, the pathway has been opened for a more inclusive understanding of what constitutes significant art." The reference to "identity" in this formulation echoes that oneness that is alleged to constitute the social being of the folk and its closeness with its environment. This is a complex of volatile ideas that is a defining part of contemporary consciousness, and hardly likely to go away soon. The overall implication, however, is that there is something in the outsider—as in the folk—which "we" have lost touch with, and in which artistic authenticity is deeply vested.

There is, however, a somewhat neutral sense, through the concept of the artworld, with which a fairly determinate meaning can be assigned to the outsider artist. The outsider artist is one who does not belong to the artworld, and who has arrived at his or her art without benefit of participation in the discourse of reasons that defines the artworld at any given moment. Let us compare, in this regard, the difference between Joseph Cornell, who could easily have been an outsider, and Henry Darger, who really was an outsider. Cornell was not so much self-taught as untaught, so far as the traditional training of an artist is concerned: he never learned to draw, or to paint. But he was a constant forager in the bins of used bookstores, with an interest in old engravings, documents from the history of the dance and the theater, and the like. At one point he came across Max Ernst's 1929 collage-novel, *La Femme 100 Têtes*, in which old engravings had been cut apart and the fragments cunningly fitted together to form, well, "surrealist" images: two prim scientists zapping a block of marble to create a pair of legs, for example. It occurred to Cornell that he himself could do this sort of thing, and so in 1931 he began to make Ernst-like collages. Moreover, his urban peregrinations took him into art galleries, including the Julien Levy Gallery, which was the first to show surrealist art in New York. Cornell showed Levy his own collages, which were exhibited, and Cornell himself was labeled an American surrealist. Given the attitude of the surrealists in America, Cornell would have been regarded as an "outsider," and would have been made all the more welcome for that reason. But he

found himself part of a group of "mainstream" artists, and he evolved along with them, and then along with other groups when surrealism gave way to other dominant forces in the history of recent modernism. He was in constant symbiosis with these, dripping paint, for example, when the abstract expressionists dripped paint, but always within the limits of his own work, which by this time had evolved into the boxes for which he is famous. Yet he was also, in deep ways, outside the movements.

Darger, so far as I know, had no such encounter, and never became, even to the tangential degree that was true of Cornell, related to the artworld at all. Certainly not during his lifetime. But he did things that avant-garde artists did—collaging and tracing, for example—and, like Cornell, never tried to draw as such. He did fill in the spaces of his luminous drawings with watercolors. Of course, he saw a lot of books, and especially a lot of children's books, altogether appropriate since the heroines of his art were the mysterious preadolescent Vivian Girls. But we live in what is sometimes called an image-rich environment, and nobody is so outside the image pool of his or her society as to be entirely picture-ignorant. The subway "writers" of the 1960s used comic strip figures in their graffiti. I was told that the peasants of Slovakia now use Campbell's soup cans in their folk art because there are two columns in front of the Warhol Museum there that are painted that way, and they know "Andy" was famous, even if there is no Campbell's soup in Slovakian groceries. But Darger did not participate in artworld discourses. He was not so much self-taught as he was the unique member of an artworld all his own.

It seems to me that it would be with reference to the artworld that one would define artists as outsiders, and on this note I would like to return to the subject with which I began—folk psychology.

Folk psychology, it will be recalled, is a stem of explanatory principles invoked by ordinary persons in every culture, and in every stage of known history, by means of which behavior is rendered intelligible through postulating the beliefs and desires that cause individuals to behave the way they do. The primary range of folk psychology is the behavior of human beings, but it is clear that the gods and the spirits in different cultures are anthropomorphized in the sense that they too are understood in terms of what they believe, and

what they want. And we even explain the conduct of animals in exactly those terms, though upon reflection we would doubtless draw some line between mice and microbes. In this respect, folk psychology is like what one might call folk physics—the beliefs about the laws of the physical world that everyone everywhere must hold in order to function in the world: that jumping off cliffs is dangerous to the body, that unsupported bodies fall, that water quenches thirst, that flowers bloom in the spring. It is not advanced science—but advanced science exists to explain what everyone knows to be the case. But similarly there must be some physiological basis in the structure of nervous tissue that enables us to hold beliefs and execute wants—but these account for, and cannot be imagined to eliminate, the categories of folk psychology. And just think of the narrative of this essay: it could hardly have been written without referring to beliefs about art, and about history, and about what artists should and should not do.

It has lately been argued that folk psychology is a piece of innate equipment, something we are born with as part of our original genetic endowment, like our perceptual capacities and our ability to learn languages. The philosopher and psychologist Jerry Fodor has advanced a thesis of mental modules, and has argued that "common sense" psychology may in fact be modular, in the sense that were we to imagine it removed from our mental makeup, nothing in what remains would substitute for it. We simply cannot help seeing one another in those terms, any more, in effect, than we can help seeing red as red—or help hesitating from walking off the edges of cliffs. There is doubtless an evolutionary story to be told of how the species should have come by its modules, but that is not our business here. What is our business is to suggest that there may very well be an art-making module, together with an art-receiving module—that art is as much an innate endowment of human beings as folk psychology. That everywhere, in every culture, human beings make art. It has been contended that no culture known since Cro-Magnon times has been without the use of pictures. It is no less true that no animals make pictures—though the fact that animals make "abstractions" is another way the artworld enfranchises different things as art at different stages of its history. It has recently been discovered that art was made in Australia sixty to 176 centuries ago by creatures who were perhaps

not yet *Homo sapiens*. It was part of Dubuffet's conjecture that there is an innate capacity everywhere and always to make art. Art brut is art made spontaneously, prior to any institutional modification—analogous to the babbling of infants, already a form of speech without being as yet part of a language. All this could be counted folk art by the same criterion that our explanatory efforts in regard to human behavior are counted folk psychology. But Dubuffet's term, translated into English as "raw art," is better, save for some of the unfortunate connotations of "rawness" as a judgment of fastidiousness. It is raw only in the sense that it is the natural state of art, before being shaped by institutions. The nineteenth-century German mathematician Leopold Kronecker once said that the natural numbers are the work of God, everything else being *Menschenwerk*—what human beings build on the given basis of the natural numbers. Analogously, raw art is the work of human nature, everything else being the work of social institutions, the artworld especially.

"The" artworld is perhaps a presumptuous use of the definite article, excusable perhaps through the role our artworld has played, historically, in the development of art since the time of the thirteenth- and fourteenth-century Florentine artists Cimabue and Giotto, not merely in terms of the great technical progress marked by Vasari, but in terms of the gradual breakdown in the nineteenth century of the realist paradigm, the seeking out of new paradigms, and the remarkable ascent to self-consciousness through which art and philosophy became virtually a single entity. The artworld in modernist times has had to find a way to accommodate the art of exotic cultures and so-called primitive cultures, as well as folk art and so-called outsider art, the producers of which are not part of the artworld, even if their products have found their way into the production and aesthetic consumption of those who are. Perhaps it would, in the light of the consciousness we have attained, to speak of artworlds, for it is rare, especially in the kinds of cultures in which it is natural to speak of the folk, not to have traditions that govern the production and the consumption of art, criteria of what is art and who are artists and what is good, bad, or indifferent, and how, finally, art is to be used. Outsider artists are, as a general rule, worlds unto themselves, with their own criteria for these things. They live and create in worlds of their own,

often, as in the case of Henry Darger, for no one but themselves, with no ambition to become part of the artworld. There is a folk psychology for such artists, of course, having to do with their beliefs and wants, but often they are outsiders because their beliefs and wants are themselves outside artistic psychology in the institutional world with which the artworld is co-implicated.

Among the artists from outside the artworld, there are some who, for all that they are artworlds unto themselves, have created work that, had it been done by someone who belonged to the artworld, as it has evolved in postmodern times, would have been greatly prized. These works belong to the intersection of the artworld and their creative worlds. The artists represented here belong to these intersections, between their worlds of art-making and the artworld. It would be wonderful to have some precise term with which to designate them, but I have nothing to offer along those lines.

Nonetheless, the evolution of a concept from folk art and primitive art through outsider art to what we might provisionally call non-artworld art has the consequence of transforming our object-oriented discourse to an artist-oriented discourse, and transforming that into one that centers on the institutional complexes that the term "artworld" designates. To be an artist "sans phrase" means to have internalized the prevailing discourse of the artworld. To be an artist "avec phrase"—at least for a certain vocabulary of phrases—is to be external to those discourses. For reasons I hope are clear, it can be supposed that a given object can now be imagined to have been made by artists inside or outside the artworld, and, if outside it, then in the various ways one can be outside. Of course, there will be objects made by artworld artists that it strains credulity to suppose were made by artists untrained in this or that technology, these or those ideas.

CRITICAL
FICTIONS:
RACE, "OUTSIDERS," AND THE
CONSTRUCTION OF ART HISTORY

MAURICE BERGER

The fundamental problem with the notion of a black aesthetic, when we apply it to the fine arts—and I always want to make that qualification because I do think the concept can be useful in other contexts—is that it involves privileging a kind of singular view of African American art that necessarily obscures the *diversity* of U.S. black artistic production. And, in its exclusive focus on one-half of the dual heritage of African American artists, it necessarily obscures the *complexity* of U.S. black artistic production. As such, the black aesthetic is basically a fallacy, a myth.

—Judith Wilson, "The Myth of the Black Aesthetic"[1]

In December 1989, an exhibition opened at the Dallas Museum of Art that questioned, among other things, one of art history's most rigid aesthetic distinctions, that between folk art and mainstream, avant-garde art. It was in the spirit of breaking down the separation between these usually separate and unequal art-historical categories that curator Alvia J. Wardlaw organized "Black Art—Ancestral Legacy: The African Impulse in African-American Art."[2] This exhibition engaged the question of black cultural "outsiderness" from a broad and holistic perspective. The curator's approach was novel, even radical, within the context of the "mainstream" museum world—an institutional universe that often relegates displays of art by African Americans to Black History Month, and where even the most famous black artists trained in the academy find less than enthusiastic representation of their work.

There is, of course, a sound historical reason for deemphasizing the theoretical or aesthetic distinction between the work of self-taught, folk, academic, and art school–educated artists: the work of almost all African American artists—often executed under regimes of slavery, physical and emotional duress, or the more subtle, but no less destructive, effects of post–Jim Crow white indifference or sublimated hostility—while central to many black communities, lies far outside the center of the upper-class, white artworld. "Black Art—Ancestral Legacy" acknowledged the cultural legacy that *all* "black Americans inherited from their African ancestors"[3]—an influence that remains an active and powerful force in the latter quarter of the twentieth century. While such influences are not confined to persons of African descent, understanding their presence in African American life is crucial to breaking down reactionary, ignorant standards of beauty, conceptual rigor, and historical significance that shape the white, Western art-historical and curatorial canon.

"Black Art—Ancestral Legacy" worked in multiple ways to challenge prevailing art-historical and curatorial methodologies. For one, it revised the classic Eurocentric understanding of American art by documenting the breadth and depth of African influences on American culture. The show comprehensively explored "the ancestral bonds which still exist among African artists and their descendants in the New World,"[4] a bond often ignored or misunderstood by art historians and curators. It located and celebrated the "diversity of black American creativity in the medium of painting and sculpture."[5] It refused to delineate between the artistic "outside" and "inside," creating a visual and art-historical narrative in which folk artists, self-taught artists, and artists from the academy and mainstream artworld intermingle in a resonant, often overlapping field of images, textures, beliefs, and ideas. It strongly considered the cultural, historical, social, spiritual, and communal contexts that help shape the artistic vision of individuals.

And it provided detailed biographical entries for each artist, connecting names to faces and faces to personal histories. The overall effect, both in the exhibition and in its accompanying catalog, was astonishingly comprehensive, as a universe of cultural, historical, and social meanings unfolded.

The exhibition resulted in a truly resonant, moving field of visual and intellectual interaction. Within the context and history of African American life and art, many discernible boundaries between outside and inside inevitably vanished. The artwork of American blacks was diverse in form, media, and content: neither beauty, nor intellectual, philosophical, or spiritual rigor, nor technical ability had a lock on any one category of production. The viewer (and the reader of the catalog) was afforded a range of sensory, aesthetic experiences and ideas about the African presence in American culture and of the vitality of African American art and artists. Throughout the exhibition's complex narrative, a number of dominant themes emerged: the formal, spiritual, and political relationship between African cultural forms and symbols and African American art; the role of art education, and of the teaching of African culture, in historically black colleges in the United States; the dynamics of memory and storytelling in African American life and art; and the social and cultural significance of African American artists reclaiming their cultural past.[6] While the exhibition did not touch on all aspects of cultural and theoretical practices in the work of American artists of African descent—it regrettably overlooked, for example, the central role of critical theory, feminism, and race studies in the work of conceptually oriented artists of the 1970s and 1980s, such as Adrian Piper, Carrie Mae Weems, Pat Ward Williams, and David Hammons—it nevertheless explored and analyzed the communal, ancestral, spiritual, and social factors that might help future generations of art historians avoid racist generalizations, misappropriations, and misreadings.

If "Black Art—Ancestral Legacy" represents an early paradigm for reabsorbing the work of folk, self-taught, and outsider artists into a more respectful and resonant art-historical mainstream, its methodology and inclusiveness remain exceedingly rare. Ironically, methodologies "created" decades ago for analyzing these more marginal aspects of American art—well before the multiculturalist ethos was to become an important force in art history and criticism—continue to hold sway in outsider art criticism and history. It is now time to take stock of the methodological crisis in the outsider art field—a situation that, while it has improved in the late 1980s and early 1990s, remains symptomatic of broader and more general problems in curatorial, art-historical, and critical practice.

Since the emergence of the intense art-historical interest in African American outsider, self-taught, or folk art in the mid-1970s, one article remains a paradigm of white, mainstream art-historical thinking about the subject: Jane Livingston's curatorial essay for the exhibition "Black Folk Art in America, 1930–1980."[7] The essay's title, "What it is," is a play on the black colloquial expression, which was common in the seventies. To understand the ultimate aim of Livingston's project, however, we must make a subtle, but no less powerful alteration of its title: *What is it?* is the question she is ultimately asking about the work of the twenty artists in her exhibition.[8]

In an effort to find an answer to this question, Livingston searched for points of commonality and consistencies, indeed no less than an understanding of why this work, in its sense of "proportional correctness" and its ability to present its "ideas unerringly through abstract means," was so "uncannily *right.*"[9] She was looking for what most curators or art historians would be looking for if faced with the challenge of surveying diverse works created by artists of the same era who, on the surface of things, share similar national, cultural, and economic backgrounds: the presence of coherence, of an "overarching atmosphere of a single tradition, even of a single style."[10]

Even while understanding that the "inexplicable sophistication" of these untutored artists emerges not from the style-based emphasis of formal art education but from the exigencies of their private, personal, and everyday worlds, the curator nevertheless tried to locate the work's stylistic, aesthetic, even "universal" essence. "We found ourselves increasingly responding to the aesthetic it represents with a sensation of convulsive recognition, as though one had seen these images before, or as if vestiges of one's own past were reappearing in fragmented segments. There was a nagging experience of recollected feeling, something like hearing long forgotten music."[11] Thus the work evoked the almost indescribable, yet "ethnically cohesive" style and logic of our primitive collective

unconscious, the spiritual, earthy, African past from which we all evolved.[12]

Livingston's methodology, in its emphasis on the idea that the works she used it to analyze are "full-fledged gratuitous art objects" that were important less for their social and narrative contexts than for their abstract forms, was unapologetically formalist. Surprisingly, she offers no convincing explanation as to why these objects are "almost always, if not literally readable to those outside of the subculture, intuitively legible and provocative to the widest audience."[13] What are the forms, images, and compositional devices that make such works so universally accessible? Given the diversity of global culture, is such universal legibility even possible? Livingston's formalism is so strong that it distracts her from the responsibility of analyzing the work through its no less relevant cultural, geographical, religious, political, and ritualistic contexts.[14] The racial category "black" no more signifies one community, one nationality, one religion, or one economic class than the category "white." It is this complexity that Livingston's innate formalism tends to understate.[15]

While Livingston did not subscribe to a rigid definition of folk art, she nevertheless fell back on an implicit (and formalist-derived) dialectic between objects made in the artworld ("high" art) and those created at its margins (folk art).[16] This "us" versus "them" mentality unfolded through a series of oppositions that appear throughout the text: academic/self-taught, urban/rural, sophisticated/naive, mainstream/folk. Livingston does not acknowledge the contradictions within such oppositions—the self-taught artist who appropriates art-historical images and styles, the folk artist who works in an urban or cosmopolitan milieu, the outsider artist who self-consciously theorizes about his process—and thus further simplifies and trivializes the subject of her inquiry. In disputing the idea that folk artists "somehow experience a life-long childhood," for example, Livingston nonetheless reverts to a generalized comparison between the repressiveness of academic art (most often produced by white artists) and the emancipating nature of folk art (frequently made by black artists):

The folk artist often demonstrates in the evolution of his style a development similar to that of the academic one, which may commence haltingly in a somewhat stilted, even contrived

mode, becoming more fluid and obviously self-confident. . . . The difference between the academic and the self-taught artist is that often as the latter becomes more proficient and complex, he becomes more raw, *apparently more clumsy and bold and uninhibitedly prolific; the schooled artist in contrast, generally becomes more refined and subtle and technically proficient. The folk artist often matures toward an increasingly polymorphous, released style.*[17]

Livingston's argument revived one of the most regressive art-historical stereotypes: that black people (and the economic poverty and cultural isolation that she sees as its extension or parallel) were innately unrepressed and in touch with deeper, primitive urges. Such thinking emerged, for example, during the rise of the awareness of folk art in the 1920s: the art of "the naive, the peasant, the savage, the unspoiled," many curators then believed, could offer white artists a model for transcending the corrupting, repressive factors of modern civilization.[18] Livingston's observations were no less racialized, as she assigned to "blackness" endemic, naturalized traits that were available to the affluent white "mainstream" only through secondhand contact with its darker brethren.[19]

As Livingston's argument ultimately underscored, the discourse around African American folk art is often more significant for what it revealed and reveals about its own motivations and methodologies than what it tells us about its subject. For one, the relationship between an artworld mainstream and its margins—a dialectic that is central to the art-historical conceptualization of the outsider—was itself specious and misleading. This formula too easily accepted the elitist notion that the artworld "mainstream" was univalent and that it was representative only of the high cultural interests of the white upper-class.

The traditional artworld center, of course, no longer holds. Multiple, overlapping, and even contradictory interests now compete in the rarefied arena of high culture: the modernist avant-garde that some interpret as the pinnacle of twentieth-century intellectual ideals and spiritual values is seen by others as an enigmatic, hostile hierarchy of exclusion and elitism; identity-based art histories are unearthing and validating the work of people of color, women, and gay men and lesbians long excluded from the canon; and such foundational

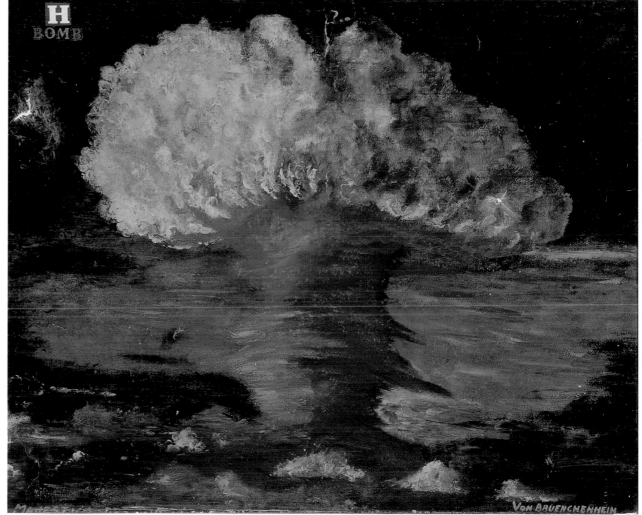

31

art-historical concepts as periodicity, quality, and standards are coming into question.

The artworld, in fact, lies decidedly *outside* the broader American and European cultural mainstream: popular music, crafts, film, television, and community, ethnic, or church-based art and theater are far more accessible to most people and come much closer to rank-and-file "mainstream" tastes than does the avant-garde. Despite the rise of identity-based methodologies and other forms of socially oriented revisionism in recent years, the artworld—in part because of its co-option by academia, in part because of its relationship to a market economy governed by the wealthy—has grown increasingly specialized and hermetic over the past two centuries. It has developed in its own values, jargon, hierarchies, and ideologies a worldview often unfamiliar to people outside the world of elite culture. "What the configuration of the high culture art world reveals," writes cultural historian Kenneth L. Ames, "is how peculiar and self-absorbed a specialized part of a larger society can become when it is disconnected from that society."[20]

By submitting folk art to the methodological biases and con-

such radically different subcultures even be shoe-horned into a single aesthetic category?

While the art-historical revisionism that occurred in the late eighties and early nineties has radically transformed and improved the critical discourse around this art, such questions are still frequently ignored by art historians and curators who would rather see this work as the product of unsophisticated people who have no conception of themselves "as artists or of their creations as art"

UNTITLED (H BOMB) / Eugene Von Bruenchenhein / 1954 / Oil on paperboard / 21 x 26" / Milwaukee Art Museum / Gift of Friends of Art

descension of this specialized community, the art historian, as the arguments of Livingston and others confirm, frequently disconnects this art from the intellectual, spiritual, and political exigencies that make it important to its own producers and communities. Who are the real outsiders? Can the category of outsider or folk art convincingly explain the work of such disparate populations as white mental patients in Switzerland and black self-taught artists in the United States? Should

or who are so sensitive to contact with the "dominant majority" that they systematically set themselves against the "normal and orderly . . . foregrounding [their] status as pariahs."[21] It is unfortunate that while this work is often claimed to be "inseparable from the rest of the world"[22] in its representation of universal values and emotions, its content and the details of the lives of the people who produce this art are all too frequently irrelevant to its analysis.[23]

The art in question and the artists who create it are anything but homogeneous and univalent. Works emerge from vastly different biographical, political, and communal circumstances: Some African American folk or self-taught artists live in urban communities, others in rural environments. Some are destitute; others are working-class. Some are Southern Baptists, others Catholic. Some are illiterate; others write statements and manifestos about their ideas and work. Some began their lives as slaves; others were born into freedom. Some work in isolation from other folk artists; others collect the work of their colleagues.

Even the most object-centered analysis of the work of these artists would have to acknowledge the wide range of media and formal sensibilities that militate against the construction of one, monolithic stylistic category. Lonnie Holley (a Birmingham, Alabama, artist) makes dynamic painted sandstone carvings as well as mixed-media constructions based on ancient Egyptian or African themes; Bill Traylor (of Montgomery, Alabama), William L. Hawkins (Columbus, Ohio), Nellie Mae Rowe (Vinings, Georgia), and Horace Pippin (West Chester, Pennsylvania) made paintings in a broad range of media and subject matter; Pecolia Warner (Yazoo City, Mississippi) made quilts; Elijah Pierce (Columbus, Ohio) made painted, narrativistic reliefs of religious and domestic subjects; Steve Ashby (Delaplane, Virginia) made rough-hewn and often erotic figurative sculptures and whirligigs; Leroy Person (Occhineechee Neck, North Carolina) made colorfully carved and painted furniture and animals; John Landry (New Orleans) made miniature, shoe-box-sized replicas of Mardi Gras floats out of beads, glitter, and cardboard; David Philpot (Chicago) makes intricate wooden staffs embedded with coins, mirrors, leather, and jewels; Thornton Dial Sr. (Bessemer, Alabama) makes polychromed mixed-media tableaux that often deal with the troubling dynamic of black life in the United States; and Bessie Harvey (Alcoa, Tennessee) made sculptures out of plant roots and limbs.

The work of these and other artists of similar sociocultural heritage explores equally diverse themes and subject matter: racism (Anderson Pigatt, *Alone Together and Alone Again*, 1972), politics (Pippin, *Abe Lincoln, The Great Emancipator*, 1942), biblical themes (Traylor, *Untitled [Black Jesus]*, 1939–1942), religious ritual (Landry, *Cardboard Zulu Float with Crown*, 1985), dreams and the unconscious (Minnie Evans, *Landscape with Head and Bluebirds*, 1978), history (George White, *Old Pioneer Days*, 1962), totems and tribalism (Harvey, *Tribal Spirits*, 1988), transcendence (William Edmondson, *Angel*, c. 1940), nature and the environment (Mose Tolliver, *Woman with Fish Shape*, c. 1975), human nature (Sultan Rogers, *Snake*, 1987), personal interaction (Pierce, *Monday Morning Gossip*, 1935), family (Harvey, *The Family*, 1988), sexuality (Ashby, *Untitled* [standing couple], n.d.), and self-portraiture (Mr. Imagination, *Self-Portrait as King*, 1988). Unlike academic or art school–educated artists who follow theoretical and aesthetic agendas, sometimes of international scope, self-taught and folk artists are, by definition, not marching to the homogenizing and proscriptive beat of the academy and the artworld. Thus, the details of their personal, communal, and intellectual lives are crucial to understanding and interpreting their sensibilities and intentions and the motivations behind their work.

The reasons for the art-historical indifference to the narrativistic details and diversity in the lives of African American self-taught or folk artists are complex and multiple. For one, many of the biases and practices that lead to prejudice against African Americans in the culture as a whole extend to contemporary art history: the tendency to ignore producers of color (including "mainstream," art school–educated artists), the impulse to reduce racist behavior or representations to intellectual abstractions, and most important, the inability to engage in any substantive degree of self-inquiry and to question one's own absolute authority to control the discourse. As Marianna Torgovnick points out, these dynamics of control, motivated by complex psychological and ideological factors, are particularly evident in the cultural construction of the outsider or the primitive, an interpretive universe mired in the politics of identity, power, and desire:

> *That a rhetoric of control and domination exists in Western discourse on the primitive is beyond question. And it exists in at least two senses; control and domination of primitives . . . and a parallel control of the lower classes, minorities, and women . . . who are linked, via a network of tropes, to the primitive. But the rhetoric of domination and control of others often exists alongside (behind) a rhetoric of more obscure desires: of sexual desires or fears,*

of class, or religious, or national, or racial anxieties, of confusion or outright self-loathing. Not just outer-directed, Western discourse on the primitive is also inner-directed—salving secret wounds, masking the controller's fear of losing control and power.[24]

The problems of writing about African American culture, however, go well beyond the issues of race, marginality, and the racist and classist construction of otherness to the methodological structure of art history itself. Because art-historical and curatorial arguments, by design, repress the details, variances, and conflicts of their subject into coherent, flowing narratives, even the most socially responsible or racially sensitive writers can fall into the trap of stereotypical, essentialized, or historicized thinking.[25] While the need to systematize and homogenize diverse and often disparate objects into neat categories can enhance the didactic role of the curatorial essay, the exhibition design, or the critical text, this avoidance of difference ultimately fosters stereotypes and distorts the purposes and meanings of cultural artifacts. In the case of survey or theme exhibitions, for example, objects are displayed through the "fiction that they somehow constitute a coherent representational universe"[26]—a goal achieved through the art-historical and curatorial processes of ordering, arranging, and classifying to produce a myth of coherence. If this fantasy should disappear, there would be nothing left of the museum "but 'bric-a-brac,' a heap of meaningless and valueless fragments of objects which are incapable of substituting themselves either metonymically for the original objects or metaphorically for their representation."[27]

Art historians and curators, driven as they are by these ideological and disciplinary imperatives, face a significant challenge in meeting this goal of refashioning an aesthetic theory that can accept culture's fragmentary and disparate nature. If new, and more socially responsible interpretive practices are to emerge, however, they must evolve not just through racial sensitivity but through a radical and self-conscious shift in the art-historical worldview. Fundamental ideas and organizational principles such as the monolithic, the abstract, and the universal must be replaced by a respect for the diverse, the concrete, and the specific.[28] This process will not be easy. Some of the discipline's most progressive critics wonder if such an exchange is even possible:

> *Can one imagine the comprehensive art museum without an authoritative European canon at the center? Would it be possible to rethink the sum of world art as a set of parallel lines of development, with ongoing processes of negotiation among them? Or is the dominance of a set of historically determined Euro-centered ways of seeing and imagining so strong, so central to the "museum effect" . . . that inclusion in a comprehensive art museum can only be in relation to that tradition?*[29]

It will take no less than a radical disruption of these reactionary ways of seeing—a deconstruction and testing of the very methodological traditions of the art-historical and museological processes—to transcend the disciplines' retrogressive attitudes toward race, class, and cultural difference. Of course, the white, privileged art historian or curator must first acknowledge his or her own personal complicity in this problem. Even the most radical revisionist thinking will not have a transformative impact unless it is more than just a rhetorical device. As the cultural critic bell hooks argues, such revisionism must be reflected in the "habits of being," including styles of writing as well as chosen subject matter. "Third world nationals, elites, and white critics who passively absorb white supremacist thinking," she concludes, "are not likely to produce liberatory theory that will challenge racist domination, or promote a breakdown in traditional ways of seeing and thinking about reality, ways of constructing aesthetic theory and practice."[30] In an increasingly diverse and global society, the art historian, critic, and curator face a crucial challenge: to acknowledge the limitations and biases of their own discipline and to self-critically appropriate existing methods (in other fields in the humanities and social sciences) or construct new ones for exploring the meaningful variances, parallel lines of development, and intersections that constitute Western culture.

Ultimately, the art historian and curator must look beyond existing methodologies in order to apprehend and celebrate these complex cultural interactions. To some extent, models already exist that might help bring about this objective. The multicultural ethos, a concept that implies the

absence of a single dominant cultural focus or center, as well as the move toward interdisciplinary structures and models, has undoubtedly allowed the art historian and curator to conceptualize culture outside of homogenizing canons and constructions. These approaches have, to one extent or another, helped liberate vernacular, folk, or self-taught culture from the myth of aesthetic creation as the product of "individual eccentrics disconnected from culture," permitting it to be seen instead as "the symbolic product of a complex and ambiguous relationship between more- and less-powerful social groups, a relationship which helps map the boundaries and chart the nature of cultural identity."[31] To understand this complex and ambiguous relationship is also to illuminate the convergences and similarities that exist between cultural objects and between their producers—the ways in which these manifestations reveal shared aspirations, ideas, beliefs, and ideals—a process that can help break down the condescending, hierarchical, and racist notion that the exotic outsider (itself a category constructed by cultural insiders) has little in common with his whiter, wealthier, or better educated brothers.

To achieve these goals, the art historian and curator must first exchange a rigid, formalist view of the art object for a "resonant" understanding of such objects in their broader cultural, institutional, and social contexts. As cultural critic Stephen Greenblatt observes, this resonance need not depend on the collapse of the distinction between art and non-art, but on a more holistic conception of the way objects, identities, and belief systems intersect, a notion that might awaken in the viewer a sense of the "cultural and historically contingent construction of art objects, the negotiations, exchanges, swerves, and exclusions by which certain representational practices come to be set apart from other representational practices that they partially resemble."[32] Such a rigorous sorting-out of art objects demands a level of intellectual honesty that is often sadly missing from art-historical and curatorial practices. Greenblatt argues, for example, that a "resonant" exhibition should pull both curator and viewer away from the celebration of isolated objects and toward a series of "implied . . . relationships and questions" about the producer's feelings, ideas, and cultural and social intent, about the museum's imperatives for classifying and showing the work, and about the viewer's relationship

"to those same objects when they are displayed in a specific museum on a specific day."[33]

In recent years, a handful of essays and exhibitions have served as a paradigm for new art-historical and curatorial approaches to outsider and folk culture. Cultural historian Gerald L. Davis' essay "Elijah Pierce, Woodcarver: Doves and Pain in Life Fulfilled" functions both as a radical critique of the outsider industry—taking on such distorting and racist concepts as the exotic, primitivism, and the culturally isolated—and as an introduction to new ways of seeing the work of African American self-taught artists. Davis rejects the two prevailing and often contradictory methodologies for evaluating and discussing such art: formalist or object-based art history (with its attention to individual genius and its unwillingness to contextualize art through social and communal factors) and anthropology (with its touristic mindset and tendency to de-emphasize the aesthetic importance of the art object). Pierce's work serves as the perfect foil for Davis' critique of existing methodologies, for it is "too stylized and too idiosyncratic to be considered 'folk' . . . yet too clearly tied to a discernible nonacademic tradition—African American Southern Rural—for the art historian to embrace him and his product."[34] As such, the artist and his work foreground the problem with preexisting definitions for self-taught art, underscoring the idea that so-called outsider practices are rarely better understood by being forced into neat, coherent art-historical categories. Davis repositions the art object and the artist himself outside of the prescriptive realm of the loner-individual and into the cultural and communal universe around him—Pierce is seen to be part of a world that has little meaning for most white Americans but exists resonantly and meaningfully for many African Americans:

> *The traditional African American folk artist does not create, work, or invent in isolation. Standards of excellence for a chosen form are learned both formally and indirectly from family members and neighbors. That is, one can be formally selected as a master's apprentice in his or her community, or one can learn, seemingly indirectly from trial and error in the context of a native aesthetic. One learns the technologies of craftsmanship, along with the more esoteric notions that complete one's mastery of a medium, to the satisfaction of established mas-*

*ters and through the recognition and acknowl-
edgment of the general community.*[35]

Davis deconstructs the myths of blackness,
outsiderness, and aesthetic isolation through an
analysis of African American history and commu-
nity—a cultural universe that is usually ignored or
shunned by mainstream white curators and critics
who would prefer to believe in the myth of an iso-
lated, unrepressed, or magical blackness. He
reminds us that contrary to these ahistorical and
generalized fantasies, "most African Americans par-
ticipate at some level in the maintenance of tradi-
tional cultural forms."[36] Yet when such outsider
artists are "discovered" by white collectors and
curators, the meaning and validating recognition of
the artist's own communities are often denied.

Davis constructs Pierce as a cultural and
social being: he gives the artist a name, a face, an
intellectual life, a cultural community, and a his-
tory—in short, a context for understanding his
work. He explores and theorizes Pierce's work
through a range of political, biographical, religious,
aesthetic, and stylistic details: the artist's vocation
as a barber and the political and social importance
of hair and hair preparation in African American
life; the relationship in black communities between
the persona of Jesus Christ the carpenter and those
African American men who are utilitarian carpen-
ters or decorative or expressive woodcarvers; the
artist's attempts to transcend the demands of the
outside world through forays into the ancient, soli-
tary woods near his father's farm in Baldwyn,
Mississippi; the artist's description of himself as
"the little black sheep, a little oddball who didn't
play much with the other kids" and his practice of
giving carved pieces to people who admired his
work so that he could "share a bit of himself";[37] the
stylistic and technical relationship of his work to
other African American woodcarvers; the cultural
origins of the artist's symbols in African American
and biblical subject matter; the artist's religious
devotion, the seriousness and purposefulness with
which he regarded his biblical first name, and his
decision to become an ordained and licensed
preacher; the system of enforced servitude into
which he was born, the sermonistic structure of his
work and how he translated his religious beliefs
and outlook into his carvings; the possibility that
his work served as an "instrument of negotiation
between his religious destiny, which he regarded as

onerous and vigorously attempted to deny for a
time, and his embrace of a full secular lifestyle,
replete with a love of dancing, an appreciation of
elegant and resplendent haberdashery, and the
companionship of women";[38] the techniques and
narrative formulas the artist used to represent his
ideas and beliefs; and the more precise, community-
based and historically sanctioned standards of
excellence that the author himself employed in
evaluating Pierce's complex oeuvre.

In the end, Davis refuses to revert to art-
historical models of the outsider artist as a cipher
compelled to represent a universal, asocial, and
nonpoliticized "selfhood," a selfhood special only in
its ability to "develop a person's unique style,"[39] a
selfhood unconnected to community or familial tra-
ditions, a selfhood that transcends the muteness of
the artist-loner by speaking through objects that
alone embody who and what the artist is as an indi-
vidual.[40] Unlike the work of most art historians
and curators, Davis' argument refuses to deny the
artist a voice in defining himself (he quotes Pierce
at length throughout his essay). Unlike the work of
most art historians and curators, his argument, to
quote Greenblatt, searches for a "resonance that
depends not [solely] upon visual stimulation but
upon a felt intensity of names, and behind the
names, as the very term *resonance* suggests, of
voices: the voices of those who chanted, studied,
muttered their prayers, wept, and then were for-
ever silenced."[41] Unlike the work of most other art
historians or curators, his argument does not belit-
tle African American communities and their cul-
tural histories by presupposing that the only art
worth studying is that which rigidly conforms to
white, upper-class canonical standards of beauty
and significance.

In recent years, a handful of curators have
approached the subject of African American art
and culture with equal intelligence and resonance.
In the summer of 1996, as part of the Cultural
Olympiad of the 1996 Olympics, the city of Atlanta
hosted two exhibitions that, to quote art historian
Thomas McEvilley, "brought some of the repressed
material of the American visual psyche into light."
The exhibitions—"Thornton Dial: Remembering the
Road" (consisting of seventy-five relief paintings,
works on paper, and sculptures by the self-taught
Alabama artist) at the Michael C. Carlos Museum
at Emory University and "Souls Grown Deep:
African American Vernacular Art of the South"

(an assemblage of more than 300 artworks by forty contemporary black artists of the Southeast that was installed at City Hall East, an extension of the Carlos Museum)—were both curated by Robert Hobbs. What set these shows apart from many earlier attempts to deal with recent African American art was their refusal to fall back on the distinctions between avant-garde, mainstream, folk, and self-taught practices.

In the end, both exhibitions took a broad view of African American culture, drawing connections between various formal, intellectual, historical, and spiritual considerations. Offering viewers an introduction "to the visual-art component of a broad, highly developed tradition that exists among the descendants of slaves in the American South," the shows also tended to examine the work through a broad methodological frame: iconography, historical and cultural influences, social pressures, economic concerns, religious and ritualistic questions, formal and stylistic issues, and the relationship of the artist to his or her community were all incorporated into the exhibition's analytical purview. Rather than understanding its subject through the now standard art-historical notion that contemporary art arose out of "the fierce determination to add one's own impetus" to the art-historical trends that have led up to it and to represent a command of the theoretical issues of the moment, Hobbs conceded that so-called self-

taught artists create according to different and diverse, though no less significant, historical and theoretical models. Thus he radically rejected the art-historical impulse to dismiss these artists and segregate them out from the "modernist-contemporary" ethos. Through his shifted methodological frame, the work of such artists as Dial and Bessie Harvey were understood to be as intellectually and aesthetically complex, as culturally vital, and as historically grounded as that of their white, postmodernist "contemporaries."

No exhibition has more radically challenged art historians, curators, and critics to rethink, both methodologically and aesthetically, their presumptions about art by African American artists than "Next Generation: Southern Black Aesthetic," mounted by the Southeastern Center for Contemporary Art in Winston-Salem, North Carolina, in 1990. Embracing the reasoning of art historian and critic Judith Wilson that the notion of a "black aesthetic is basically a fallacy, a myth," the exhibition deconstructed and challenged the categories that have long undermined art-historical efforts to place art by African American artists in a broader historical, social, spiritual, and cultural context. The exhibition and its exemplary catalog—replete with introductory essays by the exhibition's curator, Lowery S. Sims, and the artist and philosopher Adrian Piper, as well as transcripts of panels and interviews, artists' biographies, bibli-

ABE LINCOLN, THE GREAT EMANCIPATOR / **Horace Pippin** / **1942** / Oil on canvas / 24 × 30" / The Museum of Modern Art, New York / Gift of Helen Hooker Roelofs

ographies, and extensive visual documentation of the exhibition—represented a rigorous and self-conscious attempt to question the biases and rigidity of traditional art-historical and curatorial practices. As Sims observes:

> In pursuit of their individual expression within the art world, African American artists cut across many strata and classes in their own community as well as the nation at large. The acknowledgment of relationships between professional and so-called folk artists signals a willingness to integrate the clarity of intention and integrity of African American traditions with clearly defined professional goals. . . . I think that as a group [the artists in this exhibition] . . . represent the variety and richness that will characterize the African American presence in the art world. What should be clear is that blatant stereotyping or group labeling will become more difficult. These artists have claimed a wide range of artistic options for themselves and will not be hemmed in by the limitations of the art world in dealing with them.[42]

More than just a fine overview of the show, the catalog served as a comprehensive reevaluation of art-historical method in relation to such broader issues as identity politics, community, and class. The inclusion of transcripts of extended panel discussions with writers and scholars (including Richard Powell, Judith Wilson, Coco Fusco, Leslie King-Hammond, and Kinshasha Holman Conwill) and of interviews with a number of the exhibited artists further sharpened, broadened, and contextualized both the works in the exhibition and the exhibition's inherent critique of artworld politics.

The organization of the show underscored the exhibitors' critique of the art-historical and curatorial status quo: so-called self-taught and folk artists (for example, Hawkins Bolden, Lonnie Holley, and Jesse Lott) were exhibited alongside academic, avant-garde, and conceptual artists (including Terry Adkins, Martha Jackson-Jarvis, Ed Love, and Pat Ward Williams); aesthetic categories were blurred, resulting in a visual field in which it was often impossible to distinguish the work of one category of artist from that of the other; and media were mixed and varied. Such progressive aesthetic decisions resulted in an exhibition that was at once critical, elegant, and sweeping in its view of south-

ern African American culture. By accentuating and celebrating the multivalence of this culture, "Next Generation" incisively questioned the very myth of a unified, essential black aesthetic ironically suggested by the exhibition's subtitle.

In the end, exhibitions like "Black Art—Ancestral Legacy," "Souls Grown Deep," "Remembering the Road," and "Next Generation" transcend the constrictions of traditional art history and museology by refusing to evaluate the relative merit of art through the artist's educational or institutional credentials. In doing so, they bring us closer to overcoming what Judith Wilson called, in the epigraph to this essay, the myth of a monolithic, "primitive" black art—an open, resonant exhibition in which the multiple influences, legacies, and interests of African American artists are explored openly, a show in which the aesthetic quality of the work and its intellectual, spiritual, and philosophical value is made apparent through moving juxtapositions, informed wall labels and catalog texts, and an unwillingness to confine work to delimiting categories and myths. It is through just such a reconstruction of critical and theoretical practices that the "mainstream" artworld will be forced to acknowledge the marginality and fragility of the insider status it so smugly and jealously guards.

THE
PRESENCE OF MIND IN THE PRODUCTION
OF AMERICAN FOLK ART

GERALD L. DAVIS

Nostalgia. It is curious that so many contemporary collectors, scholars, and critics valorize nostalgia as the elemental impetus for owning or ennobling in print or simply admiring the works of traditionally contextualized producers of the body of expressive product popularly known as folk art. And it is worth noting that while neo-occidentalists have always seemed to have had a soft spot for these "simpler arts and crafts," the adoration of folk art, and its emplacement as a marketable commodity, has been extraordinary in these modern times, as Western societies have taken what many of us regard as a turn toward harsher, meaner, less humanly scaled social and political practices and behaviors. The powerful codependency in the quite stratified social and economic relationship between the folk artist and the folk art "consumer" seems inescapable and, perhaps, necessary.

But we—those of us who "consume" in various ways the folk art product—are also somewhat duplicitous in our carefully constructed regard for the folk arts and our concomitant search for momentary repose in a highly technologized contemporary world. Because even as we represent our frequently mawkish sentimentalizing (which we liberally impose on the folk artist) with images of malnourished psyches, we steadfastly maintain the manufactured, manipulated chasm between the "rough-hewn" folk art universe and the fine art world of more "refined" sensibilities. Nostalgia holds a seminal place in the contemporary lives of those of us privileged to be consumers of art. And few modes of expressive human activity are as symbolic of the enormous need of Western peoples for relief from cyber-technology and our intense longing for an uncomplicated, unsophisticated, humanly proportioned world such as the so-called folk arts. Nostalgia.

Admittedly, the foregoing commentary has the quality of diatribe. That is not my intention. I am angry, yes. I am angry at my folklorist colleagues who have turned their backs on our proud populist beginnings peppered here and there with strong elitist impulses. I am angered by those erudite critics of American art product who think folk art "fun." And I am embittered by those art connoisseurs who breeze through magnificent, if deliciously controversial, folk art exhibitions such as "Recycled Re-Seen: Folk Art from the Global Scrap Heap," impressively mounted by the Museum of International Folk Art in Santa Fe, in 1996, uttering asides behind white gloved hands, sotto voce of course: "but it doesn't do very much to advance the public admiration of *real* [emphasis mine] folk art!"[43] It took every bit of restraint I could muster to resist upbraiding these self-proclaimed "folk art authorities" and insisting that they remove the blinders that prevented them from participating in the rich dynamism of the folk art creative *process* inventively and imaginatively assembled by the exhibition curators and their advisers. I do not understand and I am impatient with this insistence on the part of some consumers to relegate folk art producers to a time warp so that the consumer may wallow uninhibitedly in these liberating experiences realized through the unbridled levying of nostalgia in the environment of folk art products.

The world of folk art production has never been static. While consumers irrationally insist on imaginary stasis in the manufacture and performance of traditional art and artistic modes—the nostalgic imperative—artist-producers keep keen and astute eyes on events unfolding around them and liberally borrow or appropriate whatever strikes them as useful, as long as a group or community aesthetic is not violated. Some years ago, Kentucky chair makers began widening the runners

on their rocking chairs to reduce wear and tear on wall-to-wall carpeting in modern homes. Many traditionalist painters now use acrylic paints instead of oil because of the ease of application and the depth and variety of color. Carvers may use penknives to finish objects that may have been roughed out by power tools to maintain an aesthetic that is both pleasing to and powerful for a particular ethnic or cultural aesthetic community.[44] And in quilting, the more efficient, electrically powered sewing machine is now used to execute some of the steps that used to be exclusively completed by hand.

Because the power of the traditional aesthetic form has remained so strong and continued to exist *apparently* without modification, seemingly few consumers have noticed, or have been willing to notice, the selective but very certain incursion of technology into folk art production. And while some critics identify market forces or gallery owners as the agents of change, presumably acting in the interest of increasing production, folk artists themselves have in fact determined that some aspects of the manufacture of folk art are better accomplished through the efficient use of technology and technologically generated products. There exist several examples that confirm the truth of this observation. Whether negotiating a price for a basket in his or her home or at a festival, at the conclusion of the negotiation the South Carolinian basketmaker is likely to retrieve from some place a credit card imprint machine to process credit card sales! And in New Mexico, *The Albuquerque Journal*[45] recently published a report of an acrid and seemingly fulsome discord among traditional santo carvers over the new practice of one prominent traditional carver of bringing into the state, for public sale, santos made in the Philippines of an acrylic material. This enterprising santero is guilty of several apparent violations of the tradition. The first is that the imported santos are not made by hand but are mass-produced; the second that they are not made of wood, which has religious connotations, but of a plasticlike material. And there are several additional violations of more subtle aesthetic elements in the tradition. What is remarkable and noteworthy in this latter illustration is that the traditional, or folk, artists are themselves embroiled in a determination of the appropriate degree of technological intrusion in the traditional production of carved santos. The point is that the consumers'

nostalgic need for an object produced in a static, bucolic, time-warped environment by a simple, "folksy" artist-producer uncomplicated by the vagaries of the modern world is a fiction that has little relationship to the life of the contemporary folk artist, which is lived in real time and in real homes, most with electricity, televisions, and telephones, in the company of other real people who are as much a part of "the world" as the art consumer, patron, scholar, or critic.

Some may read in the above a tone that appears to revisit, yet again, well-worn elitist/peasant dichotomies. In fact, the structure of this essay so far pulls from a more decidedly modernist interrogatory, a querying style that freely admits to the complexity of human experiences and behaviors, indeed, which depends on the recognition that the capacity to knowingly exploit the human spirit and explore the range of the human mind, or *intellect*, is not reserved to those who are privileged by wealth or even exposure to "higher" education. Thankfully, there are millions of ruptures in these social compacts that purpose to regulate the commerce and conduct of Western communities and the individuals that constitute them. Indeed, these ruptures are so much the rule that one must query who benefits from the maintenance of these notions of class and caste that are such an elemental part of the world of folk art evaluation and valuation. And what is the cost to our truer "appreciation" of the dynamic, constantly pulsing world of folk art producers, production, and product if we insist on denying folk artists creative maturity and sophistication, political and social agency, and empowering and empowered voices? Who loses, and what do they lose, if "folk" speak?

Somewhat to our discomfort, perhaps, folk artists are not waiting for permission to represent their own products and processes. And the more courageous, and honest, of our number are facilitating the opportunities for folk artists to represent themselves on their own terms. The end result of this new and highly significant element in the contemporary folk art discourse—I apologize for the lapse into postmodern language—has to be a radical reorientation of product valuation, and I mean here aesthetic process, not market price, and the introduction of folk art–producing community aesthetics into the equations that now less convincingly govern the levying of artistic judgment and merit in the evaluation of folk art product. The pos-

sibility exists that the aesthetics of folk art communities may be every bit as complex as *herrenvolk* systems claim to be, and that the people who intimately employ those aesthetic notions in the production of art may be very contemporary folk who have chosen to exercise alternative options.[46]

To forestall the conclusion that this manner of thinking works only as an abstraction, it might be instructive to refer to one of several recently published writings by a folk artist. Lonnie Holley, who is among the artists featured in this exhibition, concludes his riveting, revealing, intensely autobiographical contribution to the second volume of *Souls Grown Deep: African American Vernacular Art of the South* in the following manner:

> And my name is Lonnie Holley. I'm an African American artist, and ultimately we all can teach—all the teachers, all the professors, all of the high-minded, all the skilled-minded. Whatever the mind can do to help the little mind grow, I saw. I would prefer to see them try than to see a child die.[47]

Clearly Holley's comment seems removed from any context that would appear to support the elemental focus of this essay, that American "folk" artists demonstrate an *artistic* sensibility in their aesthetic products and, I argue, a mature, in most cases, aesthetic *intentionality*. That is, the American folk artist has in mind a community-based aesthetic standard to guide his or her expressive production and against which the success of her or his expressive product is ultimately judged by her or his aesthetic community.

This notion of a mature aesthetic intentionality has been historically problematic for scholars and critics of folk art and its producers. Yet Holley is very clear about his conceptualization of the presence of mind or aesthetic intentionality in the production of much of American folk art. Earlier in his essay, he explicitly locates the creative genesis of the work of some of his fellow African American folk artists in the mind, in the province of that part of the intellect that is shaped by community ethos and practice. I apologize for the length of the quotation here but the importance of Holley's thinking will be obvious shortly.

I think from the beginning of Souls Grown Deep, *you're saying that here is all the African*

heritage, but that wasn't the basis. . . . I think the basis was the [creative] acts that individual artists had performed . . . in the midst of humanity.

These were the basic thoughts that were being selected: Mrs. Bessie Harvey's root sculpture, Charlie Lucas coming to the point of taking his grandfather's blacksmiths work all the way up—we can make a possibility to change everything through some of the early methods of our grandparents. You take Mr. Hawkins Bolden using even the baby things, pots and pans, and then bring that to a point of stepping—a pair of pants that is made out of cotton, that comes from the cotton field, and somebody weaved it together, then he stuck more cotton in there. And then he makes in front of us a mannequin of his own vision to let us know, "Hey, life is still sitting in the midst of you all. Someone labored for this life, someone is there, this image in my mind [emphasis mine], my brother, my bad experience, getting hit, being blind." That echo, these sounds still going on in his head [emphasis mine]. . . .

You can see Joe Light experiencing his kind of mentality [emphasis mine] about his religion, and in this religion, he had allowed himself to see a vision [emphasis mine], and the kind of rejection that others had towards the things he was saying as a black Jew. Him having to take a hike, mounting a wildflower, all of these mountains he had made with so many different levels of painting. . . .

You can see a person such as Mrs. Mary T. Smith. I wanted someone from my point of view to see her strength. . . . She has gathered up the old tin, she would take a hatchet and make all these praise images with their hands up in the air and all these simple faces of different people that she had been to church with, that she had been in the holy atmosphere . . . these memories [emphasis mine] of her children and her grandchildren that she had grew up. . . . Even though I don't know how to read and write much, I'm going to tell you the very best way I can. And that's with this picture. . . . And this woman worked so hard, right beside the road, she got everybody's attention. They would stop

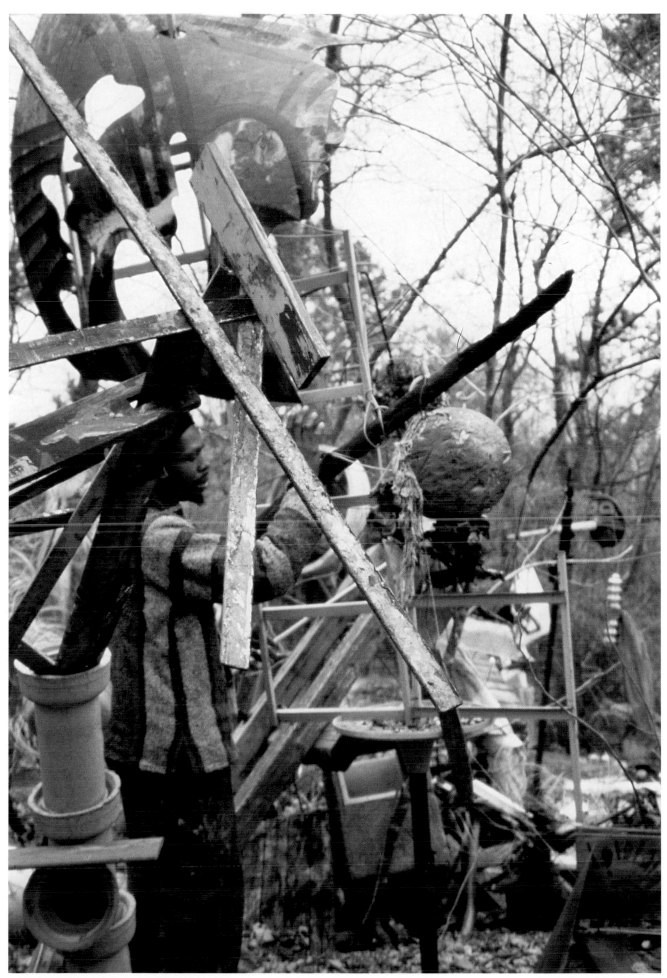

LONNIE HOLLEY IN HIS GARDEN ENVIRONMENT, 1993

and see her work. And she was really working for her Lord, she really working for her God . . . I remember seeing her at the time when arthritis has fit in her hands, and I remember seeing her at the time when she had a stroke. But I didn't want no one to say that woman was a senile old woman that was out of her mind. . . . She had a great mind *[emphasis mine], she might not could speak because of her throat problems. . . .*

. . . I remember going down Highway 61, there in Mississippi, and meeting Mr. "Son" Thomas. And Mr. "Son" Thomas using the white clay that only needed to be wetted, and that clay could harden itself harder than a rock. . . . We are the ones that have to fill these holes in each and every one of our minds, like Son Thomas say, with all of his skeletons and his skulls that he had did. He had did so many wonderful things—birds and squirrels and different things like that—out of this clay. But his memory *[emphasis mine] was mostly based on his experience as a grave digger, seeing so many lives, I imagine that at the time the coffin was closed, his* memory *[emphasis mine] was the profile, the hairstyles, and the beautification of those corpses that was in those graves. So this is what he reflected,* what was in his mind *[emphasis mine], what was in his heart, what was there was actually reflected not only through that, but through his blues and his music. . . .*[48]

Holley's comments on the work and character of some of his fellow folk artists are remarkable because we are rarely privy to the regard in which folk artists hold one another. But more important, and certainly more to the point of this essay, is the interpretive framework Holley brings to his commentaries. While it can be said of most artists that the mind is the environment for creative sourcing and the working out of conceptual considerations, that place in which inspiration is matched or mated to representational media, Holley seems clear that the mind is, as well, a *cultural site.* And since, in his commentaries, he references African American folk artists, it would follow that for Holley the *African American* mind is repository for the varieties of knowledge that, when activated in expressive media or form, fuel that particular

sort of creative invention that distinguishes African American expressive products from the products of artistic traditions of other cultural communities.

For Holley then, and for others of us who share his sense of the primacy of the mind in the traditional production of American folk art, there is this collective entity we conveniently label the group mind. And this notion of a collectively held and sanctioned body of critical knowledge that purposefully anchors the distinctive identity of a particular cultural group or community is part and parcel of any cultural community's public and private inventory and contributes immeasurably to that community's claim to uniqueness among the world's communities. It is this knowledge that is structured, categorized, and codified by communities over historical time and that serves as the wellspring for those governing expressive ideas we call aesthetics, and for those aesthetic pulsations that we recognize as artistic "sensibilities." And of course all communities will variously define and structure this treasure trove of community identity markers, behaviors, and sensibilities. And this is why we can expect the folk artist, who is by definition a member of a cultural community, to be articulate in some manner about the aesthetic principles and other shaping considerations that guide the production of a particular object or series of objects.

Some years ago, during a keynote address to a conference on "The Arts of Black Folk," I defined the term "Cultural Eye," which seemed to catch the imagination of many of the presenters and attendees. I used this term to refer to "a special phenomenological sort of vision that comes when one refracts one's enlivened racial or ethnic sensibilities through a mature cultural prism."[49] Holley's use of the "cultural mind" as it applies to modes of traditional folk art production is not too dissimilar to my identification, in cultural context, of the "Cultural Eye."

At the beginning of the lengthy quotation above, Holley seems to eschew the African basis of African American folk art production, arguing instead for the recognition of "the [creative] acts individuals had performed . . . in the midst of humanity." This reach for the universal, and the seeming denial of the African basis for much of African American cultural production, is not an uncommon sentiment among many African Americans. Numbers

of black folk, lettered and unlettered, still view Africa through those constructed colonialist prisms that rely for effect on insidious and arcane inventions of Africans as "jungle bunnies" and the African continent as "dark" (even after "enlightening" contact with Europeans). Never mind that Africa is, in fact, the birthplace of the human community and that it contains some of the earliest evidence of civilization and human social organization. But to superficially read Holley as an uninformed conservative on the matter of African influence on African American and American cultural production is also misleading. Not only does Holley represent himself as an "African American artist," but each successive mention of the mind or a product of the mind in his commentary is cited in an expressly African American experiential context. Holley does not know Africa intimately, and he may distrust those of us who would force on him notions of Africa as the birthing ground for both his person (or his ancestors) and his art. But he does know his community, how it operates, how it functions, how it performs life and art and social organization. And astutely, he celebrates the conjoining of the spirit to the soul in the shaping of the African American cultural mind—that singular communal entity, and its permutations in the individual, which holds the standards of traditional practice and that guides the crafting of expressive acts.

In this regard, Holley's commentary on "Son" Thomas is especially interesting. Let me reintroduce the comment here: "So this is what he reflected [in his sculpture], what was in his mind, what was in his heart, what was there was actually reflected not only through that, but through his blues and his music. . . ."

In a private communication in 1969, folklorist Roger D. Abrahams introduced me to the related concepts of "interlock" and "complementarity." In an important paper presented at a conference a year later, Abrahams expanded on these concepts.[50] In a work on African American sermons, I extended the Abrahams concepts to explain the high degree of exchange of features and segments across generic lines commonly found in African American narrative and musical performance. I identified my extensions of the Abrahams conceptualizations as "generic interlock" and "generic complementarity."[51] Years later I came across references to the same phenomenon identified by the African American folklorists Thomas

W. Talley[52] and Zora Neale Hurston many years before either Abrahams or I recognized this cultural mechanism. I raise this point in this rather dicey fashion because while Talley, Abrahams, and I undoubtedly came to our awareness through our academic field studies of African American narrative and performance, Holley, like Hurston, recognized these cultural features intuitively, by "refract[ing] one's enlivened racial or ethnic sensibilities through a mature cultural prism".

A bit earlier, I suggested that Holley's commentaries were remarkable. The surprise is not that Holley has a capacity for identifying and intellectualizing aspects of African American artistic expression, but that his knowledge comes so easily to the fore. As we pass through this remarkable exhibition of American folk art mounted by the honorable Museum of American Folk Art and curated by Elsa Longhauser and Harald Szeemann, we might do well to balance our inclination toward nostalgic reveries with considerations of the enormous social and cultural complexities underlying the images and sculptural forms magnificently arrayed before us. And we certainly must rethink our regard for the American folk artist and her and his ability to represent to us the expressive universe symbolized by the items in this exhibition.

Folk artists are as varied in their abilities as members of any community. Lonnie Holley is certainly articulate, but so are many others whose works we admire. If we can release folk artists from these peculiar time-warp prisons to which we have relegated them, we may learn all manner of new information. For instance, we may learn how cultural communities distinguish "successful" creations from art products that are less culturally excellent. We may discover that "good" and "bad," "beautiful" and "ugly" are not universal assessment values of artistic excellence. We may learn more about the workings of traditional crafting systems than we know presently. And finally, those of us who are professional commentators on folk art may have to radically revise our sense of aesthetics and importance as folk artists share their own informed voices with us more directly. But that may be a good thing.

HENRY CHURCH JR.
(1836–1908)
BORN AND WORKED CHAGRIN FALLS, OHIO

BY CAROL MILLSOM STUDER AND VICTOR STUDER

Henry Church Jr. was a man of many talents: he was a woodsman, blacksmith, musician, painter, and sculptor. His environment provided few teachers. Born on May 20, 1836, Church was only the second white child whose birth was recorded in Chagrin Falls, Ohio, then a new settlement on the Western Reserve. Records and diaries carefully maintained by Church's descendants describe hardships in those early years that sorely tested his family's resourcefulness. At times, they barely had enough to eat, but they always shared what they had. Staunch abolitionists, they offered a night's lodging to many a runaway slave en route to Canada.[53]

To strengthen young Church's fragile health, his father encouraged him to roam the woods instead of going to school.[54] Tramping alone there fostered the attitudes that were to endure throughout Henry's life: a sense of autonomy and a profound love and respect for nature. From very early on, Church greatly admired Native Americans, perhaps because they too respected nature. When he was a boy, his father had taken him to see an Iroquois village, one of the few that remained on the Western Reserve. The experience, the son later recalled, made a profound impression.[55]

Eventually, Church did go to school, but his education and idyllic childhood ended at thirteen, when he became a full-time apprentice in his father's blacksmith shop. Church learned his craft

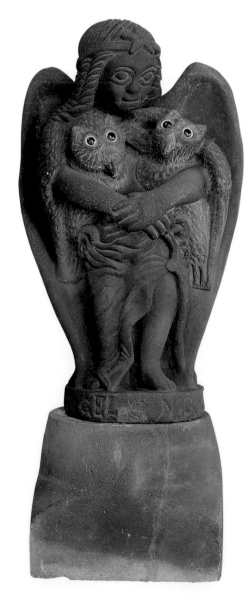

ANGEL OF NIGHT / n.d. / Stone / 18 × 11 × 12" / Collection of Frances O. Babinsky

well. A "good man in iron" is the way one early settler described him.[56] But smithing did not satisfy his creative energies or his intellectual curiosity.

Among the subjects that fascinated him were Spiritualism and its tenet that spirits of the deceased are accessible to living persons. Church is reported to have said, "It is so lovely to think that we do not have to die, but that we shed our bodies like a chestnut burr or a husk of corn."[57] A religious movement launched in the 1840s, Spiritualism possesses a core belief system but avoids formal doctrinal codes. Perhaps for that reason it attracted many, like the Churches, who were disillusioned with the dogma of conventional religions. Although Spiritualists embrace biblical narrative and the teachings of Christ, they encourage followers to find God within themselves.

Through painting and sculpture, Church gave his philosophical convictions material form. On a massive block of sandstone jutting into the Chagrin River, Church carved an unusual composition featuring a Native American woman. Around her are arranged artifacts of Iroquois life and symbols of the American state. Beneath her is a skeleton. Expressing a sentiment more characteristic of our time than his, he entitled the work *Rape of the Indians by the White Man*. It is better known as *Squaw Rock*.

Carving on the rock was begun in secret. Church was convinced that spirits guided his hands but knew that few others

shared his belief. When unsuspecting villagers discovered the completed work, he reasoned, they would attribute it to spirits and in turn become believers. But premature discovery spoiled his scheme, and he signed the work with his own name and the date 1885.[58] The artist also acknowledged divine inspiration in his *Self-Portrait*, in which supernatural beings who represent his various talents surround his head in an otherwise conventional Victorian portrait.

Respect for nature and the basic precepts of Christianity are themes that recur in Church's sculpture and in many of his paintings. Intended as a monument for the village square, *The Young Lion and the Fatling Together*, inspired by the well-known words in Isaiah 11:6, was to be an emblem of peace and harmony for the inhabitants of the rapidly growing community.[59] The sculpture *Angel of Night* holds two young owls tenderly and smiles down at them. *A Friend in Need Is a Friend Indeed*, based on Benjamin Franklin's cynical aphorism, is rendered by Church as a tribute to a dog's loyalty to his owner. In this sculpture, the shepherd's dog fearlessly defends his master from a mountain lion's attack. The artist, "passionately fond of a gun and two good dogs,"[60] may have

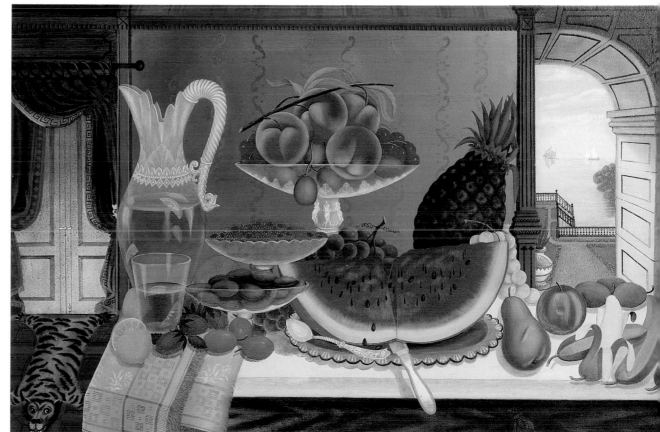

STILL LIFE / c. 1895–1900 / Oil on canvas / 26 × 38" / Collection of Frances O. Babinsky

hoped for such protection himself when he hunted in the woods where bears and bobcats still roamed.

Although Church often painted pictures of animals, particularly dogs and sheep, it is *The Monkey Picture* that is his least conventional rendering. After completing at least four different arrangements of fruit on a well-appointed table—a traditional still-life format—he created this sequel in which two monkeys have escaped their cage and are making a shambles of a staid Victorian dining room. A policeman is shown entering the room,

bent on restoring order, and we can anticipate the comical scene that will ensue as the rotund fellow attempts to corral the rambunctious animals. Deliberate distortions of space and proportion and humorous touches such as faces in inanimate objects are further departures from the conventions of still-life painting.

Church taught himself to paint. He read books on the subject; a copy of *The Art of Portrait Painting*, by Henry Murray,[61] bears margin notes in his hand. According to family legend, in order to learn about painting technique, Church visited the Cleveland studio of a boyhood acquaintance, Archibald Willard, creator of *The Spirit of '76* and leader of the Cleveland Art Studio. He studied the work of other artists through prints. *Lord Byron* and *Washington's Headquarters at Newburgh* are among the paintings that he modeled after prints or engravings. In his *Self-Portrait*, he sports a velvet cap like the one modeled by Victorian artists in England for their portraits.

Church tried his hand at a variety of media, creating works in wood, metal, sandstone, plaster, paint, and charcoal. Comparison of Church's earlier works with those dated to the late 1880s shows

increasing mastery of technique and departure from conventional formats.

To generate income, the artist painted sign-boards and banners, created backdrops for Early Pioneer's picnics, and charged admission to exhibitions of his works. He advertised himself as a painter of portraits and landscapes, a restorer of old paintings, and a worker in metal casting and plating.[62] Although his endeavors yielded few sales, Church continued to create works of art until his death in 1908.

At his funeral service and in the obituaries that followed, the blacksmith from Chagrin Falls was recognized as a unique character and was praised for his high moral standards, his strong convictions, and his genius.[63] But Church had the last word. Having prepared a gramophone record to be played at the service, he concluded, as a Spiritualist might, "Good-bye at present."[64]

Although Henry Church achieved only a local reputation during his lifetime, since his death his work has been shown at the Whitney Museum of American Art (1980), the Abby Aldrich Rockefeller Folk Art Center (1982), and The Cleveland Museum of Art (1978 and 1996).[65]

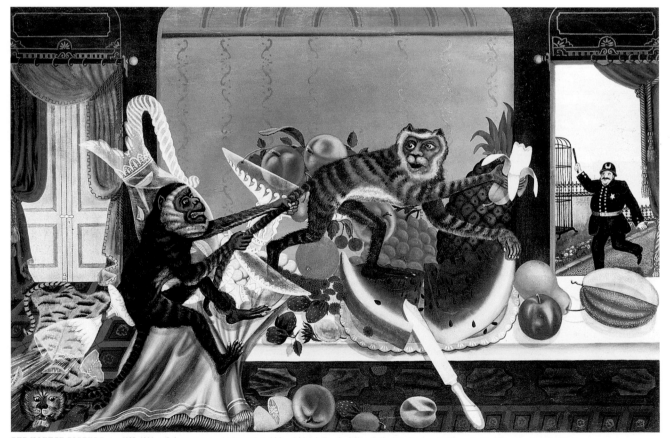

THE MONKEY PICTURE / c. 1895–1900 / Oil on canvas / 28 x 44" / Abby Aldrich Rockefeller Folk Art Center, Williamsburg, Virginia / 1981.103.1

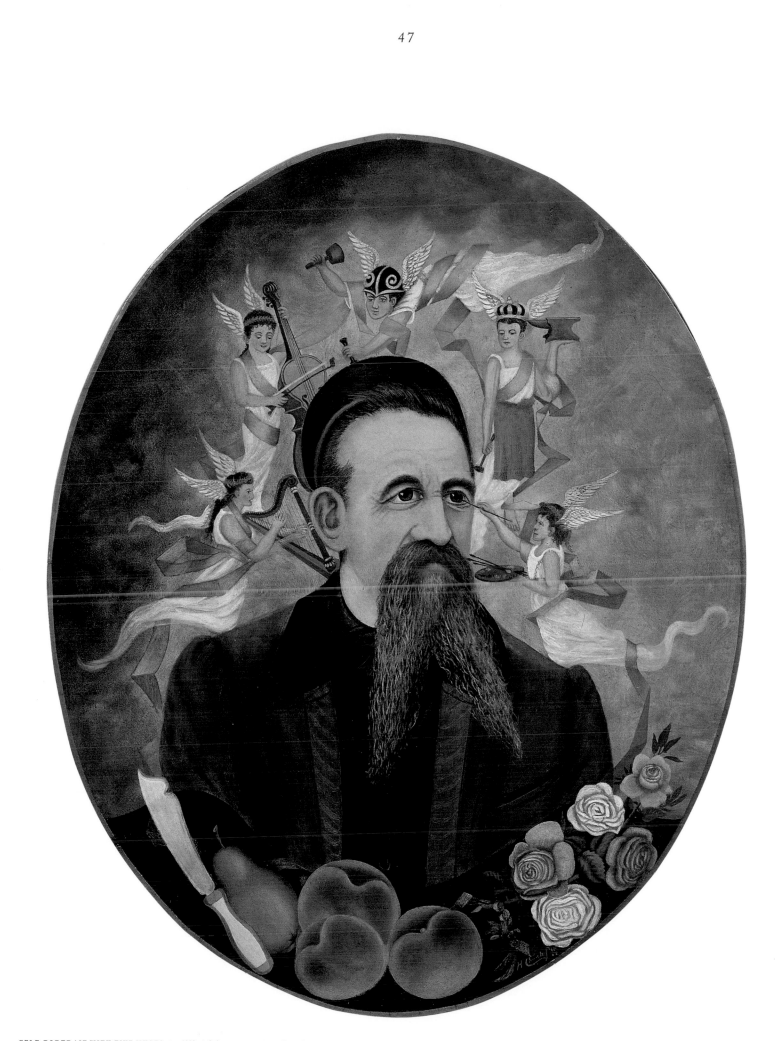

SELF-PORTRAIT WITH FIVE MUSES / **c. 1880** / Oil on composition board / 29 ¾ × 23 ½" oval / Courtesy Joan T. Washburn Gallery, New York

JOHN KANE
(1860–1934)
BORN WEST CALDER, SCOTLAND
WORKED PITTSBURGH

BY JUDITH E. STEIN

The first American twentieth-century self-taught artist to receive national recognition during his lifetime,[66] John Kane was a man who "had no time to paint, no money to paint and no earthly provocation or encouragement to paint," in the description of one commentator.[67] Nonetheless, Kane was impassioned about making art, inspired by "mills, factories, coal barges, trains, tracks, sheds, sheep, cattle, plow horses, hills, valleys, meadows, [and] streams," by his own account.[68] He was an artist to whom even robins cried out, "Paint me, John. Paint me,"[69] and who once sat down and sketched a burning hotel after determining that it was beyond saving.[70] Before he lost a leg in a freak accident at age thirty-one, the brawny Kane helped construct Pittsburgh's streets, bridges, and factories. Subsequently, he worked as a day laborer painting houses and steel boxcars, gamely maneuvering with his peg leg. In his memorable paintings of America's Northeast, Kane depicted the world around him "both the way God made it and as man changed it."[71]

Born in Scotland of Irish parents, the future painter emigrated to western Pennsylvania in 1879 at the age of nineteen. Thirty-one years previously, another young Scotsman had settled in the same Pittsburgh area. Like Kane, this earlier outlander had known hardship and privation in the Old World and was imbued with the American dream of prospering through hard work. Kane's older countryman was Andrew Carnegie, who through luck and his keen business acumen became the richest man in the world. Kane's financial rewards, in contrast, were meager in the best of times. In 1928, nine years after the millionaire's death, the artist paid Carnegie homage by depicting his birthplace in Dunfermline, Scotland, with Carnegie's portrait bust hovering in the sky above.[72] Although the two had never met, their lives were unwittingly entwined.[73]

Kane's first job in the United States was as a gandy dancer, tapping down rocks between the ties of the Baltimore and Ohio Railroad at McKeesport, Pennsylvania. Like as not, the rails laid down after Kane's hard labors were manufactured at Carnegie's nearby steel mill, which the savvy industrialist had fitted out with the recent advances in steel-making technology. Plentiful steel facilitated the expansion of the railroads, and as the need grew for more steel, both Carnegie and Pittsburgh flourished.

According to Carnegie's "gospel of wealth," it was the duty of men of great means to live simply and to redistribute their money responsibly. Thus the industrialist became a philanthropist, founding, among other benefactions, Pittsburgh's Carnegie Institute of Technology in the first years of the twentieth century. Soon after it opened, Kane tried to enroll in Carnegie Tech's art school, but he could not afford the materials and tuition. He proceeded to teach himself what he needed to know by copying the illustrations in art books in one of the free public libraries endowed by Carnegie.

In 1896 Andrew Carnegie helped found the Carnegie International Exhibition, an annual show of contemporary painting. By the 1920s Kane had transcended his lack of formal training and was working on his art at every opportunity. Twice he submitted work to the prestigious International, and twice its jurors rejected the painted copies he naively thought were appropriate. But in 1927, the

HIGHLAND HOLLOW / **c. 1930–1935** / Oil on canvas / 26 ½ × 36 ½" / Carnegie Museum of Art, Pittsburgh / Gift of Mary and Leland Hazard, 1961 / 61.2.1

sixty-seven-year-old Kane catapulted to the attention of the national art-world after the jury accepted his original composition.

Seven years after this debut, Kane died of tuberculosis. Most of his 156 recorded oil paintings were done during this short period of time.[74] In his final years, Kane dictated his life story to a newspaper reporter. He called his autobiography *Sky Hooks*, a title he defined as "the curves of steel from which a house painter hangs his scaffold—by which you pull yourself to the top."[75] This visual metaphor of aspiration evokes the motto "Onward and upward," which was Andrew Carnegie's favorite maxim.

Kane's capital was his own body. A man of guileless charm, he prided himself on his physique, even identifying on that basis with Abraham Lincoln, who had been "a healthy robust young fellow like myself."[76] Of the several self-portraits that Kane painted, three stand out as arguably the most singular American paintings of the twentieth century. *Seen in the Mirror*, an unusual double image, documents the very process by which an artist paints his own portrait. In this work, Kane cast himself as a disembodied and unclothed profile bust regarding his likeness in a framed looking glass. Seemingly punning on the concept of "reflection," Kane inscribed the canvas with a freely recalled version of a verse by the eighteenth-century Scottish poet Robert Burns: "WAD THE POWERS THE / GIVEFT TA GAE US / TA SEE OUR-SELS AS / ITHERS SEE US"

The following year he painted the second self-portrait, described by Frank Crowningshield in 1938 as "one of the most extraordinary pictures of our time."[77] The critic would have known it through verbal descriptions only because Kane had effaced it some nine years previously. Nationally acclaimed following his 1927 Pittsburgh debut, Kane had come to the attention

SEEN IN THE MIRROR / 1928 / Oil on canvas / 8 1/2 × 6 3/4" / Collection of Janice and Mickey Cartin

of the young modernists who formed the Harvard Society of Contemporary Art. In 1929 they invited him to exhibit in Cambridge. Of the six paintings he sent them, one was returned as unsuitable for display. It was "a giant canvas—more than six feet high—[showing] the nude and full-length figure of

the artist in profile." Crowningshield spoke of its startling likeness, "the faithful tracery of the veins . . . the swell of the muscles [and] the artist's artificial leg, with all its straps and complicated supports." Naively, Kane had not foreseen that others might find his unconventional nude self-portrait unseemly.

Following the painting's return, Kane "doubted its true merits" and, determined not to waste the canvas, he "painted out the self-portrait to make way for . . . the portrait of his brother, Patrick, in the uniform of the Black Watch." Today in the collection of The Chrysler Museum of Art, this "double" painting is a prime candidate for modern radiography, which would reveal many details of the phenomenal, invisible image below the surface. Chances are, radiographical exploration will help us better understand the dramatic configuration of the next self-portrait he painted.

In the same year, Kane created the third self-portrait with which we are concerned here, the striking, hierarchic composition in the collection of The Museum of Modern Art.[78] This unflinching view of a powerful man facing his eighth decade is all the more remarkable for its art-historical overtones. Did Kane come across an illustration of Albrecht Dürer's self-portrait executed in the millennial year 1500 while perusing art books in a Carnegie library? It certainly looks that way. Both artists chose a bilaterally symmetrical pose, with the subject looking out to confront the viewer. Both chose austere, dark backgrounds that evoke early Flemish depictions of Christ. Unlike Dürer, Kane depicted his two hands, a challenge for a self-portraitist who typically does not render the hand used for painting. Kane paid careful attention to the frame, demarking triple arches to emphasize his head, placing his loosely fisted hands "behind" the lower boundary, and bowing out his elbows toward the vertical edges, making contact on one side. Had Kane created only this one image, his standing as one of America's most important painters would be undiminished.

THE GIRL I LEFT BEHIND / 1920 / Oil on board / 15 ⅜ x 11 ⅛" / Collection of Janice and Mickey Cartin

SELF-PORTRAIT / **1929** / Oil on canvas over composition board / 36 ⅛ × 27 ⅛″ / The Museum of Modern Art, New York / Abby Aldrich Rockefeller Fund

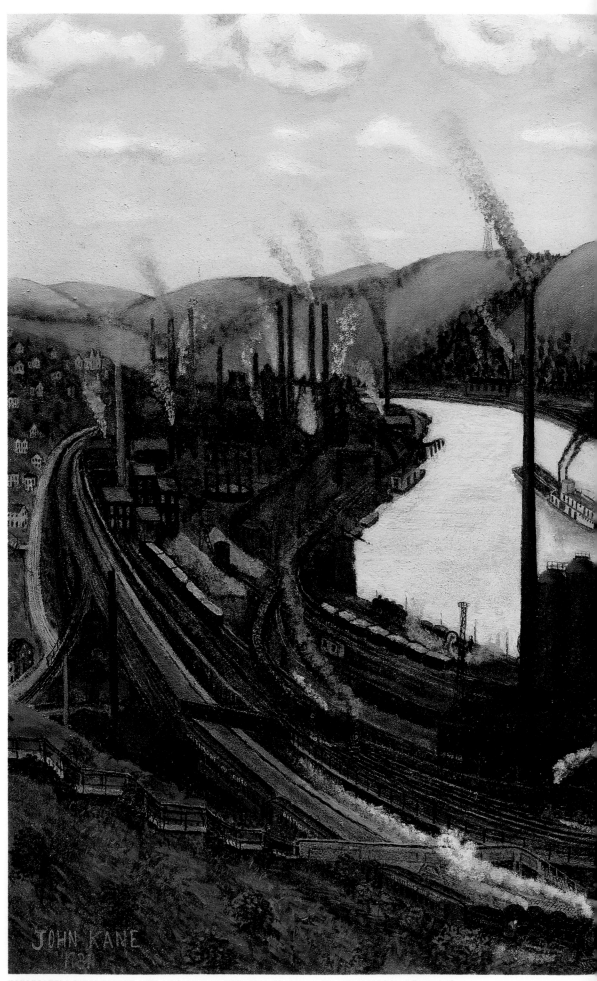

MONONGAHELA RIVER VALLEY / **1931** / Oil on canvas / 28 × 38" / The Metropolitan Museum of Art / Bequest of
Miss Adelaide Milton de Groot (1876–1967), 1967 / 67.187.164

EDGAR ALEXANDER McKILLOP
(1879–1950)
BORN COOPER'S GAP TOWNSHIP, POLK COUNTY, NORTH CAROLINA
WORKED BALFOUR, NORTH CAROLINA

BY JACK L. LINDSEY

The mountains and foothills of western North Carolina have long nurtured rich traditions of folklore and craftsmanship. The area's early demographics included Native American, Scotch-Irish, Welsh, German, and African American populations, and this diversity ensured a wide range of traditional belief systems as well as a blending and hybridization of various folk customs and visual aesthetics. Folk artisans working in wood, clay, metal, and fiber helped to codify and define these rich and varied aesthetic traditions, molding communally held preferences of style and singular vision into solid, tangible form.

Edgar Alexander McKillop was such an artist. Born in rural Henderson County on June 8, 1879, McKillop was one of four sons of Henry and Lena Allen McKillop. Like many families in this largely agricultural region, the McKillops had a small-scale farm that generated annual income that barely rose above a subsistence level. Edgar remained on his parents' farm, involved in agricultural labor or employed at odd jobs, lumbering and coopering, until his marriage in 1906. He and his wife, Lula Moore, and their two daughters moved frequently, following available work in the local mountain communities of Tracey Grove, Hillgrit, and Shut-In until around 1926, when McKillop gained employment at the cotton mill in Balfour, North Carolina.[79]

A self-taught machinist, McKillop patented a bobbin-cleaning device he called a "quill skinner." Although his employment at Balfour Mills was brief, his involvement was profitable, and his skills as a talented tinkerer and repairman became well known within the community. His daughter, Lelia, remembered, "he'd go around and fix clocks and fix stoves; and anybody had something to repair, he

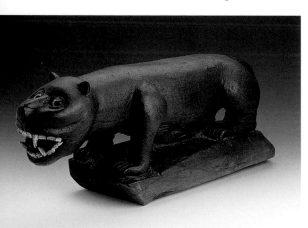

MOUNTAIN LION / c. 1940s / Black walnut, bone, and glass eyes / 9 ⅝ × 7 × 24 ¼ " / Milwaukee Art Museum / Gift of Mr. and Mrs. Robert Beal and Isabelle Polacheck

went around and worked. . . . When we were children . . . he'd take cornstalks and make cows and little things."[80]

At about the same time that he left the mill, McKillop was offered the wood from several large black walnut trees, if he would cut and haul them away from the property of a local man. Acquiring this wood began a period of concentrated carving that would last until shortly before his wife's death in 1938. Ingenious, inventive, and adaptive in his ability, McKillop began to experiment with carving and quickly developed the skills to bring life to the images he envisioned in the raw chunks of wood. McKillop produced a wide range of fantastic animals, human and animal figural groups, clocks, and canes, and carving became a full-time occupation, if not an obsession. Lelia McKillop remembers, "he worked, I think, night and day part of the time on them. . . . It was just in him. He didn't take any schooling . . . he just turned out all these things. . . . It was just in him."[81]

Working almost exclusively in local black walnut, McKillop produced forms that are striking in their rough-hewn quality but finely smoothed and finished over their carved surfaces. He sometimes combined various found bones, horns, teeth, or claws as insets in his work, and sometimes ornamented and patterned the surfaces using a wood-burning tool. Several of his neighbors remember his direct approach to carving: working in his yard with mallet, chisel, and knife, all of his own manufacture. When a piece required multiple parts, he would carefully fit and join each one using his skills as a cabinetmaker.

McKillop's dramatic output and intense dedication to carving produced an amazing menagerie of animal, human, and fantastic creatures that populated the small, four-room mill house in which he and his family lived. Within this fantastic assembled environment, groups of carvings suggested new images. Early works were adapted, augmented, or recombined by McKillop in later carvings. Patterns and images from nature, animal life, and folk stories were combined with politics, current events, and biblical and musical references to produce his personal versions of truth and

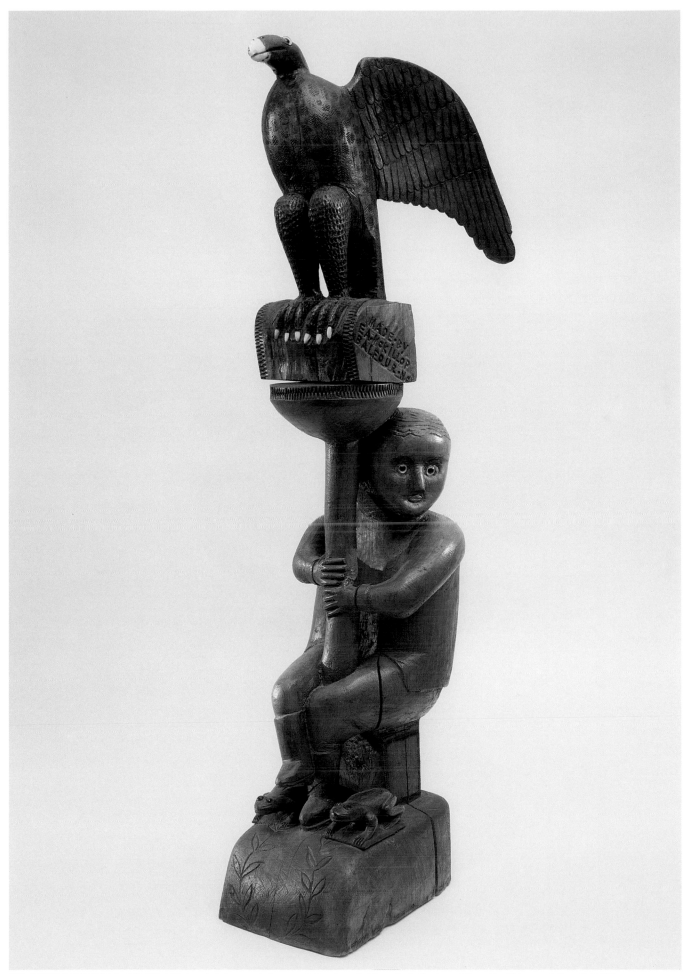

MAN HOLDING AN EAGLE / **c. 1928–1929** / Black walnut, bone, and glass eyes / 52 × 13 × 18" / From the Collections of Henry Ford Museum & Greenfield Village

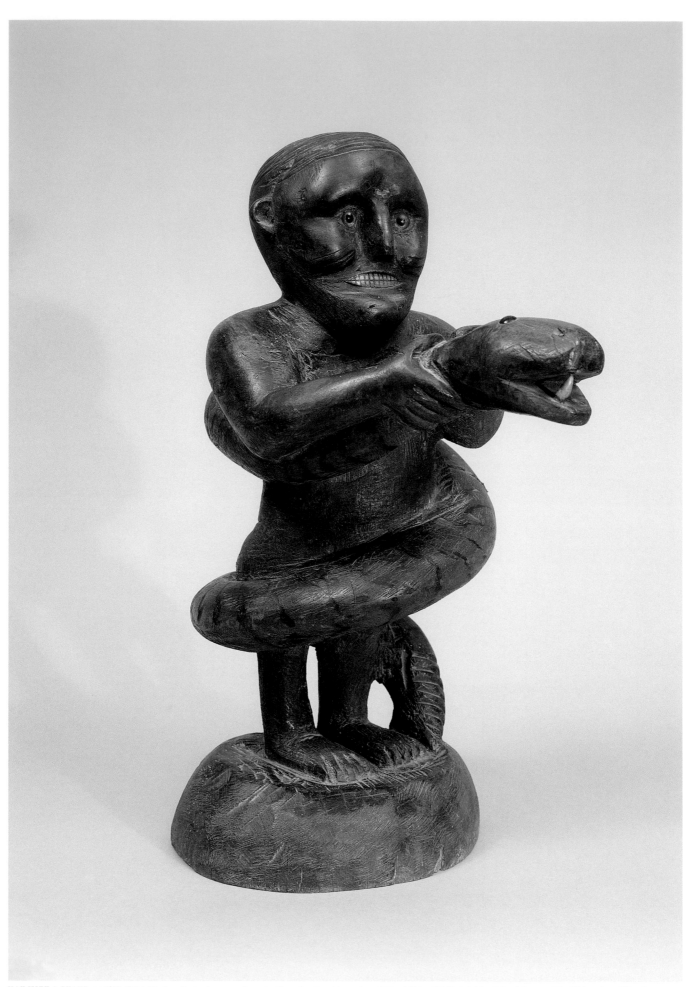

MAN WITH A SNAKE / **c. 1926–1933** / Black walnut, glass eyes, bone teeth, and painted bone fang / 22 × 10 ¼ × 15 ⅛" / Ackland Art Museum, The University of North Carolina at Chapel Hill / Ackland Fund

experience. One cane, populated over its entire surface with fish, reptiles, and land animals, and surmounted with a figure of a man, attests to the artist's knowledge of a wide range of animal life and may represent the story of man's evolution. Dreams may also have supplied inspiration. When asked how he came up with some of his ideas, McKillop is reputed to have said, "Well, you just eat a big mess of fatback and go to bed and go to sleep and dream how to do it."[82] Other, more imaginary or exotic images, such as his dragons, giraffes, leopards, and gorillas, may have been inspired by illustrated periodicals.[83]

Confident and convinced of his own talent, McKillop welcomed visitors to his house and at times charged a small admission to view its interior wonders. He also converted an old pickup truck, adding shelves and curtains to its back and filling it with carvings to produce a traveling road show. One of his large forms, the *Hippoceros*, contains a Victrola mechanism that played a recording that proclaimed, "E.A. McKillop, a born carving man!" McKillop was justifiably proud of his self-taught skills, and his self-promotion and showmanship ensured a wider audience for his work, as well as the reinforcing praise and admiration from his neighbors he seems to have craved. Most of his surviving work bears a bold signature or inscription, usually in large carved or burnt letters "MADE · BY / E.A. McKILLOP / BALFOUR · N.C. / HAND · CARVED." This pride in accomplishment accompanied by an active self-promotion to a wider audience is a pattern seen among a large number of early self-taught artists, many of whom retained and assembled works into dense, cohesive environments, just as McKillop did, creating and exhibiting their own constructed "worlds."

Many of his works were traded, sold, and dispersed just before his wife's death, and he did little carving after that. McKillop died on August 4, 1950. The recollections of his friends, relatives, and neighbors suggest that the carver produced an amazing number of additional forms that have not yet been rediscovered. While relatively few of McKillop's carvings have thus far been firmly identified, those that are known attest to his inspired ingenuity, dedication, and talent. Edgar Alexander McKillop was independent, persistent, and driven, and his fantasies and realities hewn in wood provide a vivid and rich witness to his life, imagination, and energy.

BILL
TRAYLOR
(1856–1949)
BORN NEAR BENTON, ALABAMA
WORKED MONTGOMERY, ALABAMA

BY JOHN L. MOORE

By now the incredible story of Bill Traylor is well known. This freed slave who could not even write his own name began to draw in 1939, at the age of eighty-three. In just three years, seated on a box on Monroe Street in Montgomery, Alabama, he produced more than 1,500 of some of the most important modern American drawings. His materials were of the most basic kinds: pencil, charcoal, a small straight-edge stick, and poster paint on recycled cardboard, some of it the thin cardboard used to give form to laundered shirts. The works were small in scale and fit easily onto the 18-by-24-inch drawing board he held on his lap.

A 24-year-old trained artist, Charles Shannon, met Traylor on Monroe Street in Montgomery only weeks after he first began to draw. Shannon became Traylor's friend and is largely responsible for promoting and preserving the rich treasury of the older man's works. Today, Traylor's drawings are found not only in many museums and galleries, but also in the collections of many trained artists. My own first viewing of the drawings of Bill Traylor was in 1982 at a New York gallery. I was immediately impressed by the sheer economy of his drawings, with his use of simple geometry drawn in pencil to suggest underlying structure, and with the curved lines he used to define his forms, which he filled in to create full-bodied, animated forms of people, animals, and birds. The drawings were full of life, at once eloquent and dynamic. Traylor incorporated the smudges and stains existing on the cardboard into lively and believable fields for his images to exist within. In *Untitled*

(Figures with Pitchfork), two men, one bearded and holding a pipe, provide a humorous moment as they seem to strut and hop across the page, each with a bird on his head. One figure may be attempting to strike at the bird on his head with a long stick. The composition is a beautiful play of straight and curved lines in its suggestion of some ritual dance or just a playful moment.

Traylor did not draw from direct observation, but rather reproduced events processed through memory. For example, one fine spring day, Traylor, in deteriorating health, told Shannon about the drawing *Untitled (Man with Mule Plowing)*, a reference to his life on the farm: "I wanted to be plowing so bad today," he said, "I draw'd me a man plowing."

Untitled (Fighting Dogs) captures the aggressive quality of two ferocious full-bodied dogs as they leap at each other, mouths open, revealing long fangs. Both have large heads and thick necks, and the black dog appears to breach the barrier (the gray vertical) between them. The animation in this drawing is further enhanced by the straight and curved lines that run through and over each of the dogs. Spots and abrasions in the paper add to the vitality of the scene, and the eye is carried upwards to the black diagonal line that bisects the sheet in its top left corner, providing an interesting contrast to the undulating contour of the black dog's back.

In *Untitled (Man and Large Dog)*, the reversed scale of man and dog is interesting. This combination also appears in a number of Traylor's other drawings, in which fierce, massive, red-tongued

UNTITLED (FIGHTING DOGS) / 1939–1942 / Poster paint and pencil on cardboard / 27 ½ x 22" / Collection of Patrice I. Pluto

dogs on leashes are walked by meek and tiny owners. In some cases, Traylor depicts dogs attacking men. Many of his drawings show men drinking, and there are many scenes of men with clubs chasing chickens and other men. The activity of chasing chickens may be about catching dinner, but men with clubs in upraised hands in pursuit of one another may well be part of a different narrative. After a bout of drinking, the men have perhaps become combative, leading to the chase scene. However, we never see images of actual harm. The scenes are good-humored, not murderous. And if certain of Traylor's drawings were laid out in sequence, an ongoing visual narrative could be constructed.

As Traylor advanced in his work, the drawings became increasingly complex. In one series of drawings, he combined figurative forms of different kinds to create surreal constructions. *Untitled (Plant/Animal Form with Man and Dog)* is an imaginative and somewhat sinister drawing. In this work, dog, man, bird, and plant forms are connected to a decapitated but animated human form drawn from mid-torso down. A stock figure of Traylor's, a man pointing, is bending forward from the heel and ankle of the upraised leg of the decapitated figure, directing our attention to something he has observed off the page below him. A dog is attached by its two front legs to the opposite side of the decapitated figure's same leg. A fine example of Traylor's subtle ingenuity, the negative spaces between the various parts activate the composition, while tonal gradations, smudges, and various small spots in the paper further add to the work's visual impact.

At least as complex, if not more so, is *Untitled (Outline of House with Figures)*. In this drawing, the viewer is presented with simultaneous interior and exterior views of a house. Silhouetted figures of men and dogs populate the scene. Two men in hats, one standing and the other seated, are drinking. The standing figure has two smaller figures attached to it and appears to cross over a line drawn diagonally from the front of the house to a brown boatlike structure behind it. A bearded figure leans against the outside doorway of the house. Another man, accompanied by a large dog, is attempting to gain entrance over a wall. This was one of many drawings Traylor produced in his efforts to find a way to show figures inside a house. The drawing is further enhanced by Traylor's elemental simplicity: thick red lines and the black opening of the door define the space of

the house, and the darkness of the gray ground and the ghostlike, brown, seated figure provide dramatic effect. In contrast, *Untitled (Lamps on Mantelpiece)*, a symmetrical construction drawn in flat black against a tan field, appears spare and almost abstract. In this piece, three horizontal bars of various widths join two curved, mirrored sections. Elaborating this symmetry, two oil lamps, at the far ends of the mantel, and a single goblet, placed in the center, give an elegant and sophisticated look to the composition.

UNTITLED (MAN AND LARGE DOG) / 1939–1942 / Pencil and poster paint on cardboard / 28 × 22" / Courtesy Luise Ross Gallery, New York

Taken as a whole, Bill Traylor's drawings provide an engaging and personal perspective both on the small section of humanity that passed by him on Monroe Street and on his lifetime of memories. Traylor was a man who had been strong and had stood six feet tall in his prime. When he was old and sick, and had lost the use of his legs, he slept on the floor in the back room of a funeral parlor. Just when his life was near its end, he was able to reach back into his lifetime of experiences and prevent his memories from slipping into the unconscious by creating art out of them. I am sure that he could not have begun to imagine the impact his drawings would have on artists today, many of whom look at Traylor's drawings and wonder how to tap some of what he found.

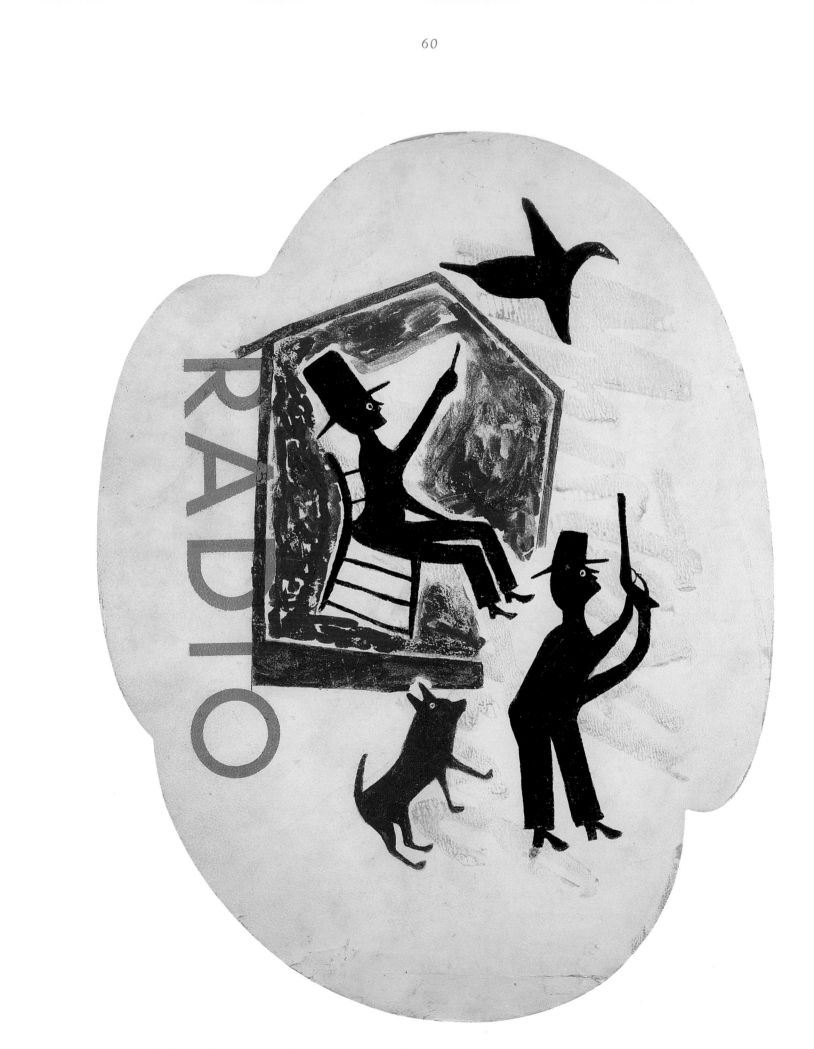

UNTITLED (RADIO) / **1939–1942** / Poster paint and pencil on cardboard with gold paint / 32 × 24 ½" / Collection of Judy A. Saslow

UNTITLED (BLACK SEATED FIGURE) / **1939–1942** / Pencil and poster paint on cardboard / 14 ½ × 8" / Courtesy Luise Ross Gallery, New York

WILLIAM
EDMONDSON
(c. 1870–1951)
BORN AND WORKED DAVIDSON COUNTY, NEAR NASHVILLE, TENNESSEE

BY ROBERT STORR

Right there in the noon daylight, He hung a tombstone out for me to make.

—William Edmondson

In "high" art, simplicity is an achievement. In "primitive" art, it is thought to be a given. The love affair that modernists have long had with such traditional art forms is based, like all love affairs, on a willing suspension of disbelief and a willful ignorance of the complexities of the beloved who comes to represent all that is pure. What modernists jealously desired in "primitive" art was the direct statement of archetypal forms that they, steeped in the idealized naturalism of Western art, could only arrive at by paring away all its inherited conventions. They prized the apparent directness of folk or tribal artists above all because these "primitives" seemed innocent of the mixed motives that belabored the souls and sapped the creative daring of their European and American counterparts. Late nineteenth-century art took it for granted that to be cultured was to be corrupt, compromised; in a wide compensatory swing, twentieth-century art assumed that true originality, unblemished by original sin, was the birthright of the uncomplicated, if not the uncultured.

UNTITLED (THREE DOVES) / c. 1935–1940 / Limestone / 7 ¼ × 10 ¼ × 6" / Collection of Jill and Sheldon Bonovitz

Unfortunately for the "primitive" artists, the price of being loved in this manner was to be underestimated. Countless studies now analyze the ways in which this has tainted our understanding of non-Western art and its tributaries, and countless polemics point out the moral and political lessons that those lapses in curiosity, research, and understanding indicate. These essays were a much needed corrective to the prejudicial romanticism of the past. In time, however, the righteousness that clings to many of their authors has itself become a problem. For in their eagerness to demonstrate that so-called naive artists are not in fact culturally underdeveloped beings, the crucial role of naïveté in the creative process has itself become devalued.

Baudelaire, the first great modernist critic of the visual arts, phrased it best. "Nothing is more like what we call inspiration than the joy the child feels in drinking in shape and color. . . . Genius is no more than childhood recaptured at will, childhood equipped now with man's physical means to express itself, and with the analytical mind that enables it to bring order into the sum of experience involuntarily amassed."[84] So deeply embedded in the ideology of modernism are such thoughts of a paradise regained that we must stop to ask ourselves if we still actively believe in them or merely nod to these sentiments out of wistful reflex. So disabused have we become that even Baudelaire's faith in the imagination now seems optimistic. Moreover, one can easily see how dangerous this equation can be when applied to the work of the artists outside the world-weary milieu in which he wrote.

Which brings us directly to the case of William Edmondson, creator of some of the most severe and delightful stone carvings to have been made in America during the twentieth century. It is churlish to gainsay the acuity of the small group of early admirers who brought Edmondson's work to public attention. They were right about his talent, and as far as their dealings with him are concerned, they seem to have done right by him as well. But all the same, their enthusiasm came at a cost. Consider the appraisal of Louise LeQuire, a devoted advocate who wrote: "Edmondson's childlike faith

is represented by his works."[85] LeQuire was not alone in this assessment of the tombstones, religious figures, Edenic animals, and occasional secular subjects in which Edmondson specialized. What, for instance, was the average newspaper reporter to make of a man who explained his late-blooming artistic vocation in the language of conversion?

> I was out in the driveway with some old pieces of stone when I heard a voice telling me to pick up my tools and start to work on a tombstone. I looked up in the sky and right there in the noon daylight, He hung a tombstone out for me to make. I knowed it was God telling me what to do. God was telling me to cut figures. First He told me to make tombstones; then He told me to cut the figures. He gave me them two things.[86]

Indeed, it would seem that Edmondson owed his fame in the 1930s as much to the fact that he made good copy as to the work itself. After all, the Lord hadn't just stopped in the driveway but had also spoken to him from the head of his bed "like a natural man." "He talked so loud He woke me up," Edmondson recalled. And "He tol' me He had somethin' for me."[87] Meanwhile, Edmondson described his animal images in charming country slang as "varmints" and "critters." All in all, Edmondson fit the bill of a self-effacing folk hero to a tee, and where his image needed accents to enhance his appeal to northerners, journalists obliged with Uncle Remus imitations. In 1937, for instance, *Time* printed the following:

> Dis here stone n' all those out there in de yard come from God. It's de word in Jesus speakin' his mind in my mind. I mus' be one of his 'ciples. Dese here is mirkels I can do. Cain't nobody do dese but me. I cain't help carvin' I jes does it. . . . Jesus has planted the seed of carvin' in me.[88]

Not all of Edmondson's supporters fell into this trap, however. Louise Dahl-Wolfe, who was the first to photograph his work and who brought it to the attention of Alfred H. Barr Jr., director of The Museum of Modern Art, where Edmondson showed twelve works in 1937, matched her big-city savvy with the small-town artfulness of Edmondson's speech and sounded a sympathetic warning.

> You had to realize that William was very playful and fanciful in what he said. He'd make things up on the spur of the moment to explain things and you never knew whether that was the real reason. . . . I would say that he was an old-fashioned southern black who was used to talking to white people in a way that was respectful but at the same time he often had his tongue in his cheek and was clowning.[89]

Related testimony to Edmondson's canniness was offered by Mary Brown, a niece who remembered that "He was kind of shrewd. He just did a lot of things. He was a person to kind of experiment. . . . He didn't have a lesson or nothing."[90] Certainly, Edmondson managed just fine. After a lifetime of poorly paid work, he owned his own house; after God's summons, he figured out how to fashion his own tools from old railroad nails; when he needed it, he procured stone from quarry workers who dropped off their odd lots while making deliveries to regular customers. In short, Edmondson planned ahead with the resourcefulness of a small-time entrepreneur.

Practicality of this kind does not easily square with the conventional image of the visionary primitive. Immaculate conception in artistic matters presupposes guilelessness in worldly affairs. Or such is the undivided nature of the "noble savage" in aesthetic legend. So, one asks, did Edmondson have visions, or was he just making things up to please indulgent listeners? I think we can take his word for it that he did see things. But what he saw is not so clear to us as it was to him— but for the things he made, which are very clear-cut indeed. As to the visitations he described, they have been filtered through cultural and linguistic barriers that screen out any form of spontaneous faith with a fine mesh of skepticism, condescension, and embarrassed repression.

Contemporary sensibilities make scant allowance for what used to be called inspiration. The word itself makes us uncomfortable to the extent that we take it literally to mean that a spirit we cannot name or account for has invaded our minds or suffused matter. To be inspired is to see things that are not there with eyes that are no longer our own. It may be, for example, that the visual furnishings of everyday life that previously seemed ordinary and unchanging suddenly appear to be inhabited by some animistic force. Or perhaps

a word that for no discernible reason echoes in our heads abruptly assumes the dimensions of an object. Such intuitions, along with the disorienting euphoria they instill in those prepared for them and the fear they stir in those who are not, are anything but primitive in the sense of ill-defined or imprecise, and they are not all that rare.

Uncommon, however, is the person who acts on them. Such a person is, almost by definition, an artist. To be an artist, one must cultivate the ability to see something whole and retain it until it has been fully articulated, even if, in the process, it radically changes aspect. ". . . if you can't hold it in your head, you can't shape it," said folk artist James "Son" Thomas, and he is right.[91] This is where faith comes in. If the imagination provides the image that permits one to anticipate the incarnation of something that has yet to exist in any other form, the rightness and seeming inevitability of result derives from a prior conviction that what the hand has made was in a certain way preordained and beyond its control.

UNTITLED (NOAH'S ARK) / c. 1930 / Limestone / 22 ¼ x 16 ¼ x 14 ¾" / Collection of Robert M. Greenberg

That is what Edmondson was talking about when he said, "the Lord working His will through my hand."[92] But he added, "Can't nobody do these but me."[93] Enter the prideful craftsman and the ego of the self-conscious artist. To be sure, it took a long time for Edmondson to come around to this way of thinking. "I is just doing the Lord's work," he told a Depression-era interviewer, "I didn't know I was no artist till them folks come told me I was."[94] It is probably true that until outsiders began to make a fuss about what he was doing he had no reason to see himself as an "artist" in the conventional terms, though neither was he a mere artisan cranking out tombstones and birdbaths according to traditional formula. There is also a measure of aw-shucks deflection in

his disclaimer, the sly caution Louise Dahl-Wolfe picked up on.

What matters more than his recognition as an artist by art lovers and promoters was his own late recognition of himself as a man with a gift and a purpose. "Wisdom, that's what the Lord give me at birth, but I didn't know it till He came and told me about it."[95] This realization came at the end of a long life of low-wage labor, principally as a farmhand and a janitor. Without the soul-dulling routines and social humiliations of such toil, Edmondson experienced for the first time the freedom of unalienated labor, and the satisfactions of the day-by-day congruity of his transformative will and the objective world around him. The creative impulse that had been awakened in him was truly a revelation. This said, he took nothing for granted and was as subtly alert to the limitations of his opportunity as any sculptor working under any circumstances. Thus Edmondson knew that the ultimate worth of innate talent is contingent on use. "It's wonderful," he said, "when God gives you something, you've got it for good, and yet you ain't got it. You got to do it and work for it. God keeps me so busy. He won't let me stop to eat sometimes."[96]

The least of his concerns was self-expression. It was God's word that needed to be preached and the spirits "locked in a stone" that commanded "Let me out—let me out."[97] And so Edmondson would say of his work, "It ain't got much style. God don't want much style."[98] There is nothing modest in this declaration, nor anything quaint either. On the contrary, the idea of a styleless art has been a constant of aesthetic theory as far back as one wants to go, just as the notion of releasing vital forms trapped in matter has guided the practice of artists from Michelangelo to Giacometti. Piece together the various statements Edmondson made in light of such comparisons and one arrives at the surprising conclusion—which is not so surprising, after all, when you reflect on the plain emblematic images he tailored—that Edmondson was, without "lesson[s] or nothing," a classicist for whom form was a priori and impersonal, and the artist its agency rather than its originator.

The metaphors of classicism were mythological; those of Edmondson were biblical, as is customary in the religious society of the American South. The muses beckoned the carvers of ancient Greece to their work; God called Edmondson. Otherwise, we are dealing with the same phenom-

UNTITLED (SEATED GIRL WITH CAP) / **c. 1935** / Limestone / 21 × 7 × 10½" / Collection of Mr. and Mrs. J.M.O. Colton

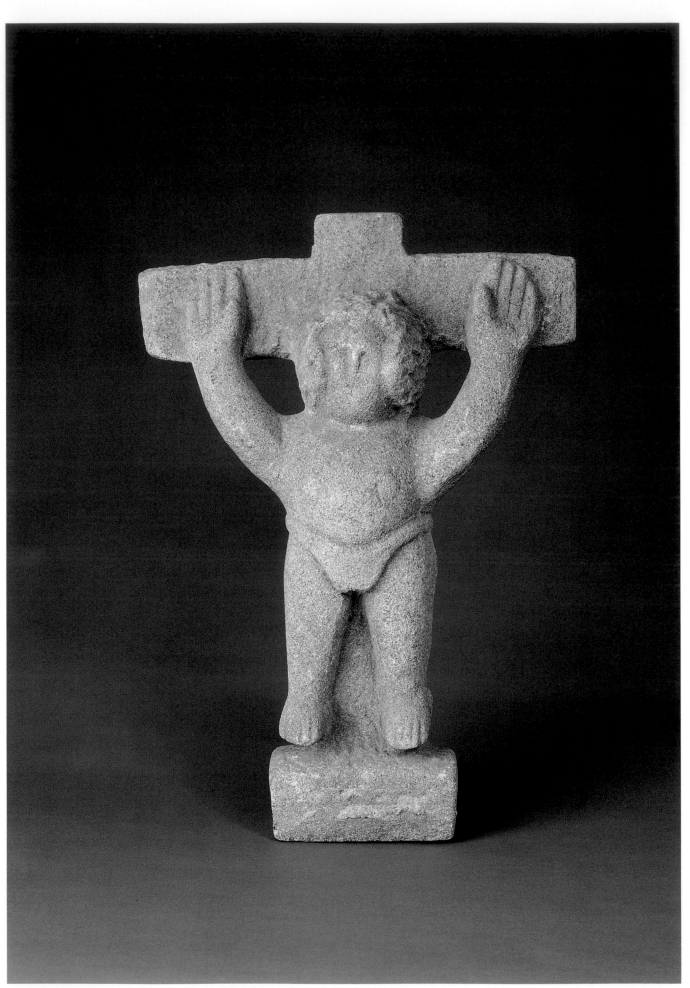

UNTITLED (CRUCIFIX) / **c. 1940** / Limestone / 20 ½ × 14 ¾ × 14 ½" / Collection of Robert M. Greenberg

enon at the same level of intensity—the miraculous transubstantiation of images. "I see these things in the sky. You can't see them, but I can see them," Edmondson once said.[99] About that he was not shy. But I would argue that he *was* being "naive." Not in the pejorative sense that this word has acquired in reference to untutored artists, but as Baudelaire initially meant it. Read the poet's words again with the knowledge we have of Edmondson's belated revelation, his methodical ways, his determination to protect his gift from the overly inquisitive, and the manifest pleasure he took in the world he made out of the world he saw.

Nothing is more like what we call inspiration than the joy the child feels in drinking in shape and color. . . . Genius is no more than childhood recaptured at will, childhood equipped now with man's physical means to express itself, and with the analytical mind that enables it to bring order into the sum of experience involuntarily amassed.

What makes Edmondson an artist in the fullest measure is the *achievement* of "naïveté," rather than its "natural" occurrence. So when I read about God stopping him on the driveway or bellowing from his bedstead, I do not ask myself what the Deity looked like on this occasion or why He conceals Himself from the rest of us. I assume that, for artists, He will always take the form and choose the moment that suits Him and them best. Then again, we may be speaking of goddesses or some other demiurges. Meanwhile, I conjure up the work of Philip Guston, who painted the Lord's cartoonish hand reaching down from the heavens with a brush or the lightninglike dagger in the clouds that Raymond Pettibon draws, and realize that they too dressed the source of their inspiration in the disguise of divinity, thereby depicting it as uncanny, imperative, and absolute. Edmondson would have enjoyed their company. I am sure that he belongs in it.

MORRIS
HIRSHFIELD
(1872–1946)
BORN RUSSIA POLAND
WORKED NEW YORK CITY

BY CARTER RATCLIFF

Morris Hirshfield was an artist of sitting rooms and dressing rooms, of cats and furniture, of uneventful days at the seaside and in the mountains. Yet his world is not merely cozy. As girlish as they are, his nudes have a monumental vitality. A Hirshfield cat turns on us the stare of a tiger. And yet, actual tigers also appear in his paintings, as do lions and other wild beasts. These creatures of the jungle and savannah are perhaps only the imaginary cousins of the real house cat, yet they have a secure place in Hirshfield's universe. They stand for the intensity of passion that runs through the artist's scenes of domestic calm—and through the dense, meticulous textures of his paint. Hirshfield pictures space and light, self and world, as no other painter has done.

Hirshfield's first career was in the garment industry; he was particularly successful as a slipper manufacturer. He became a painter after retiring at the age of sixty-five. Yet he did not set aside his knowledge of fabrics and tailoring. Fabrics themselves are prominent in three of the four Hirshfield pictures included in "Self-Taught Artists of the 20th Century: An American Anthology." The nude woman he calls *American Beauty* is framed by two heavy curtains. *Beach Girl* wears a white blouse with the texture of a braided rug. And *Girl with Angora Cat* is filled with fabric: the human figure is seated in a lushly upholstered chair; the bodice of her dress is trimmed in ribbon and embroidered, while the skirt bears a pattern of lines, or perhaps the lines indicate sharp pleats. The cat she holds in her lap is exceedingly fluffy—it is presumably an Angora, though it's tempting to imagine that the creature is clothed in some variety of plush. In Hirshfield's world, nearly everything looked patterned and sewn. In the fourth work, *Waterfalls*, there are no figures to wear clothes, but the sky, the foliage, and the foaming water all have a feel of luxuriously worked fabric.

Of course, Hirshfield's pictures are not simply displays of texture. They are structured. One could say that they are composed, yet that would be slightly misleading. Traditionally, a composition is judged to be good if its various elements are harmoniously balanced and comfortably contained within the frame. Symmetry, which so often provides a Hirshfield image with its organizing principle, is understood as a fault, and some viewers may see such pictures as *Waterfalls* and *American Beauty* as too evenly balanced, hence too static—in short, badly composed. Judgments like these miss an essential point.

In making a picture, Hirshfield employed structural devices analogous to those of tailoring or dressmaking. Like a building, a piece of clothing is usually constructed around a central axis, and that is how many Hirshfield pictures are organized.

WATERFALLS / 1940 / Oil on canvas / 20 × 28" / Private collection / ©Estate of Morris Hirshfield / Licensed by VAGA, New York

Though strict, his bilateral system permits variety—see, for example, the swagged effect produced by the cords that hold the curtains open in *American Beauty*. The structure of a Hirshfield picture is always flexible, like that of a suit or a dress relieved of its rigid axial symmetry by the stride or gesture of its wearer.

It would be going too far to say that Hirshfield's human figures are clothed in the forms of architecture and landscape. In fact, they wear regular clothes or nothing at all. Nonetheless, even Hirshfield's nudes are crowded by patterned fabrics. Within his frames, there is little open space.

He fills his skies with the downy, repetitive shapes of clouds. Around the head of the *Girl with Angora Cat*, the air seems to solidify into a pattern. Dense and curving, it looks like a variation on her coiffure.

Hirshfield's pictures suggest something about the way we inhabit our world—not donning it, exactly, but wrapping ourselves in its familiarity. Weaving the array of visible things into a variety of attractive fabrics, tailoring them to his idea of an ideal reality, he alerts us to the embrace in which the world enfolds us. Showing the very air as an intimate presence, he was remarkably original, yet there is no evidence to suggest that he wanted to be anything but a realist of the most familiar kind.

In 1939 Sidney Janis, a member of the Advisory Committee of The Museum of Modern Art in New York, included Hirshfield in an exhibition there entitled "Contemporary Unknown American Painters." Several years later, in a book on what were then called "primitive" artists, Janis wrote that despite Hirshfield's affinities with the dadaists and surrealists, he had no knowledge of them.[100] He was, it seems, indifferent to the art of the avant-garde. In 1940, while Janis and Hirshfield were attending an exhibition at the Brooklyn Museum of work by local artists, Janis was surprised to learn of the aesthetic ideal that Hirshfield had set for himself. Though Hirshfield was included, he did not wish to linger before his own canvas. According to Janis, "he took my arm and said he wanted to show me a real work. . . . It was a pretty and sentimental picture in the worst manner of the British portraitists of the late eighteenth century."[101] Deeply impressed, Hirshfield said that he "would give anything" to be able to produce a painting of that sort.

Hirshfield's accomplishments were far superior to his hopes. Janis was shocked to discover the disparity, and we can relive that shock by comparing Hirshfield's *Lion* to the banal illustration that guided him in the creation of this painting. Without seeming to be conscious of doing so, he transformed a set of pictorial clichés—the king of the jungle at his most wearily familiar—into an image that still looks fresh nearly six decades after it was painted. When he worked from observation or memory, without reference to a ready-made picture, the things of everyday reality underwent the same sort of transformation. The ordinary became extraordinary. It is, of course, impossible to say how this

happened. At most, we can learn to see the world as Hirshfield saw it—or as he felt his way into it, as into the garments of an infinitely capacious wardrobe. And perhaps we can feel the intensity of his awe and desire at the moment when all the lush fabrics fall away to reveal the flesh of a woman.

BEACH GIRL / 1937–1939; dated 1937 / Oil on canvas / 36 1/4 x 22 1/4" / The Museum of Modern Art, New York / The Sidney and Harriet Janis Collection / ©Estate of Morris Hirshfield / Licensed by VAGA, New York

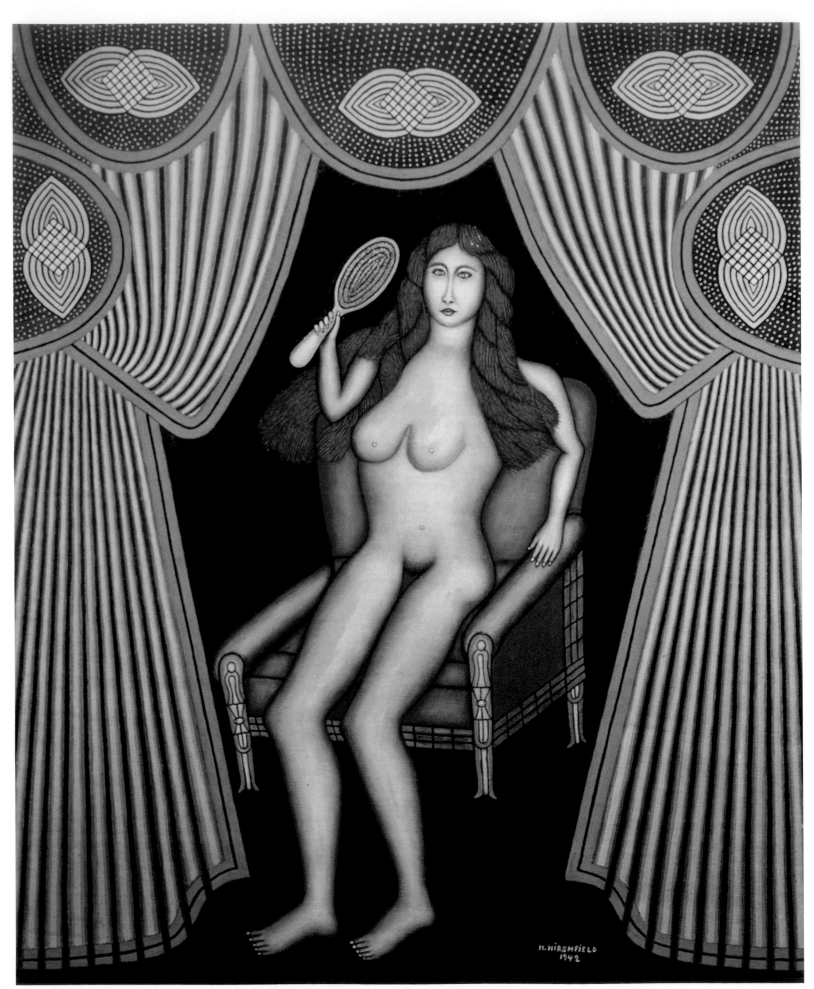

AMERICAN BEAUTY / 1942 / Oil on canvas / 48 × 40″ / Courtesy Sidney Janis Gallery, New York / ©Estate of Morris Hirshfield / Licensed by VAGA, New York

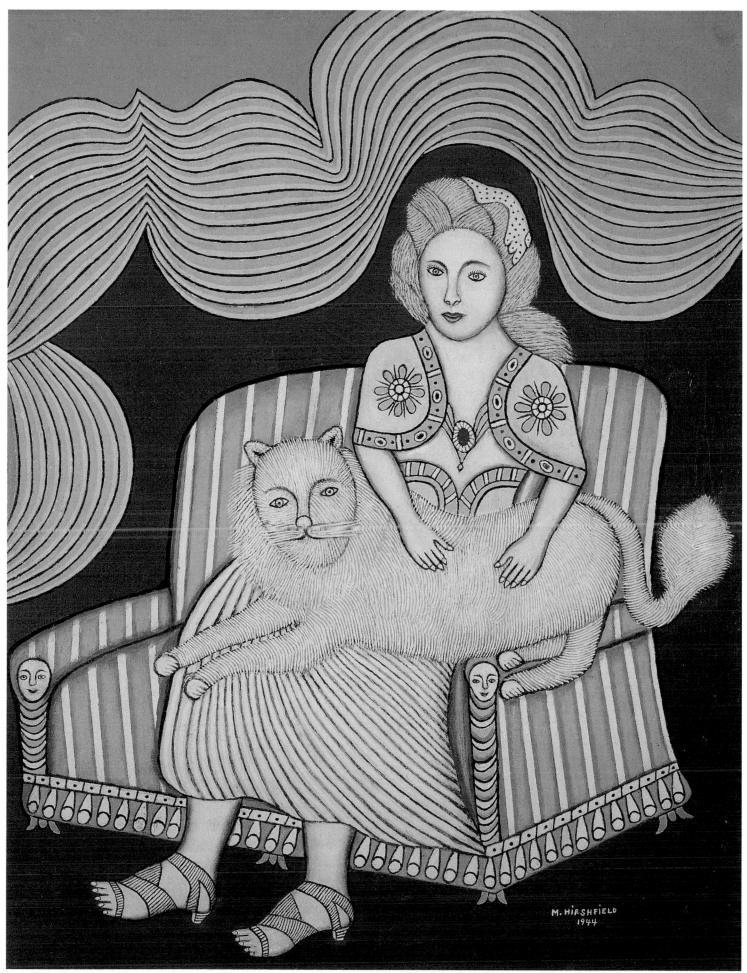

GIRL WITH ANGORA CAT / **1944** / Oil on canvas / 36 × 28" / Private collection / ©Estate of Morris Hirshfield / Licensed by VAGA, New York

HORACE
PIPPIN
(1888–1946)
BORN AND WORKED WEST CHESTER, PENNSYLVANIA

BY JOHN W. ROBERTS

By most informed estimations, Horace Pippin is one of the most important African American visual artists of the twentieth century. During his relatively brief career as an artist, Pippin produced some 100 paintings and a number of burnt-wood panels on themes as varied as war, family and community life, religion, and nature. In their mammoth study, *A History of African-American Artists*, Romare Bearden and Harry Henderson attribute Pippin's success to the fact that "his need to organize and express the reality of his life visually cut through all impediments so directly and profoundly that he arrived at concepts in painting that were extremely modern."[102] Whether it was a result of this ability to produce modernist images or of his exotic style, as others claim, Pippin's work was immediately embraced by art historians and connoisseurs from the moment that it was brought to public attention. Since the late 1930s, when his work was first shown, Pippin has been one of the most often exhibited African American visual artists. In addition, his works are still avidly sought by private collectors and museums. Today, examples of Pippin's art hang in the homes of many prominent Americans and are part of the permanent collections of major museums across the country, including The Metropolitan Museum of Art, the Whitney Museum of American Art, the Hirshhorn Museum and Sculpture Garden, The Phillips Collection, the Philadelphia Museum of Art, and the Pennsylvania Academy of the Fine Arts.

From these obvious acknowledgments of extraordinary accomplishment in the visual arts from representatives of the elite art-world, one might be inclined to conclude that Pippin enjoys a secure place alongside other masters of American visual art. However, when one reviews the considerable amount of commentary on his career, mainly in the form of biographical sketches and exhibition reviews, one is struck by the adjectives used to describe his work. "Naive," "primitive," "folk," and "self-taught" are descriptors frequently employed to characterize the products of his verdant creative imagination. In assigning the work of Pippin to these categories, art historians and other commentators are undoubtedly seeking to align his creative endeavors with those of others whose process of creativity he seems to share. However, in their efforts to establish a relationship between Pippin and the artists with whom they associate him, scholars tend to offer little or no analysis, comparative or otherwise, to justify his inclusion in these ill-defined categories of creative cultural production. Rather they most often recount Pippin's biography in order to demonstrate similarities between his life history and those of

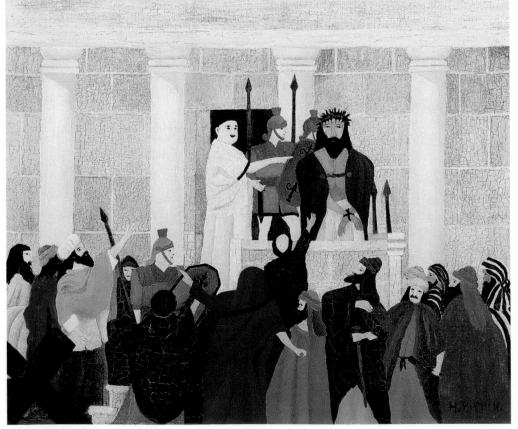

CHRIST BEFORE PILATE / 1941 / Oil on fabric / 20 x 24" / Collection of Joseph D. and Janet M. Shein

other artists with whom he is most often compared.

The tendency of scholars to resort to the biographical in discussions of Pippin's art represents a common approach in the examination of the work of most artists whose works do not fit into an identifiable Western tradition. In the case of Horace Pippin—and, I would venture to say, of most artists whose work does not seem to fall into

MR. PREJUDICE / 1943 / Oil on canvas / 18 x 14" / Philadelphia Museum of Art / Gift of Dr. and Mrs. Matthew T. Moore / 1984.108.1

a recognizable Western tradition of artistic production—the emphasis on biography as enacted by art historians represents an attempt to account for the seeming emergence of individual artistic genius in sociocultural milieus and in artistic media in which such genius is presumed to be nonexistent. Whether Pippin's career as an artist is addressed in elaborate detail or causally invoked in brief dis-

cussions, his life story is almost invariably the focus.[103] For most of Pippin's biographers, his identity as an African American male who produced works of visual art that rivaled those of his academically trained contemporaries in symbolic complexity would seem to provide sufficient justification to initiate a search for the source of his artistic talent. Although his biographers often point out that he showed early signs of artistic ability during his years as a public school student, won an art competition as a youngster, and continued to work to perfect his artistic skills by sketching during his years in the army, they do not place much emphasis on these early productions as those of an artist honing and nurturing his skills. Nor do they envision Pippin's early creative efforts as artistic endeavors revelatory of budding genius. Instead, his biographers repeatedly point to his early childhood in a small African American community in Goshen, New York, his having been raised in an impoverished single-parent household, his limited formal education, and his unpretentious career in a succession of low-paying jobs to establish his unlikely candidacy for artistic accomplishment worthy of attention by representatives of the mainstream artworld.

To explain Pippin's extraordinary accomplishments in art under such unlikely circumstances, his biographers most often point out that, despite his rather commonplace existence as an African American in the early decades of the twentieth century, his ability to produce art of uncommon quality stems from his unique circumstances as an African American—circumstances that set him apart from and within his own community. Invariably, they point to his loss of the use of his right arm in World War I and the pension that he received as a result as the most important event in his life and the defining moment in his becoming an artist. According to many of these writers, Pippin's disability and the government check on which he was forced to live, though insufficient to provide for the needs of his family, not only set him apart in the small town of West Chester, Pennsylvania, where he moved after he was discharged from the army, but also afforded him an unusual opportunity as an African American for contemplation and the ability to indulge his imagination. To emphasize his isolation from his community, the solitary scenes of his working laboriously to burn images into pieces of wood with a fireplace poker by balancing the

wood with his maimed arm and his painting with illumination from a single lightbulb in his modest home in West Chester are recounted endlessly in the telling of his life story. His achievements in overcoming the limitations imposed on him by his disability are represented not only as a solitary endeavor but most often as a heroic one. Although the biographers disagree on exactly who discovered Pippin's artistic genius and how, this culminating chapter in his life story most often unfolds in a grand way—he was, it is said, discovered by some of the giants of modern art during his day. Generally, his biographers contend that his talent was accidentally discovered by N.C. Wyeth, the father of artist Andrew Wyeth, and famed art historian Christian Brinton.[104]

While the biographical information that accompanies discussions of Pippin's art may be useful in situating him and his art in a particular sociocultural milieu at a particular moment in history, it hardly serves as a substitute for critical discussion. The same can be said for labeling his work "naive," "primitive," "folk," or "self-taught." In recent scholarship, all of these modifiers as applied to artistic traditions and producers of aesthetic forms have been critiqued and found wanting in one way or another.[105] Scholars commonly point out that these labels more accurately describe a relationship of power and privilege and share more of a concern with mentality than with tradition. That is, the scholarly discourses in which products of the creative imagination are labeled "naive," "primitive," "folk," or "self-taught" are based on a pronounced evolutionary perspective that inscribes an ethnocentric and binary we/they division. Within this evolutionary perspective, an alla-chronic discourse is produced, assigning those so labeled as living and creating in the past of more enlightened and modern others.[106]

Of equal importance, the use of such labels to describe Pippin's work effectively places it in categories of creative cultural production in which artists and artistic products unrelated not only temporally but also culturally are judged and evaluated in similar terms. That is, these terms do not describe any particular cultural tradition of creativity. Rather they affiliate or combine products of disparate creative cultural traditions into a seemingly homogeneous category without regard for the cultural tradition of origin, the aesthetics of specific creating communities, or the criteria of evaluation within these communities. Moreover, these terms have historically allowed for the development of discourses that (re)produce otherness as a pathological condition.[107] In many ways, the inordinate emphasis placed on the biographical or rather the particular aspects of the artist's life story that get emphasized reflects the art historian's view of the art placed in these categories as the expressive embodiment of pathology. That is, in the production of these biographies, art historians endlessly reiterate those conditions and situations such as poverty, lack of formal education, and even non-traditional family structures that have traditionally acted as signs of social and cultural pathology in discussions of culturally different others. In most respects, the inordinate emphasis on the biographical in discussions of Pippin is intended to justify the placement of his art in these categories by definitively establishing his alienation and difference from so-called masters of Western visual art.

In attempting to find a more appropriate focus for a discussion of the art of Pippin, perhaps we should take seriously the position of Bearden and Henderson, who conclude that "He is wholly an African-American artist. His life as a black American is the basis of everything he painted." In offering this assessment of Pippin as an artist, Bearden and Henderson seek to reclaim him from what they envision as the limiting and even demeaning category of "folk artist"—a categorization that they claim has been detrimental to a full appreciation of his artistic accomplishments and vision. They suggest that as the product of an African American artist, Pippin's art can and should be evaluated from an African American cultural and historical perspective and within traditions of creative cultural production associated with people of African descent.

Within the African American tra-

dition of creative cultural production, products of the creative imagination that have historically been labeled "naive," "primitive," "folk," or "self-taught" may be thought of as the result of a process of vernacular creativity. Although Pippin's work has been associated with the vernacular in African American culture since the 1930s, his relationship to this mode of creative cultural production has been established primarily through trite allusion and classification rather than analysis. For example, the famed art collector Albert C. Barnes, in the essay that he produced for the catalog accompanying the first formal showing of Pippin's art, set the tone for much of the later discussion by scholars who would attempt to ground this art in the African American vernacular. In describing Pippin's work, Barnes alluded to the fact that his paintings "have their musical counterparts in the Spirituals of the American Negro."[108] Other commentators have been more explicit in their evocations of vernacularity in discussing Pippin's art. Alain Locke, the intellectual and spiritual father of the Harlem Renaissance, described Pippin as "a real and rare genius, combining folk quality with artistic maturity so uniquely as almost to defy classification."[109] And David C. Driskell, the dean of African American art historians, has recently continued this tendency to locate Pippin's art in the African American vernacular. Driskell claims that

"Pippin relied strongly on the lore of local people, including their interpretations of the Bible, as well as on the history he read and the memories of his own experiences at home and abroad."[110] As these comments indicate, art historians and other commentators envision an influence or relationship of Pippin's art to the vernacular but usually come short of declaring him a vernacular artist.

The hesitancy to label Pippin as a vernacular artist is more than justified.

Although his created images reveal an ongoing interest in representing aspects of the historical and everyday experiences of African Americans, his process does not lend itself easily to analysis of him as a vernacular artist. As his critics have amply demonstrated through their efforts to place him in categories associated with non-Western traditions of artistic production, the absence of a vernacular tradition of creating visual images on canvas in African American communities means that his process cannot be aligned easily with those of other artists who work within traditions of African American vernacular creativity. This does not mean, however, that he did not represent processes associated with an African American tradition of vernacular creativity in producing visual images. In fact, I would argue that his knowledge of processes and expressive strategies associated with this tradition, especially those characteristic of narrative performances, informed his work in various ways. In the most general sense, efforts by scholars to assign him the status of a vernacular artist have not been based on a concern with his process of creativity, but rather on his biography and the numerous images that he created to represent the everyday experiences of African Americans. In other words, Pippin's status as a vernacular artist hinges on a class-based definition of "folk," a definition that equates folkness with lower-class status and cultural difference, rather than with a process of creativity.

In many ways, Pippin's placement in categories that mark him as a vernacular artist obscures the fact that, despite his social background and lack of formal training in techniques of Western painting, his art is deeply grounded in Western traditions of visual representation, especially in a formal sense. However, his use of forms identified with Western modes of artistic representation does not make him unique among artists within the African American tradition of creative cultural production. Historically, African American artists working in diverse media have appropriated Western forms to represent cultural ideas and images evocative of the black experience in the United States and have, in the process, inscribed both consciously and unconsciously creative forms and performances associated with the African American vernacular. While scholars have employed various analytical approaches in examining artistic uses of the vernacular by African American artists, especially in

THE TRIAL OF JOHN BROWN / **1942** / Oil on canvas / 16⅛ × 20⅛" / Fine Arts Museums of San Francisco / Gift of Mr. and Mrs. John D. Rockefeller 3rd / 1979.7.82

the production of written texts, they have focused most often on the ways in which expressive forms identified with this tradition find new meanings in creative contexts and, more recently, in developing theoretical models for understanding intertextual processes characteristic of the African American tradition.[111] While these approaches are useful in providing an understanding of the intricate and complex ways in which African American modes of creative cultural production inform one another,

An examination of Pippin's process of engaging the vernacular can provide an important entrée into an understanding of his created products; this will help us to understand his accomplishments as an artist. For example, in an anecdote recorded by Edward Loper, another painter and a friend of the artist, Pippin offers a rare glimpse into his process. In response to a query from Loper, Pippin exclaimed: "Ed, you know why I am great? . . . Because I paint things exactly the way they are.

THE BUFFALO HUNT / **1933** / Oil on canvas / 21 ¼ x 31" / Whitney Museum of American Art, New York. Purchase / 41.27

they tend to focus on the products and results of an active artistic engagement with indigenous expressive forms rather than on the processes by which artists appropriate them aesthetically. By neglecting to consider the processes by which African American artists appropriate the vernacular, scholars have tended to naturalize its uses by artists creating within an African American tradition.

. . . I don't do what these white guys do. I don't go around here making up a whole lot of stuff. I paint it exactly the way it is and exactly the way I see it."[112] In approaching Pippin's work, we should take his response to Loper as a serious assessment of the process that informed his engagement with the vernacular, and his statement should be taken as an expression of both an artistic and an anthro-

pological sensibility a combination of sensibilities being increasingly recognized as coterminous in the production of certain kinds of cultural knowledge. In other words, I want to suggest that a productive way of highlighting Pippin's relationship to the vernacular is to approach his work ethnographically, as a kind of native visual ethnography. Viewing Pippin's work from such a perspective provides a means of understanding in a more objective manner the processes by which he transformed his memories and observations of the everyday and the ordinary, the vernacular, if you will, into powerful visual images evocative of the unique lifestyle and perspective shared by people of African descent.

In an important sense, Pippin's work has always been read ethnographically, and it has been these unacknowledged ethnographic readings that have led to problematic classifications of his art. That is, the labels that have been used to describe Pippin as an artist and to categorize his work have been used in an assumption that his art is based on firsthand knowledge of African American culture and performance practices and thereby provides easy access to the cultural otherness of African Americans. In one sense, the kind of critical reading of his work that I am suggesting may not seem to disrupt this reading to an appreciable degree. In another more profound sense, however, it offers the possibility of effecting a major alteration in our reading of Pippin as an artist by transforming our conception of him from that of an ethnographic subject to that of an artistic agent. It is as an object of ethnographic investigation rather than as a producer of aesthetic knowledge and pleasure that he has been forced to become, in the minds of his critics, the embodiment of the very aesthetic that he attempted to represent in his art. In effecting this transformation, we are enabled in an effort to confound meanings deeply inscribed in such labels as "naive," "primitive," "folk," and "self-taught" to describe him as an artist. From an ethnographic perspective, we can envision him as a stable, creating, and controlling presence in the production of knowledge about the African American vernacular experience through artistic representation, rather than as one whose art was guided and controlled by naive attempts to represent it. In the process, we embrace the possibility of being able to rethink how his art can be read as the expressive embodiment of both aesthetic and cultural knowledge.

In suggesting an ethnographic approach to Pippin's art, I am neither claiming that we should ascribe to him the literal status of an ethnographer, certainly not in the scientific sense implied by this designation, nor suggesting that Pippin's purpose in creating visual images was identical to that of an ethnographer. Instead, I am suggesting that his process, which involved an attempt to represent the cultural lives of his subjects from their point of view, holds some procedural and representational features in common with ethnographic inscription. In addition, I am suggesting that, in reading the images that he created, we embark on what art historian Johannes Fabian has described as a "special kind of ethnographic work," the decoding of inscribed "oral performance."[113] In pursuing this special kind of ethnographic work, according to Fabian, we must attempt to "listen and match recorded sounds and [visual] symbols with communicative competence, memories and imagination."[114] In this way, we can begin to appreciate Horace Pippin as a mature and sensitive artist whose art is informed by an earnest desire and extraordinary talent for creating visual images that capture aspects of the African American historical and vernacular experience in aesthetically pleasing and arresting visual narratives.

GRANDMA
MOSES

(ANNA MARY ROBERTSON MOSES)
(1860–1961)
BORN GREENWICH, NEW YORK
WORKED EAGLE BRIDGE, NEW YORK

BY JANE KALLIR

Anna Mary Robertson Moses—better known as Grandma Moses—has for many decades occupied an anomalous position in the history of twentieth-century self-taught art. Her origins and the story of her recognition by the art establishment place her firmly within that generation of American self-taught artists (Horace Pippin, John Kane, and Morris Hirshfield foremost among them) who came to prominence in the 1930s and 1940s. Had she died within a few years of her discovery, as did the others, there would be little to differentiate her from them, either in the nature of her work or in the circumstances of its creation. However, against all odds, Moses, eighty years old at the time of her first one-person exhibition in 1940, lived to have a flourishing twenty-one year career. And due to a fortuitous combination of circumstances involving both the yearnings of the post-war American psyche and the strength and quality of the artist's work, Moses became America's first superstar painter, acquiring a broad-based popularity that far transcended the narrow boundaries of the artworld elite. For this reason, Moses has often been perceived as standing apart from the folk tradition that originally nurtured her and provided a context for her initial discovery. In this field of "outsiders," she is, curiously, the ultimate outsider.

Moses was originally part of a contemporary folk art boom that began in 1927, when Kane was admitted to the Carnegie International Exhibition, and peaked in 1942 with the publication of the first survey of the subject, Sidney Janis' *They Taught Themselves*. This boom grew from an attempt to emulate the European avant-garde, which in its desire to break free of academic con-

THE BURNING OF TROY / **1939** / Oil on Masonite / 9 x 11¼" / Private collection / Courtesy The Galerie St. Etienne, New York

vention had for some years been seeking inspiration from the work of untrained artists. Until this period, there was no substantive market for such material, and the first generation of twentieth-century American self-taught painters initially had no realistic hopes of succeeding professionally. Prevented by economic necessity from pursuing artistic careers early in life, most of them turned to art as a hobby in old age. Yet they were not without aesthetic ambitions: though remote from museums and other institutions of the "high" artworld, these painters had a conscious notion of composition and a very deliberate engagement with the craft of picture-making; they honed their skills by looking at books or copying greeting cards and prints. In all of these respects, Moses was entirely typical.

Born in 1860 on a farm in Greenwich, New York, Anna Mary Robertson had always liked to draw and paint "lambscapes" as a child, but she was expected to devote most of her time to helping with household chores. After marrying Thomas Salmon Moses in 1887, she was too busy raising their five children and running their farm to attend much to art. However, after Thomas died in 1927, Moses suddenly found herself with time on her hands. She began by embroidering "worsted" pictures, which were in keeping with her training as a homemaker and with the feminine folk arts of the nineteenth century. However, arthritis made it difficult for her to wield a needle, so on the advice of one of her sisters, she switched to paint.

A practical and thrifty woman, Moses would have considered the notion of "art for art's sake" a frivolous indulgence. So when she had more pictures on hand than could easily be given

away as gifts, she endeavored to reach a wider audience by sending some to the local country fair, along with some jams she had made. The result was not auspicious: she took a prize for her jams, but the paintings went unnoticed. For several years, she had a group of paintings consigned to a "women's exchange" at the drugstore in nearby Hoosick Falls, but it was not until 1938 that these attracted any attention. A traveling engineer and art collector, Louis Caldor, decided to buy the whole lot and to introduce the artist to the New York City art scene. Again, the results were not immediately encouraging, but Caldor finally succeeded in winning the support of Otto Kallir, a specialist in Austrian expressionism who was also interested in folk art.

By October 1940, when Grandma Moses debuted at Kallir's Galerie St. Etienne in New York City, the discovery of new "primitives" (then the term of choice) had become something of a fad. Yet Moses almost immediately stood out from the crowd. The defining event was a Thanksgiving festival mounted at Gimbels Department Store after the St. Etienne show had closed. Moses was persuaded to come to New York and deliver a public talk. In her little black dress, accompanied by her prizewinning jams, she charmed the hard-boiled New York press corps as had none of the other folk painters of her generation. It was not until several years later that Kallir took on the official management of her career, but when he did—in 1944—the outcome was phenomenal.

The first biography of the artist, *Grandma Moses: American Primitive*, became an instant bestseller when it was published in 1946. The first greeting cards, published that same year, elicited some sixteen million orders, four times the anticipated press run. Her work was exhibited all over the country—and then all over the world. For those who could not afford originals, there were prints, posters, collector plates, and even drapery fabric. Moses became one of the first artists to reach a mass audience through radio, film, and the then-new medium of television. Newspapers and magazines coast to coast heralded her as a kind of late-life Cinderella. She appeared on the covers of *Time* and *Life*, met President Truman, and corresponded with Eisenhower and Kennedy. As she continued to grow old, reaching what seemed to be a miraculous age, every birthday was celebrated like a landmark event; her 100th was declared "Grandma Moses Day" by New York's governor,

Nelson Rockefeller, as was her 101st, in 1961. She died in December of that year.

The endurance of Grandma Moses' renown—more than fifty years from the time of her first show until the late 1990s—must give pause to those who would contend that her fame was just a passing fad or merely the result of clever marketing. Yes, the artist's personality did play a role, although she was not nearly as accessible to the electronic media as celebrities are today, and she kept her distance by seldom venturing away from her farm. It was, in fact, her sincerity—her ability to remain authentic and forthright despite all the fuss—that so endeared her to the public. To the American nation, just recovering from World War II and entering the Cold War, Moses represented a vision of a simpler, better time. Her career itself seemed proof of the old adage "It's never too late." Moreover, this message was reinforced by the art itself.

The secret of Moses' achievement lay in her ability to meld memories of an almost extinct nineteenth-century past with renderings of the rural landscape that were very much of the present. Like almost no self-taught painter before or since, she was able to capture the moods and subtle coloration of different times of year and of day, and even of differences in the weather. The accuracy of her landscapes brought her paintings to life, allowing her audience to enter into the work rather than to view it as a distant souvenir of bygone customs. The viewer's identification with Moses' anecdotal vignettes was enhanced by their abstract style, which transformed her little figures into symbolic everymen and everywomen. Moses' paintings thereby established a link between the past and the present that seemed to guarantee the future. At the dawn of the nuclear age, her work was perceived as a statement of faith in the enduring value of nature. In this way, the art combined with the artist's personality and wondrous story to provide hope and reassurance to a fearful American public.

Yet Moses' fame had drawbacks, causing her to become separated from the general run of contemporary folk artists and to be disowned by many members of the artworld elite who had originally supported the contemporary folk art revival.[115] Folk art is intrinsically a "low" art form that is accepted into the "high" art arena only if and when it serves the art establishment's agenda.[116] However, the art establishment as a whole remains suspicious

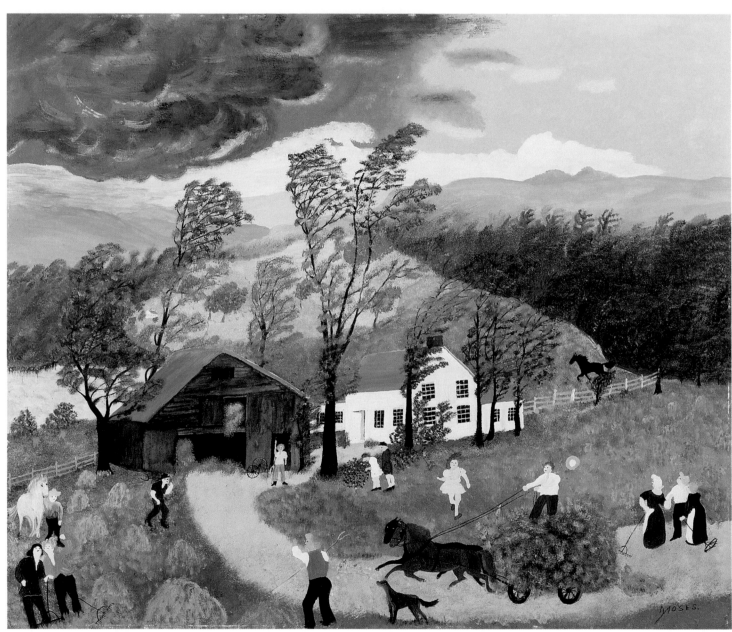

THE THUNDERSTORM / 1948 / Oil on Masonite / 20 ¾ × 23 ¾" / Private collection / Courtesy The Galerie St. Etienne, New York

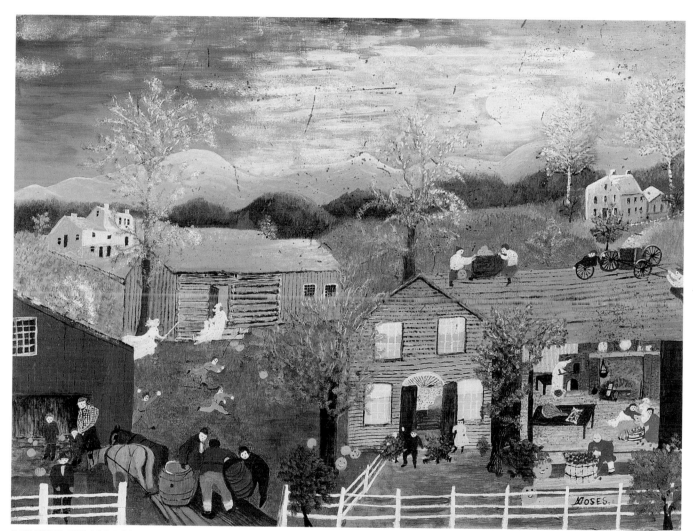

HALLOWEEN / 1955 / Oil on Masonite / 18 × 24" / Private collection / Courtesy The Galerie St. Etienne, New York

of popular tastes. In the case of Moses, popularity was widely taken as de facto proof of mediocrity.

Moses' popularity was also assumed to have sullied her mythical purity as a folk painter. Some automatically accused her of cranking out paintings for the marketplace, but in actuality success had a positive influence on the artist. Spurred by the widespread appreciation of her art, Moses increasingly took herself seriously as a painter, and an examination of her work over time demonstrates that she learned and developed from experience, just as any "real," trained artist would. Unfortunately, Moses' great renown inspired a large cadre of followers and imitators whose work has too often been confused with hers. However, if one compares the works of these so-called memory painters with those of Grandma Moses, it becomes apparent that few if any ever grasped her overriding command of the landscape. Without this magic

purists get mired in calibrating gradations of amateurism and professionalism, influence and originality. When an artist becomes incredibly famous, as Grandma Moses did, the problem is compounded, since imitators inevitably compromise an artist's appearance of uniqueness.[117] With all this hairsplitting, few in the current folk art field take the time simply to look at the paintings. Grandma Moses did something that almost no other modern folk artist has ever done: she invented a wholly original style and proceeded to develop it over a protracted professional career. Measured on its own terms, Grandma Moses' achievement must be hailed as among the greatest of any self-taught painter.

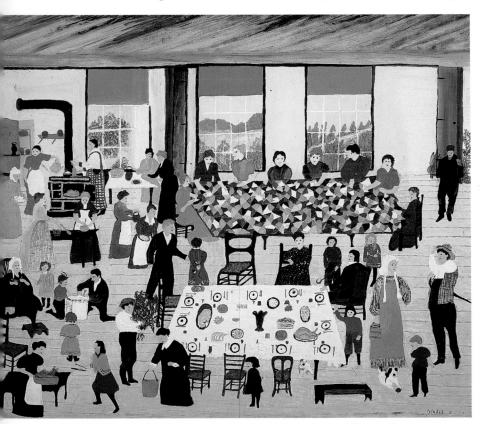

THE QUILTING BEE / 1950 / Oil on Masonite / 20 x 24" / Private collection / Courtesy The Galerie St. Etienne, New York

element to bring their compositions to life, most memory painters created cutesy scenes of "olde" America that were suitable for children's book illustrations but not much more.

The "problem" of Grandma Moses derives from the misguided (and ultimately impossible) quest for an art untainted by any external forces. Ignoring the fact that no art exists in a vacuum,

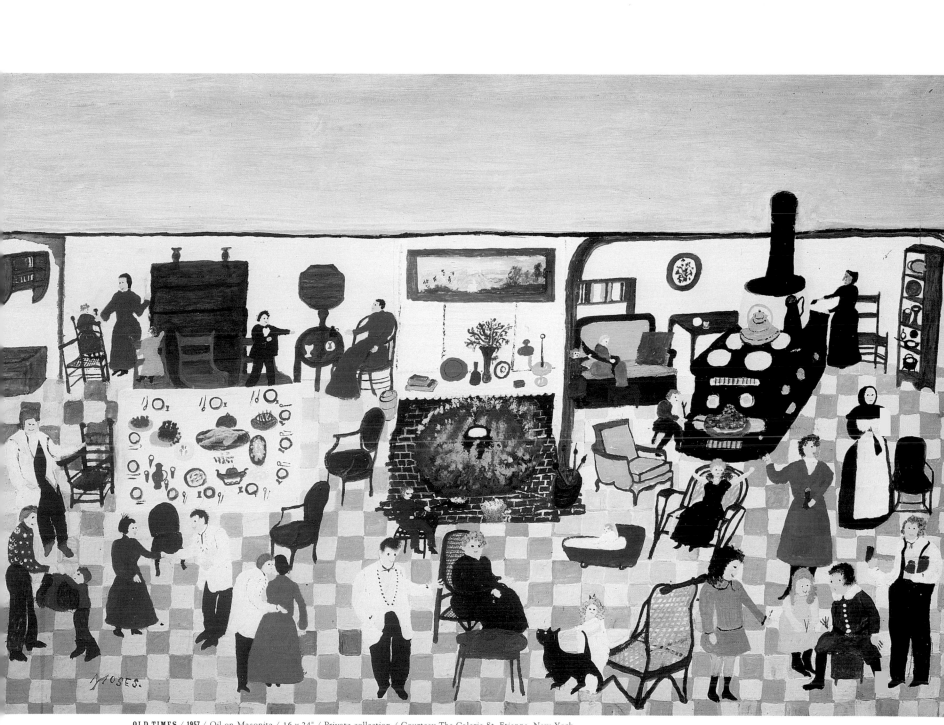

OLD TIMES / **1957** / Oil on Masonite / 16 × 24" / Private collection / Courtesy The Galerie St. Etienne, New York

A life tangentially documented by rolls of miraculous architectural drawings, hundreds of illustrated pages crammed with imaginary buildings, ideal cities, rhythmic hand-lettered text, plus short stories, novellas, and 3,000 unwrapped copies of a self-published novel preserved in a relative's garage until its "discovery" in 1990.

A.G. RIZZOLI

(ACHILLES G. RIZZOLI)
(1896–1981)
BORN POINT REYES, MARIN COUNTY, CALIFORNIA
WORKED SAN FRANCISCO

BY NORMAN BROSTERMAN

boards. A quiet, little, working man with a small house on a blue-collar street, an "outsider" more of focus than in fact, like Hampton, Rizzoli was also highly religious, and conventions of Christian architectural iconography permeate his art.

The true life story of Achilles G. Rizzoli, edited version I—1896: born Marin County, California. 1912: moves to Oakland and begins studies at the Polytechnic College of Engineering. 1915: the symmetrically Beaux Arts, eclectically wondrous Panama-Pacific International Exposition opens in San Francisco. 1916–1923: joins San Francisco Architectural club and takes classes in drafting, rendering, and mechanical engineering. 1936: goes to work for mediocre Bay Area architect Otto Deichmann and stays until 1970. 1981: dies.

"Outsider architect" is an imprecise but useful categorical construct for describing the sad, but brilliant draftsman of the fantastic, Achilles G. Rizzoli. Like James Hampton, the famed folk sculptor who created the aluminum-foil masterpiece *Throne of the Third Heaven of the Nations Millenium General Assembly* in spare hours away from his job as a janitor for the General Services Administration, Rizzoli worked full-time until the end of his life, almost forty years on his employer's drawing-

The true life story of A.G. Rizzoli, edited version II—1896: born to poor Swiss immigrant dairy farmers. 1913: sister Olympia becomes pregnant out of wedlock. 1915: father steals gun and disappears. 1923–1933: writes a novel, *The Colonnade,* under the pen name Peter Metermaid; the novel's hero, Vincent Reamer, was "afraid of maids but unafraid of colonnades." 1933: moves with his mother to the house at 1668 Alabama Street where he sleeps in a cot at the foot of her bed until her death. 1935: first Achilles Tectonic Exhibit (A.T.E.) of drawings opens to the public in the front room of his home; almost no one but neighborhood children attend. 1936: father's remains discovered—an apparent suicide; at age forty, Rizzoli sees female genitalia for the first time—underneath the skirt of three-year-old neighbor Virginia. 1937: mother dies; he sends her elaborate birthday cards (to his own address) for twenty years after. 1977: after a stroke, is moved from his house of almost forty-five years to a nursing home. 1981: dies a virgin.

With his comical admixtures of building styles bracketed by text balloons that seem to mimic mid–twentieth century print advertising, it is tempting to consider A.G. Rizzoli as a sort of P.D.Q. Bach of architecture—a well versed insider parodying the standard historical forms during the last gasp of the Beaux Arts, a self-conscious stylist wielding irony for a post-modern punch-line. Indeed, included among the scores of acronyms that pepper his drawings are A.M.T.E. (Architecture Made To Entertain), D.A.E.R. (Daring Architecture Entertaining Royally), and A.S.S. (Acme Sitting Station—a toilet).

Rizzoli may have begun his forty-year graphic odyssey with tongue partially in cheek, but creating and refining the renderings and texts soon crystallized into a sincere means to stabilize and anchor his singular, introverted existence. Like Martin

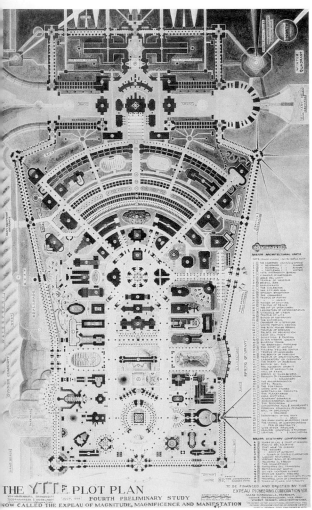

THE Y.T.T.E. PLOT PLAN—FOURTH PRELIMINARY STUDY / 1938 /
Colored inks on rag paper / 38 ¼ × 24 ¼" / Courtesy The Ames
Gallery, Berkeley, California

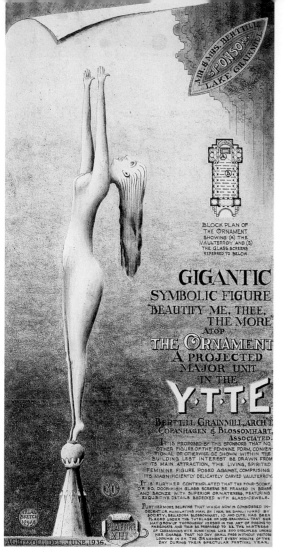

THE ORNAMENT / 1936 / Colored inks on rag paper / 17⅞ × 8⅞" / Private collection

Ramirez, Henry Darger, and other "outsider" artists with whom his work is uncomfortably exhibited, Rizzoli *needed* to draw. By utilizing his practiced rendering skills, the missing components of Rizzoli's life— social, spiritual, and sexual (symbolically at least) could be fabricated. But like a great majority of architects, Rizzoli typically lacked much facility to render free-hand. Adrift without the straight-edge, triangle, and compass, forms of life were largely out of his technical reach. And while he did draw incidental people, especially Jesus, in an un-polished, almost childish hand, a different, grander treatment was reserved for the people he knew.

Rizzoli's most remarkable works, the large-scale architectural elevations he called "Symboli-zations," are portraits of people as buildings—his mother, coworkers, and neighborhood children meticulously drawn and preserved for eternity as churches, towers, or curious skyscrapers. For Rizzoli, whose reticence interfered with the ability to verbally express his deeply felt spiritual passions and stifled sexuality, these stand-ins for the relatives and acquaintances most of us take for granted made up the sum of his life's relationships.

While fixing the inhabitants of his personal orbit—Mother (repeatedly drawn as a "Kathredal"), Shirley Jean Bersie, Grace M. Popich, Virginia Tamke, and others, Rizzoli also began work on the perfect realm that they might inhabit, a symbolic world's fair or fantasy city he called Y.T.T.E. (Yield To Total Elation). Bilaterally and axially symmetrical like the 1915 San Francisco Panama-Pacific International Exposition to which it has been compared,[118] the Y.T.T.E., notwithstanding symbolic buildings with names like the Eagerray, Nevermine, Roomiroll, and Tootlewoo,

would have been familiar to architecture students at any American university from the late nineteenth century on. Planning on the French Beaux Arts model, over-sized presentation drawings of imaginary projects combining elevation, plan, details, and notes, framed with decorative borders in pencil and ink and finished with watercolor— these were the rigorously defined components of a standard architectural curriculum and their utilization by Rizzoli sets him apart from most of the so-called self-taught.

Achilles Rizzoli was a trained technician whose stifled passions and "abnormal" socialization erupted into four decades of highly individual artistic creativity. A competent draftsman but no architect, Rizzoli's buildings are pastiches of tired historicism. But it isn't really architecture or a personal pathology (his mythological namesake also had a mother problem) that gives his drawings such urgent integrity. Imagination, vitality, and a unique vision—what we hunger for in all art, outsider or in—is what sets Achilles Rizzoli apart, and while his life's story may engender pity in some, the world that flowed from his pencil is a match for any.

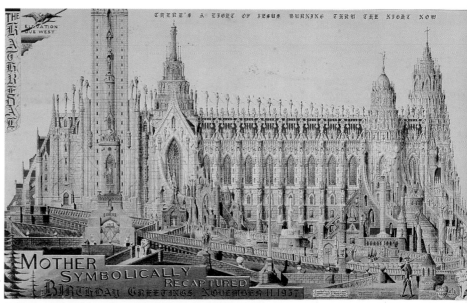

MOTHER SYMBOLICALLY RECAPTURED/THE KATHREDAL / 1937 / Colored inks on rag paper / 30⅛ × 50¼" / Courtesy The Ames Gallery, Berkeley, California

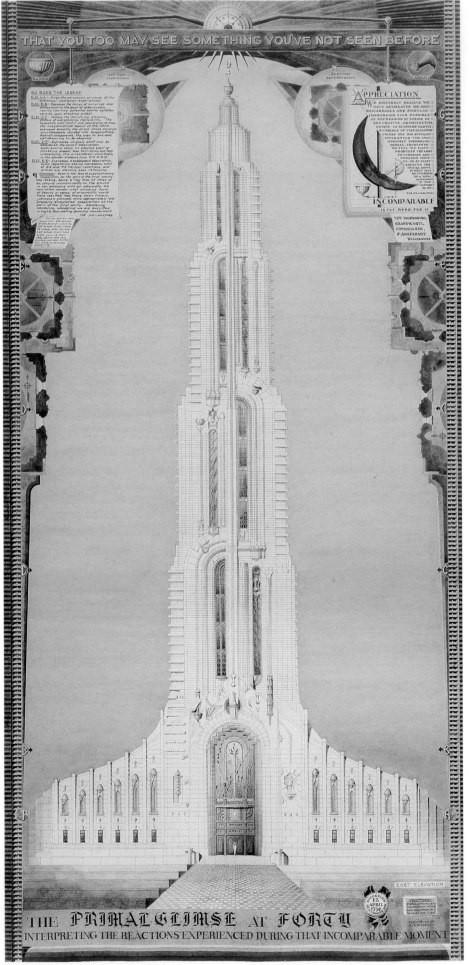

THE PRIMALGLIMSE AT FORTY / 1938 / Colored inks on rag paper / 54 × 26 ⅝" / Courtesy The Ames Gallery, Berkeley, California

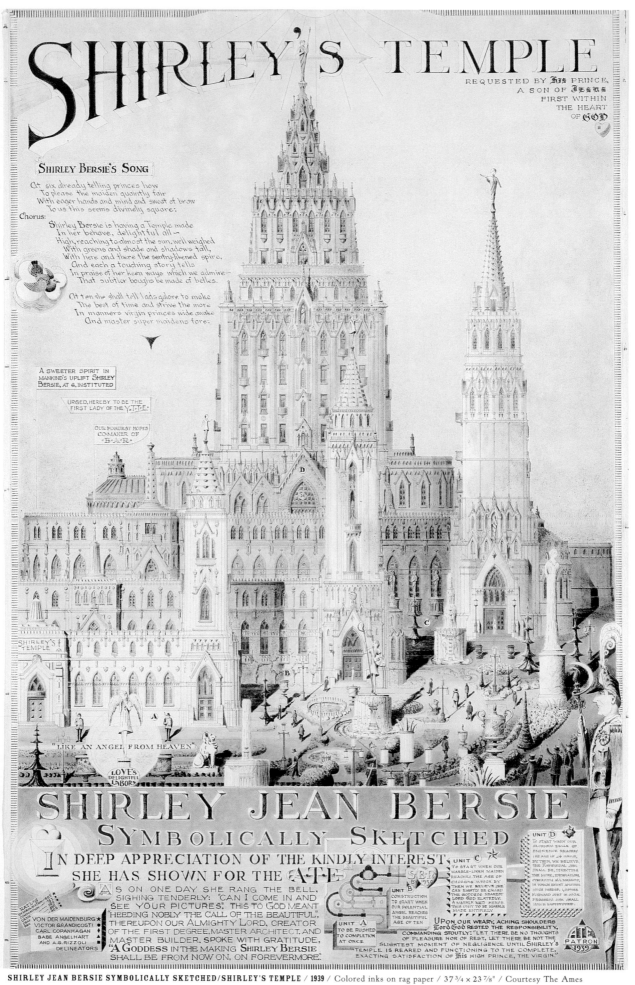

SHIRLEY JEAN BERSIE SYMBOLICALLY SKETCHED/SHIRLEY'S TEMPLE / **1939** / Colored inks on rag paper / 37 ¾ × 23 ⅞" / Courtesy The Ames Gallery, Berkeley, California

JUSTIN
McCARTHY
(1892–1977)
BORN AND WORKED WEATHERLY, PENNSYLVANIA

BY JON IPPOLITO

Justin McCarthy invented baseball and hockey, presented the Ten Commandments to the Israelites, and crossed the Delaware to defeat the British Army during the Revolutionary War. This much we know from his own admission; as recounted by N.F. Karlins, he occasionally spoke of himself and the historical subjects of his paintings as though there was no separation between the two. To take him at his word, then, is to assume he was also Wilt Chamberlain, Humpty Dumpty, a mound of plums, a pack of dogs. He was an Eskimo skinning a bear, Jesus at the Last Supper (and Judas too), and bevies of buxom women—women wearing the latest Schiaparelli jacket, the latest Eiffel Tower hat, or nothing at all.

And why not take him at his word? McCarthy was all these things in the only way that matters to his paintings: that is, he painted in com-

RIO DE JANEIRO / n.d. / Gouache and ink on brown paper / 21 x 27" / Collection of Didi and David Barrett

plete sympathy with his subjects. His paintings offer no dispassionate observation, no irony, no point of view. There is not even distance: the objects or figures in his crowd scenes may be small, but all are as close as he could paint them without losing sight of the whole. McCarthy didn't fuss over details, angles of vision, or pregnant moments; he just got it down, the whole thing, all at once. Never mind if the monkey on ice skates in *Spanky and Dave Pitts Ice Capades 1964* threatened to whirl beyond the dimensions of McCarthy's Masonite support: he bent the chimp's arm and leg right back inside the frame, with little regard for anatomical credibility. If the prominence of the mounted figure in the foreground of *Queen Elizabeth* threatened to block some of the queen's attendants from view, well, by damn, he would just warp perspective until we could see her entourage from the front, from overhead, or from the side—in short, from any combination of viewpoints that would allow them to fit. They are, after all, just daubs of color on a rectangle, registered by an eye so hungry for images that it would accept without reproach nearly everything that came its way.

Where this hunger came from is hard to say. McCarthy never received any art lessons, unless you count a visit to the Louvre during a family trip to Paris when he was sixteen. Perhaps it was by process of elimination that he turned to art: he flunked out of law school, grew tired of hauling bags of cement for the Penn Dixie Cement Company, and was even dismissed from a position as an aide in the same mental institution where he had previously been a patient after a nervous breakdown. Did years of rehearsing extravagant claims for the liniment he peddled encourage the self-indulgent fantasies McCarthy chose to depict in oil paint? Did a stint mixing chocolate in a candy factory inspire a penchant for inventing visual confections? From whatever wellsprings his painterly acumen flowed, it arrived without any of the standard accompaniments of a formal artistic training. He couldn't draw—a fact many of his more enthusiastic admirers conveniently overlook—yet this in an odd way may have reinforced McCarthy's retinal, rather than cerebral, approach to painting. To draw is to make judgments, to discriminate light from shade, to put detail here rather than there, to establish a line between this and that. For McCarthy, by contrast, every square inch of the

canvas was equally deserving of his brush. (Could the string of failures McCarthy suffered in his personal life have encouraged him to take a nonjudgmental approach toward himself, toward his subjects, even toward the picture plane? Ultimately, it doesn't matter: it's not a question of whether there was discrimination in the man, but whether we find it in the work.)

Even McCarthy's range of subject matter seems less a deliberate choice than a wide-open embrace. If public life—a career, artistic success, attention from his fellow residents of Weatherly, Pennsylvania—proved unproductive, he would compensate by filling his waking hours with painting every image that came his way, by whatever means. Born before the automobile existed, McCarthy witnessed a century that saw an explosion of media, including the proliferation of glossy tabloids and women's magazines, the blossoming of the Hollywood publicity machine, and the incursion of television into American living rooms—and he reveled in this glut of imagery. This man who had fared so badly at the hands of capitalism's harsh economic realities, whose father had in fact committed suicide after losing his fortune in the 1908 stock panic, turned to the spectacles of that same capitalist society for a surrogate vision of himself made whole. His visual inventory reflected the allure of glamour on a small-town boy. And glamour was everywhere: on the mount of Calvary, in the Mummer's parade, in the pages of *Playboy*, in newspaper ads for fur coats, in televised night games at Washington Stadium, or scenes of a "U.S. Matador Guided Missile Blasts Off from Its Base in Libya, Africa." To flip through McCarthy's oils is to view the same films and television shows that he did, from *The Ten Commandments* to the

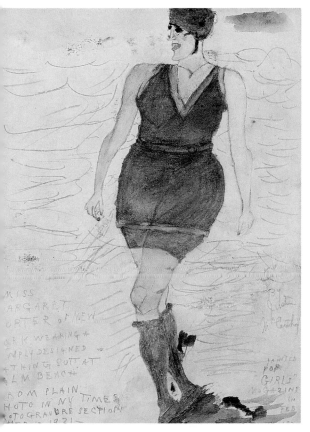

MISS MARGARET PORTER OF NEW YORK WEARING A SIMPLY DESIGNED BATHING SUIT AT PALM BEACH / 1921 / Watercolor and graphite on newsprint / 11 15/16 × 9" / Private collection

nightly news to *That's Entertainment.* Nor was McCarthy more selective in the way he chose to display his oils: Dorothy Strauser, the artist who first brought McCarthy's work to public light, almost literally stumbled upon his paintings strewn across a courthouse lawn.

If there was anything judgmental

QUEEN ELIZABETH / c. 1960 / Oil on Masonite / 21 1/2 × 28 1/2" / Collection of Norbert and Gabrielle Gleicher

about McCarthy's painting, it was his sense of color. He never needed more than six or seven colors to light up a canvas, and these were rarely blended; the tonal variation in his hues comes more from the Masonite or canvasboard showing through his brushwork. Like Matisse, McCarthy painted thinly, so that light could bounce off the painting's ground and reflect back through a translucent layer of color. The effect can be magical. In *Mobile's America Junior Miss*, a pastrylike woman carries a bouquet across some kind of arena, but the real star is her coral-colored dress, which sings against a chalky audience dabbed on a dark ground. *The Oregon Club*, a fey band of Mummers, seems to parachute across a slate-blue sky to land on a field of brilliant ochre. The depiction of animals, probably inspired by nature programs on television, afforded McCarthy a pretext for novel colors and forms. In his homage to the denizens of the deep, a magnificent school of striped and speckled fish undulates through a crowded sea. And what paean to doghood can rival his *Wild Dogs*, a bustling, tussling train wreck of yapping yellow and black shapes? In his *Elephants*, painted a decade later, hides and tusks disintegrate into blue-gray and alabaster brushstrokes in a watery oasis near the painting's center, but McCarthy manages to knit these fragments into a vibrant fabric of abstract commotion. The painting is an apt metaphor for a life trampled by fate—and redeemed by painting.

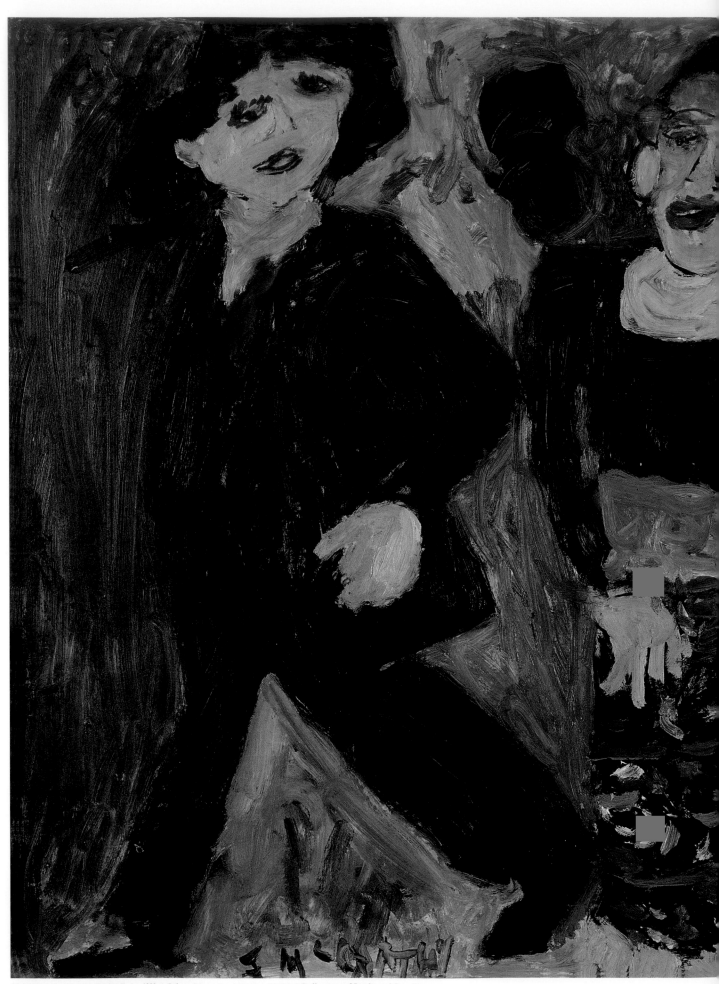

CLOTHES MAKE THE WOMAN / **c. 1963** / Oil on Masonite / 24 ½ × 36 ½" / Collection of Linda and Ray Simon

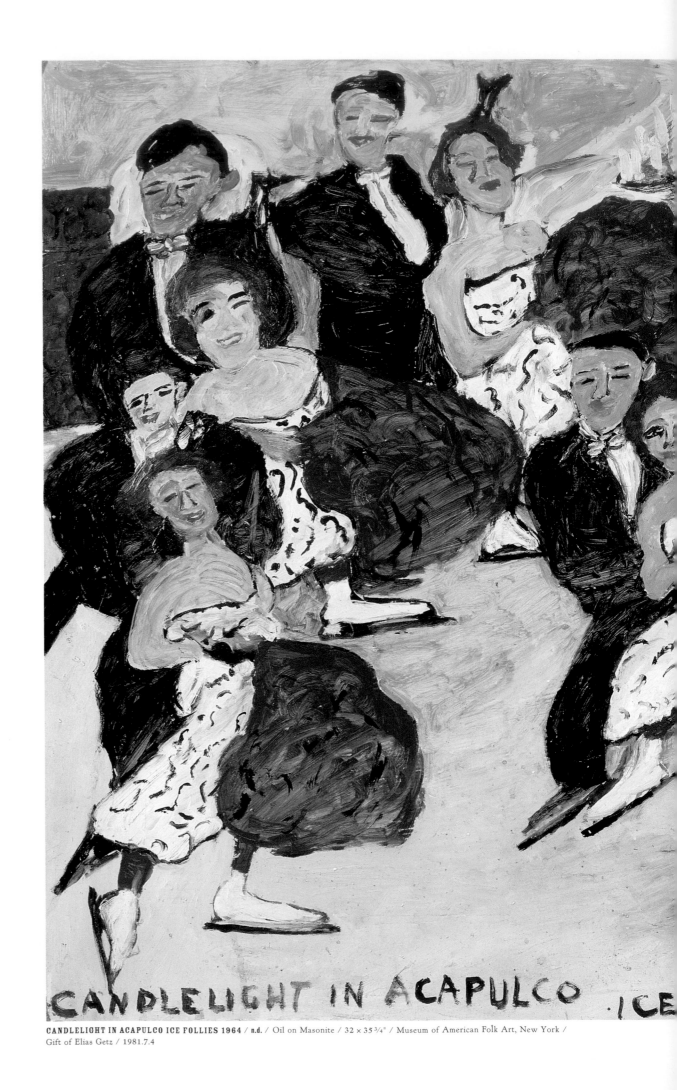

CANDLELIGHT IN ACAPULCO ICE FOLLIES 1964 / **n.d.** / Oil on Masonite / 32 × 35 ¾" / Museum of American Folk Art, New York / Gift of Elias Getz / 1981.7.4

1964
OLLIE'S

J. McCARTHY

ELIJAH
PIERCE
(1892–1984)
BORN BALDWYN, MISSISSIPPI
WORKED COLUMBUS, OHIO

BY MICHAEL D. HALL

The tall barber named Elijah who carved and painted between haircuts in Columbus, Ohio, was a folk artist. The images that took shape at the point of his knife and brush were folk art in the truest and best sense of the term. A community and a culture speaks in the art of Elijah Pierce. Ironically, however, the folk essence of Pierce's work is too often misunderstood and overlooked in the art culture where it has found its most enthusiastic critical advocacy and its most aggressive market. If I were to guess why Pierce's work confuses the contemporary artworld, I would

MUSIC BOX / n.d. / Carved and painted figures inside commercial wood box / 9 ¼ x 15 ¼ x 7" / Collection of Sarah and John Freeman

have to posit that a certain alterity in contemporary modes of perception frustrates its interpretation (and by extension its appreciation) as folk art. Pierce is an artist who suffers from being too near to, and at the same time too far from, the common experience of his current audience.

The popular stereotype of folk art promotes the notion that the "folk" (the makers and users of folk art) are essentially exotic others, that they inhabit a world removed and very different from our own. The "fisher folk" of Nova Scotia, the "hill folk" of Appalachia, the "Amish folk" of Indiana, and any other folk that might readily come to mind are all geographically and culturally distant from our mainstream culture. Elijah Pierce, a barber in a contemporary urban setting, hardly fits our notions of folk. He watched the same television shows we watched. He read our same newspapers and, like most of us, he went to work every day and paid his bills and taxes. His world is not one we can remove and distance from our own. His world is our world—he is us.

Yet Elijah Pierce was not exactly like most of us. He was, after all, an African American born in the rural Deep South who migrated north in the 1920s to live out his adult life in the African American community of a large midwestern city. He was deeply religious and was active in both his church and the Masonic lodge, to which he belonged for twenty years. Few (if any) collectors, dealers, or curators involved with folk art today could claim to have much in common with Pierce's life experience. His world, in fact, was exotic enough to prompt study by anthropologists and other social scientists interested in the aspects of American culture that were and are outside the mainstream. Most of our information on Pierce's youth was gathered by an ethnographer. The best field study of the carver's interactions with the black community of Columbus was done by a folklorist. In our

contemporary world, Elijah Pierce, born in the nineteenth century to a father who had once been a slave, was indeed an "other."

Like the man who made them, Pierce's carvings are both familiar and remote. Stylistically, they speak directly from the near worlds of comic strips and popular advertising as we find them in magazines and newspapers from the 1930s and 1940s. We also find precedent for many of Pierce's images in our Sunday school books and illustrated Bibles, as well as in a wide range of photographic sources available in our print media. Elijah Pierce was a great recycler of the visual elements of our popular culture. Consequently, his art is visually an art of the familiar. Challenging this familiarity, however, we find that much of the content in Pierce's work speaks from very far places. The Bible stories recounted in his carvings are less and less read and told in our increasingly secular society. Likewise, the heroes and champions in his commemorative portraits seem obscure in the passing of time. To Pierce, however, Noah, Jonah, Samson, Job, and the numerous other biblical figures that populate his "sermons" were all well known. They were all real figures in a family lineage that he knew flowed uninterrupted from the far-off past into his experiential present. Similarly, the Joe Louis, the Marian Anderson, and the Jesse Owens that found their way into Pierce's work were all enduring spirits in the consciousness that gave the carver his self-identity.

Thus, in the carvings of Elijah Pierce we have an exotic art from within, rather than from outside, our own community—an art rendered exotic by its cultural roots, but an art nevertheless familiar and very centered in the dominant culture where it both derives and generates its greatest social and visual resonance. There is something disquieting about an art that reminds us that we, ourselves, are "folk." And there are further complications if we pursue this notion. Elijah Pierce is best understood as a storyteller—a keeper of the oral histories and myths by which his clan or tribe knows itself. The idea of a clan (with its attendant authoritarian structure and exclusive identity) is highly problematic today. Few in the art audience are ready to accept the authority of Pierce's messages as something to be observed in their own daily lives. Fewer still would attest to holding membership in anything that could be called a clan. Then there is the matter of the tone in Pierce's

work. The blend of arrogance and humility that motivated Pierce to assume his "clan storyteller" role as both a mission and a service infuses his work with a tone of rectitude that is off-putting to many. Yet this same preachy-pious tone is the very thing that sustains our affection for medieval and early Renaissance art.

The Pierce perspective is both rigid and generous. The Pierce message is always couched in terms of absolutes, yet Pierce himself was a man beset by doubt, ambivalence, and guilt. He was also a man who allowed his homespun sense of humor to impart a wry (and occasionally corny) counterpoint to his artistic style. In my numerous conversations with him, Elijah frequently turned our discussion to the carving he entitled *Obey God and Live*—his most moving polemic on authority and disobedience. Here, Pierce tells a story of transgression, damnation, forgiveness, and redemption, and in the telling transforms a defining Western myth into a candid autobiographical saga loaded with evocative allegory and symbolism. Pierce the storyteller attempts to reorder the world. His sermons are lessons. His sports champions, entertainers, and political reformers are the role models he would have us admire. Pierce the chronicler tells us how the world was and is; Pierce the teacher-preacher tells us how it ought to be. Lessons? Myths? Sermons? Now we find the real rub. That kind of art is acceptable as long as it can be neutralized through our understanding that it is somebody

ARCHIE GRIFFIN / **1976** / Carved and painted wood with glitter / 16 ⅛ x 14 ⅛ x 3 ⅝" / Columbus Museum of Art, Ohio / Museum purchase

else's lessons, myths, and sermons we are talking about. At arm's length it's quaint—it's folk art.

But getting close and reimagining ourselves as "folk," how do we reconcile our discomfort? For starters, I suggest that we attempt to newly integrate our cognitive understandings of ourselves and the stuff we identify as art. Although the didactic aspect of Pierce's work is generally disparaged in the art being produced in the name of contemporary elite culture, it is everywhere present in the popular culture that surrounds us. The sledgehammer directness of Pierce delivering his message is precisely that deployed by advertisers promoting cars, soft drinks, and fast food. It is, however, the antithesis of the subtlety we have come to expect from the "high" art of say, Barnett Newman or Mark Rothko. True, Andy Warhol and his fellow pop artists were supposed to show us how to reintegrate the blatancy of our popular culture into our aesthetic canon. But Pierce pushes the point even further. As the folk artist among us, he forces us to understand and appreciate cultural connectedness itself as a necessary part of the whole idea of art.

There is much talk today about information and communication. Our culture continuously transmits and receives information. The process that attends the sorting out of all this interaction, however, increasingly requires that information be classified and then appropriately filed away for future retrieval and use. We learn to expect that our popular culture and our elite culture constitute very different transmissions broadcast on two quite different frequencies. Elijah Pierce matured as an artist in a circumstance in which the popular culture of black middle-class America was the cultural container for his art. Translocated into the domain of white elite culture, his work loses much of its essential meaning—it becomes a transmission received in a hail of static. This need not be so. Folk art by definition is a con-

LOUIS VS. BRADDOCK / n.d. / Carved and painted wood relief with glitter; mounted on painted corrugated cardboard / 21 ½ × 23" / Collection of Jeffrey Wolf and Jeany Nisenholz-Wolf

versation between insiders. In an "us to us" dialogue that satisfies this model, we seem fully conversant with the signals sent out in the sixteenth century from the Sistine Chapel. So why the static when we tune in the broadcasts from a twentieth-century barbershop in Ohio? Adjust the dial, I say. We need only expect culture to be inclusive and continuous, rather than exclusive and disjunctive, to relocate and more effectively utilize our folk art. We also need to live with the implications inherent to our professed belief that poetic encodings of the truths we live by can be found in unlikely places as surely as they can be found in our standard texts.

Perhaps all affective art is folk art in one way or another. I would like to think so. Traditional folk art centers itself in the dialectical experience of the community that gives it both its requisite sameness and its permission for difference—the expectation that it must express both the normative values and beliefs of a community and the originality and uniqueness of its specific maker or makers. Successful contemporary folk art (like that made by Pierce and others) manifests this same genius and becomes our art when we acknowledge ourselves as the folk in question—the community framing the dialectic in which these gestures function as art. To recover the dream of folk art, we need to remember the aspects of our culture that remain the common goods by which we know ourselves. Along the way, the stately black storyteller who made art between haircuts in Ohio slips graciously back into our midst to remind us, again, how things that we already know still might be.

CRUCIFIXION / **Mid-1930s** / Carved and painted wood with glitter; mounted on wood panel / 47 ½ × 30 ½″ / Columbus Museum of Art, Ohio; Museum purchase

MARTIN
RAMIREZ
(1895–1963)
BORN JALISCO, MEXICO
WORKED AUBURN, CALIFORNIA

BY ANN TEMKIN

In the early 1950s, downtown New York had become the epicenter of the art-world, and art-making required active partici-pation in a vigorous community. The partici-pants set out to articu-late an American visual vocabulary, the first that would dictate interna-tional art history. Yet while their collective activ-ity was all important, the operative rhetoric was one of absolute solitude. Barnett Newman identi-fied his subject as "the self, terrible and constant." Jackson Pollock described his work method as being "in the painting." Critic Harold Rosenberg explained the movement as "the creation of private myths."

ably employed as a rail-road worker at some point. Beyond its refer-ences to his Mexican roots, Ramirez's art can-not be combed for clues to a life story any more than that of the abstract expressionists. Instead, like that of the New Yorkers, his work can be read as autographic: Ramirez's drawings form and record the process by which he becomes who he is. These drawings assert Ramirez's identity to his viewers (he perhaps the most important of these) as they inscribe him as a pervasive presence in his work. He creates a self precisely by virtue of what he makes.

The ongoing formation of Ramirez's iden-

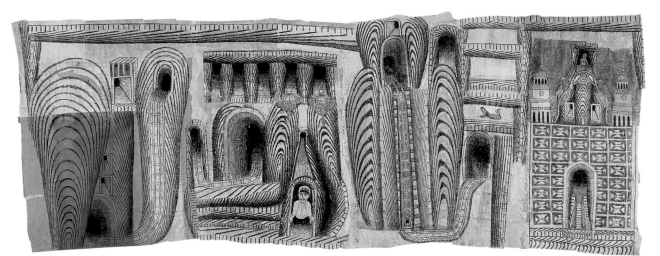

UNTITLED / c. 1953 / Graphite, tempera, crayon, and collage on paper / 36 × 90 ¼" / Collection of Jim Nutt and Gladys Nilsson

Their rhetoric makes a modernist place for the art of Martin Ramirez, who lived and worked during the 1950s in a state mental hospital in California, ignorant of art bars and magazines. For Ramirez, the concept of art as a way of existence was not an intellectualized decision but a matter of fact. Beginning in 1948, he learned how to build up pages from small fragments of scavenged papers pasted together with starch and spit, so that he could make pencil drawings on them. After his art was discovered by Dr. Tarmo Pasto in 1954, he was given new paper, colored crayons, and chalk, and by the time of his death in 1963 his body of work included more than 300 drawings.

Little is known of Ramirez's life prior to his hospitalization—he was born in Jalisco, Mexico, found homeless in Los Angeles in 1930, and prob-

tity is found in the choreography of wondrous net-works of lines filling hundreds of drawings, which are at their most virtuosic in his monumental land- and cityscapes. The draftsman draws and demon-strates his doing so: the line shifts and travels, never ready to settle into a predictable design. Ramirez provides a line that flattens three-dimen-sional form into legible two-dimensional pictorial space without modern European conventions of volume or perspective. It is a line in which repeti-tion and rhythm provide impossible jumps in scale that viewers readily accept. Ramirez makes inge-nious use of ins and outs, apertures and fermetures, tunnelings and billowings. Like a seashell, his draw-ings have lines that are very clear, patterns that are apparently basic, and yet an overall form that is infinitely mysterious.

In many of Ramirez's landscapes, the movement of his line is emphasized and enhanced by a multitude of drawn and collaged trains, trucks, cars, and buses. They wind their way over the page as a cue to the viewer, inducing him or her to take time to travel in the drawing. Sometimes the lines articulate hills and valleys, castles and cathedrals, arcades and roadways. Sometimes a rich concentration of tunneling lines alone can provide the sense of great depths and distances containing unknown possibilities.

Ramirez's imagery poses the paradox of whether the space of the drawing is intimate or immense. In the end, it is both. At times a gigantic figure stands upon a sphere, finding the earth itself the only adequate platform for her grandeur. Elsewhere, tiny people and animals are engulfed by linear networks that offer no horizons. The lines create a seemingly unending universe even as they secure the drawings as snugly as zippers. The textures of the patched-together pages, often revealing inherited print or images from the underside, give an aura of history far beyond the actual age of the drawing. Ramirez inhabits the work as the work inhabits Ramirez: it makes him a home (creating the time and space for his wanderings), and he makes a home for it (literally hiding drawings in his clothing or bed).

Harold Rosenberg observed that the vastness of abstract expressionist painting concerned the vastness of New York City, not that of the mountains or the desert. It is the vastness of a small island in which one neighborhood houses speakers of countless languages, one skyscraper hundreds of businesses. Ramirez plays with that same exhilarating interplay of microcosm and macrocosm, in which a small theater brings forth innumerable dramas.

The device of the proscenium is one that appears frequently in Ramirez's work, in a rich body of drawings that provide a counterpoint to the complexities of his kingdoms and roadways. In each case, a figure or set of figures appears in the center of a linear network that forms a stage setting: curtaining lines along the sides that imply recession into deep space, a broad platform floor (sometimes adorned with tiny characters who give an ornamental salute to the actor above), and a wide band across the top, often in a shell or leaf pattern suggestive of theater architecture. These drawings present a specific population that suggests imagery Ramirez may have known in Mexico:

UNTITLED / c. 1950 / Graphite and tempera on paper / 27 3/4 x 23 7/8" / Collection of Jim Nutt and Gladys Nilsson

Madonna-like women, animals, musicians, and banditos on horseback. The figures are cheerful as they confront the viewer, almost certainly getting him or her to return their grins. No one in particular is Ramirez, and yet they all are. They are metaphors for the artist: adventurer, performer, creator. Ramirez's figures present a self who travels through his drawings just as his trains do, and whose journeys overcome the seeming limits of available resources. The body of Ramirez's drawings convert the artist's solitude—whether sought or imposed—into the shared experience that knows no boundaries of time or space.

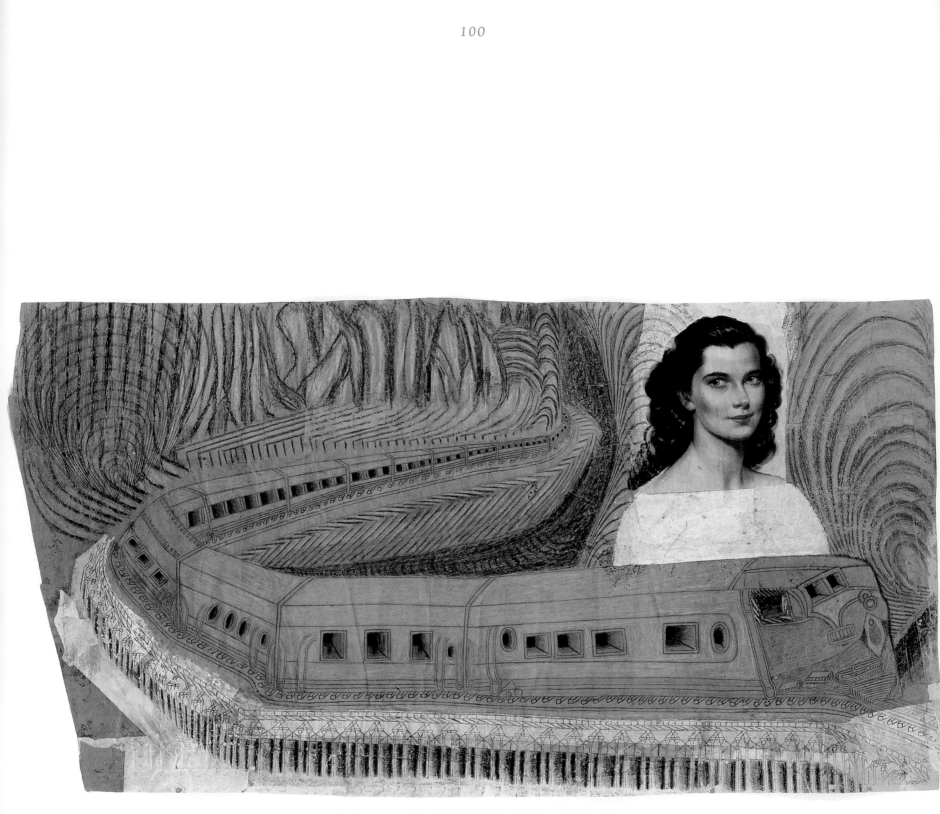

UNTITLED / c. 1950 / Graphite, tempera, crayon, and collage on paper / 32 × 60 ½" / Collection of Jim Nutt and Gladys Nilsson

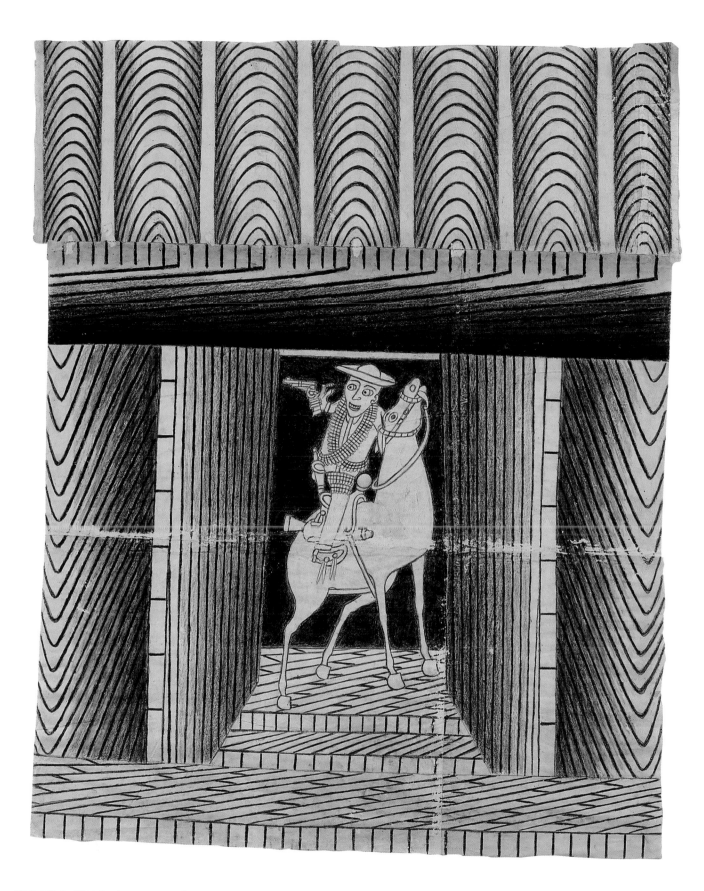

UNTITLED / **c. 1950** / Graphite, tempera, and crayon on paper / 46 × 36" / Collection of Jim Nutt and Gladys Nilsson

HENRY
DARGER
(1892–1973)
BORN AND WORKED CHICAGO

BY ELLEN HANDLER SPITZ

Gazing hard at images by Henry Darger, I let them push me away. They create me as an outsider by not allowing me to rest. Neither my eyes nor my mind. Certainly not my feelings. They send me plummeting back into the depths of my own childhood. How do they do this, I ask myself, and why? All these little girls seem so familiar at first with their pigtails, bobs, and pinafores, but it is impossible to connect with them. Before I can do so, they change. Benign at first glance, they reverse unpredictably and arbitrarily. What appears familiar swerves convulsively toward the sinister. They metamorphose into creatures resolutely and irrevocably alien. Sprouting insect wings, ram horns, dragon tails, even male genitalia, they inhabit scenes that fail to communicate intelligibly, scenes that violate rules of pictorial representation, narrative coherence, and emotional significance, scenes that suddenly, while you are looking at them, turn threatening. Hundreds of little girls flee from and submit to inexplicable dramas that commingle brutality with innuendoes of cryptic sexuality.

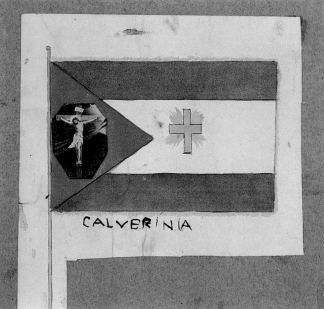

UNTITLED (CALVERINIA) / n.d. / Watercolor and collage on paper / 7 × 8" / Collection of Nathan Lerner Living Trust / 14 F-B

Looking for a long time at Darger's imagery can produce sensations of horror because his pictures project a state of barely controlled instability. They reveal a world like the one portrayed by Holocaust historian Primo Levi where violence occurs randomly, and all efforts to perceive continuity and causality are doomed. Cues, symbols, citations, little scraps gleaned from the outside world lead nowhere; apparently meaningful signs in Darger's world defy deciphering. A solipsistic universe, Darger's *Realms of the Unreal*, as he named it, makes its beholder into a witness of panoramas of pain. A delegitimized witness, however, condemned to watch without understanding.

The Darger girls themselves return me to New York City, to my blond younger sister—who, with her corkscrew curls, looked very much like one of the seven angelic "Vivian Girls" Darger created—and to our very proper mother (there are no human mothers in Darger's oeuvre), who took us, each spring and fall, to Best and Company on Fifth Avenue, where we were expected to acquire seasonal wardrobes for school and for special occasions. Many of Darger's panoramas—*At Sunbeam Creek/Two Adventures at Torrington*, for instance, and *Don't Worry, We Blengins Will Help You Escape*—evoke the catalogs that arrived in the mail predictably before those shopping trips, and which my sister and I would pore over, examining all the nice little girls with their bland expressions, turned-up noses, and neatly coiffed hair.

In the foreground of Darger's landscapes, crowded with writhing vegetation, menacing flowers, gigantic insects, lightning bolts, gas jets, and feverish activity combined onerically with stasis, I reenvision these Best catalog children. Demurely posed in their smocked sunsuits, bonnets, velvet-collared Chesterfield coats, and patent leather mary-janes with double straps, I knew they were not like us. We got dirty; we pinched and grabbed; we screwed up our faces just to aggravate our mother, and we refused to eat our spinach. They never did. You could tell. Sweet, innocent, and sedate, made to be looked at, they existed for the sake of ornamenting the world of adults. Like Darger's girls, like my paper dolls, they had no insides. They were flat. You could do whatever you wanted with them.

Unlike the Best children and most paper dolls, however, the Darger girls undergo terrible ordeals. Awful things happen in *The Realms of the Unreal.* Why? Are the girls being punished despite of or because of their apparent innocence? Ceaselessly, they are victimized; they are pursued, exposed to danger, mutilated, choked, strangled, disemboweled. In a scene uncannily reminiscent of bedtime at the convent school in Ludwig Bemelmans' 1939 children's book *Madeline,* huge clawlike hands appear over terrified pairs of girls who are depicted under covers in their beds. In another, eleven naked girls with tiny penises are tied by ropes to trees and stumps and to one another while Disneyesque birds and a rabbit peer quizzically at them. Within any given scene, whether dressed or undressed, whether posing or playing, fleeing or freezing, they are always vulnerable. Always exposed.

How do we enter into relations with pictures anyway? People say "That grabs me," "that pulls me in," or "I get it." Projection and identification are common tools: you put yourself in; you find yourself there. As in the favorite children's game, the hokey pokey, you gradually come to realize you have moved from being partly in and partly outside the circle to being all the way in. Here, however, the game does not work. Darger is not playing. Darger is strictly for real, and it is clear he does not want to play with us. His pictures keep us out. His circle is locked, and we have no key.

Not only that, these images, the more I look at them, refuse us space. Like the suffocating girls themselves, we are denied our subjectivity. Even spectatorship is warded off. The images are hermetically sealed as if behind thick panes of psychological glass, so that to enter them (if one could) would mean breaking, shattering, causing even more pain. Everywhere I look, the pictures seem to ward off anguish, even by summoning it; hence this invisible barrier. It is both their subject and their object. Looking at them not only puzzles me now; it embarrasses me. Imagine staring through a one-way glass at a person who doesn't know you are there, the way one does in a nursery school: you stand in the booth behind a glass through which toddlers cannot see you as you observe their play. Imagine watching, through one of these panes, a child who is not playing happily, a child who is irredeemably hurt, who is naked, crying, unloved, unsure of who he is, trying to cover his wounds with pretty colors, lines, shapes, even words, trying desperately to stay alive by inventing a private pictorial tent for his own survival.

Not made to be seen by me, never shown to or discussed with any other living human being, these works by Henry Darger turn me into an outsider. For what is it, after all, that I am looking at? Can you behold without understanding? Feel without comprehending? What tools shall I bring to this observation? To connect them with my own life, as through the Best catalogs, or *Madeline,* or the *Annie Rooney* comic strips Darger cites, may be to fool myself into thinking I understand more than I do. For the alienation here is radical. Unlike surrealist imagery from the same historical period, where dystonic response is the desideratum, here it is unwilled. Or willed unconsciously through suffering.

Maybe bringing frames from public art to bear on products of private fantasy is a deception. I prefer, at least in this case, to valorize a beholder's authentic agitation and give credence to the discomfiture called forth by Darger's oeuvre. I prefer not to ignore the fact that because of their content, his images may, for some viewers, prove seductive: they may tease and titillate. Sexuality steals in here, accompanied by aggression. Sometimes we feel we almost get it: an elaborate meditation, isn't it, after all, on innocence and sin? Darger was, as we know, a devout Catholic.

But in the end, I submit, the pictures reflect only the viewer. They open no window onto themselves or him. We find no way to get inside them, and we may not wish to, for they are so profoundly disturbing. Too much pain here, they cry: KEEP OUT! Instead of an aperture, they give us a colorful set of mirrors through which, if we are brave and persistent, we may be able to discover something important about ourselves. About Darger and the tortured complexities of his inner life, they give us merely the illusion of knowledge.

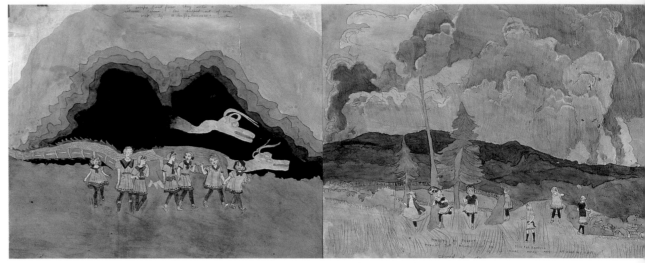

UNTITLED (OUT OF THE CAVE/PURSUED BY FOREST FIRES/FEAR OF RATS AND MICE) / **n.d.** / Mixed media on pieced paper /
19 × 70" / Collection of Kiyoko Lerner / 62

UNTITLED (WATCHING THE STORM THROUGH WINDOWS) / **n.d.** / Mixed media on pieced paper / 19 × 70" / Collection of Dr. Siri von Reis

UNTITLED (AT SUNBEAM CREEK/TWO ADVENTURES AT TORRINGTON) / n.d. / Mixed media on pieced paper / 19 × 71" /
Collection of Kiyoko Lerner / 106

PETER
CHARLIE BESHARO
(PETER ATTIE BESHARO)
(1898–1960)
BORN SYRIA (LEBANON)
WORKED LEECHBURG, PENNSYLVANIA

BY LEE KOGAN

Peter Attie Besharo, perhaps best known as "Peter Charlie," is most remembered for paintings of visionary space travel with ethnic and religious overtones. The artist came to public attention long before, but it was not until 1990 that the truth about his life began to emerge.

them. Besharo also decorated a portion of St. Catherine's, the old Catholic church in Leechburg, but none of that art remains. Some time after his work was done, services ceased to be held there and the building became a town health center, its interior walls repainted.

The discovery of accurate facts pertaining to an artist's life helps to debunk the myths that so often develop as artists—particularly self-taught artists—are exoticized, romanticized, and then marginalized. That self-taught artists' very names are bandied about inaccurately underscores their relative insignificance in the mainstream artworld. It is a wonder that an enlightened dealer even recognized Besharo's unique gifts when some of his paintings were brought to her gallery by the son of the artist's landlord.

As is true of many self-taught artists, Besharo created privately. He lived at the Penn Lee Hotel in Leechburg, Pennsylvania, and after his death in 1960, approximately seventy paintings were found in a nearby garage where he rented space for a studio and storage area. But unlike Henry Darger (of Chicago), C.A.A. Dellschau (of Houston), and Morton Bartlett (of Boston), Besharo did attempt to share some of his art with others. He gave presents of paintings to at least two people close to him: his local doctor and a second cousin living in New Hampshire. Unfortunately, in neither case did the recipients value the paintings or remember what they did with

The artist variously called "Peter Charlie," "Charlie Peter," "Bochero," and "Boshegan" was born Peter Attie Besharo. He came to America in 1912, a teenager from what was then the Mount Lebanon area of Syria, between Beirut and Tripoli. His village was probably Kafargzina, where his mother, Waide, was living in 1921, according to New York Life Insurance Company records. Although he claimed on at least one occasion to be Armenian and to have fought against the Turks, there is no evidence to support this. Historically, Armenians had been persecuted under the Ottoman Empire; at the turn of the century, many fled to the relatively isolated Lebanon. Besharo's confused identity may have been compounded by the U.S. immigration authorities, who lumped together as immigrants from the former Ottoman Empire "native Syrians," "Turks," and "Armenians."

Besharo was the only Arab in Leechburg, except for a haberdasher, who may have encouraged him to come to the town and did employ him for a short period. After that job, he struck out on his own, and until he died in 1960, he remained self-employed. He may, in keeping with Syrian custom, have held a "traditional dislike for working for someone else."[119] More than one Leechburg resident remembers Besharo as a peddler in the early years, traveling with a backpack, selling dry goods, yard goods, and men's apparel in the coal-mining camps located within a fifty-mile radius of Leechburg. While rather rare in Syria, peddling was common among Syrian-Lebanese newcomers and, according to Philip and Joseph Kayals' study of Syrian Lebanese assimilation in America, not an "ethnic oddity" but "part of an emotional, psychological, social and historic inheritance . . . a key to the Syrian-Lebanese Americanization process."[120]

A devout Catholic, Besharo had probably been a Syrian Maronite Christian when he came to

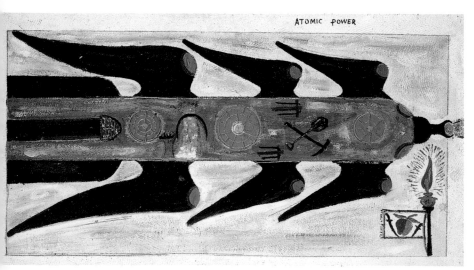

UNTITLED (ATOMIC POWER) / **n.d.** / Mixed media on board / 15 x 27" / Collection of Robert M. Greenberg

America. Without a community to support a Syrian Christian church, Besharo became a regular church-goer at St. Catherine's. One old Leechburg resident remembered that Besharo voluntarily painted the ceiling of a Catholic church in neighboring Hyde Park. The artist's faith, fostered from childhood, might shed light on his religious subject matter and serve as a springboard for the study of his work.

For at least twenty years until his death, Besharo was a sign and housepainter, and one of his freehand painted signs is still standing in Leechburg. A faded but still distinct FREE PARK-ING sign may be observed at the side of the garage in Diamond Alley owned by J.E. McGeary, propri-etor of a hardware store where Besharo kept his commercial paints, brushes, and ladders, as well as his paintings.

Besharo had an interest in lettering—in basic sign painting—and often combined text with image in his paintings. A number of works include text that identifies the visual imagery. In *Untitled (Atomic Power)*, thin black letters spelling out ATOMIC POWER are painted in a white margin above a winged missile hurtling across the canvas with fuel spewing from its head. There are some mis-spellings and inconsistencies. The word "rosary," for instance, is spelled correctly in *Untitled (Mary Power Hibernated)*, but appears as "rosery" in *Untitled (Hounted Rosery 100/100)*. One might also interpret "hounted" as a misspelling of haunted. Frequently, the intriguing words, abbreviations, numbers, and other references in Besharo's paint-ings are ambiguous. No key was found to decode his frequently used initials E.S.C., which appear in *Mary Power Hibernated*, *Untitled (Infant & Children)*, and other works. Placed in the lower right corner of these works, the letters seem to function as a logo or signature. But in other paintings, they appear in other locations. Besharo's closest rela-tives, his New England cousins, bore the family name Salem, and his cousins were named Eva and Charlotte, so perhaps E.S.C. is a sort of combined family monogram. The letters also hint at the word "escape." But of course these readings of the code are conjecture, at best. Sometimes text is just a design element, as in *Mary Power Hibernated*, where words form an attractive border around the paint-ing as well as an arclike pattern in its lower center.

In Besharo's most ambitious paintings, text supports the cosmology that he created. In *Hounted Rosery*, the artist portrays a world set in his future,

the year 1963, integrated with interplanetary beings and in which "Christianity" will be free of "neglect without creed power." In *Mary Power Hibernated*, he forecasts that Christianity will triumph, this time in "1962?" through a "synod," a "sobor" of the "best leaders." A large number of decoratively caped clergy interspersed with figures from other worlds project "clear wisdom and unity." In *Untitled (Wars)*, below the title within the painting, the artist depicts a bleeding cross superimposed on a centrally placed scale that weighs the power of

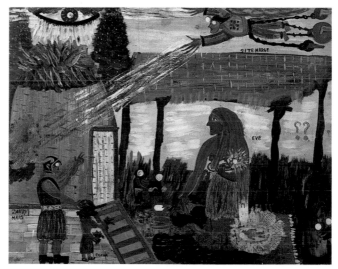

UNTITLED (EVE WITH SPIRITS) / n.d. / Oil on paper / 23 × 29" / Collection of Janice and Mickey Cartin

"Allah" and other "Gods." Allah, on one side, is symbolically represented with a white, upwardly turned ram's horn and the Gods, on the other, are depicted as a black and downwardly turned ram's horn. But Besharo believed the power of the Arab nations to be weak compared with forces with access to atomic power. (Some of his references suggest that atomic forces are controlled by Jews.)

In some of Besharo's paintings, Arabic let-ters and words appear to be utilized as elements of design. His inclusion of these letters and words—religious, moralistic, and personal—suggests some-thing about recurrent ethnic references.

Familiar with oil paint from his commercial enterprises, Besharo favored oil for his paintings. He painted in a vigorous, linear style and used a deeply saturated palette as well as strong earth tones. His paintings abound with peasant figures, some wearing the typical Ottoman fez, warring fig-ures with bows and arrows, helmeted interplane-tary "aliens" often reaching out in an embracing way, rockets, Egyptian icons, mermaids, suns, all-seeing eyes, crosses, candles, rosary beads, and scales.

The frequent use of dates in his paintings also raises intriguing questions, for which the answers are often elusive. Historical records do not reveal outstanding events occurring, for example, on September 1, 1912, the date referred to in *Infant & Children*. However there are leads. Besharo emigrated in 1912, possibly to avoid the conscription that had become compulsory in 1908, when Syria, under Ottoman domination, was engaged in a bloody war in the Balkans. Two

themes that relate to Besharo's ideas and subject matter.

The artist's obsession with outer space was recalled by the owner of Tony's Lunch, where Besharo commonly ate dinner, usually bringing with him a roll of butcher paper and spending the entire evening making calculations—plotting the distances of the planets and the moon as he tried to determine when the earth was going to "run out of oxygen." His New Hampshire cousin vividly remembered the artist's scientific interests revealed during two visits to her house. His physician recalled that he seemed a man "ahead of his time."

Though private, Besharo was not a recluse, as had been thought by those who discovered his paintings after his death. He was described as pleasant, a man with friends in town, and a loving generous "uncle" to his relatives' children. Snapshots of the artist show him with friends and in groups. Besides church, which he attended regularly, he belonged to a fraternal lodge, the Loyal Order of the Moose, and these involvements attest to a desire for assimilation

UNTITLED (MARY POWER HIBERNATED) / n.d. / Oil on canvas / 17 x 24¼" / Collection of Helen and Jack Bershad

other dates referred to in *Mary Power Hibernated*—July 28, 1954, and August 5, 1954—may also have personal significance. On July 28, 1954, *The New York Times* reported on the passage of an atom bill after a thirteen-day filibuster, on a bid by Iran to end its isolation, and on the signing by London and Cairo of a Suez Pact for British exit from Egypt. On August 5, a supersonic jet fighter was unveiled by the British, a new missile unit was to join NATO forces, the Army McCarthy hearings were held, and spaceship design using solar energy was submitted by amateur and professional rocketeers in Austria. All of these news reports deal with

that was typical of early twentieth-century Syrian immigrants.

Besharo came from a country dominated by an aggressive power. In the United States he lived through the two world wars, the Cold War, and the development of nuclear energy. His strong Catholic orientation and ethnic underpinnings, along with his passion for the possibilities of interplanetary integration, all had an impact on Besharo's vision of potential terrestrial and celestial power and peace. He created the basis of a new world through his artwork.

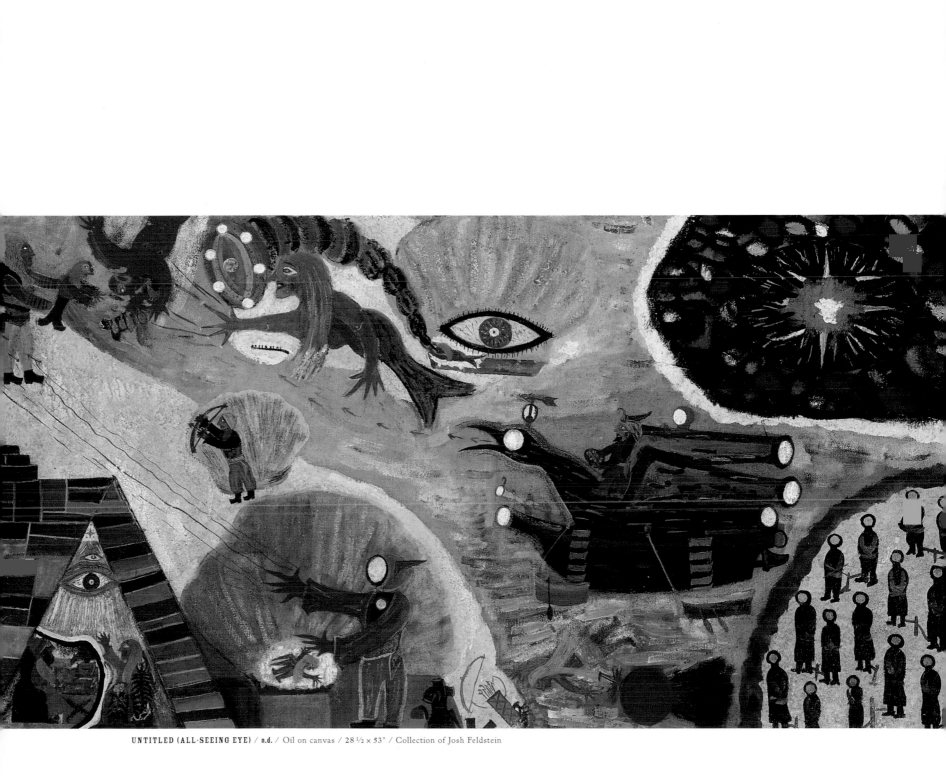

UNTITLED (ALL-SEEING EYE) / **n.d.** / Oil on canvas / 28 ½ × 53" / Collection of Josh Feldstein

JOSEPH
YOAKUM
(JOSEPH ELMER YOAKUM)
(1890–1972)
BORN ASH GROVE, MISSOURI
WORKED CHICAGO

BY DERREL DE PASSE

Joseph Elmer Yoakum was one of the most original interpreters of landscape in the twentieth century.[121] His unique style has inspired a surprising number of academically trained painters and has been compared with that of some of the greatest outsiders in art.

Like the world-traveled and often eccentric American visionary painters of the nineteenth century, Yoakum's artistic imagination was fed by an exotic childhood. The artist spent his early days with railroad circuses that took him to places

THE THREE GREAT FALLS IN MISSOURI RIVER NEAR GREAT FALLS MONTANA / **n.d.** / Colored pencil and pen on paper / 19 x 12" / Collection of Edward V. Blanchard and M. Anne Hill

seldom seen by Americans of his generation. In later life, he retold the fantastic stories of his youth as another visionary artist, Elihu Vedder, had done—with "just enough detail to convey the

impression of their truth."[122] While sometimes embellished in the manner of circus bombast, his tales generally had some basis in fact. His link to the Navajo, for example, was not by birth, as he told his friends, but through an aunt who had been adopted by a Navajo family as a child.[123] He came to share this pueblo people's love of beauty, as well as their twin passions for traveling and geography.

Yoakum was born on February 20, 1890, in Ash Grove, Missouri, to parents of Cherokee, Creek, African American, and European ancestry.[124] He left home for the first time when he was around ten years old to join the Great Wallace Circus as a horse handler. Eventually, he traveled all over North America and Europe with four other leading railroad circuses. He rose to the position of bill-poster with the advance department, the part of the circus with expertise in geography.[125] The artist also claimed to have been a valet to the circus impresario John Ringling, who was renowned as an encyclopedic source of geographical facts and figures.

Yoakum continued to be involved with the circus until 1908, when he returned to his family home in Ash Grove, where he married and raised a family.[126] He held various jobs, including assistant to the superintendent of the St. Louis and San Francisco Railroad. After the railroad went into receivership, he relocated his family to Fort Scott, Kansas, and found work in the coal mines.[127]

Army service in France during World War I rekindled Yoakum's wanderlust. Following his divorce from his first wife shortly after the war, he wandered the globe for nearly two decades, supporting himself through a variety of jobs on railroads, at sea, and probably also with a company that produced circus posters, before settling in Chicago in the 1930s. Recalling his years as a wanderer, the artist said: "I had it in my mind that I wanted to go different places at different times. Wherever my mind led me, I would go."[128]

By the 1950s, Yoakum had begun making art, but he did not pursue this calling in earnest until his retirement in the early 1960s. He later

described his creative process as "spiritual unfold-
ment." By this he meant that the subject of a draw-
ing was slowly revealed to him as he worked on it.
The term was first used, in a religious context, by
Mary Baker Eddy, the founder of Christian
Science.[129] The artist came to embrace her religious
philosophy after an illness during his days with
Buffalo Bill's Wild West show.

"In the Native American context there is no
separation between the world-as-dreamed and the
world-as-lived," according to Lee Irwin.[130]
Similarly, in Yoakum's art, as in his retelling of his
life story, reality and dreams are conjoined. Many
of his landscapes are carefully labeled with the
names of places actually visited by the circus or by
the cargo ships he sailed. However, like other
American visionary paintings, these writhing,
organic landscapes possess the quality of a dream.
To achieve this dreamlike effect, Yoakum "uses his
imagination as a springboard for his art," according
to Washington Allston, "rather than the world he
perceives through his senses."[131] He reduces inan-
imate objects, like mountains and clouds, to a lim-
ited number of highly original and dramatically
stylized formal motifs that are recombined in a myr-
iad of ways as the mood and design require. In cre-
ating form, he emphasizes line over color, although
he is as superb a colorist as any fauve.

While unschooled in art, Yoakum never-
theless was likely inspired by untraditional art
sources encountered on his travels and in his
reading. For example, his early landscapes
(c. 1962–1965), such as *Catskill Range New Hamp-
shire*, bear a striking resemblance to pencil studies
for circus posters, sketches that were sometimes
enhanced with splashes of watercolor. He also
appropriated the picture-within-a-picture technique
used in circus advertisements to present within a
single poster the same performers in multiple circus
acts. Examples of this technique may be found in
many drawings, such as *Lake Maude in North Center
of Lakeland Florida* and *Twin Mountain Range in
Upper New Zealand, World's Highest Foot Bridge*. In
Twin Mountain Range, a small, ovoid, sectional view
of one mountain's interior reveals a shark hungrily
eyeing a tiny fish. This little scene is humorously
mirrored in the larger composition that accompa-
nies it, where two elongated mountain forms resem-
bling giant gray fish with pointed snouts appear to
fight over a piece of bait, which is actually an
impressionistic Blackfoot bridge decorated with a

repeat diamond design reminiscent of Native
American basketry.

Strange faces also peer out of Yoakum's
rocks, trees, and mountains. In *Cedar Valley Range
Utah*, a grinning, ghostlike, disembodied white head
rests on the rim of a large, sandstone-colored,
perched rock that suggests a disembodied head.
These images recall a ghost story told in almost
every North American Indian tribe about heads
with no bodies, called the Rolling Heads.[132] The
anthropomorphic element, especially characteristic
of the artist's later works, reflects his familiarity
with Native American culture and its mythological
concept of the world as the abode of spirits.

MT HOREB OF MT SINI RANGE OF CANAAN ASIA ON PALESTINE / **c. 1966** / Crayon, pen, and watercolor
on paper / 12 × 18" / Collection of Ann Shaker / Courtesy Fleisher/Ollman Gallery, Philadelphia

Whether by design or as a result of mem-
ory, Yoakum introduced into many landscapes sym-
bols common to Pacific Northwest tribal art, such
as the oval for eyes, S forms for eyebrows, and U
forms for bird feathers. In *Mt Horeb of Mt Sini
Range of Canaan Asia on palestine*, a dramatically
stylized mountain in blue pastel pencil suggests a
tribal box decoration with its large central oval and
curvilinear formline. An idealized Hamatsa bird-
monster with its distinctive crooked beak and
curved open eye appears to be carved into the left
rim of the mountain, its head feathers indicated by
flowing S curves. One of the most imaginative art
forms produced by Kwakiutl tribal carvers, masks
representing fabulous bird-monsters were worn
during the Hamatsa winter dancing society—which
the artist may have seen in the Pacific Northwest or

This is of Chick Beaman
1st End man with Williams & Walkers
minstrell Show in years 1916 to 1930
by Joseph. E. Yoakum

THIS IS OF CHICK BEAMAN, 1ST END MAN WITH WILLIAMS & WALKERS MINSTRELL SHOW IN YEARS 1916 TO 1930 / 1968 / Ballpoint pen, graphite, and colored pencil on paper / 15 1/2 × 11 3/4" / Collection of Jim Nutt and Gladys Nilsson

Idaho Falls BrainTree pass

IDAHO FALLS BRAINTREE PASS / n.d. / Ballpoint pen and watercolor on paper / 8 × 10" / Collection of Jim Nutt and Gladys Nilsson

E.S. VALENTIN CRATER / **1964** / Crayon, pen, and watercolor on paper / 19 × 24" / Collection of Sam and Betsey Farber

at tribal dances and art fairs in Chicago sponsored by the American Indian organization of which he later was a member.

Yoakum's most extensive travels coincided with the height of railroad tourism, when the transcontinental railroad reached the doorsteps of the Native American cultures in the Southwest and the Pacific Northwest. Not surprisingly, his landscapes reveal the influence not only of Native American designs and themes, but also of art produced for the railroads to advertise the natural wonders along their routes. Works by Thomas Moran and other artists were translated into mass-marketed scenes distributed in free booklets, souvenir albums, calendars, and postcards. From these sources Yoakum drew inspiration in terms of composition and palette, as well as certain design elements, like the perched rock, diagonally oriented road, and elaborate titles.

Perhaps the most frequently mass-produced view is of two rounded mountains separated by a river, road, railroad tracks, waterfalls, or lake. This composition is used repeatedly in early guidebooks, such as *The Pacific Tourist* (1884), in numerous postcards, and throughout Yoakum's oeuvre as well, in such landscapes as *Lake Maude in North Center of Lakeland Florida*, *Mt Gebel Ataoa near Suez Egypt*, and *The Three Great Falls in Missouri River near Great Falls Montana*. *The Three Great Falls* could have been inspired by a Moran etching of *Lower Falls of the Yellowstone* from *The Pacific Tourist* and later postcard renderings of this view. The guidebook's description of the falls suggests Yoakum's stylized interpretation: "The river above is broken into rapids, and . . . the mass [of water] is broken into most beautiful snow white drops. . . . Midway in its descent a ledge of rock is met with, which carries it away from the vertical base of the precipice."[133] The artist also incorporates three rocky pinnacles, painted pale green, which resemble the hoodoos in early postcard views of Yellowstone's Tower Falls. The strong verticality of these limestone rock towers provides a dramatic contrast to the strong vertical markings of the large squat rocks to the right of the falls, which appear in postcard views of Tower Falls as well.

Sparked by diverse artistic sources, Yoakum invented a rich vocabulary of forms, patterns, and design elements. With his unique visual language he created a universal landscape inspired by memories of his traveling days. The extraordinary vision of this solitary dreamer has enabled us to see the unseen, or what Matisse called the "inherent truth," in the world of objective reality.

P.M. WENTWORTH

(PERLEY WENTWORTH)
(DATES UNKNOWN)
BIRTHPLACE AND WORKPLACE UNKNOWN

BY EMILY BARTON

We know little about the life of outsider artist P.M. Wentworth, but his paintings, which combine exuberant and apocalyptic images, indicate a privileged access to the sublime—to the extraterrestrial world and the world of God, which often inform one another in his rich, strange, meditative works. What little we do know of Wentworth's life only enhances the mystery everywhere apparent in his art. Curators originally thought that his initials, P.M., were a private symbol for his work as night watchman at a naval station. The discovery of a signed drawing later proved his given name to be Perley, but the curators' mistake is fruitful; the work that Perley "P.M." Wentworth left behind clearly and joyously depicts the soul of the night, the slow seep of the sublime into the everyday world of work. Wentworth described himself as a seer of visions in the sky or on blank paper, and his process of artistic creation as re-creating or tracing those lines. He frequently wrote descriptive legends on the pictures so that his somewhat abstruse subjects would be understandable to outside observers. Wentworth thus provided, through image and supplementary text, an evocative map of a world most of us are unable even to see.

Both literally and figuratively, Perley Wentworth's employ as a night watchman serves as a key to understanding his often imposingly strange works. The job of the night watchman is to guard, literally to keep his eyes open, though because most of the world is asleep, he finds himself surrounded by darkness and quiet. Exactly such an attitude of watchfulness and heightened receptivity is what causes desert wanderers to see lush oases where there aren't any and night drivers to see the ghosts of animals skittering across the road; however, in the case of the watchman, such tricks of well-trained vision are merely the necessary side effects of the attention to detail his work requires. And though the job description means "someone who watches at night," the construction of the term also suggests "someone who watches *the* night." Such close attention to the darkness, it would seem, is exactly the process Perley Wentworth has described in his art.

Viewed in this light, Wentworth's images give us insight into the mystical components of nature that we so often overlook. Take, for example, the image *Untitled (11/22/53 / 6 PM)*—the "PM" signifying both the time of its creation and the mark of the artist's name. Here we see a black circle against a deep blue background, and a man's stern face, as if in mosaic, inside the circle. We can read the ragged-edged circle in a number of ways: as a lonely planet; as a meteor with the map of a face upon it, like the canals we see upon Mars; as a crater on Earth revealing the ancient ruin of a face or the image of God; or even as a single cell, frozen on a slide, which bears the mark of the human or divine force that created it. These interpretations may seem various and contradictory, but they are in fact perfectly harmonious with one another. At the same time the artist shows us a modern man's conception of the world as visible through telescope and microscope, writ large and writ small, and the lone thinker's conception of the world as sacred, mysterious, the work of a remote and "other" creator.

Or take his *Untitled (Imagination/Creation of the/World)*, an odd, disturbing picture in which two genderless hands (presumably belonging to a well-manicured God) squeeze an object that is part human brain, part spacecraft, and part mushroom cloud to release a flood of light from which the bodies of two people— Adam and Eve, whose names, along with Abraham's, bubble up from the roiling jumble

UNTITLED (MOSES—TABERNACLE—FOOT OF MOUNT—SINIA) / c. late 1950s / Pencil, crayon, and tempera on paper / 17 × 22" / Collection of Jim Nutt and Gladys Nilsson

UNTITLED (IMAGINATION/CREATION OF THE/WORLD) / n.d. / Mixed media on paper / 30 × 25 ½" / Collection of Matt Mullican and Valerie Smith

Wentworth used his heightened vision to probe both the world of things and that of his imagination, and to synthesize the two into a seamless whole.

These works speak of a wholly private but fully articulated system of belief, founded in an ability to see and interpret the wonder of the natural world where a less attuned mind might see only emptiness. A true visionary, Wentworth had a spiritual affinity with the night sky; he respected its darkness and mystery, yet lost himself in rapture at the power of its terrible beauty. Employed to look after a place at night, he did not think of home, or fret over what happened during the day, or continually rehash the petty details of his life. Rather, Perley Wentworth saw the eternal laws of nature and the forces, however frightening, that drive them. Through the twin acts of imagination and creation, Wentworth learned to see the faint glow of the uncanny that lingers around the edges of the visible and to document the basic truths of what cannot be known.

of word-matter to the image's right—emerge, translucent in the serene landscape. The careful layering of color on color and pencil on erasure on more pencil, which gives the picture its nearly impossible tonal delicacy and richness, also reflects a strange, subtle layering of religious imagery with that of alien occupation and scientific apocalypse. For in the hands' embrace we see at once a kind gesture of enclosure and an incipient gesture of threat; in the translucence of the figures, we can see either life taking shape or its dissolution. Here at once are the natural process of creation (embodied in the sun and the moon) and man's unique ability to annihilate the world with his brain-cloud-ship. *Imagination/Creation of the/ World* is at once a fanciful depiction of the art of making and a realistic depiction of the effects of nuclear assault.

UNTITLED (11/22/53 / 6 PM) / 1953 / Charcoal, gouache, and pastel on paper / 14 ½ × 22" / Collection of Robert M. Greenberg

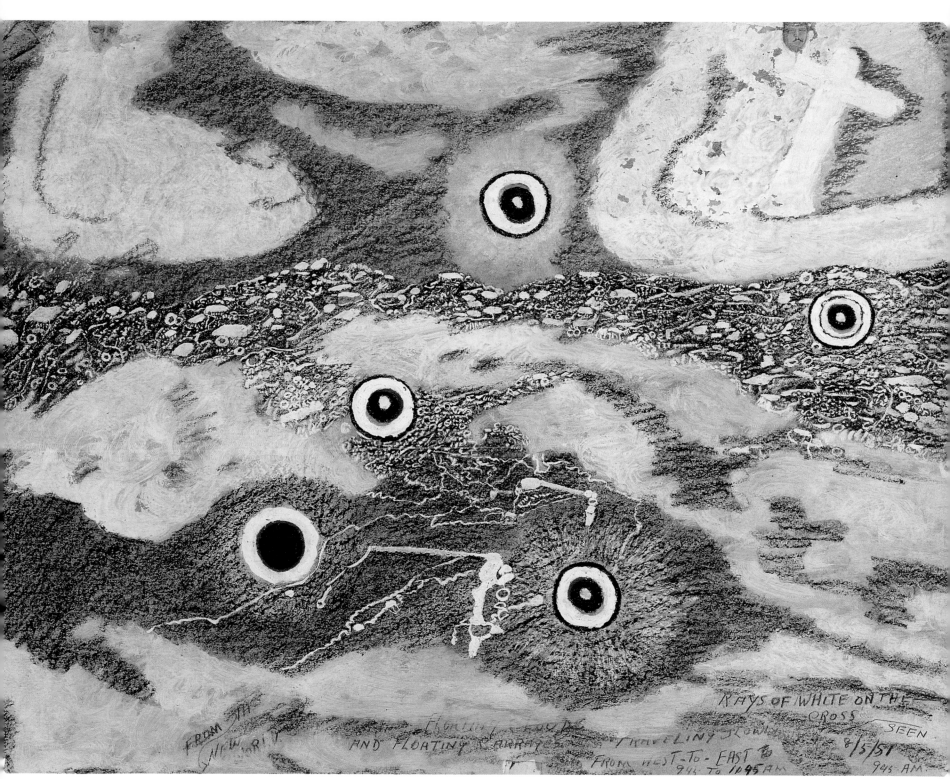

UNTITLED (RAYS OF WHITE ON THE/CROSS) / 1951 / Pastel, pencil, charcoal, and mixed media on paper / 17 × 22" / Collection of Robert M. Greenberg

EUGENE
VON BRUENCHENHEIN
(1910–1983)
BORN MARINETTE, WISCONSIN
WORKED MILWAUKEE

BY MARVIN HEIFERMAN

During a ten-year period in the middle of the twentieth century, in the cramped rooms of a house without heat, a refrigerator, or a telephone, behind a storefront on a mid-American street, Eugene Von Bruenchenhein took thousands of photographs of his wife, Marie. These were not ordinary snapshots, but odd tableaux: Marie with her stockings rolled down around her ankles like shackles; Marie wearing leather shoes with fetishistic ankle straps; Marie wearing pearls around her neck in one picture and tightly wound around her breasts in the next;

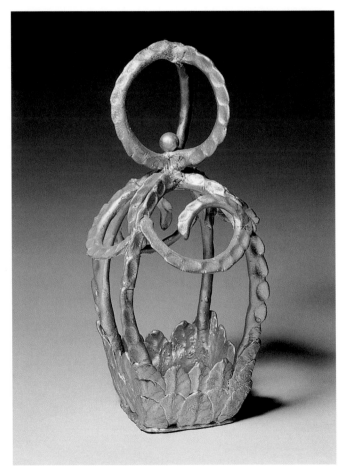

UNTITLED (CERAMIC VESSEL) / 1960s–1970s / Paint on clay / 13 × 6 × 6" / Collection of Jill and Sheldon Bonovitz

Marie in a see-through bandeau top or with a wan smile on her lips and hands behind her back, as if she were tied up and enjoying it; Marie with her hair pulled up and underpants pushed down; Marie on her back, legs up in the air, heavy high heels dangling over her head; Marie nearly naked in her living room, her husband's make-believe Eve, star-

ing at a coiled snake made of plaster, the kind you can still buy at souvenir stands in the Southwest; Marie in double exposure, her face floating over clouds and landscapes in photographs her husband titled, with a heartfelt sincerity, *Desire of Nature* and *Glory in Trees and Wind and Her*.

Eugene Von Bruenchenhein was a small man, described by friends as a lover of polka music and white cats, who in his youth was prone to introspection and in his later years to apocalyptic inner visions. Born in 1910, Von Bruenchenhein—raised by his father, a sign painter, and his stepmother, a chiropractor who painted floral still lifes and published pamphlets on evolution and reincarnation—showed early interests in art, science, and personal expression. He experimented with painting and wrote romantic poems about life's loneliness, about how seasons change and youth fades, and about nature's divine beauty.

A resident of Milwaukee, Von Bruenchenhein was employed in the 1930s as a carpenter's helper and a florist, and from 1944 until his early retirement fifteen years later, as a bakery worker. Too short to serve in the armed forces in World War II, he spent his free time building a greenhouse in the backyard of his family home. A collector of exotic plants, a student of botany, and a member of the Milwaukee Cactus Club, Von Bruenchenhein had developed a keen appreciation of hothouse beauty. He met Eveline Kalke in 1939 at the Wisconsin State Fair Park and, during their three-and-a-half-year courtship, wrote love songs to her, "the queen of his existence." After their marriage, Von Bruenchenhein began photographing his wife, who now called herself Marie. In an obsessive and hermetic collaboration, husband and wife, artist and model, often worked late into the night, staging pictures.

Photographs of Von Bruenchenhein from the period show him costumed as a caveman or posing shirtless in the sunny backyard, wearing a large sombrero. But behind his camera at night, this connoisseur of pinups and girlie magazines, this collector of *National Geographics*, proved himself a willful director of erotic tableaux. Working compulsively and with limited materials, Von

Bruenchenhein transformed his wife into a queen, into a goddess, used her as a model for "art nudes" like those celebrated by camera club members across the country and popularized by the photography magazines of the time. Von Bruenchenhein developed his own film, making black-and-white prints in his bathroom darkroom, and with Marie's assistance hand-colored many of the images they created together.

A willing subject, Marie was transformed, not only by the abundance of her husband's photographic attention, but also by the scanty costumes and dime-store accessories that he covered

UNTITLED (BONE TOWER) / **1970s** / Chicken and turkey bones, glued and painted / 33 ½ × 10 ½ × 10 ½" / Collection of Jill and Sheldon Bonovitz

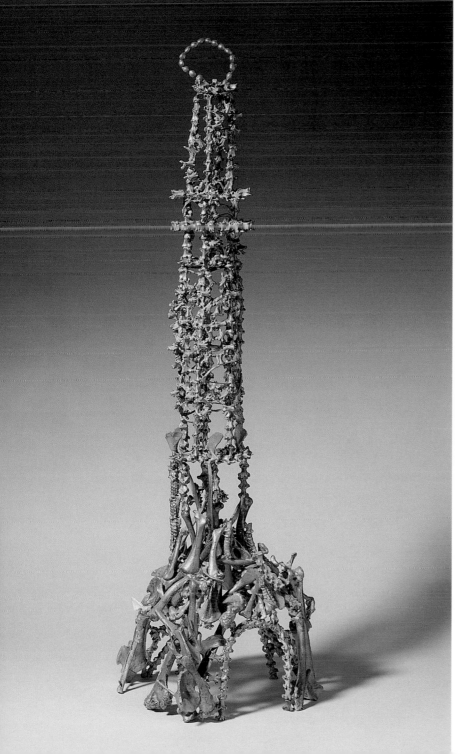

her with—crowns made of tin, ropes of pearls, Christmas ornaments, flowers, pieces of gauzy, see-through fabrics. The effect was part Dorothy Lamour, part Gypsy Rose Lee, part odalisque, part compliant hausfrau. Marie's expressions vary only slightly. In most of the pictures she looks somewhat affectless, in some she smiles, and in a few she seems to be gazing off in a state of erotic or spiritual transcendence. But most of the time, she sits on a little oriental rug, or lounges on a chenille bedspread, or kneels on remnants of patterned fabrics like the White Rock Girl—a zigzag of elbows and knees. Positioned in front of draperies patterned with heavy roses, peonies, hibiscus blossoms, and the lush foliage that lent a hint of luxury to an era grounded in wartime sacrifice, there is Marie, in poses that speak of an appreciation of art, beauty, and desire, and hint at bondage.

Von Bruenchenhein's portraiture sessions continued through the mid-1950s, when issues of *Playboy* magazine and suggestive photographs of the model Betty Page began to circulate widely. He switched to using outdated army-surplus film that gave the color slides he shot a lush but quirky color palette and a claustrophobia heightened by his increasing interest in contrasting colors and patterns. Seen singly or in limited number, Von Bruenchenhein's photographic portraits look adoring, idiosyncratic, and charming. While they might seem repetitious when seen in quantity, they offer something more—a record of the artist's ritualistic compulsion to go over the same territory again and again, perhaps in the hope of getting it right, perhaps to reach some other, harder-to-define psychological or spiritual goal.

Von Bruenchenhein was not alone in his photographic fascination or zeal. In the nineteenth century, F. Holland Day and Julia Margaret Cameron repeatedly costumed and photographed models, friends, and loved ones enacting religious, moral, and sometimes erotic narratives. At the turn of the century, an extended series of portraits by E.J. Bellocq documented moments from the lives of the prostitutes of New Orleans' Storyville district, whose direct stares at the camera and evocative poses might have titillated but never overwhelmed their humanity. Two decades later, the renowned Alfred Steiglitz broke modernist ground in his unconventionally conceived and composed portraits of his wife, artist Georgia O'Keeffe, and Paul Outerbridge used the techniques of commercial

photography to perfect the slick kinkiness in his outrageously colored nudes. At the same time Von Bruenchenhein was photographing Marie, Harry Callahan, in an extended series of portraits of his wife, Eleanor, and daughter Barbara, balanced an exhaustive photographic inquiry against the need for visual and emotional intimacy. From Irving Penn's stylish and adoring photographs of his wife, Lisa Fonssagrives, to Emmet Gowin's mythologized photographs of his wife, Edith, photographers have documented the women at the center of their everyday and erotic lives.

While Von Bruenchenhein's photographic ambition is clear, the medium was only the first he chose to explore during his eccentric career. Because Von Bruenchenhein was an amateur photographer, his work remains outside the discourse of conventional photographic history and criticism; the medium was, for him, a passing passion, a starting place. Inspired by reports and magazine photos of hydrogen bomb tests in the Central Pacific in 1952, Von Bruenchenhein later turned to finger painting torridly hued and consecutively numbered pictures of cataclysmic destruction, mushroom clouds, underwater nightmare worlds, volcanoes, planetary landscapes, mysterious architectural fantasies, and flowers. He crafted delicate, tiny thrones and tall towers made from chicken bones saved from TV dinners or donated by neighbors, which Von Bruenchenhein bleached, dried, and then painted, using brushes made of bits of straw bound together with tufts of Marie's hair. He sculpted ceramic crowns and concrete masks. He not only filled his house with thousands of objects and poems and taped recordings on cassettes, but also painted inscriptions on the walls, ceilings, floors, and furniture.

Von Bruenchenhein described himself on an incised plaque in his kitchen as a:

> *Freelance Artist*
> *Poet and Sculptor*
> *Inovator [sic]*
> *Arrow maker and Plant man*
> *Bone artifacts constructor*
> *Photographer and Architect*
> *Philosopher*

Except for a ten-year hiatus, from the late 1960s through the late 1970s, this man worked in bursts of frenzied activity until his death in 1983. He left behind an original universe of visionary images and apocalyptic works that were triggered by a private photographic devotion.

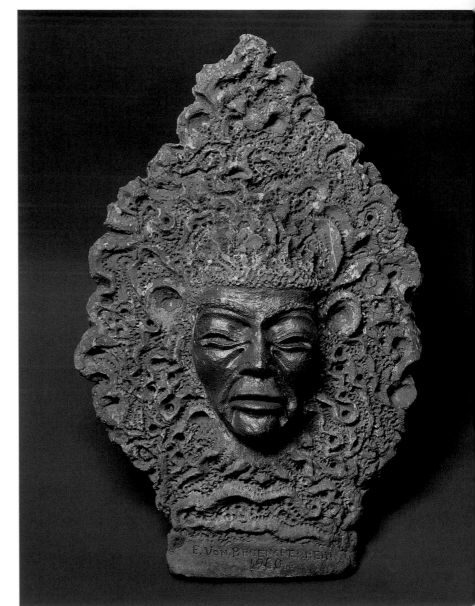

UNTITLED (BLUE HEADDRESS SURROUNDING GOLDEN FACE) / 1960 / Painted concrete relief / 35 × 22 × 7" / Courtesy Carl Hammer Gallery, Chicago

EUGENE THINKS OF MARIE: MONTAGE BY EUGENE / Gelatin-silver print from multiple negatives; handwritten text / 10 × 8" (image: 10 × 5 ⅝") / John Michael Kohler Arts Center, Sheboygan, Wisconsin / 1984.10.276b

UNTITLED / Gelatin-silver print / 10 × 8" (image: 9 ⅜ × 7 ¼") / John Michael Kohler Arts Center, Sheboygan, Wisconsin / 1984.10.278

UNTITLED (BONE CHAIR) / **Late 1960s** / Chicken and turkey bones, glued and painted / 8 ⅞ × 4 ½ × 4 ½″ / John Michael Kohler Arts Center, Sheboygan, Wisconsin /
1984.10.4

JESSE
HOWARD
(1885–1983)
**BORN SHAMROCK, MISSOURI
WORKED FULTON, MISSOURI**

BY MICHAEL D. HALL

Up on Hell's 20 Acres and the Suburbs of Hell, his two spreads on either side of Old Jeff City Road, you can see where it all began, all that daring, single-minded reduction of the rich evanescence of speech to the hard discrete permanence of print which made modern civilization and which now burdens it to distraction.

> —Richard Rhodes, "Jesse Howard: Signs and Wonders," *Naives and Visionaries*

Maybe the thing that sets Jesse Howard apart from the legion of curbside orators haranguing passersby on the streets of all our major cities is that Howard gave voice to his rantings and ravings in paint. I've often thought this. Even more often, I've marveled at the process that transformed Howard from a public nuisance into an artist and

hundreds of painted signs and banners that he planted in his yard and plastered on the outside of his house to confront all who passed along the road in front of his home outside Fulton, Missouri. The world according to Howard was a collage of news, bias, opinion, Scripture, and political commentary. It was also a visual collage—an abstract overlay of graphic design and typography. Howard's signature block style of printing typically incorporates black letters set off against white backgrounds. For emphasis—and, I would argue, for aesthetic effect—he interspersed his text with words and punctuation rendered in a distinctive red-orange. When the artworld found Jesse Howard, it found wit, wisdom, and impertinence in white, black, and red.

UNTITLED (EISENHOWER SAYS PEACE) / 1953–1960 / Paint on Masonite / 20 x 48" / Kansas City Art Institute, Kansas City, Missouri

converted his painted diatribes into art. "Self-Taught Artists of the 20th Century: An American Anthology" presents a timely opportunity to more thoroughly pursue the question of Jesse Howard and his unusual creative expression.

To begin, we need to acknowledge that Howard's running commentary is impressive as a physical production. Over the years, he created

What the artworld perceived in the course of this discovery, however, was something more. Howard and his work have attracted artworld partisans concerned with two very distinct issues. The first of these involves Howard's social activism—the political aspect of the man and his work. The second concerns the more abstract issue of the aesthetic value of text itself as a form of

visual art. As a political figure, Howard emerges as something of an American folk hero. His fierce independence and his zealous defense of his First Amendment rights center him in the enduring myth defining the American experience as one of individualism and personal freedom. "Ornery," "hard-boiled," "feisty"—these are some of the adjectives typically used to describe Howard by the artists and collectors who made the pilgrimage to Fulton to meet him. Howard the agitator, claiming a family tie to Jesse James (the renegade "Mr. Howard" of another era), became a political celebrity in one corner of the 1970s artworld.

The right-wing and conservative nature of much of what Howard said and incorporated into his commentary doesn't seem to have dismayed his early admirers at all. Neither did the fact that he played fast and loose with the information sources that inspired his pronouncements. In the cult of personality that inclined so many 1970s collectors to mythologize the "folk" creating contemporary folk art, Howard (as a persona) became a mediation between the style and the content of his own work. Few commentators have noted that Howard's understandings of Washington, D.C., the Bible, and Soviet foreign policy were all equally impressionistic. Instead they focus on the artist's irrepressible spirit and his maniacal determination to imprint himself on his world. Howard's lifestyle became meaning for an audience enthralled with the discovery of an artist they perceived as one part Davy Crockett, one part Gustave Courbet, and one part Rush Limbaugh.

On the art side of the folk art equation, Howard attracted notice because his work seemed curiously compatible with other works being produced in avant-garde circles during the 1970s. Word-image art, as it was known in the period, came to include a host of gestures, including typography, ideograms, signatures, documentations, geometrical figures, numbers, and graffiti. Howard's signs were discovered as art in exactly the same time frame in which the writer Emmett Williams was first gaining broad renown for his concrete poetry and the painter Cy Twombly was finding belated critical acclaim for his idiosyncratic script paintings. In the context of word-image art, Howard's signs are abstract and highly conceptual inventions fully compatible with the legacy of 1960s pop art, as well as with the newer forms of expressionist and pattern painting of the 1970s.

In what has become a historic pattern, the proponents of folk art found in Howard's work further support for their argument that naive (self-taught) art can exemplify all the stylistic qualities that evolve in the aesthetic searches of the modernist avant-garde. The enfolding of Jesse Howard into a contemporary aesthetic canon conforms to a "folk art as fine art" model established more

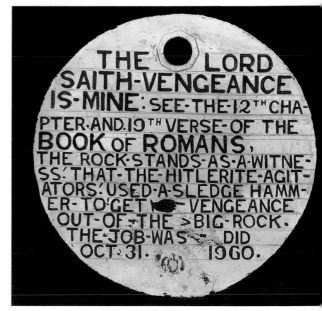

UNTITLED (THE LORD SAITH VENGEANCE) / 1960 / Paint on metal drum lid / 22 ¼" diameter / Kansas City Art Institute, Kansas City, Missouri

than sixty years ago, when nineteenth-century American weathervanes were first discussed as "Picasso-like" in style. In the same way that Jon Serl's anxious figure paintings had made him the folk art Edvard Munch and Miles Carpenter's kinetic whimsies had made him the folk art Alexander Calder, Jesse Howard's signs made him the folk art Twombly, or Williams, or Jenny Holzer—a mix of assignations that vary according to the disposition of the commentator. In the ongoing confounding of the folk and fine art categories, one thing is clear: as surely as folk art is shaped by the mainstream, the mainstream broadens and deepens as folk art flows into it. Without the signs of Jesse Howard, our corpus of word-image art would most certainly be the poorer.

Still, the question of Jesse Howard remains complex. His brand of vaunted patriotism is artistically problematic. The political outrage that fired Thomas Paine's pen presumably also inspired Goya's brush. If we listen closely, however, we also hear outrage cited as the inspiration behind the militia sentiments we read on bumper stickers everywhere today. Jesse Howard's signs walk a fine line and force us to distinguish between patriots and malcontents as well as between a satirical artist and a nag. Howard's signs gather artistic credibility as their graphic and expressionistic qualities carry them beyond sloganeering. Curiously, they gain power as they disassemble from the concert around Howard's home and move individually into collections as discrete objects—fragments of a

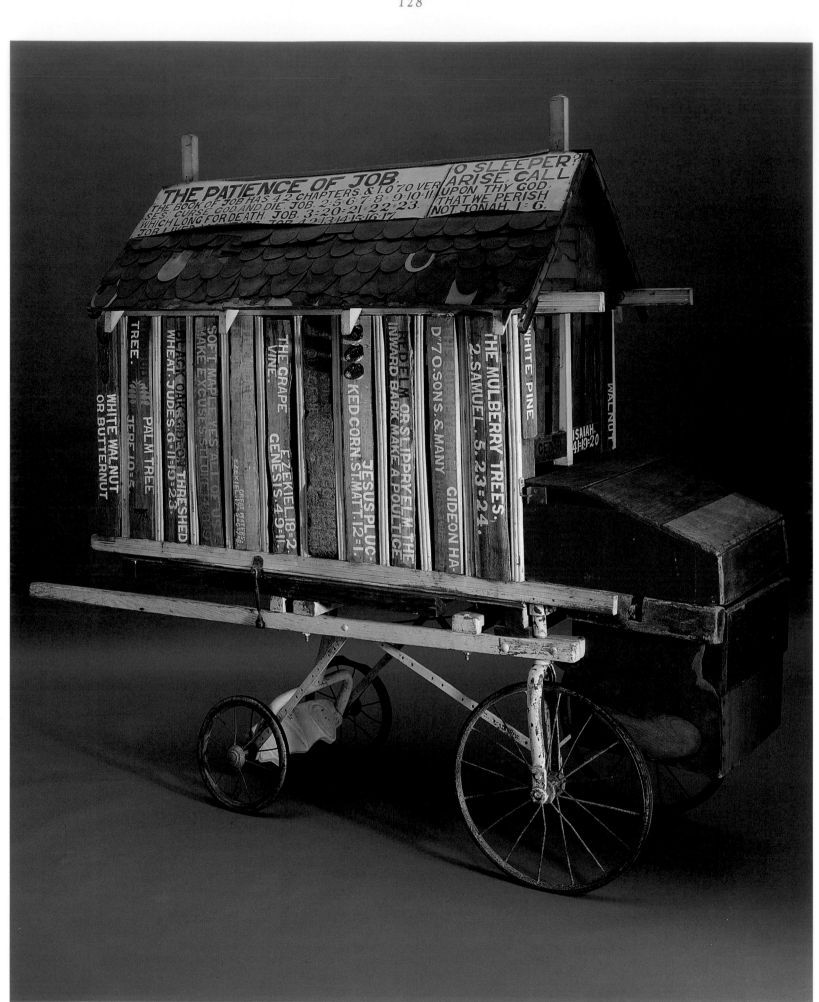

UNTITLED (THE PATIENCE OF JOB) / 1953 / Mixed media / 64 × 57 × 19″ / Kansas City Art Institute, Kansas City, Missouri

more complicated work in progress. Removed from Howard, the signs take on a life of their own—a life open to fresh interpretive emphasis. At this remove, their message is less literal and Howard's statement becomes less a harangue and more the raw self-affirmation that haunts so much of the best art of the modern era. As contemporary art, the signs synthesize the spirit of abstract expressionism and the look and feel of popular culture. We begin to understand Howard as an artist with both a public and a private view—the same dual perspective that imparts compelling tension to the works of Georgia O'Keeffe, Jackson Pollock, or any other modernist of note.

From a modern art perspective, it is the constructed quality of Howard's work that holds our interest most. Manipulating blocks of text and the individual characters of the alphabet, Howard orchestrates his work in a thoroughly constructivist way. Howard's is an art of part-to-part relationships: the parts of his social discourse intertwist with the parts of his visual architecture. The message in each sign is subsumed into a larger block composition. Every character takes its place in a black-and-white grid punctuated in red. These grids are carefully composed and many evidence subtle but important revisions. Each completed sign is a distillation of both thought and feeling.

To confront a Howard sign is to recall Rhodes' term "single-minded reduction." Howard, however, was not a minimalist. If anything he was a maximalist, and it is the maximalism in his art that gives it both its charm and its expressive power. Identifying the tectonic quality in Howard's signs, we begin to understand the structural mandate that informed the artist's approach to the making of the

entire environment built on and around his home. At any given moment, this environment was a complete and closed composition possessed of an open-ended potential for growth and change.

In Howard we find a provincial eccentric from a contemporary folk community, orchestrating his world as something we have to acknowledge as highly individualistic art. In Fulton, Howard's peculiar formulations isolated him and he became something of a pariah. Beyond Fulton, he is similarly isolated within still another community. Despite its considerable acclaim, his work remains problematic in an artworld where many collectors and curators find the issues of Mondrian and religious fundamentalism hard to reconcile. Nevertheless, the painted signs persist—as irritations and fasci-

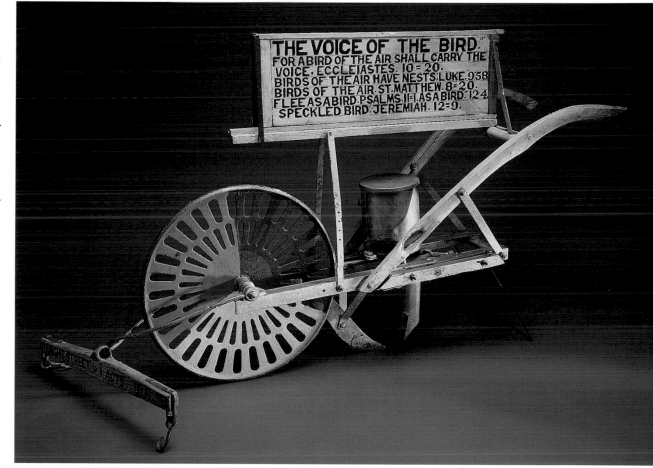

UNTITLED (THE VOICE OF THE BIRD) / 1955 / Painted wood and metal cornplanter / 37 × 56 × 18" / Kansas City Art Institute, Kansas City, Missouri

nations, as parts and wholes. Their inclusion in "Self-Taught Artists of the 20th Century: An American Anthology" provides us with an opportunity to understand them—and Howard's achievement—in a current art context. Nobody ever said art was easy, and the good news is that Jesse Howard has left us ample proof that folk art isn't either.

EDGAR
TOLSON
(1904–1984)
BORN LEE CITY, KENTUCKY
WORKED CAMPTON, KENTUCKY

BY MICHAEL D. HALL

Any art is inevitably stamped by the values and habits of the society that creates and sustains it.

—Michael J. Lewis, architecture critic

Ever since their introduction into the American art scene in the late 1960s, the carvings of Edgar Tolson have been continuously reimagined and reinterpreted in an evolving art history as well as in the art marketplace. After thirty years of Tolson, the time seems right to inquire into the sociocultural conditions that have created and sustained his art in the contemporary American art dialogue.

As with many individuals identified as contemporary folk artists, Edgar Tolson is problematic. Confusion starts, I think, with the obvious ambiguity inherent in the term "contemporary folk art." Does it designate a period sensibility? a cultural style? the art of a period subculture? There is little agreement as to what, exactly, should be included under this dubious rubric. Even if there were, we would still have to contend with the further com-

ADAM AND EVE / 1979 / Carved and painted wood and pencil / 10 1/4 × 10 3/4 × 7 1/4" / National Museum of American Art, Smithsonian Institution / Gift of Herbert Waide Hemphill Jr. and Museum purchase made possible by Ralph Cross Johnson / 1986.65.269

plexity brought to the folk art problem by Michael Lewis' critique. And it's here that the Tolson question moves away from issues of classification and gets interesting. Assessing Tolson's work in relation to the argument that society makes, marks, and sustains art, we immediately have to ask whether the society shaping these carvings is to be found in the rural, provincial environment where they originated or in the cosmopolitan, urban milieu where they are marketed, consumed, designated as contemporary folk art, and appointed for inclusion in exhibitions such as "Self-Taught Artists of the 20th Century: An American Anthology."

The earliest presentations of Tolson's work were supported by assumptions appropriated from traditional folk art scholarship and, to some extent, from the field of folklore studies. In these presentations Tolson was cast as "folk"—a member of a traditional and closed social group, which in his case was the rural regional culture of the southern Appalachian mountains. As folk art, his carvings were presumed to speak to and from his folk community. They were compared with the carvings of the nineteenth-century Pennsylvania woodcarver Wilhelm Schimmel, and in time came to join Schimmel's work in the collections of many of America's foremost folk art museums. From a folklore perspective, Tolson's work does reflect the traditional and fundamentalist beliefs of the Appalachian people. His dolls visually personify the stoic, flinty demeanor of "the mountain people" and his narrative tableaux illustrate stories from the Book of Genesis as they have been told by country preachers for generations. The Appalachian folk and their values seem accurately reflected in this, their folk art. Curiously, however, few of Tolson's neighbors ever owned his work. When they did, it was more for its value as a conversation piece or a memento of its maker than as something perceived as invested with their own personal or cultural self-identity. In its own backyard, Tolson's folk art was something of an anomaly.

Beyond Appalachia, however, three other distinct communities have had a real use for Tolson's carvings. Each has aggressively incorporated Tolson and his work into its own cultural mythology. In the process, each has (as Lewis

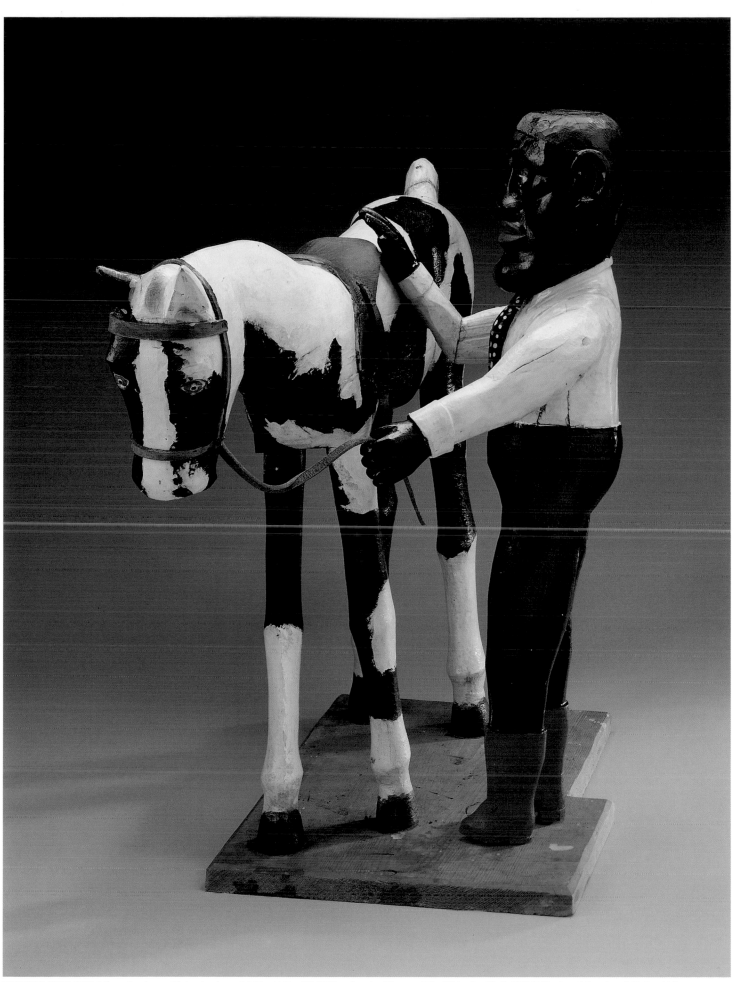

MAN WITH PONY / **1958** / Carved and assembled painted wood / 23 × 11 ¼ × 32" / Milwaukee Art Museum / The Michael and Julie Hall Collection of American Folk Art / M1989.314

would assert) stamped its own mark on Tolson's work and our understandings of it. The first of these groups is made up of craft collectors and folk-life festival promoters. This community views Tolson the whittler as the last of a line of traditional woodcarvers. To this constituency, Tolson the handcrafter is a bulwark against postindustrial technology and its overly intellectual, abstract art.

landscape. Confronting any Tolson piece, we cannot fail to feel some ambivalence. Two sets of hands seem to have shaped the image before us— Tolson the Appalachian Schimmel and Tolson the craft fair circuit rider have both been at work here.

The second urban society claiming Tolson's art is essentially an academic community made up of artists and museum professionals. This community is immersed in the project of modern art and committed to its attendant notion of art as self-expression. The art preference in this camp runs to works that are formally designed and intellectually abstract. The university-affiliated painters and sculptors who first brought Tolson's work out of Wolfe County, Kentucky, shared the modernist belief in art as a formal language to be continually reconfigured by innovative artistic "seers." In their eyes, the formal simplicity and peculiar austerity in Tolson's work rendered it modernist in spirit. And in the independent, charismatic persona of Tolson himself, they perceived the prototypical modern artist. They interpreted

SIX FIGURES / 1966–1971 / Carved and painted wood / Various dimensions: 11 ½ to 13 ½" high / Private collection

Frequently, through the 1960s and into the 1970s, Tolson was trotted out and put on display at regional and national folk-life festivals and craft fairs. In these events, Tolson the living artifact became one with clog dancers, quiltmakers, and the clay turners of Jugtown in North Carolina. His deft knife and his often stated affection for "good old poplar wood" were duly noted and admired by the largely suburban community that supports handicraft revivals and spreads the "process and materials" craft aesthetic across our contemporary

Tolson's inclusion in the 1973 Biennial Exhibition at New York's Whitney Museum of American Art as a sign that the hegemony of modern art was opening to a new pluralism. They also found their American dream of individualism and their artistic dream of originality palpably manifest in the dolls and tableaux they took away from the carver's workshop trailer. By 1975 a small but vocal coterie of curators and artists had ordained Tolson as a modernist (albeit in Gothic masquerade), and in so doing had impressed his art with another distinc-

tive mark.

The most recent community to reformulate Tolson's work comprises a coalition of collectors, critics, and dealers who cross between the more established folk art and fine art camps. This new community has emerged as the purveyor of an art production known as outsider art—drawings, paintings, and various sculptural creations produced by asylum inmates, prisoners, visionaries, and others cut off from art traditions of any sort. Tolson's autogenesis as an artist, combined with his poverty, alcoholism, and geographic isolation, qualify him as an outsider. Stories of Edgar the hard-drinking, Bible-thumping patriarch inspired outsider art buffs to venture into the mountains in search of a creative force that would invert the norms of their own bourgeois world. Beyond the humdrum of their daily experience, they wanted Tolson to be outrageous. To offset the blandness of their middle-class America, they needed the carver to be colorful. To counter their habit of politeness, they expected the mountain man to be intemperate and profane. Showman that he was, Tolson obliged them. Within the container of its own understandings, the outsider art community came to view Tolson as a kind of mystic and collected his carvings as a form of idiosyncratic expressionism—the obsessive creations of an isolated and alienated vision. By 1985 the outsider mantle had become the latest overlay of values and habits reshaping Tolson's art.

One may ask how Tolson's work can serve so many masters. One may also question whether it even should. The vitality that pervades the carvings seems to be the key to their multivalence and hence their broad-based usefulness and appeal. Truly vital art in a pluralist world should serve multiple masters. One might even argue that the most interesting art today is that which is called to do so. Rethinking Tolson in a contemporary dialectic, one acknowledges the folk traditions that inform and prescribe the content of his carvings. Simultaneously, one admires the formal abstraction that gives his work its visual power—an abstraction clearly akin to that which modern artists have long discovered in the work of so-called primitives. Synthesizing further, one becomes open to the carvings as appealing handmade objects in wood—craftwork of a rather high order. Finally, one confronts these same carvings as art outside the mainstream—anxious and introverted works of sculpture that speak to us of infrequently visited locales on the margins of our cultural map.

Years ago, in one of my first forays into folk art criticism, I discussed Tolson's work as an exemplar of "one man, one pocketknife" art. Without diminishing the importance of the individual painter or sculptor, I would side today with Michael Lewis and argue that we have for too long ignored the fact that the making of art is a social, collective process in which sculptors or painters are not the sole creators of the works they author. My measure of Tolson is enhanced by the fact that his work has been so powerfully and usefully fashioned by so many who have found a place for it in their personal lives and in the lives they share with others as a community. Freshly seen in a dialectic where many people and many pocketknives are necessary to the making of art, Edgar Tolson, folk sculptor, craftsman, modernist, and outsider, extends his impress on our national imagination. His carvings, for their part, insinuate themselves into my consciousness as poetry of a most singular and eloquent sort. Few objects resonate more in the space between my eye, my mind, and my spirit than do the taut personages Tolson always referred to as his "dolls." They seem to me to be emissaries from the place in my imagination where self and other meet, and where the ancient and the modern meld as one.

SISTER GERTRUDE MORGAN

(1900–1980)
BORN LAFAYETTE, ALABAMA
WORKED NEW ORLEANS

BY WILLIAM A. FAGALY

Sister Gertrude Morgan was never officially ordained a Sister nor is it certain that her birth name was Morgan.[134] Nor to anyone's knowledge did she ever have any formal training in art. The artist herself claimed that she was the seventh child born to her parents and that she was delivered on the seventh day of the week, the seventh day of April, in the year 1900.[135] An African American woman, she grew up in the Deep South during the Depression, long before the civil rights and feminist movements. At times in her life she was homeless and depended on the kindness of acquaintances for food and shelter. Her death in 1980 was not reported immediately, and she was buried in an unmarked grave in a potter's field in New Orleans.

Why is this woman's life of interest and why will she be recognized by history as one of America's most treasured citizens? In spite of the many obstacles and the great adversity she faced throughout her life, Morgan had an undying faith—a faith in the teachings of the Christian religion. She loved her fellow beings and demonstrated a special compassion for small children. Her lifelong mission was to warn all that if they did not live an upright life without committing sin, they were doomed to everlasting loss in the afterlife. This dedication was unwavering and consumed her whole existence.

To carry out this single objective, she first associated herself—in her late twenties and early thirties, following her move from her birthplace in Lafayette, Alabama—with James B. Miller's Rose Hill Memorial Baptist Church in Columbus, Georgia. In 1934 she received her first revelation to preach and moved to Montgomery and later to Mobile, Alabama, where she became a street minister so that she could spread the gospel to anyone who would listen. When she relocated to New Orleans in 1939, she became associated with two other African American women, Mother Margaret Parker and Sister Cora Williams. Together these women, wearing black vestments, established a small chapel and day-care center and orphanage. In 1956 or 1957 Sister Gertrude received her second divine revelation, which again changed her life. Having been told she was to be the bride of Christ, she exchanged her black robes for an all-white attire that she wore daily for the remainder of her life. Around this time, she also began to make art in the form of simple crayon drawings, after many years of not indicating any interest in producing art. While her earlier efforts had been the product of a child at play, now her art-making had a definite purpose—to facilitate her evangelical teachings that salvation is found through faith and grace, rather than through good works and sacraments alone.

A couple of years later, yet another event occurred that altered the course of her career. While she was performing on the corner of Bourbon and Saint Peter streets in the French Quarter, her gospel singing and small drawings came to the attention of art dealer and entrepreneur E. Lorenz Borenstein. Recognizing her unique talents, he invited her into his gallery, Associated

UNTITLED (DO YOU THANK GOD) / n.d. / Paint on paper / 12 ½ x 19" / Collection of Jill and Sheldon Bonovitz

JESUS IS MY CO-PILOT / **c. 1970** / Watercolor on paper / 17 × 4 × 4″ / Collection of Deborah and Robert Cummins

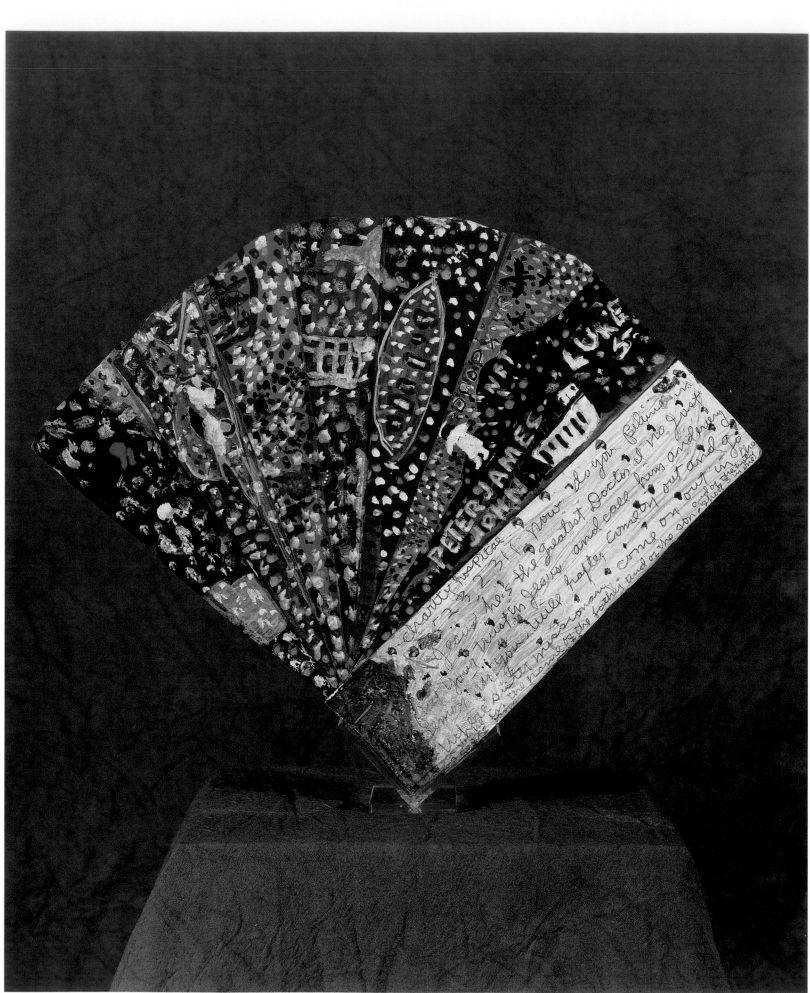

CHARITY HOSPITAL 523,2311 / **c. 1970** / Acrylic and ink on cardboard / 13 × 16" / Collection of Alvina and Paul Haverkamp

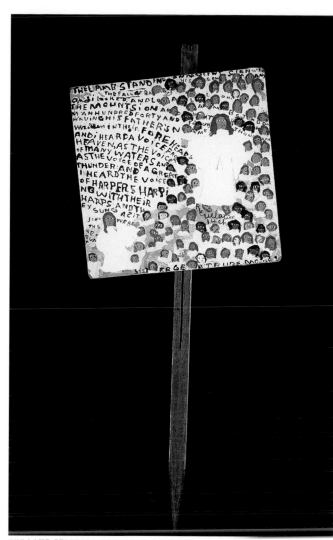

THE LAMB STANDING ON MT. ZION WITH HIS COMPANY / **n.d.** / Pencil and acrylic on Masonite / 23 ¾ x 23 ¾" / Collection of Sandra Jaffe

Artists, located at 726 Saint Peter, to show her artwork and perform her music. When Preservation Hall, a venue for traditional jazz, opened in that space in 1961, Borenstein moved the art gallery next door and continued to show and promote Sister Morgan and her talents. The odd association between this unlikely pair lasted for nearly twenty years and served them both well. With his cunning ways and dogged promotion, Borenstein made the work of Sister Morgan well known throughout the country. He sold her work and provided a venue for her to perform. He also looked after her welfare and attended to her simple needs.

Sister Morgan is remembered today as one of America's cherished self-taught artists. The simplicity and directness of her artwork convey a powerful message. The small, muted-color crayon drawings on cardboard made in the late 1950s mainly illustrate straightforward narratives as described in the Bible. Her work flowered during the sixties and early seventies, becoming charac-

terized by larger, more complex compositions in a mixture of acrylics, ink, watercolor, and poster paint. It was during this period, in 1966, that she began to make pictures representing her concept of the New Jerusalem as recounted in the Book of Revelation. These bright, multicolored paintings, which were to become one of the signatures of her oeuvre, depict what appears to be a modern twelve-story apartment building with the exterior wall eliminated to reveal rooms populated with people and furniture. Often, bands of angels in white robes fly through the sky overhead. Sister Morgan illustrated this last book of the Scriptures in many forms, and it became the focal point of her teachings and her artistic output. In a few extremely ambitious and complex works, which she referred to as "charters," each chapter of the entire book is illustrated. Another repeated theme from this period portrays Sister Morgan dressed in white and flanked by a white-skinned "dada Jesus" and "dada God," her spiritual husbands. While there are other occasional works with autobiographical references, the main thrust of her art was based on religious teachings. This emphasis is apparent in the way that Sister Morgan's biblical transcriptions—both printed and in script—become an integral part of her compositions.

In her late work of the middle and late 1970s, the brushwork became loose and imprecise. Two years before she died, Sister Morgan received yet another command from the Lord: she was instructed to stop painting and making graven images. Perhaps these occurrences—the change in her painterly style and the message from her Heavenly Father—were also related to and precipitated by her failing eyesight.

Anyone who ever met and knew Sister Gertrude Morgan will assert that she radiated a powerful presence that some found intimidating. Her gravelly, alto voice and her stocky figure commanded attention, and her insistent message was unavoidable, yet infectious. Just as she proclaimed, "Jesus is my airplane," Sister Gertrude Morgan, through her teachings and her art, has enriched the world and taken it to a higher level.

CHRIST COMING IN HIS GLORY / *1965–1970* / Crayon and acrylic on hard board / 6 × 9 ¼" / Collection of Sandra Jaffe

Mingin
GLORY.

NELLIE MAE
ROWE
(1900–1982)
BORN FAYETTEVILLE, GEORGIA
WORKED VININGS, GEORGIA

BY JOHN L. MOORE

Nellie Mae Rowe produced an extraordinary body of work that demonstrated her ability to create in both two and three dimensions. Rowe's doll sculptures, installations of found objects, altered photographs, and drawings were of people, birds, dogs, pigs, or strange combinations of animal and human forms. The vocabulary of images in these bold and sophisticated works came from her memories, dreams, and everyday experiences, as well as from her imagination. In Rowe's early drawings, done on scraps of common ledger paper and cardboard, one can see the rich source materials for her later, larger works.

Rowe had an unusual gift in her ability to conjure up things—images that escape the normal eye. Her works connected her two worlds—the real and the imagined—causing us to see and to question our own sense of reality. Some of the so-called imagined imagery derives from African American folklore familiar to older southern blacks. Even I remember bits and pieces of strange stories told to me in the 1950s by elderly folks from

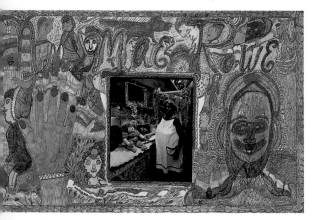

THE DAY PEOPLE VOTED AT THE VOTING POLL / 1978 / Felt-tip pen, pencil, and hand-colored photograph / 20 × 30" / Collection of Lucinda W. Bunnen

Georgia. An older relative once told me how, coming from church one Sunday, she witnessed a man jump from the back of a wagon, turn into a dog, and run into a cemetery. *Something That Ain't Been Born Yet*, an early drawing of Rowe's from around 1940 or 1950, reminded me uncannily of that story when I first saw it in a private collection in New York.

Drawing came naturally to Rowe, who was born July 4, 1900. She drew from the time she was a young child until she married for the first time in 1916. She did not resume her artistic endeavors until after her second husband, Henry Rowe, died in 1948. Repetitive rhythmic patterning and color give a rich, textured flavor to Rowe's drawings, and she had the ability to make outlined forms of

unmodulated color convey weight and presence. Her drawing style and compositional arrangements embodied the very essence of life, energy, and the unknown.

In Rowe's drawings, creatures exist within creatures. Fantastic birds sing and strut, fat dogs have wings and project human presences, and people's heads float in space. Whether drawn from everyday experiences or out of her head, these works are rich in their suggestive narratives. Interesting surprises often lurk in what appear to be straightforward drawings. For example, the seated woman in *Yellow Boots* takes on a birdlike presence from the elaborately patterned garment fanning out like tail feathers between her legs. Against a backdrop similar to those found in early photographic studios, the woman sits alone in a landscape, with a suitcaselike shape at her right side, causing the viewer to wonder whom she awaits or where she might be traveling. *Yellow Boots* also reveals Rowe to be an imaginative and highly sophisticated colorist. The drawing is framed by an incomplete blue border and the yellow of the boots is repeated around the collar of the garment and in the hands of the figure, which is executed in alternating areas of red and orange.

Rowe's doll sculptures and the people in her drawings are of various colors. Sometimes they represent individuals of a specific race; at other times the color of the figure may be just a design choice. In *Untitled (Two Figures and Animal)* there are two seated figures. One is yellow and wearing an elaborate dress; the other, dark brown, appears to be dressed in a red bodysuit from the neck down. They hold hands as if one is providing comfort to the other. The yellow figure appears to represent the artist. The two figures are connected to the floating bust of a male figure by a spiraling form extending from the head of the figure dressed in red. The intense pink and red field between the figures is further complicated and mystified by a birdlike image. Rowe seems to have developed an imaginative freedom similar to that of Russian artist Marc Chagall, with his predilection for the irrational and the transcendental. His paintings, like Rowe's, are full of mysterious forces: people float

and animals are anthropomorphised. *Nellie on Blue,* an image of Rowe herself, is one of a number of black-and-white photographs Rowe transformed with color. She colored her dress and the interior of the room the same blue. A small window in the room has red curtains, and there is a strange totem-like structure crowned by a stuffed toy rabbit. All of the images seem to emerge out of a decaying space.

Rowe was fascinated by images of people from popular culture, and she often depicted wrestlers or other sports figures, entertainers like Ray Charles or Elvis, or just hip-looking people. *Untitled (Figure with Dark Glasses)* is a drawing of what seems to be a hippie sporting a mustache and wearing dark glasses. This figure, which could be either male or female, is connected at its nose to a fantastic, human-headed animal. A leg extends from the animal's head, and inside it is another human figure. A beautifully rhythmic space of light blue and white is created where the tail of the animal and the chest of the hippie overlap. In this drawing, Rowe demonstrates a range of creative patterning, from the draped and curving body of the animal to the elaborate hair of the human. In *Untitled (Woman and Plaid Background)*, a standing female figure, presented from the waist up, is set against a red-and-white striped, chevron-patterned background. This pattern is then overlaid with pencil lines running in another direction. The figure is dressed in a green-and-white, vertical-striped sleeveless top. Where other works can look mysterious and even sinister, this has a cartoonish quality to it. The figure, with one hand placed on her hip, could be a comic play on a woman waiting impatiently for someone to show up. In contrast, *Untitled (Girl on Orange Chair)* depicts a woman at ease, seated, slightly turned away from the viewer, positioned as if to have her portrait drawn or her picture taken.

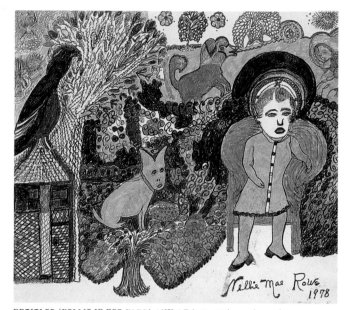

UNTITLED (NELLIE IN HER YARD) / 1978 / Felt-tip marker and pencil on Foamcore / 17 ½ × 20" / Museum of American Folk Art, New York / Gift of Judith Alexander / 1997.5.1

Many self-taught artists claim their work to be in the service of a greater power. Rowe had a strong belief and faith in her Lord. Some of her drawings deal with the illnesses and disabilities of people around her. She would draw suffering souls and ask the Lord to help them. For Rowe, drawing was not just depictive; it was transformative and supernatural. Things constantly change into other things, and "haints" (strange, ghostlike, haunting images) are often in evidence. What the artist seems to suggest is that she had been given a gift: to create objects that would reveal mysterious and strange forces in the world. Ultimately, however, it is Rowe who appears at the very core of her work. She once said, "When I'm gone they can see a print of my hand. I love that, to see a print of my hand. I'll be gone to rest, but they can look back and say, 'That is Nellie Mae's hand.'" Although Rowe was speaking about drawings she made of her hands, this statement can be applied to all of the wonderful and vibrant works she left behind.

UNTITLED (TWO FIGURES AND ANIMAL) / c. 1979–1980 / Crayon, marker, and oil pastel on paper / 15 ¼ × 11 ⅛" / Museum of American Folk Art, New York / Gift of Judith Alexander / 1997.1.16

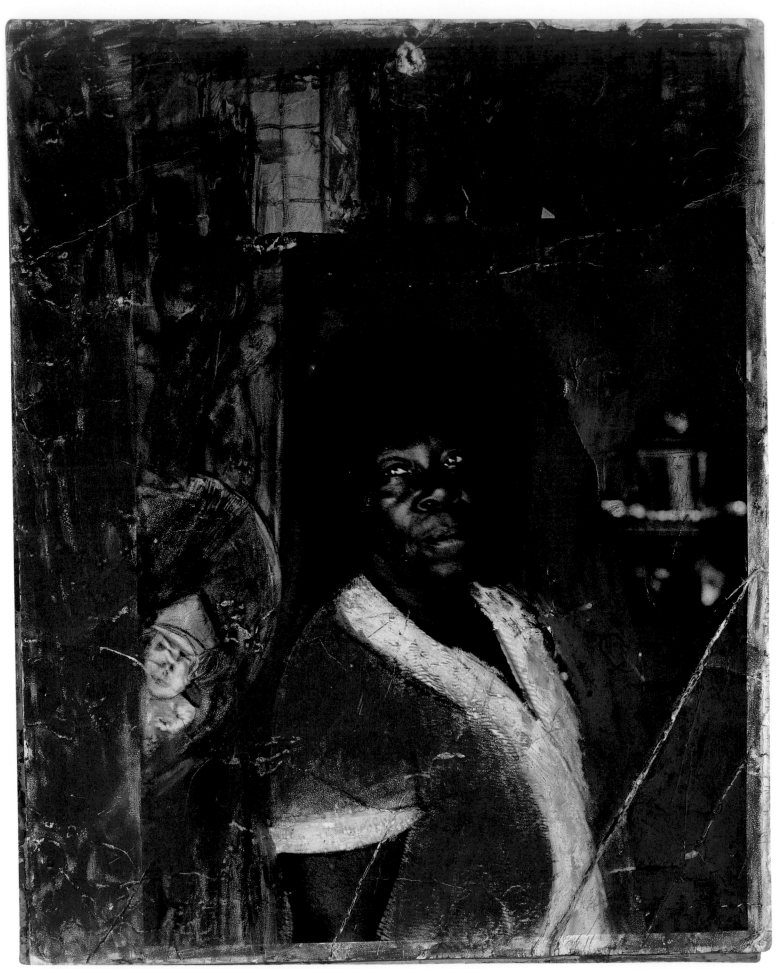

NELLIE ON BLUE / n.d. / Paint on photograph and paper; mounted on cardboard / 10 × 8" / Private collection, New York

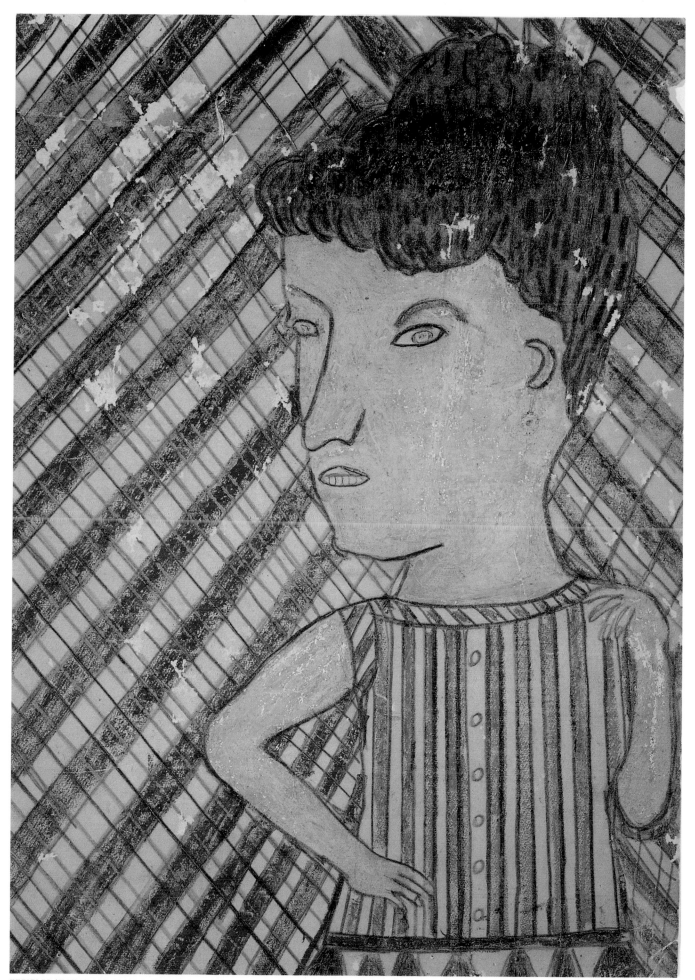

UNTITLED (WOMAN AND PLAID BACKGROUND) / **1950s** / Pencil and crayon on vinyl wallcovering display card / 15 ¼ × 10 ¾" / Museum of American Folk Art, New York / Gift of Judith Alexander / 1997.1.3

STEVE
ASHBY
(1904–1980)
BORN AND WORKED DELAPLANE, VIRGINIA

BY MASON KLEIN

Steve Ashby received little formal education, never traveled, and was unable to read or write. His lack of a driver's license further limited him to the area around his hometown of Delaplane, Virginia. There, except for a brief stint as a hotel waiter, he lived his entire life within walking distance of the country store, working on the affluent gentlemen's farms that still conceal the backwater culture of Fauquier County. A longtime worker on the same farm where his father had been a freed slave, Ashby was virtually indentured to the land himself. He and his wife, Eliza, who worked as a domestic at an exclusive girls' boarding school, lived in a converted one-room schoolhouse that had been abandoned by the state of Virginia.

Although, according to his sister Dora Ashby Butler, he had made small carvings throughout his life, it was only after the death of his wife in 1960 and his retirement shortly thereafter that Ashby started to create what he called his "fixing-ups." Initially, these works consisted of small plywood figures, cut out first by hand and later with an electric saw, that he embellished with model airplane paint, often attaching photographs (mostly faces), various found articles such as hair, clothes, his wife's or neighbors' jewelry, and even nuts from his hickory trees, which became breasts on his female figures. He was soon converting tree trunks and branches into similarly enlivened, near life-size figures and groups, which, in the summertime, he placed outdoors, dangling them from the trees around his house. The narrative possibilities of animation clearly fascinated and, perhaps most important, entertained him. He thus began to experiment with kinetic sculpture, which he animated either

UNTITLED / n.d. / Latex and oil house paint on wood with fabric, fur, straw hat, metal rod, wire, nuts, tin, and nails / 12 ½ × 22 ¾ × 23" / Collection of Robert A. Roth

with propellerlike blades activated by the wind or with whirligigs (traditional folk toys). Many of these sculptures re-create various sexual acts when activated.

Often Ashby's characters are the people with whom he was most familiar—washerwomen, seamstresses, fishermen, bicyclists. Some ideas, he claimed, were derived from dreams; others clearly were gleaned from fashion and girlie magazines. Female figures predominate, spruced up in the latest popular fashion and costume jewelry, stylishly posed or seated, wearing striped hats, colorful shoes, and print or sheer dresses. What distinguishes even these subjects, altering their otherwise prosaic quality, is their uncanny presence and personality. These works, despite their seeming anonymity, were, for Ashby, more than just sculptural realizations—they became real companions.

It was as if the retired widower had realized that, by making his "fixing-ups," he could revive more than a remnant of wood or a stray branch destined for his stove. By piecing together these assemblages, he could relate parts of his life, memories of people, fantasies that, in one way or another, had grown distant. He could return to both the world he had known, the drama and pageantry of the horse races at Upperville, and the one he had only glimpsed and imagined from the pinups and sundry luxuries in *Playboy*.

While generally unconcerned with craftsmanship and even less so with an idealized notion of beauty, Ashby was visually most successful with his individual figures, which often subtly hint at abstraction. Despite their almost cartoonlike innocence, sexuality pervades many of these figures as well. They are either partially exposed (*Untitled*

[crouching woman with left foot raised]), involved in some private activity (*Untitled* [woman with red hat, green skirt and urinating apparatus]), or engaged in explicit sexual activity (*Untitled* [pink kneeling woman with head of rocking man]). Yet Ashby does not rely solely on such overt techniques in order to achieve a degree of empathy, humor, or eroticism in his characters. Although *Untitled* [pale woman and sheer dress] depicts a partially exposed woman, other works, like *Untitled* [pink faced boy with blue cap and plaid pants] or *Untitled* [woman with striped hat and green buttoned coat], are no less vulnerably rendered, each conveying a self-conscious awkwardness (perhaps reflecting Ashby's own sense of self). It is often the very crudeness of his figures and mechanical groupings that enhances their playful charm and contributes to their compelling mixture of toylike simplicity and unrepressed physicality. In true bricolage tradition, the absence of refinement is part of Ashby's exploitation of the inherent character and given limitations of his "found" materials.

The unabashed detail of much of his work alludes to another, less apparent level of sophistication and meaning: the artist's hilarious, unsettling view of the liberalization of sexual behavior. Ashby was an African American man born in Virginia in 1904 and subjected to the Victorian mentality of southern society. As such, the burgeoning of sexuality and rapidly changing social mores that mark the economic boom of the post–World War II era must have seemed like an extraordinary decimation of the mannered world around him. His panoply of characters and sexual scenarios, from *Untitled* [Mickey Mouse sodomy whirligig] to *Untitled* [woman and mule], thus reflects not just the kaleidoscopically dysfunctional view of society provided by just about any small-town magazine rack, but also the absurdly voracious way commerce and sexuality interact. *Untitled* [cunnilingus urinating woman axe murderer whirligig] clearly alludes to the popular thirst for such sensationalism, while also parodying the oppressive morality and respectability of the middle class.

Beyond their extreme humor or entertainment value, Ashby's erotic scenarios—which on one level seem to glorify carnal knowledge—must be considered in relation to the hypocrisy of American puritanism. This, along with the almost fetishistic, object-oriented reclamation of social debris that constitutes Ashby's sculpture, reminds us of the extent to which the importance of sex only increases in direct proportion to the degree to which it is profaned. Through the benign exhibitionism or erotic shenanigans of his characters, he gives a profound twist to the advertising and fashion industries' commercialism of desire. For Ashby, the fetching and idealized fashion model/sex symbol assumes her real, mostly unspoken status as sexualized commodity. In *Untitled* [woman in sardine can], for example, he democratizes consumerism, differentiating little between the selling of sex and the advertising of food.

Having lived his life within limits, Ashby was finally able to break through and transcend the predictable expectations, the beliefs and ways of his environment. His passionate yet unsentimental re-creation of what he had long observed suggests the compulsiveness of someone trying to satisfy a long-suppressed urge. This late rush of creativity may simply have been kindled by the isolation of a widower who had never lived even a moment of his life alone. More likely, it was the realization that his gift of observation, which had previously sustained his comfortable status on the periphery of the world, could also change that reality.

UNTITLED / **n.d.** / Fabric, lace, metal, thumbtacks, wire, human hair, and acorn with magazine photo collage on carved wood / 8 × 6 ½ × 5 ½" / Collection of Robert A. Roth

UNTITLED / n.d. / Latex and oil house paint, dolls' eyes, fabric, and feathers on carved wood; plastic pill container as matchholder on reverse / 11 1/2 × 8 3/16 × 3 3/4″ / Collection of Robert A. Roth

EDDIE
ARNING
(CARL WILHELM EDWARD ARNING)
(1898–1993)
BORN GERMANIA, TEXAS
WORKED AUSTIN, TEXAS

BY NAN BRESS

Born on January 3, 1898, Eddie Arning lived and worked throughout his youth on his family's farm in a German-immigrant agricultural community near Kenney, Texas. Arning's peaceful life changed dramatically when he was in his twenties and symptoms of mental illness manifested themselves. Bouts of severe depression and alleged violent outbursts led to a diagnosis of schizophrenia,[136] and Arning was eventually committed for a year to the Austin State Hospital. After his release, his symptoms gradually resurfaced, however, and he returned to the hospital in 1934. There he remained for thirty years.

Around 1964, the symptoms of mental illness abated and Arning was transferred from the state hospital to a nursing home. Shortly before his furlough, Arning, by then in his late sixties, began to draw. Helen Mayfield, an art teacher at the Austin State Hospital, had provided Arning with coloring books and crayons. He became immersed in the activity and quickly completed a half-dozen books. Noticing his imaginative use of color and the rich patterns created by his crayon strokes, Mayfield offered Arning blank paper and suggested that he create his own pictures. Arning soon began devoting entire days to this creative endeavor. Over the course of the next decade, he used wax crayons and oil pastels to produce nearly 2,000 drawings.

Arning's initial experience with coloring books clearly contributed to the graphic, two-dimensional quality of his art. On occasion,

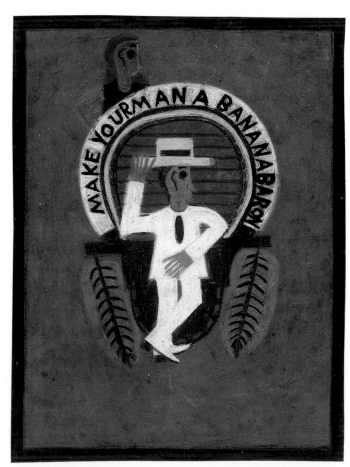

his pictorial simplifications approach the realm of abstraction, as exemplified by the exhibition drawings *Untitled (Flagless Ship)*, *Untitled (Baseball Diamond)*, and *Untitled (Colored Balls)*. Each work, however, retains a respectful connection to its figurative source, thereby highlighting Arning's desire (or need) to ground his drawings within a concrete world.

As Arning broadened his approach, he began to draw from an increasingly diverse spectrum of popular imagery, including photographs, advertisements, illustrations, and reproductions of works of art. Arning culled this material from magazines circulating at the nursing home—a somewhat eclectic selection ranging from *Good Housekeeping* and *McCall's* to *Field & Stream* and *Psychology Today*. A number of folk art historians have sought to discover the precise sources of Arning's work,[137] and this research has uncovered, for example, that *Untitled (Man Sitting on Post)* was inspired by a large photograph from *Life* magazine that accompanied a story about an ex-convict. Likewise, the "Cabana Banana Giveaway" advertisement in *McCall's* magazine was the source for Arning's *Banana Baron*.

In addition to identifying the sources of Arning's work, it is equally important to consider how Arning experienced and responded to popular culture. First, we must recall Arning's essential isolation from the outside world for more than thirty years. This isolation is perhaps directly reflected in the recurrence of certain kinds

BANANA BARON / 1970 / Oil pastel on paper / 25 ⅝ × 19 ¾" / National Museum of American Art, Smithsonian Institution / Gift of Mr. and Mrs. Alexander Sackton / 1987.51.10

of subject matter. For example, a number of works, including *Untitled (Man Sitting on Post)* and even *Untitled (Child in Cradle)*, feature a single male figure located within a seemingly vast background. Furthermore, Arning's perceptions of the "real world" were largely shaped by and filtered through magazines, which in themselves presented the world at a distance— Arning did not draw the man sitting on a post from memory or firsthand experience, but rather from a photograph in a popular magazine of a man thus seated.

Arning's distance from contemporary culture also separated him from the content or "meaning" of his source

UNTITLED (CHILD IN CRADLE) / **c. 1965** / Crayon on paper / 15 × 23" / Courtesy Fleisher/Ollman Gallery, Philadelphia

imagery. That he drew upon such a diverse range of subjects, from religious scenes to land-, sea-, and skyscapes to cigarette advertisements, suggests an undifferentiated or unhierarchical approach to content. For example, Arning's *Banana Baron* evinces little concern for the dapper figure as a hawker of bananas or any commodity, but rather a keen awareness and interest in the image's form—the whiteness of the Baron's suit as it imbricates the rich background and the figure's angularity and how it stands out against the circular slogan above him.

Such an approach

UNTITLED (NATIVITY) / **n.d.** / Crayon and oil pastel on paper / 21 ½ × 31 ½" / Collection of Edward V. Blanchard and M. Anne Hill

can be compared with that of many pop artists, who during this period also drew upon the everyday imagery of modern life. In contrast to Arning's physical and perhaps psychic distance from contemporary culture, artists such as Andy Warhol and Jasper Johns were immersed in contemporary culture and in turn used their central position to comment upon commodity culture and its promotion. By means of an anonymous, deadpan mode of representation, these pop artists "distanced" themselves from their subjects even as they coexisted with them. By contrast, Arning, who essentially existed outside of commodity culture, closed the gap between subject and artist by making each of his borrowed sources very much his own. His characteristic use of bold colors, his attention to geometric patterning, and his repetition of forms become almost a signature of a particular creator with a personal, idiosyncratic style.

The lovingly worked surfaces of his drawings suggest an individual, craftsman-like approach. Every inch of paper is covered with vigorous markings, which are often several layers deep. Arning would often rub the surfaces of the finished drawings to produce a polished texture. Also like the careful craftsman, Arning completed many of his drawings with a hand-drawn representation of a frame along the outer borders of the paper, as in *Untitled (Child in Cradle)* or *Untitled (Yellow Man with Cross)*. This effort to "complete" the works interestingly echoes Warhol's desire to have his Factory-made works understood as "finished products." But unlike Warhol's soup cans or Brillo boxes, which equate art-making with commerce and commodity, Arning's drawings, with their evocation of craft, allude to a time prior to modern mass-production when goods were carefully hand-finished by artisans.

It would be incorrect, however, to oppose absolutely Arning's almost nostalgic pictures with Warhol's modernist savvy. Arning's inclusion of a hand-drawn frame, for example, suggests that he desired his works to be understood as art objects. Similarly, he occasionally signed his drawings with the phrase "Artis [sic] work by E.A. Arning." That

Arning copied at least one image from an issue of *Art News*, a *Madonna with Child*, reveals that he did have a certain "insider" awareness of both art-making and the artworld.[138] Letters to his bene-factor Alexander Sackton also suggest that Arning had a conception of himself as an artist, but one who approached the practice with pride and crafts-manship: "I am still doing fine," he wrote to Sackton in February of 1969, "bussy [sic] at work

ence that perhaps rejected the direction that mod-ern art took into pop art or minimalism in favor of a slightly different, slightly more personal universe.

This universe came to a close in 1974; when Arning left his nursing home to live with his sister, he also stopped drawing. Three years later, he moved back into a nursing home, where he remained for the rest of his life. After a brief ill-ness, Eddie Arning died at the age of ninety-five

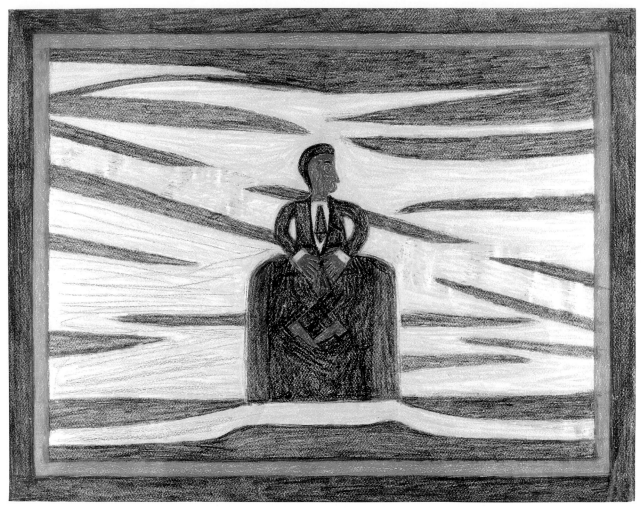

UNTITLED (MAN SITTING ON POST) / 1968 / Crayon and oil pastel on paper / 22 × 28" / The Anthony Petullo Collection of Self-Taught & Outsider Art

like I always did. I have draw a lot of pictures. I hope that you will like them. I been usend [sic] those wax Crayola. I think that the picture look real nice. . . ."[139]

Sackton, Mayfield, and other benefactors provided Arning with artist's supplies and arranged for the exhibitions of his drawings. The enthusias-tic reception that greeted his work and the finan-cial benefits that resulted enabled the artist to move to a better nursing home facility. Certainly, the collectors who sought out Arning's work may have simply appreciated their manifold charms, but in particular his drawings have attracted an audi-

in McGregor, Texas. Today, his drawings are in the permanent collections of such museums as the Abby Aldrich Rockefeller Folk Art Center, Williamsburg, Virginia; the Museum of American Folk Art, New York; and the National Museum of American Art, Smithsonian Institution, Washington, D.C.

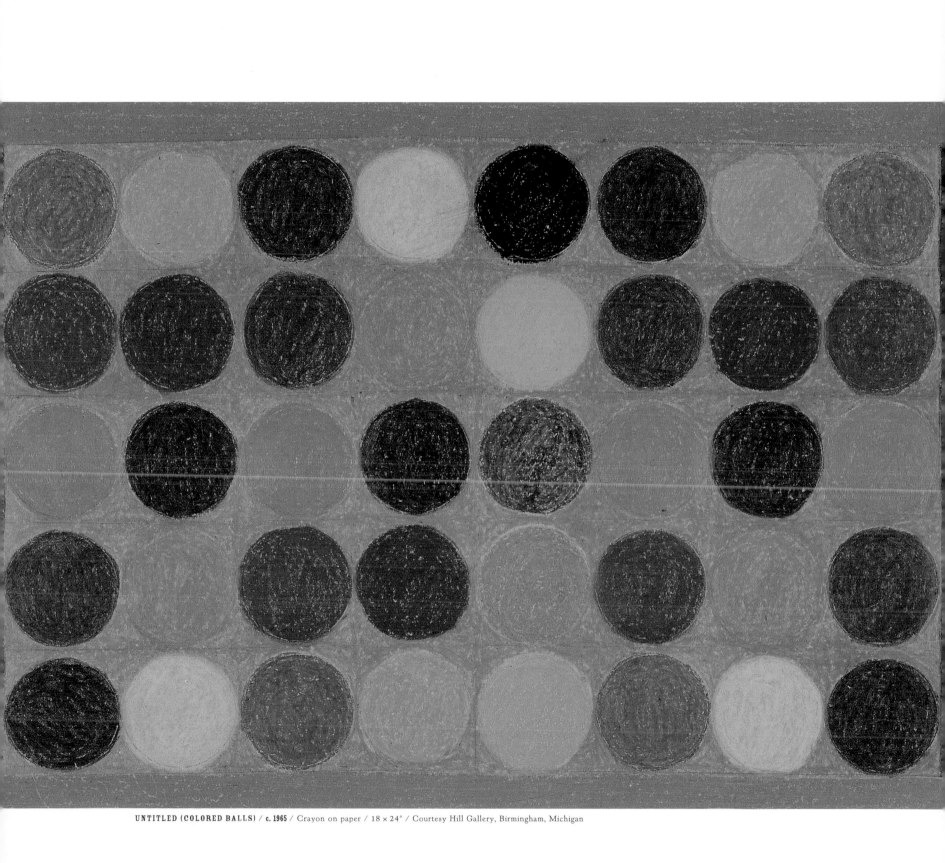

UNTITLED (COLORED BALLS) / **c. 1965** / Crayon on paper / 18 × 24" / Courtesy Hill Gallery, Birmingham, Michigan

EMERY
BLAGDON
(1907–1986)
BORN CALLAWAY, NEBRASKA
WORKED GARFIELD TABLE, NEBRASKA

BY KENNETH J. GERGEN

One of the most significant aspects of "grassroots" or outsider art is its invitation to denizens of "the inside" to expand the perimeters of dialogue. Grassroots artists are typically cut away from the dominant discourse of the arts; their argots are often unheeded and demeaned. Thus, the invitation to expansion is not always welcome: there is great comfort in closed circles. At the same time, because the dominant discourse is now globalized—buttressed and sustained by economic interests—it also tends toward homogenization, repetition, and derivation. The center moves slowly toward enervation and ennui. Marginal voices are essential, then, to aesthetic vitality. The queer and the parochial interact to form the necessary impediments to the impetuous impulse toward the single word.

In its rugged delicacy and crude complexity, the work of Emery Blagdon confronts us with the possibility of expanding the conversation. While the work does resonate at times with early constructivism, and elements of the structural and the

abstract are abundantly evidenced—along with glimpses of the conceptual and the "found"—Blagdon was ignorant of these rarefied concepts and their instantiations. His work must be confronted—and ultimately appreciated—as "other."

Blagdon was a native of rural Nebraska. Raised on a farm, the oldest of six children, he attended school only through the eighth grade. Thus, until he was eighteen years old, the farm was the chief site of his education; after that, it was the road. Blagdon roamed the country as a hobo, hitching rides on freight trains, working at odd jobs, traveling for some ten years. It was only when his bachelor uncle died and left him a substantial farm estate that he returned to the Garfield Table near the Sand Hills of central Nebraska. At forty-eight years of age, leasing his land for income, he began painting and building sculptures for the first time. These activities were his exclusive occupation for his remaining thirty years.

Did Blagdon himself believe that these were contributions to art? There is little to suggest so.

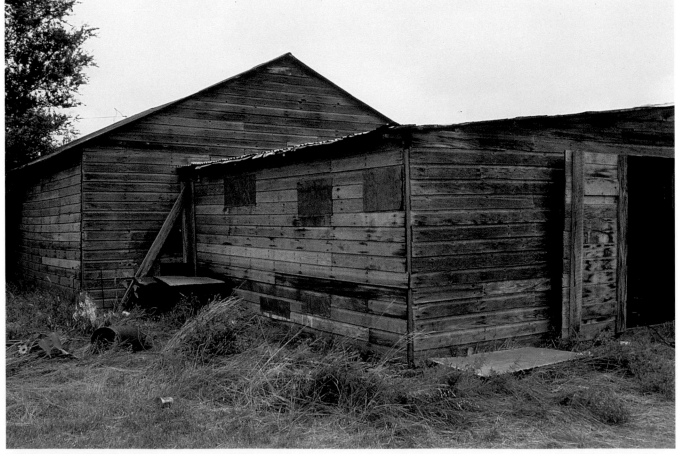

ORIGINAL SHED, EXTERIOR / **1956–1984** / Metal, wood, and aluminum foil environmental installation / 8' × 12' × 12' (front structure) / 12' 3" × 26' × 20' (rear structure) / Collection of Dan Dryden, Don Christensen, Trace Rosel, and Eleanor Sandresky

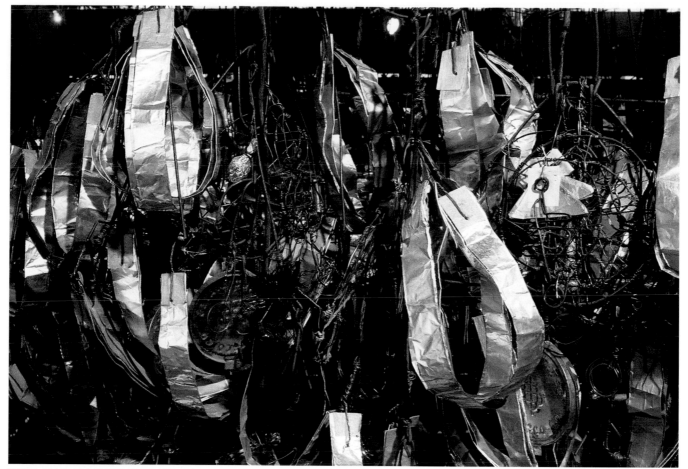

DETAIL OF LARGE HANGING PIECE / 1956–1984 / Wire and foil / Collection of Dan Dryden, Don Christensen, Trace Rosel, and Eleanor Sandresky

Rather, according to Dan Dryden—the local pharmacist who had many conversations with the artist and later became the curator of his works, Blagdon was constructing "healing machines." The fantastical assemblages—more than 600 in number and composed of wire, aluminum, wood, ribbon, beads, plastic, and other materials—were functioning components of the machine. Nor were the paintings freestanding expressions: they also formed elements within the machine design. For Blagdon, each element contained electrical activity, holding static charges that generated a complex aura or electromagnetic field. Indeed, Blagdon gave treatments to the locals, many of whom celebrated their effects.

When placed together, these various assemblages formed a colossal machine, which Blagdon displayed in an 800-square-foot shed, stringing the entire installation with Christmas lights. In an account of an early visit to Blagdon's farm, Dryden described the scene thus: "When I entered his shed/studio, my vision was in shock. Lights danced on the thousands of bits of foil and wire and ribbon. It was as if the universe had come into the dark little shed and all the stars were contained in the great mass." Discussing how the machines cured illnesses, Blagdon added, "A scientist could explain this; I can't. I just know that it works."[140]

With this sentiment, Blagdon articulates the cultural unconscious, the unsteady but unstinting prehension of technological potency. From the small wonders of the telephone, radio, automobile, television, and jet transportation to the grand spectacles of the Hoover Dam, the Golden Gate Bridge, the Empire State Building—and finally the humbling horror of the atomic bomb—technology has served as a profound stimulus to the cultural imaginary. Modern art has surely resonated with the hegemony of the technological. In its emphasis on the abstract, the conceptual, the constructed, and the elemental, one might even say that the dominant aesthetic of modern art has been an expression of the technological imagination. Artists have been variously moved by this imaginary—we find expressions of dismay and even horror at the proliferation of the technological (Umberto Boccioni, Edward Hopper), an appreciation of the sparing beauty of its forms (Marcel Duchamp, Lyonel Feininger, Wassily Kandinsky), and its potential for irony

(Jasper Johns, Jenny Holzer) and even mirth (Robert Delaunay, Nam June Paik). However, Blagdon's healing machines seem to speak in a different voice.

In the nineteenth century, the sense of the sublime—that unabated and unspeakable awe of those forces beyond the grasp of reason—was largely derived from encounters with nature: the Alps, Niagara Falls, the Grand Canyon. However, as science historian David Nye proposes, in twentieth-century America, technology has gradually replaced nature as the source of the sublime.[141] In one register, the sublime is deeply disturbing: it suggests lethal power beyond human control, the sublime of atomic fission. In a contrasting register, the sublime betokens a primordial power of good, possibly the revelation of a spiritual fundament. In my view, this is the inspiration that gives birth to the healing machines. Blagdon unearths for us the roots of science in alchemy, and resensitizes us to the possibility that science is a revelation of the Divine Will. By reckoning with Blagdon's healing machines as contributions to contemporary aesthetics, we add significant dimension to the dialogue. With a fresh, elemental zeal and an enduring adoration for the incomprehensible power unleashed by the human reconstruction of matter, Blagdon brings forth mystery from the merely mechanical and restores the relationship between science and myth. As we appropriate these assemblages into our contemporary dialogue, conceptual and aesthetic horizons are expanded and we are significantly enriched.

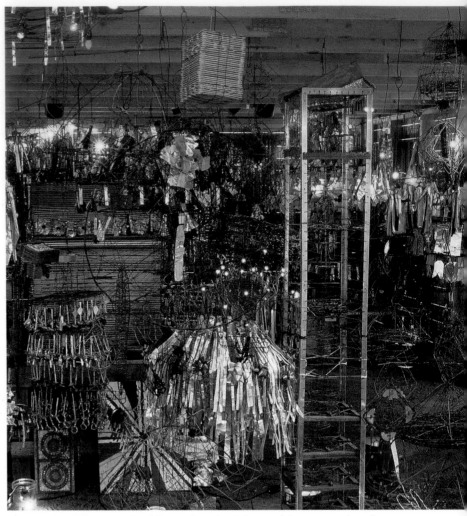

LYON BIENNALE INSTALLATION / 1997 / Metal, wood, and aluminum foil environmental installation / 12' 3" × 26' × 20' / Collection of Dan Dryden, Don Christensen, Trace Rosel, and Eleanor Sandresky

UNTITLED / 1956–1984 / Oil enamel on wood / 8 ¼ × 11 ¾ × 1" / Collection of Dan Dryden, Don Christensen, Trace Rosel, and Eleanor Sandresky

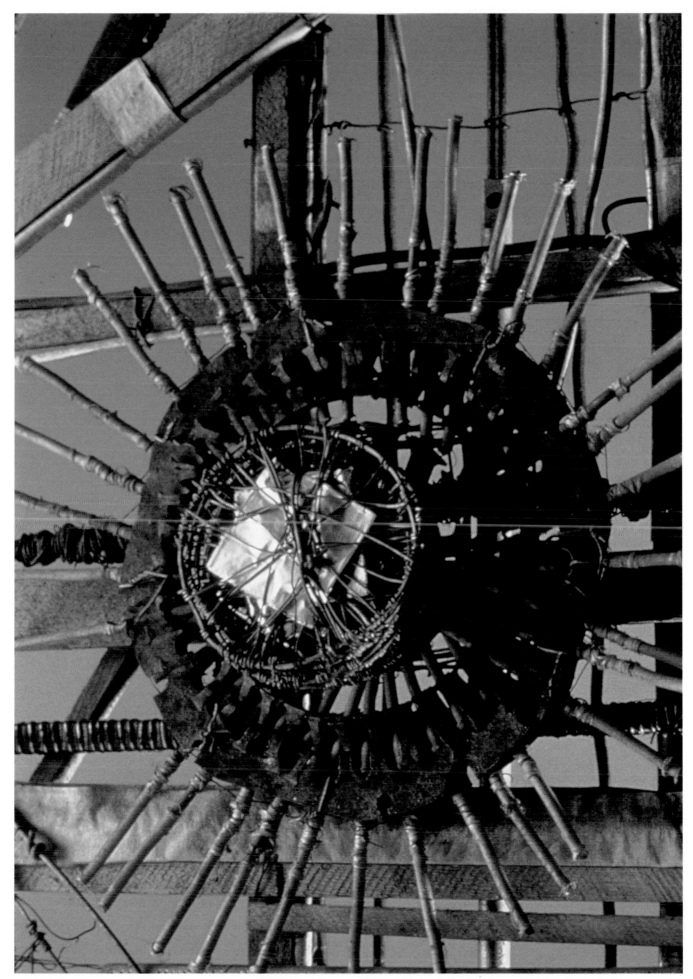

DETAIL OF WALL PIECE / **1956–1984** / Wood and metal / Collection of Dan Dryden, Don Christensen, Trace Rosel, and Eleanor Sandresky

LEROY
PERSON
(1907–1985)
BORN AND WORKED OCCHINEECHEE NECK, NORTH CAROLINA

BY JAY TOBLER

Leroy Person's first work of art was the transformation of his house in eastern North Carolina. Working in the distinctive chip-carving style he would later develop for his art, Person fashioned his home with decorated window frames, doors, and lintels. The environment extended to the street as he lined his property with a fence of carved tree limbs. These efforts went unappreciated by his family, however, and when his wife went away to visit family in Boston, he dismantled his work and disposed of it.

While this initial artwork survives only through hearsay, it hints at the transforming vision that defines Person's output. From his furniture to his smaller sculptural tableaux, his work is marked by the remarkable need and ability to transform the commonplace. With modest homemade tools, Person reworked cast-off blocks and broken furniture into highly stylized dioramas and the improvised chairs he called thrones. His iconography was drawn from the world close at hand—trees, flowers, his tools, and above all, birds and animals. Like his raw materials, each of these humble sources was recast by Person's prodigious imagination.

Person lived his entire life in Occhineechee Neck, a small, rural community located on the edge of a swamp, surrounded by pine trees and tobacco farms. He was severely asthmatic and retired early from his job at a nearby sawmill. At home, with time on his hands and the desire to work, he began to carve.

Soon after Person had destroyed the works on and around his home, a visiting neighbor, Ozette Bell, spied a bag of wooden blocks that were to be used as kindling for the family's wood stove. Bell, who recognized Person's talent, encouraged him to carve these pieces of wood, suggesting that they could be used as teaching tools for the blind. From these, Person developed the intimate arrangements of people and animals for which he is known.

Person had two distinct, though inter-related, sculptural styles. Every inch of his two-dimensional work is covered with robustly incised designs that typically incorporate floral motifs with heavily abstracted letters and icons. Person's relief carving originated with the renovation of his house and was later featured in his wall plaques, his picture frames, and the flat surfaces of his furniture.

Person's three-dimensional sculpture is similarly well worked, with deeply carved crenulated surfaces. These carvings differ from his utilitarian objects in that they are explicitly representational and fulfill a more traditional role as art. These works are usually quite modest in scale and depict figures and animals in a geometric, highly stylized fashion. Occasionally, these two styles come together in pieces of furniture like *Untitled (Table)* (1975–1980), which includes a large tableau at its base.

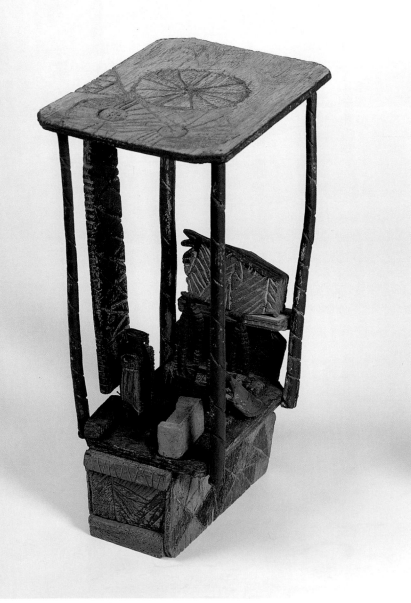

UNTITLED (TABLE) / 1975–1980 / Wax crayon, spray paint, aluminum, and nails on wood / 27 × 19 × 12″ /
The Robert Lynch Collection of The Daisy Thorpe Gallery at North Carolina Wesleyan College

As a way of further transforming the cast-off material from which he worked, Person developed a unique method of coloring the surfaces of his art. He took dime-store crayons and, rubbing forcefully, buffed the wood with the colored wax. With the exception of a few early works, such as *Untitled (African Throne)*, Person's reliefs and sculpture have a hard crayon sheen, the color nearly melted into the wood.

He was gifted with a good color sense, and his palette ranges from muted, natural tones (such as the autumnal shades in *Table*) to clashing, high-contrast color schemes. Interestingly, Person's wife was a quilter who was adept in several traditional African American styles. While it is impossible to pinpoint the influences passed between husband and wife, it is clear to the knowledgeable eye that Person's reliefs frequently resemble quilt compositions and color patterns.

Much of the artist's subject matter was drawn from the natural world around his home. As Ozette Bell explained, Person lived his entire life in the country. His house was surrounded by woods, and he could sit on his porch and carve while admiring the trees and wildlife at hand. Pine trees, lilies, snakes, roosters, hens, and crayfish are all frequent motifs.

Leroy Person loved to carve birds, especially the peacock. Here his inspiration came from an unlikely source—the 1970s NBC peacock with its rainbow plumage. Collector Robert Lynch, Person's major patron, noted the influence of television, particularly cartoons, on his sculpture. Looking at his art, it seems logical that Person was attracted to animation, with its brilliant colors and exaggerated forms.

Person also included in his reliefs outlines of his tools, including his wrench and, less often, a round, saw-toothed blade. As curator and author Roger Manley notes in *Signs and Wonders*, North Carolina is still a largely rural state, and the industries of lumber, furniture, and textiles play a large role in local economies. The prominence of these industrial icons in Person's work reflects the significance of the timber business in his life and community. As Manley suggests, the prevalence of skilled manual labor can encourage sculptors like Person through a familiarity with tools and techniques as well as a pragmatic do-it-yourselfism.

Stylized letters also appear in Person's work, where they are often melded into overall compositions so that they are barely discernible. "He could write a little bit," as Ozette Bell says, and it is sometimes possible to locate his initials or words (one plaque reads "PINETREES") buried within weblike designs. Person's writing has the appearance of hieroglyphs and is another example of the degree to which he visually reinterpreted the world through his art.

As much as it is the product of a singular imagination, Person's art is also the articulation of a bold vernacular African American aesthetic. Its subject matter, palette, and carving style can all be related to traditional African ideological and artistic concerns. Monitoring the flow of culture is tricky business (though the quilts created by Person's wife present a possible African cultural connection). If Person was indeed the inheritor of a cultural legacy, it was a legacy absorbed by virtue of his remarkable sensitivity to the world immediately around him—its inhabitants, its shapes and colors, and even its values as reflected through religion and work. His art is the sharing of these observations as transformed by his vision.

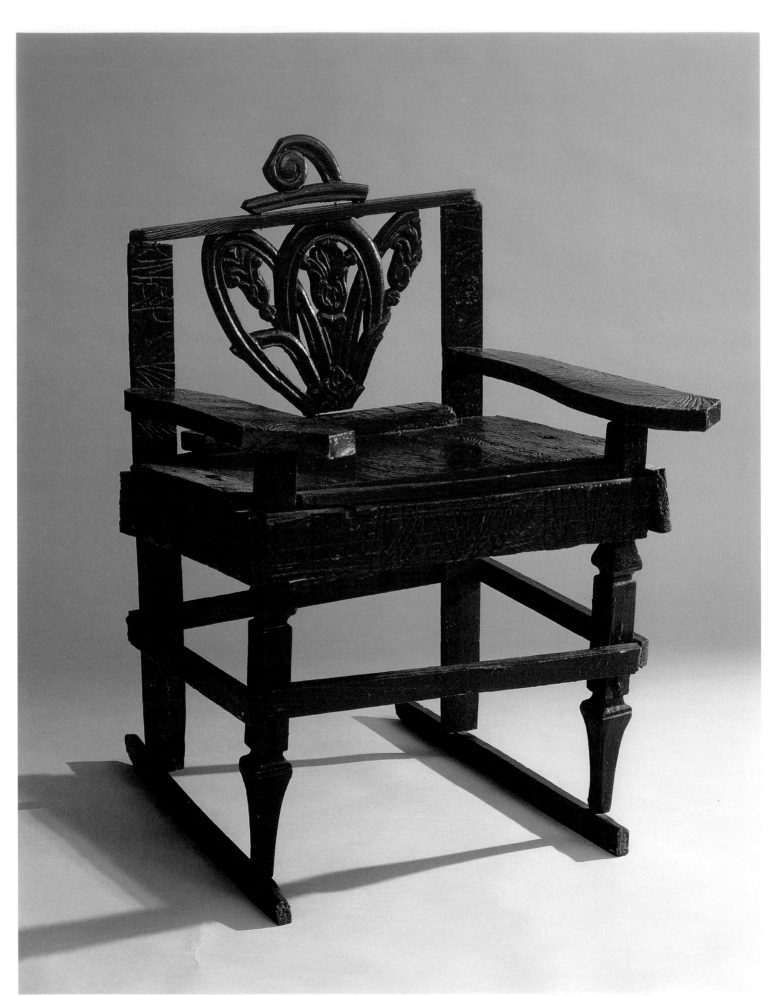

UNTITLED (ARMCHAIR) / **1979** / Enamel on wood / 39 × 26 × 28″ / Collection of Frank Maresca

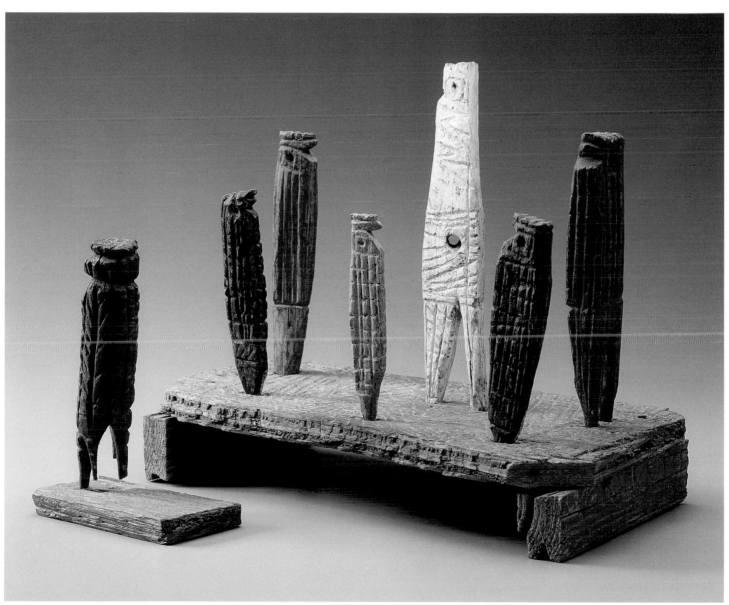

UNTITLED (HEN AND CHICKS WITH ROOSTER) / **1970–1985** / Paint and crayon on wood / hen and chicks: 13 × 15 3/8 × 8 1/2" / rooster: 5 13/16 × 7 5/8 × 2 11/16" / Museum of American Folk Art, New York / Gift of Roger Cardinal in memory of Timothy Grutzius / 1995.14.1

WILLIAM A. BLAYNEY

(WILLIAM ALVIN BLAYNEY)
(1917–1985)
BORN CLAYSVILLE, PENNSYLVANIA
WORKED PITTSBURGH, AND THOMAS, OKLAHOMA

BY MARSHALL CURRY

In a letter to the curator who organized William Blayney's first museum show, the artist expressed hope that the exhibition would expose his religious paintings to a wide audience, since "that is one way that the Gospel can be shown unto people." A Pentecostal evangelist with a roadside ministry, Blayney had been using the works for decades to illustrate the sermons that he preached from his trailer, and he believed that even on the walls of a museum, they would retain their apostolic power. Viewed secularly, the crowded paintings are curious and compelling. But the works' real power and meaning lie in the fact that they are religious paintings—urgent, complex, and passionate like the religion they celebrate and interpret.

Since Blayney used the paintings to teach the Gospel (many have holes in the corners where he hung them up with clothesline while he preached), it was important to him that they be accurate visual representations of the Scriptures. He peppered the works with biblical quotations and chapter-and-verse citations indicating the sources of particular images, and when a beast is described in the Book of Revelation as having seven heads and ten horns, he is careful to paint it with precisely that number. In a tape-recorded explanation of one piece, he describes the pains he took to get Satan exactly right, giving the Dark One characteristics of both a dragon and a snake, since he was referred to as both in the Scripture. In another piece, a diptych, *The Sealed Book of the Revelation of Jesus Christ*, which depicts the apocalyptic visions described in the Book of Revelation, Blayney's meticulous literalism yields a nice detail: his painting includes John, the author of the book, as a small figure, witnessing the scene from above, where he floats with the help of an angel.

But Blayney did not limit himself simply to illustrating Scripture; he also used his work to interpret it. The paintings *Babylon* and *Anti-Christ and Reign of the Gentile Kingdoms* depict the dream of King Nebuchadnezzar from the Book of Daniel. In the king's dream, a giant statue with a gold head, silver chest, bronze thighs, iron legs, and clay feet appears and is then smashed to pieces by a boulder. Daniel explains to Nebuchadnezzar that the different parts of the statue represent the future succession of earthly kingdoms that, in the end, will all be destroyed by an omnipotent boulder—the Kingdom of God. Blayney takes Daniel's interpretation one step further, however, viewing the Old Testament story through the lens of Christianity. He labels the boulder that hurtles through the sky: "The Rock of Christ." He also labels the statue's body parts with the names of historical empires that—as prophesied—followed Nebuchadnezzar's reign: Persia, Rome, etc. In doing so, Blayney implies that religious prophesy and historical fact are not as incompatible as people might think.

This is an idea often expressed in Blayney's paintings. His works focus on the fantastical side of religion—on mystical visions, miracles, and monsters—but then struggle to integrate that fantastical side into contemporary life. *Babylon* includes a timeline that marks events ranging from Titus' destruction of the Temple in Jerusalem to the discovery of America to World War II. By placing recent events into a continuum with biblical history, Blayney seeks to erase the distinction between the sacred world and our own.

He makes a similar effort in two paintings that combine images of science and religion. In the first, *The Sealed Book of the Revelation of Jesus Christ*, Blayney depicts a view of heaven, with each of the planets in our solar system stretching out below (Earth, with its moon, and Saturn, of course, adorned with rings). The second, an untitled work, shows a cross section of the earth with its crust, mantle, and core labeled. A note explains that the inner core is composed of "highly radioactive molten minerals" and then cites Revelation 19:20: "... the lake of fire and brimstone." By mixing modern science with biblical imagery, Blayney again stresses the relevance of the Scriptures to modern life.

Even works that contain no biblical imagery are often framed with a scriptural citation. A 1969 sketch, for example, entitled *What Can I Do for My Country*, depicts an eagle holding a scale in its

DIPTYCH: ANTI-CHRIST AND REIGN OF THE GENTILE KINGDOMS (RECTO) / c. 1960 / Oil on board / 47 × 67½" / Collection of David T. Owsley

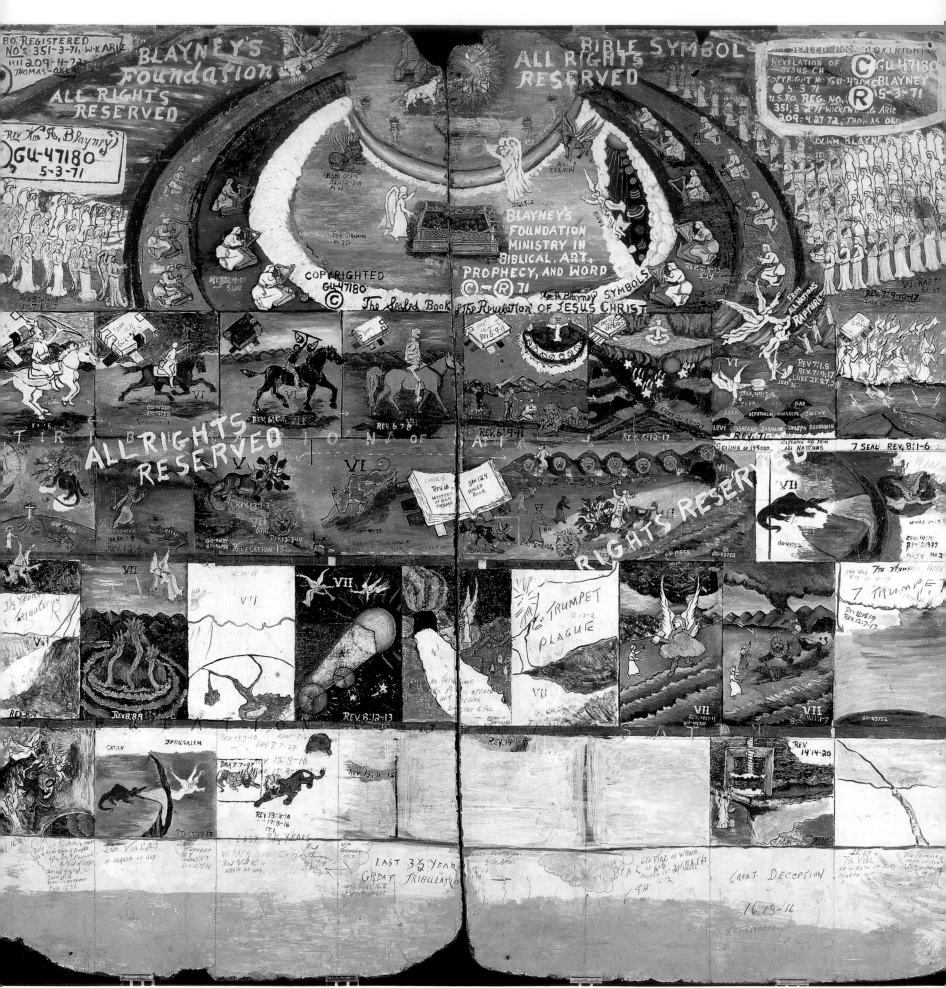

DIPTYCH: THE SEALED BOOK OF THE REVELATION OF JESUS CHRIST (VERSO) / c. 1960 / Oil on board / 47 × 67 ½" / Collection of David T. Owsley

beak. On one side is "greed, lust, sins, segregation, dope, and war"; on the other, "elections, free speech, peace, freedom for the individual, and the press." To this otherwise secular drawing Blayney adds, "Revelation 6:12–17." The verses describe the end of the world: "There was a great earthquake . . . the sun turned black . . . the whole moon turned blood red and the stars in the sky fell to earth. . . . The sky receded like a scroll rolling up and every mountain was removed from its place. . . ." With this quote from Scripture, Blayney seems to be urging us to hurry up and deal with our social ills. Get your houses in order, he is saying; take the side of righteousness. Because the day of reckoning—when divine justice will be meted out—is coming soon.

Possibly Blayney's most explicit visual synthesis of the biblical and modern worlds is *Revelation of the United States of America*, which is also one of his more disturbing paintings. Here the apocalyptic Book of Revelation is reimagined with a combination of biblical and twentieth-century details: a trooper stands above the bloody bodies of a woman and child that he has shot, a man brandishes a decapitated head at a priest, a greedy figure clutches a necklace, and others kneel before a many-headed beast.

What is surprising about this work is that the beast—even as it spits bolts of lightning—appears much less diabolical than the humans who surround it. One might expect otherworldly, biblical embodiments of evil to be frightening, but in this and other works, Blayney painted them with a caricatured whimsy. It is his human contemporaries—the sinful people who live next door or appear on the local news—whom he depicts with harsh, unforgiving brutality.

Perhaps the reason for this is that even Blayney had trouble erasing the boundary between the biblical world of prophesy and monsters and the contemporary world of science and politics. Perhaps, as steeped as he was in religious passion, he was a human being first, and his earthly fears were more urgent and more acute than anything found in the Book of Revelation. Satanic beasts might be terrible, but, in most of us, they do not arouse as deep or as visceral a terror as does a policeman who guns down families.

It is Blayney's earthly concerns that may explain the copyright symbols and exclamations of "all rights reserved" that are emblazoned across many of his paintings in huge red and white letters. The fact that he covered his works with such prominent legalese, even though it distracts from the paintings' subjects, indicates that—at least sometimes—spreading the Good News was secondary to protecting himself against plagiarists. An Islamic saying is apt: "Trust in Allah, but tie your horse." Perhaps Blayney, whose unshakable faith assured him that he would be saved by God in the final apocalyptic battle, was not so sure about the day-to-day battles here on Earth. In those, he would have to defend himself.

Blayney, a self-confident evangelist and a vulnerable human being, knew the tension that exists between the realm of the sacred and that of the mundane, and with his paintings, he attempted to mitigate that tension and bring the two realms together. What results is a potent body of work—colorful expressions of fervor and fear, explorations of sacred mystery, and urgent calls to repentance and salvation.

HOWARD
FINSTER
(b. 1916)
BORN VALLEY HEAD, ALABAMA
WORKED PENNVILLE, GEORGIA
WORKS SUMMERVILLE, GEORGIA

BY NORMAN J. GIRARDOT

People won't give me time to die . . . [so] I'm a speedin' up now 'cause the world needs it now. My hands are shakin' but not wore out 'cause I'm startin' to shed old skin like a lizard or snake gettin' ready for new skin. I lost 'bout a gallon of skin like dan'ruff. It shed like fish scales and I've got 'bout three-fourths of new skin.
—Howard Finster, interview with Norman J. Girardot, Summerville, Georgia, 1992

Howard Finster is still painting up a storm at the age of eighty-one. As he closes in on some 45,000 painted objects, the demand for this remarkable preacher-painter-shaman's work continues to grow—although it is sometimes said that the work has deteriorated with his increasing notoriety and financial success. But Finster is not terribly concerned about what the Atlanta and New York dealers think about the big-city marketability of his recent work. That was never the point—his art was always intended as messages available to everyone. These were, moreover, urgent missives from God that were first biblically channeled through Finster's sermons as a Baptist preacher and then, since his visionary transmutation as an artist in the mid-1970s, through his crafty hands, mottled paint, and pop pantheon of Jesus, Santy Claus, and Elvis. Although the medium and audience have changed, the message has always been pretty much the same: "come see the spirit that is within even the despised of the earth and repent, the end is near," a theme that is not just a preoccupation of evangelical Christians during these end-of-the-millennium days. This semiotic agenda is organically rooted in Scripture and in the natural scriptures of the earth—that is, in Finster's worn King James Bible, in undefined nature, and in American popular culture (see, respectively, *Sights Appear on My Mountains, Sighns of the Times*; *History of Plant Farm Museum*; *Green Gourd*; and *The Model of Super Power Plaint [Folk Art Made from Old T.V. Parts]*). Though tedious for the "cultured despisers" who have closed their eyes and ears to the strangeness of the familiar, Finster's message is endlessly reiterated by myriad visual, discursive, and now Xeroxed signs of the times. For Finster, titanic quantity counts as much as, or more than, aesthetic quality. Continuous (and sometimes heavy-handed) repetition is, after all, the key to good preaching and effective advertising.

Throughout all of the makeshift variety, visual fecundity, and stupendous numbers of Finster's artistic production, the message has stayed essentially the same—allowing, of course, for some interesting evolution in inventive technique, choice of medium, and visual content. Yet at the same time (both *in* time and *during* this end-time), everything has changed: the world, Finster himself, his spirit, his Paradise Garden, his family, his art, and his audience. His gloriously motley works sell for thousands of dollars each, and major chunks of his protean Garden have been hauled off and permanently deposited in individual collections (*Coin Man*, for instance) and in Atlanta's High Museum of Art. Like the Coca-Cola and Nike commercialization of the recent Olympic Games in Atlanta, there has been a progressive routinization and commodification of Finster's awesome charisma. It's now 1-800-FINSTER!

HISTORY OF PLANT FARM MUSEUM / **1982** / Enamel on plywood / 55 × 46½" / Collection of Robert M. Greenberg

Inevitably, after the first fresh blush of visionary creation and the establishment of a paradise on Earth, there comes a serpent, an 800 number, and the Fall: old age and decay, physical infirmity and spiritual depletion, individual vacillation and family jealousies, creative weariness and artistic repetition, consumptive financial considerations, and the carping forgetfulness of a public lusting after the new and different. While all visitors must now pay admission (except on Sunday), decay and death freely enter the Garden on prancing feet. So in the twilight of his life, Finster's once tireless preacher's voice quivers with phlegm and his gnarled hands tremble with age and arthritis. "Laundrymat pens" have replaced his beloved brushes for doing the "detail work" on his precut and primed stock of plywood Elvises, Coca-Cola bottles, cheetahs, and angels. Despite his self-proclaimed ability to regenerate his own

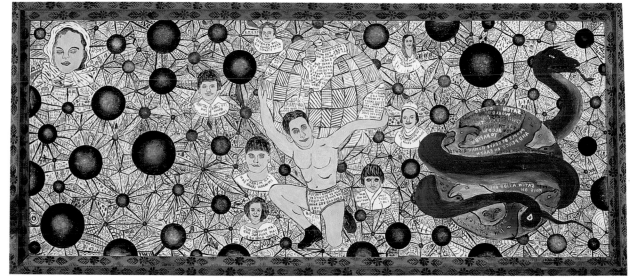

THE WEIGHT OF THE WORLD / 1982 / Enamel on wood / 20 ¼ x 48" / Collection of Robert M. Greenberg

skin like a lizard or snake, the plain fact of life is that all things run down, even the seemingly perpetual motion machine of Howard Finster's soul, heart, and hand. The heart is willing; the spirit and hand have weakened.

Living now in the "executive section" of Summerville, Georgia, a few miles away from the concrete and biblical debris of his Paradise Garden, Finster is looking forward to his own death during these last dim days. Along with his new "vibratin' bed" and sixty-inch television, he has installed his own "anticipatin' coffin" in a special painted shed amidst the gaudy-junky splendors of the decomposing Garden—right over from the columned temple of the giant thirteen-foot Coke bottle (although the bottle itself has been sold to the highest bidder), directly behind the lopsided UFO wedding-cake building known as the World's Folk Art Church, and just a short distance from his old studio (now an outlet store for the never-ending deluge of painted folk art bric-a-brac, all available for purchase by cash, check, or credit card). Facing the specter of old age and the demons of wealth,

celebrity, family intrigue, and death, Finster waits and paints for the end to come. He does not, however, play the banjo or harmonica as much as before. Life goes on, money comes in, but the harmonious joy of spontaneous song is heard less frequently these days. There are shadows and sadness within the Garden.

Finster's coffin is no ordinary coffin. A gift from a visitor to the garden, the coffin, like just about everything else that comes within the purview of Finster's manic vision, has been transformed and signified. Indeed, it's a wonderful exemplification of Finster's ongoing gift for rough-and-ready installation art. The coffin is inscribed with various biblical parables and his own funky-folksy sayings, and its interior has been fitted with a full-length mirror upon which there is a small painted casket that reportedly awaits a portion of Finster's "criminated" ashes (the balance of his ashes are to be sprinkled like fertilizer throughout the Garden).[142] The mirror is a reminder of mortality both for Finster (who doesn't need much reminding these days) and for all those curious, jaded, and paying pilgrims who come to see God's Last Red Light within his decaying Arcadia. All the better "to see 'yourself' with," says this Stranger From Another World.

But what is it that we see? Certainly not ourselves, since that would be too frightening. We generally miss what is right in front of our eyes. Typically we prefer to see what we want and hope to see. In confrontation with a raw shamanistic force like Finster, whose person and art, if not his fundamentalist Christian idiom, threaten to

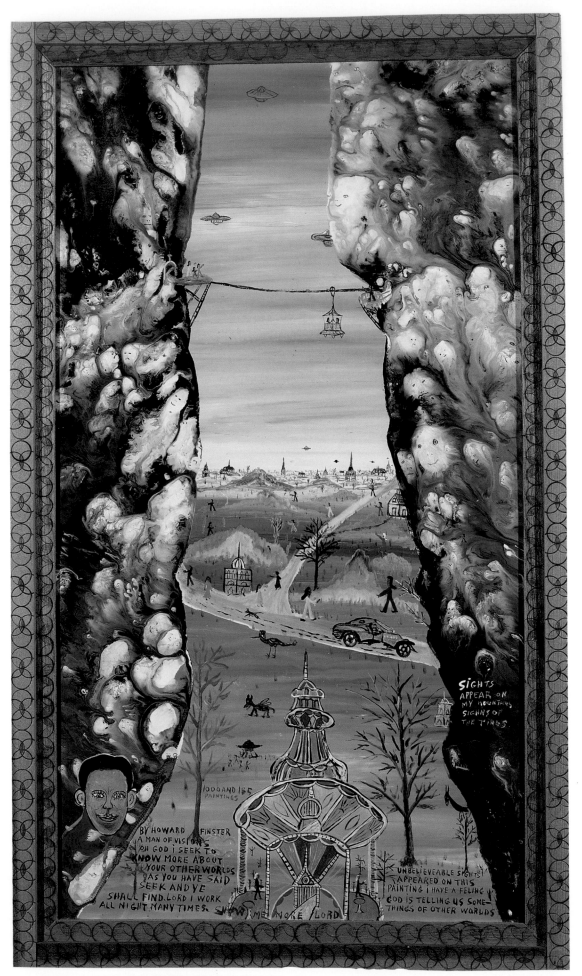

SIGHTS APPEAR ON MY MOUNTAINS, SIGHNS OF THE TIMES / 1978 / Enamel on Masonite or plywood / 26 ½ × 16 ¾" /
Collection of Didi and David Barrett

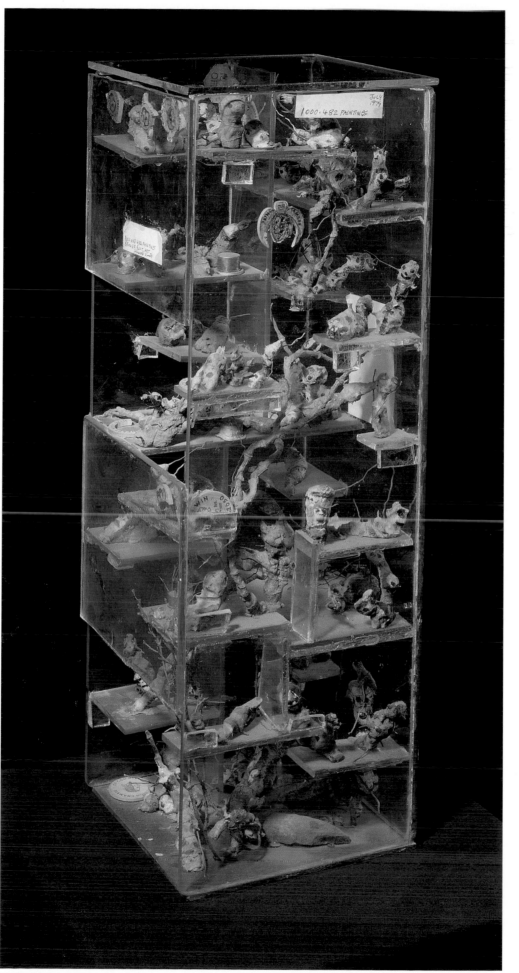

BROWER ROOT HOTEL / **1978** / Glass, enamel paint, brower roots, and wooden coins / 25 × 8 × 9″ / Courtesy Fleisher/Ollman Gallery, Philadelphia

mirror our own innermost secrets, we look not to the present but to the past, to an idealized time of the beginnings before the Fall—before Finster became more like ourselves. In terms that the late great scholar of comparative religions, Mircea Eliade, would have appreciated, we are slaves to our own childlike (if not childish) nostalgia, our emotional longing for a "raw vision" or paradise that is at the generative core of art and religion. It is in this sense that the Finster works selected for "Self-Taught Artists of the 20th Century: An American Anthology" take on special significance. They dramatically reveal the composition of the Finster universe at the time of creation—the primordial time before there were thousands of too-cute cutout cheetahs and angels. These works of the beginning-time powerfully reveal his crafty persona as a backwoods bricoleur (consider, for example, the handiwork seen in his inlaid wooden tower [*In My Father's House*], carved clocks, and stained frames, and the gloriously resourceful and imaginative play on material at hand in *Brower Root Hotel*). At the same time, they also display his ability to create whole new imaginary worlds of haunting cosmogonic form and meaning (as suggested by the atomic or planetary structure seen in *The Weight of the World*). These macrocosmic artistic worlds are, moreover, directly and solipsistically expressive of Finster's innermost microcosmic soliloquies—something seen most egotistically in his Christ-complex identifications in works like *They Used My Cross to Crucify* and *The Weight of the World*.

But we delude ourselves if we assume too quickly, in the spirit of the Egyptian god who created the world with a masturbatory spurt of inventiveness and then shriveled to insignificance, that Finster's creative energies were utterly exhausted in the late 1970s and early 1980s. Our difficulty has more to do with our own wavering span of attention and our inordinate fondness for first things than it does with Finster himself or with his latter-day art. It is, therefore, our own untutored nostalgia coupled with Finster's frantic singularity of intention that tends to deaden our confrontation with the totality of the Finster universe, especially his postlapsarian pictures, words, and cutouts. To look carefully at Finster's massive outpouring of artworks finally becomes too much of a bewildering and oppressive exercise. Too much gushes forth in every shape, idiom, medium, material, and style.

Too much cut-up and cutout stuff that says "been there, done that." And all of it seems to be permanently locked onto the same strange, and randomly scrambled, cable channel where the Psychic Friends Network, the O.J. Simpson trial, the Bible, Jerry Springer, Pat Robertson, and the World Wrestling Federation also dwell.

The challenge is to see that, no matter how exciting the early work and how clichéd some of the mass-produced later work has become, Finster still manifests an extraordinary ability to find striking new permutations of image, color, and form. The enduring meaning of Finster's work can be seen not only in the wild and free production of the creation-time, but in the overall passage from Alpha to Omega, even in the great void of betweenness so often populated by his chaotically grinning cutout critters. We dare not forget that there are some spectacularly odd examples of images that brilliantly transcend the repetitive cutout genre (the *Cow Woman* series, for example). All of this work from the beginning-time to the last days is full of messages where the medium itself is not always the meandering message. These are pictures, after all, worth a thousand words. Although, just to be sure and for good measure, Finster most often gives us ten thousand words along with the pictures. Scribbled pictures and painted words: both work together to represent and proclaim a message. Both work, as St. Ignatius Loyola, Jerry Della Femina, and Howard Finster know, by making spoken words and forgotten messages visible, or remembered, images. Visual imagination anchors aural memory and facilitates communication.

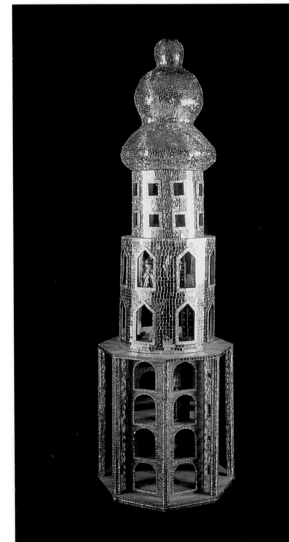

IN MY FATHER'S HOUSE / 1977–1979 / Mixed media / 78 x 24" diameter / Collection of John Wieland Homes, Atlanta

The problem with Finster at the end of his life and at the end of the millennium is that he has cast himself so powerfully as his own television set. And in an age of the remote control, it is all too easy to act instantly on our regressive nostalgia. Mesmerized by his original creative antics, we fail to see the cosmic programming that continues right before our eyes. The shows we see these days are most often reruns, it is true. But, then again, some of the programs still seem to come from Finster's own secret X-Files. Whether broadcast from this earth or from alien worlds, from microcosmic or macrocosmic soliloquies, it seems that there is only one very worn comedic plot. But this tale of redemptive suffering and laughing is, after all, the perpetual soap opera message of nature's Way, of God and the gods' revelation, and of all the world's mythologies.

Art, religion, and culture are the constant redecoration of the chaos of time and space around us. They are myth and ritual activities that craftily create meaning and color within the black-and-white telecast of mere chaos and static noise. The secret is this: there is within even the test pattern of chaos, and within the unspeakably jumbled beginning, middle, and end of Howard Finster's artistic universe, a hidden order of messages within messages, of impossibly intricate and luminously scrolled forms and words inscribed within all creatively painted images and imagined worlds. Even the randomly ragged coastlines of conventional meaning are the illuminated manuscripts of nature; even the roughly painted plywood panels of sequined movie stars are the pop icons of salvation. If only we can see the message and ourselves in the mirror—with a little help from Benoit Mandelbrot, Elvis Presley, and Howard Finster. The issue of the colored clutter and wadded words of Finster's art is not so much a matter of *horror vacui* but the man-ifestation of a bizarrely biblical fractal fraktur. It is a matter of seeing a marginal message even in the muddle of the middle and the end. It depends not on the once-and-for-all cosmetic filling of vacuous space at the creation-time, but upon recognizing and remembering the meaning—maddered marks, gauche glyphs, languid lines, colored curlicues, serpentine signs—within even the repetitious end-time chaos of scriptural worlds, organic shapes, and cultural forms.

Cloying words and cutout images dwell within the void. Jesus Christ and Howard Finster hang on a cross that traces the beginning and end of time. And in between the beginning and end there are liminal brower roots, colored gourds, spotted cheetahs, wooden towers, concrete gardens, plywood templates, and painted signboards. For Finster, all of this is a scrawled spiral vortex of images and words at the cosmic intersection of an iconic heaven and discursive Earth. All is the "butterfly effect" of resonant representation and meandering metaphor. In the beginning, the painted Word was writ large in white tractor enamel on God's extended finger. And the Word was made flesh with a brush and a "laundry-mat pen." And always there are revelatory tracings of animals, Elvis, and Jesus in the clouds. There's a divine telecast "ever'where." Worlds within worlds. Pictures and stories. Signs and sighs. Significations and soliloquies. A creative Order and a Blessed Chaos. A Holy Clutter and a Redemptive-One-Eight-Hundred-Snake. They're "ever'where": in the End as they were in the Beginning.

WILLIAM
L. HAWKINS

(WILLIAM LAWRENCE HAWKINS)
(1895–1990)
BORN UNION CITY, NEAR LEXINGTON, KENTUCKY
WORKED COLUMBUS, OHIO

BY MASON KLEIN

After beginning to paint seriously in the mid- to late 1970s, William Hawkins was awarded a prize at the 1982 Ohio State Fair Exhibition for his *Atlas Building*. Typical of his cityscape portraits of well-known architectural sites in Columbus, the painting also reveals much about its creator. With its impressive stack of rows of windows rising massively to fill the space so that the front corner of the top of the building overlaps the work's painted "frame," the building seems not so much cropped by its internal border as having broken forth beyond the very notion of limits. The painting is appropriately titled as well, for Hawkins was indeed a titan, who not only was eighty-seven years old at the time and in the midst of creating a protean body of work until his death eight years later, but had spent most of his life as a truck driver hauling building supplies and goods around the city.

Like many of the subjects he chose to paint—wild and mythical animals, the American Wild West, dinosaurs—Hawkins' life and late, intense creative flourish were characterized by a certain rough, energetic improvisation. As a child growing up in rural Kentucky, he copied photographs and illustrations of animals, mostly from calendars and horse-auction announcements that his grandfather had saved. He drew with "anything I could make a mark with," claiming even to have used laundry blueing. A forager of neighborhood trash heaps, Hawkins would throughout his life recycle junk and develop a skill for bricolage—an ability to use whatever was at hand. In order to add texture or to build up the surface of a painting, for example, he combined cornmeal and enamel house paints discarded by the local hardware store to produce a modeling paste, which he then applied to salvaged, often irregular scraps of interior wood paneling, plywood, or Masonite; often, before he actually began to paint repetitive decorative patterns around the borders of his paintings, he tacked on various odds and ends of wood molding to his frames.

Hawkins was raised by his maternal grandparents on their farm, and he attributed much of his self-reliance, optimism, and socialization to this experience. By the time he was a teenager, he had learned how to operate, maintain, and repair farm tools and equipment, fix buildings and fences, care for and breed livestock, and break horses. A skilled horse trainer, hunter, and trapper (who "got the highest prices in the county for his skins!"), Hawkins was, among his many different jobs later in life, engaged in house construction, demolition, plumbing, house painting, and automotive and

TIGER AND BEAR / **1989** / Enamel, paper, duct tape, and sand on board / 42 × 48" / High Museum of Art, Atlanta / T. Marshall Hahn Jr. Collection / 1997.84

COLLAGE WITH STEEPLES / **1988** / Enamel and collage on Masonite / 48 × 60" / Courtesy Ricco/Maresca Gallery, New York

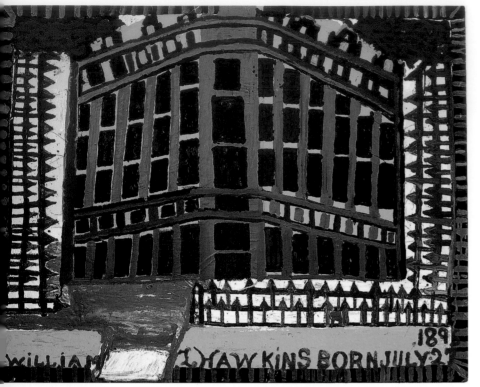

WILLARD HOTEL / **c. 1987** / Enamel on Masonite / 48 × 60" / Collection of Robert M. Greenberg

general repairs; at one time, he even managed a brothel. His sense of pride and independence, which he had achieved in his youth on the farm, always prevailed. It is celebrated in the dignity and spiritedness of his animal paintings, if not in the way he elevated the stature of local architecture to a level of monumental grandeur commensurate with its higher, civic purpose.

Similarly, Hawkins believed that his life had a purpose, and he reaffirmed this by inscribing his paintings, "WILLIAM L. HAWKINS. BORN KY. JULY 27, 1895." This was another way for him to remind the world of his special gifts, and of the importance of leaving one's mark. "I talk different from anybody else," he said, "I'm on this earth for something." And when his paintings really began to sell, he helped countless members of his community who, unlike himself, had difficulty overcoming social and economic difficulties. He wanted everyone, all the strugglers, to know that they could count on him.

This respect for the struggle to survive informs much of his work. It underlies, for example, the overt predatory action depicted in *Tiger and Bear*. A mixed-media work of extreme contrasts, *Tiger and Bear* underscores both sides of a conflict between the title animals: a hyperreal, action cartoonlike image of a tiger, which he collaged so that

it appears foreshortened, lunges out from the painting's pictorial depths with its claws splayed, conveying only deadly force; its victim, an anthropomorphized bear whose feeble, upheld paw seems almost to quiver, echoing its upright but defensively receding posture, anticipates its demise. Between the two adversaries, Hawkins has placed a photograph of a nesting bird, alertly presiding over its eggs, emphasizing the danger of complacency, and he even blended the grasses of the nest with the underbrush of the tiger's habitat. Rooted at the juncture of action, in the lower, central portion of the work, this scene of calm vigilance serves as a foil against the fickleness of nature, and as a fulcrum on which nature's dynamic balance rests— and shifts. This constant movement resonates in the sway of the palm trees that seem to bend in the wake of the tiger's advance; yet scaling these trees, fearlessly, are the minuscule, silhouetted figures of a man and a monkey.

African American and scarcely literate, with only a third-grade education and limited marketable skills when he first moved to Columbus in 1916, Hawkins clearly identified with his narrative of resourcefulness and courage. Whether he believed in the myth of the western hero or not, it was the American pioneer, the self-sufficient loner pitting his wits against nature, that captured his imagination. He saw himself as an amalgam of American heroism and diversity, claiming in fact to have black, Indian, and white ancestry. He was a man of enormous self-confidence, and as an artist he was no less competitive, even assuming an entrepreneurial attitude in terms of his artistic production and commercial progress. "I don't turn nothin' down," he once claimed. "*You* turn it down, I'll draw it. [If] you don't feel like you can fool with it, *I'll* take it and make something of it." And when Hawkins met Elijah Pierce and saw his sculpture, he questioned Pierce's choice of such a labored, slow medium, while boasting of his own ability to produce work quickly. Hawkins had little time to waste, which partly accounts for the practical appeal the process of collage held for him, and his increasing use of it: why paint something that was time-consuming, he figured, when it could be depicted almost instantly?

Hawkins' tendency in his earlier work was to depict the world within an overall decorative pattern, in which specific forms remained unshaded, unmodeled, and relatively flat. The col-

lage techniques of his later work, however, allow for more complex narratives, pictorial effects, and spatial recession. Both styles relate to the artist's overriding physical relationship to the world: the former as an outgrowth of his experience as a truck driver, negotiating road maps and the continuously unfolding, changing, and linear spatial relations inherent to such a job; the latter as bold, confrontational, and, in part, an elaboration of his passion for storytelling.

After being "discovered," Hawkins began to experiment. He enlarged the scale of his work, intensified his palette, attempted more abstract graphic design, and adopted new procedures of working, such as placing his panel flat on a table and pouring enamel directly from the can. His manner of visual paraphrase—deriving his work from popular imagery—likewise became more subtle, and more of a challenge, as he indulged in stylistic diversity, recycling found images into subjects of entirely new form, "so they [the viewers] see something new." Hawkins' audience was never ancillary to his work, and he constantly restated his goal—to please his "clients," believing that a painting that couldn't sell wasn't "worth a damn!"

Perhaps because he was a jack-of-all-trades, an all-purpose tradesman, Hawkins approached painting as just another job, as another opportunity to capably prove himself. What ultimately superseded his inventiveness or craftsmanship, however, what enabled him to humanize the city and soften its edges, and what defined him as artist, was his honest and ennobling vision. It permitted him to paraphrase religious works such as Nativity scenes or the Last Supper with an ecumenical lightheartedness and populism that allowed for the rediscovery of something new. In an age of overarching anxiety and conflicting emotions toward the city, Hawkins' optimism might seem anachronistic, no less outdated than his belief in the role and importance of nature in and to the city. His embrace of the city was less a refusal to decry the epidemic of urban decay than a conviction born of someone for whom urban riches could never suffice, of someone who longed also for the riches of nature.

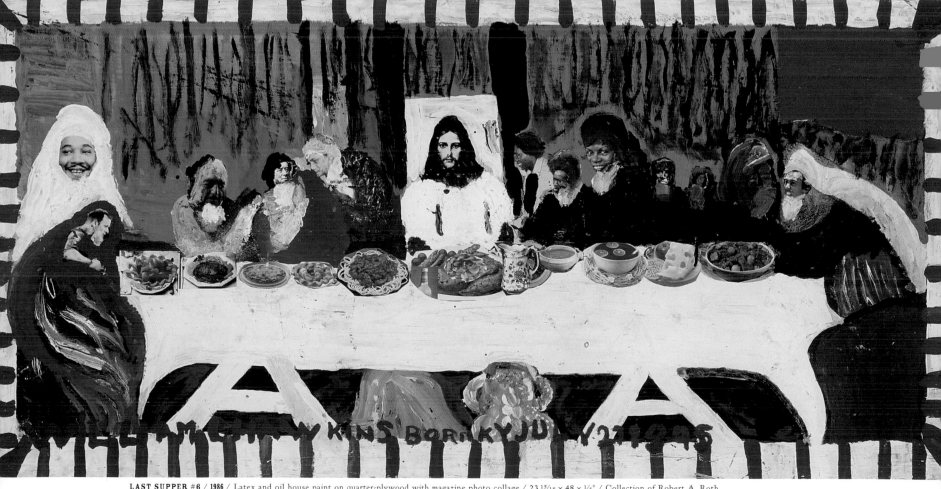

LAST SUPPER #6 / 1986 / Latex and oil house paint on quarter-plywood with magazine photo collage / 23 ¹⁵/₁₆ × 48 × ¼" / Collection of Robert A. Roth

THORNTON
DIAL SR.
(b. 1928)
BORN EMELLE, ALABAMA
WORKS BESSEMER, ALABAMA

BY ROBERT HOBBS

Since 1987 Thornton Dial's paintings and sculpture have challenged and transformed standard conceptions of folk art. In his work he confronts such issues as racism and civil rights, ecology, sexual politics, the homeless, natural disasters, the plight of veterans, industrialism and postindustrialism, the death of the American city, and unemployment. Dial's life in rural and urban Alabama was not very different from the common experience of blacks in the first half of the twentieth century who migrated from rural tenant farms to industrial areas. Instead of leaving the South for Chicago or Detroit as many did, Dial moved from the small town of Emelle, Alabama (near Livingston), on the western side of the state—an area of cotton plantations that is also dotted with fields of sweet potatoes and corn—to Bessemer, which is part of the highly industrialized area known as the Birmingham District.

Born on September 10, 1928, to a girl about thirteen years in age, Dial was never acknowledged by his father. When he was nine years old, he left school to work at such jobs as helping out at a local ice house or digging sweet potatoes. "I come up the hard life," Dial has recalled.[143] His memory of the difficulties sustained in his youth is corroborated by the nickname Patches, which described the unfortunate condition of his clothing. When Dial was ten, his mother, Mattie Bell, had the opportunity to marry, providing she agreed to give up Thornton and his half-brother Arthur. The two boys first lived with their great-grandmother Martha James Bell; after her death and their subsequent move to an aunt's home for approximately two years, they moved to Bessemer. Here they were brought up by their great-aunt Sarah Dial Lockett, to whom Dial remained devoted until her death in 1995.

Over the years, Dial has worked at a number of jobs, often holding two or three simultaneously, as well as planting big gardens and raising livestock. His main employment, with Pullman Standard, involved him in most of its departments, including punch and shear, where in the 1970s he assumed the critical role of running the center seals to the foundations of boxcars. He remained with the company for almost thirty-three years. Concurrently, he worked intermittently for approximately thirteen years at the Bessemer Water Works. During downtime at Pullman, he was forced to seek jobs painting and building houses, laying bricks, cementing sections of highways, relining tin, pouring iron, fishing commercially, and fitting pipes.

While moving about from job to job, Thornton Dial made things. He built his own house, remodeling and renovating it many times until it pleased him. In the course of rebuilding it, he invented a new style of bricks that he cast in the form of soda cans so that they could be set vertically and would fit conveniently into one another. He also made fishing lures, often using plastic wrap and wire to create intricate and innovative constructions. At one time, he created wooden crosses and cement urns for local cemeteries. In addition, the need to express his feelings resulted in series after series of welded-steel and mixed-media constructions using found objects, including roots and a variety of cast-off objects. Often, he decorated his yard with these objects, but at times, either because of a lack of encouragement from his neighbors or because of fears of reprisals from the white community if his implicit critiques of social wrongs were discerned, he buried or recycled his work. While he obviously valued these objects as symbolic ways to redress grievances and to give a tangible form to feelings that he had been programmed

CONTAMINATED DRIFTING BLUES / 1994 / Desiccated cat, driftwood, aluminum cans, glass bottle, found metal, canvas, enamel, spray paint, and industrial sealing compound on surplus plywood / 67 × 49 × 17½" / The William S. Arnett Collection

not to express in his daily life, Dial was not comfortable considering them lasting works of art. Their improvisational quality, predicated on impermanency and a need to express deep-seated feelings, is analogous to the nature of the blues. Although scholars have not so far connected Dial's art to this musical mode, his work can be considered its visual equivalent.

In the fall of 1994 Dial made explicit this connection with the blues when he focused on the theme of pollution as a result of finding the desiccated body of a house cat in a crawl space in his aunt Sarah Dial Lockett's house. The cat had unsuccessfully tried to escape the flood of early December 1983 that had affected most of Dial's community, called "Pipeshop," and filled his house with a foot and a half of water. As a memorial to this animal and possibly an elaboration on his commonly used tiger theme, Dial made it the centerpiece of *Contaminated Drifting Blues*, a simulated midden consisting of driftwood from the Gulf of Mexico, crushed soda and beer cans (including a prominent red Coke can on the bottom left), metal shavings, bedsprings, a "C" clamp, and a glass bottle.

Shortly before making the piece, Dial had vis-

ited fellow self-taught artist Lonnie Holley, who had found a circa 1960s bomb shelter underneath a deserted shotgun house in his neighborhood. Its association with Cold War politics and widespread fears of radioactive fallout are no doubt concerns that catalyzed Dial's *Contaminated Drifting Blues*. At the time that he made this work, Dial was thinking about how his childhood hometown, Emelle, had become a nuclear waste site and was deeply concerned about a proposal for a nuclear waste dump in Bessemer.[144]

The title *Contaminated Drifting Blues* recalls the well-known blues song "Drifting Blues," by Wallace "Pine Top" Johnson, which features this chorus:

You know I'm drifting,
and I'm drifting just like a ship out on the sea.
Well, I'm drifting and I'm drifting like a ship out
on the sea.
Well, you know I ain't got nobody in this world
to care for me.

Not only does the title reinforce Dial's work, but the references to the sea could characterize *Contaminated Drifting Blues*, with its earth-

THE NEW BIRMINGHAM AND THE OLD BIRMINGHAM / **1993** / Rope, wire, vines, found wood, roots, corrugated tin, stones, soil, oil, enamel, spray paint, and industrial sealing compound; on canvas mounted on wood / 82 × 133 × 7 ½" / The William S. Arnett Collection

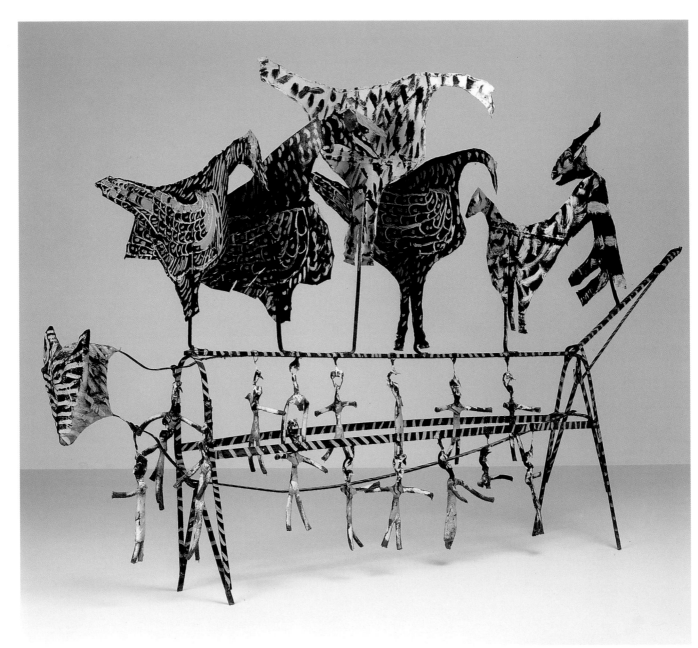

THE TIGER CAT / **1987** / Steel, tin, enamel, tubing, and tape / 69 ½ × 107 ½ × 57" / The William S. Arnett Collection

colored panel placed in front of a larger acrid blue-green one that could represent either water or sky.

This relationship with the blues deserves investigation in order to understand how Dial's art is related to this rich and vital twentieth-century tradition. Dial himself stressed the importance of the blues to his life when he said, "For years, music was my only pleasure."[145] Over the years, he has appreciated a wide range of blues works, including music by B.B. King and Fats Domino, his longtime favorites. On Friday nights, after getting off work at 11:00 P.M., he would spend a couple of hours in Bessemer juke joints such as Duke's Club or those that he remembers were run by Andy Hall and Bill Hardy. He recalls that the interiors of these clubs were painted in rich patterns that captured the flavor of the music. The overall improvisational character of these painted walls can in general be considered a vernacular tradition important to Dial's paintings, and these paintings may represent one way he has effected visual equivalents to this important musical form and the places from which it came.

Music first called "blues" in the 1920s actually made its initial appearance around 1900 in the Mississippi Delta region. One possible source may have been "slave seculars," which lampooned spirituals, as critic Sterling Brown notes:

> Bible stories, especially the creation, the fall of Man, and the flood, were spoofed. "Reign, Mastr Jesus, reign" became "Rain Masser, rain hard? Rain flour and lard, and a big hog head, Down in my back yard."[146]

The blues are often considered a cross-cultural blend of African American work songs, field hollers, and traditional European-American ballads.[147] However, blues tunes, unlike slave songs, were mostly solos in which individuals expressed deep personal feelings. William Ferris argues, in his *Blues from the Delta*, that this music most likely developed after the Civil War because it commonly relies on the accompaniment of a guitar, and this instrument was not illustrated in pre–Civil War literature.[148] Blues lyrics favor such subjects as bad luck, a broken family, callous or unrequited love, a general feeling of being ill at ease with a cold world of trouble, and a sense of rootlessness. All of these topics, except unrequited love, are of crucial importance to Thornton Dial's art.

A number of African American musicians and scholars and others believe that the blues represent a special understanding of what it means to be black. Although some have attributed this music's great success to its inherent universality, others, such as B.B. King, have emphasized its way of establishing bonds between African Americans. King noted, "If you've been singing the blues as long as I have, it's kind of like being black twice."[149] Philosopher Cornel West believes that blues and other forms of black music constitute an "Afro-American humanist" tradition.[150] And American studies specialist Jeffrey Stewart perceives the blues to be a culturally sanctioned mode for channeling African American tribulations:

> The blues is not just the language of oppression and the realization that there's no way out of this belly of racist capitalism. It is the ability to overcome . . . to sing a song of transcendence, of madcap joy in the midst of all hell. It is the ability to laugh to keep from crying, to open the heart instead of shutting it once she's gone, and to say "I didn't want the · · · · · · · anyway." The blues is perhaps best represented by the concept of irony that connects us to the slave's experience of building America, from sunup to sundown, and being called lazy. . . . The blues aesthetic is living and expressing the contradictions between the American ideal and black reality.[151]

Scholars have written that the blues established a way for African Americans to cope with adversity by finding an artistic medium capable of conveying their feelings, enabling them the opportunity to appreciate the irony of their situation, sharing the commonality of knowing that others have experienced similar difficulties, and transcending negative feelings through the sheer beauty and power of their chosen medium. One might say that, similarly, Thornton Dial's paintings and sculpture allow him the opportunity to do all these things.

The blues have appealed mainly to an older generation that has used them to cope with the contradictions of residual forms of slavery or its ongoing aftereffects in a democratic world. According to Ferris, this music is "the expression of a generation which grew up before the Civil Rights Movement and attitudes expressed in their verses are very

EVERYBODY GOT A RIGHT TO THE TREE OF LIFE / **1988** / Enamel, tin, glass marbles, and industrial sealing compound on wood / 48 × 96 ½" / Philadelphia Museum of Art / Gift of Ron and June Shelp / 1993.150.1

different from those of 'soul' singers like James Brown and Aretha Franklin."[152] To this, one might add that the southern rural blues singer is usually male, whereas the urban blues outside the South is often epitomized by female vocalists.

When Dial asserts that his art is "about reality" and is "concerned with the way things really is," as he has said on a number of occasions to this writer, he is in accord with an overall attitude of blues singers who believe in the veracity of their message and their mode of conveying it. In *The Spirituals and the Blues*, James H. Cone records this certainty among a number of performers:

> [I]t is necessary to view the blues as a state of mind in relation to the Truth of the black experience. *This is what blues man Henry Townsend, of St. Louis, has in mind when he says: "When I sing the blues I sing the truth." . . . Or as Furry Lewis of Memphis puts it: "All the blues, you can say, is true." . . . In the words of Memphis Willie B.: "A blues is something that's real."*[153]

This emphasis on reality might help to explain why the theme of the road often recurs in Dial's art. According to the following lyrics:

> *When a woman takes de blues,*
> *She tucks her head and cries.*
> *But when a man catches the blues,*
> *He catches the freight and rides.*[154]

And this requirement that authentic art must be faithful to objective reality without the aid of a deus ex machina may be a reason for Dial's unrelenting examination of humanity's depths in such pieces as *The Lord's Plan*, *Rolling Mill*, and *City Lines*.

PURVIS
YOUNG
(b. 1943)
BORN LIBERTY SECTION OF MIAMI
WORKS MIAMI

BY WENDY STEINER

Perhaps no artist so vividly reveals the problems in the category of outsider art as well as Purvis Young. Possessed of an inventiveness, energy, and technical virtuosity on a par with major "high" painters of the twentieth century, he has been treated as a sort of noble savage—grouped with folk and naive artists, protected from sophisticating influences, and interpreted in the light of middle-class stereotypes of poverty and deprivation. Young reinforces the cliché that creativity can thrive in the simplest of souls, and the outsider label provides a justification for keeping him simple.

As is typical of outsiders, Young's life reads like a conversion narrative. Born down-and-out in 1943 in the slums of Liberty City, Miami, Young was serving time for armed robbery by the age of eighteen. While in jail, he discovered his talent, and shortly after his release, a book on Chicago mural artists led him to his vocation. "I said, Man I ain't gonna stand on no street corner all day, I'm going to *paint!*"[155] Young soon began drawing and collaging books, taping up his walls with sketches and paintings, and covering scraps of wood and bottles and carpet rolls with washes of color and exuberant figuration. Now his murals appear in his neighborhood on the walls of the Culmer/Overtown Library and at the Northside Metrorail Station; he has had more than two dozen one-man exhibitions in France, Canada, and the United States; and his work has been bought by museums in New Orleans, Newark, New York's Harlem, and Miami. He has been saved by art, but he has not lost the common touch. "Rembrandt walked among the peoples and that's what I do,"[156] says this self-proclaimed historian of the "hood." Despite his growing fame and prosperity, he lives in the same streets and style as ever.

The contrast between Young's talent and his social status has been the controlling fact in his reception. A Santeria priest, Silo Crespo, who is the artist's friend and guide, claims that "Purvis cannot express himself with speech, but he expresses himself with paint,"[157] and a video of the artist made by a librarian in Overtown indeed shows him inarticulate and awkward. However, any number of "high" artists have been impractical, unworldly, and inarticulate. What sets outsiders like Young apart from them is this well-intentioned isolation. It makes Young's work somehow off-limits to critics and exempts the artist from developing the internalized critical sense needed for self-editing. When asked whether Young's work has changed significantly over the years, John Ollman, director of the Fleisher/Ollman Gallery in

YELLOW TRUCK / c. 1990 / House paint on wood / 22 × 24½" / Collection of Jill and Sheldon Bonovitz

Philadelphia, which represents a significant body of the artist's work, says no, adding that the only difference is that it looks a bit less cluttered than before, since pieces are removed by eager dealers before they have been on the walls long enough to

on in the normal interaction between artist and audience are either beyond the powers of the outsider or for some reason undesirable in people of a certain background. It implies, too, that Young's talent is so fragile that even after a twenty-year practice it could be ruined by high-art influence.

If we look at the few artistic ideas Purvis Young is given credit for having, however, they indicate no lack of sophistication. He reports that Rembrandt, El Greco, and van Gogh are his favorite artists.[158] He disdains commercial television in favor of public broadcasting, particularly shows on Africa and American Indians, and he paints "peoples who aren't happy, the homeless and people who are knocking each other trying to get over the blue eye" (Young's term for the white establishment).[159] His figures with hands stretched high above their heads are, he says, "reaching for a better life,"[160] and his choice of artistic materials is in keeping with his social conscience. "What you find on the street is yours," he claims. "You don't have to pay man for it. It was there for

LOCKED UP THEIR MINDS / 1972 / House paint and wood on plywood / 84 x 84" / The William S. Arnett Collection

be densely worked over. This lack of artistic evolution, though not necessarily a bad thing, is a function of Young's isolation. His massive and very uneven productivity, which in an artist like Picasso has been considered self-indulgence, is treated as proof of Young's genuineness—something to be fostered and protected. The outsider label makes a virtue of what for an "insider" is considered a fault, implying that the learning and development that go

you."[161] This sounds like the outline of a full-blown artistic program: an exploration of street life in which the artist guards his independence from "the blue eye" by appropriating the discards of official culture.

Though Young spends a lot of time looking at art books in the Overtown Library, commentators willfully ignore his "high" art affinities in favor of his folk roots. Under the guardianship of

CITYSCAPE WITH BARS AND EYES / 1973–1974 / Mixed media on wood / 57 ¾ × 79 ½" / Private collection, New York

BOAT PEOPLE / **1990** / House paint on found wood / 49 × 14" / Collection of Mr. and Mrs. Daniel W. Dietrich II, courtesy Fleisher/Ollman Gallery, Philadelphia

a Santeria priest and living in a neighborhood of Haitian and Cuban immigrants, Young would seem a likely vehicle for African-inspired iconography and style. Certainly there is some of this: his sway-backed dancers, the stylization of his figuration and his flat, fragmented picture plane, the baby-faced "angels" who hover in the sky above his cities. Yet the works of Jean-Michel Basquiat and José Bedia contain many such folkloric elements, and no one would be tempted to consider them outsiders.

It is almost heretical to point out Young's affinities to the twentieth-century avant-garde, and yet they are unmistakable. Cubism sets the stage for his collage, Dada for his found objects, abstract expressionism for his paint splatters, Fritz Hundertwasser or Paul Klee for his decorative city geometries. Young makes the wall between abstraction and figuration permeable, as evidenced by his processions of stylized black bodies in *Bearin' the Funeral* melting upward into an indistinct design. Like many "high" art painters and sculptors, he is an accomplished book artist. The fluent ballpoint lines in his drawings resemble the bent wires of Alexander Calder in their expressiveness and seeming spontaneity, and his color can be so luscious that one finds oneself thinking of Paul Cézanne, Mark Rothko, or Howard Hodgkin. In *Bearin' the Funeral* Young's picture plane becomes, in a deconstructive witticism, the frame around an actual framed painting inside it, and in *People's All Busy* the figures appear both on a central projecting plane and in the background "frame" around it. Like Jasper Johns, Young paints on window shades,

collages with measuring tapes, and joins painted panels with masking tape; his rough assemblages of urban debris remind one of works by Robert Rauschenberg. And if influence is not what is at stake here (after all, which way does influence flow between the outsider and the avant-gardist in the twentieth century?), Young still looks more like a "high" artist than a naive one. His work suggests not primitivism but urban pastiche and an inter-cultural challenge to conventional ways of seeing.

The category of outsider sets up the wrong expectations for Young's work. "Technique" may be too calculated a preoccupation for an outsider, but the virtuosity of Young's technique is extraordinary. What difference does it make whether he had no formal training in art and lives in an inner-city neighborhood when one sees the dancing punctuation of heads across *547*, the counterpoint of rectilinear trucks and curved figures in his city-scapes, the graceful symmetry of his magnificent arched horse heads, his idiosyncratic blend of urban rawness and communal warmth? In the presence of such achievement, one wonders who is truly naive: the artist or the critic who accepts the outsider designation. We would do well to remember that creative genius is always something of a miracle, whether it emerges amid the hardships of poverty and deprivation or the materialist banalities of middle-class existence.

LONNIE
HOLLEY
(b. 1950)
BORN AND WORKS BIRMINGHAM, ALABAMA

BY TERESA PARKER

Whether art imitates life or life mirrors art is a discussion which has little applicability to most African American traditional communities. In such communities life and art are inseparable.

—Gerald L. Davis,
"Elijah Pierce,
Woodcarver," *The Artist Outsider*

In the highly individualistic, postmodern world, art and life are rarely so inextricable. One finds little continuity between the lives many individuals lead and the art they create, collect, or study. In contrast, Lonnie Bradley Holley is a self-taught artist whose life and art are, in fact, one. Spending most of his time in a traditional African American community in Birmingham, Alabama, he creates pieces that not only recall the stories and people from his childhood but also express the personal ideologies he has developed as an adult. Moreover, Holley enables others to bridge the gap between art and life by creating works that address the concerns and issues affecting all people's lives. In other words, Holley uses his art as a mirror of and for society that, in turn, compels viewers to examine themselves and the world around them.

Holley's world is the Airport Hills area of Birmingham, which lies directly north of the Birmingham International Airport and approximately five miles from the city's downtown. Although Holley was born in this area on February 1, 1950, he went on to spend many of his

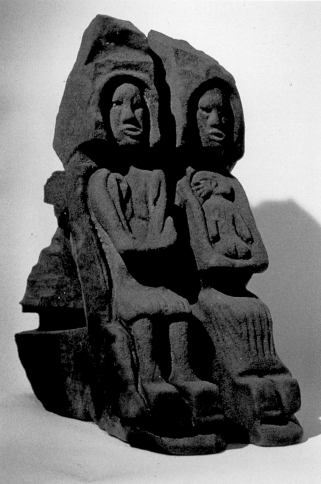

RULING FOR THE CHILD / **1982** / Carved sandstone / 20 x 9 ½ x 15" / The William S. Arnett Collection

childhood and teenage years in other neighborhoods around the city. As an adult, he also lived in Florida, Louisiana, and Ohio. He returned home in his late twenties, and he has remained there since. Living with his five children in a small house on a wooded two-acre, hillside lot, Holley overlooks the surrounding neighborhoods and, in the distance, the city's downtown skyline.

Like many black families who left behind their rural surroundings and embraced the urban environment of Birmingham, Holley's ancestors moved to the area in the 1940s from Daleville, Alabama, a small town located in the southernmost part of the state. Ultimately, Holley's grandfather led the family to the Airport Hills neighborhood, where he became a prominent community leader. Not only did he help establish the Airport Hills First Baptist Church, one of the first churches erected in the area, but he also built 65th Street, the main north-south corridor intersecting the neighborhood. Holley explains, "that was in the forties that my grandfather with an ox and a wagon, he brought that whole road . . . straight across."[162] His grandfather also worked at Sloss Furnaces, which was "once the center of Birmingham's iron and steel industry."[163] Thus, Holley's grandfather contributed to the development of his own community as well as to the city as a whole.

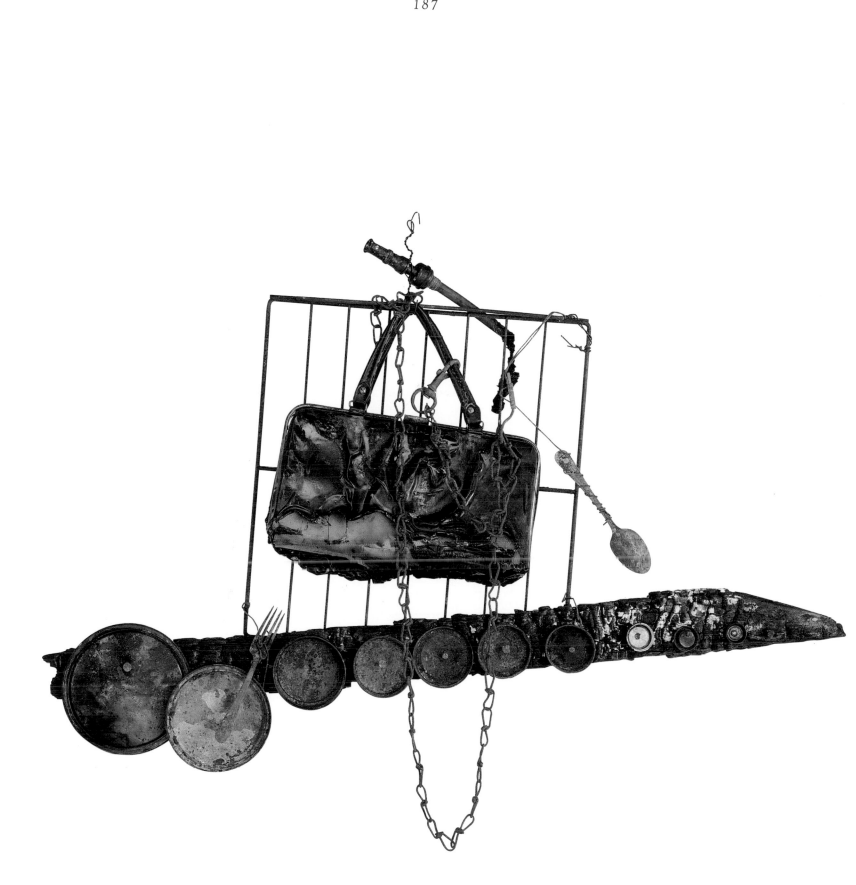

LITTLE TOP TO THE BIG TOP / **1993** / Metal lids, pocketbook, eating utensils, garden hose, oven rack, chain, wood, wire, and found metal / 26 × 39 × 5½" /
The William S. Arnett Collection

One of twenty-seven children, Holley became familiar with the various individuals in this community as he and his mother scavenged the neighborhood for cast-off clothing and other materials for the family. In particular, he grew close to his elderly neighbors, whom he regularly visited to help with household tasks. He reflects:

I remember going to people's houses, knocking on the door, and asking them is there something you've got for me to do. In the neighborhood and getting coal and getting wood in this time of evening for the older ladies that had wood-burning stoves. . . . A lot of times if you sat down with the elder people in your community, they told you stories, not lies but stories of their life, things that had occurred and they had experienced.

Holley thus not only collected material goods from the people in his community, but he also gathered their stories. Ultimately, he would learn to use both in his artwork.

As he meandered through his neighborhood, Holley also encountered artistic mentors who schooled him in the African American visual aesthetic. He recalls:

I remember my first seeing African American art in the community. . . . It was an interesting sight because these people often had a lot going on around them . . . their living space was jammed and packed with ideas that they had thought of over the years.

Crowding their living spaces with eclectic collections of both found and used objects, such individuals offered no formal instruction but rather an example of how recycled items may be artistic as well as utilitarian.

Holley draws from such childhood lessons in his artwork. He uses coat hangers, suitcases, clothing, cutlery, machine parts, chairs, and a varied assortment of other items that others have thrown away. Searching the alleys and flea markets of Birmingham, as well as scavenging the local Salvation Army or Goodwill, in order to make pieces such as *Him and Her Hold the Roots* and *From the Little Top to the Big Top*, Holley demonstrates an

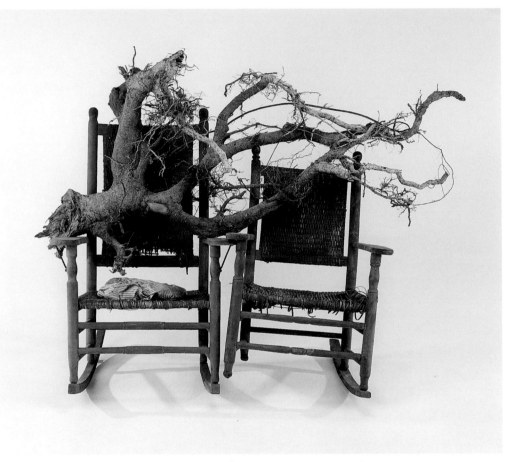

HIM AND HER HOLD THE ROOTS / 1994 / Rocking chairs, pillow, and root / 45 ¼ × 73 × 30 ½" / The William S. Arnett Collection

ability to find creative uses for others' trash.

Many such pieces draw from the stories he heard as a child living in Airport Hills. This narrative recycling is evident in the works Holley has created to honor his now deceased neighbors. Reflecting on his oeuvre, he explains:

So many parts are here: Miss Sarah Kelley, Mrs. Reed, my Aunt Georgia. . . . I can see them, I see parts of what they left behind and I can see them and I can speak about how they lived. . . . I've done art that honors mostly every old person that I ever had in my mind to think about because I was always one that was interested in sitting and listening.

Beyond celebrating the history of his own neighborhood, Holley's pieces also honor the city as a whole. For example, many works allude to Birmingham's once thriving iron industry. Speaking proudly of the city's and, particularly, his own industrial heritage, he states, "I'm an iron baby because I was born here in Birmingham, Alabama." Concern for the city's future tempers this pride, however, as he witnesses the city waste its valuable iron resources. Yet he admits, "I'm not just talking about Birmingham, Alabama . . . my mind [is] for the whole earth." Therefore, as he travels the planet he collects cast-off items that he uses in his artwork to address the tragedy of global waste. He explains, "You've got to be able to do something with this material besides bury it. . . . We've got to think about another way to do it." For Holley, this means making art.

As the pieces powerfully articulate the artist's concerns, they, in turn, guide viewers to question their own environmental ethics. Art historian Robert Farris Thompson has studied Holley's works within the West African idiom and argues, "Operating by analogy with the combined material signs of the *nkisi*[164] tradition, Holley is developing a form of visual signification. The contents of these *moralizing* charms, as it were, are open, public, communal."[165] In other words, Holley's creations transcend his own personal ideology and speak, if not preach, to the community at large. Holley echoes this interpretation when he explains, "I think basically here I tried to speak to others about what we are doing to our earth, and our earth being the biggest community of them all."

Ironically, the immediate community from which Holley speaks is rapidly disappearing, as officials from the Birmingham Municipal Airport have purchased almost all of the land in the hillside neighborhood in order to secure a safer approach for the north-south runway. As a result, they are now forcing Holley to relocate his family and art environment. Occupying one of the area's few remaining homes, he laments, "This was once a live community. Now it's a dead one." Yet Holley acts as a kind of neighborhood historian as he fervently creates works that record the stories of his community. He explains, "I still have the community with me because I have . . . more precious memories that one can ever tell or be told."

Holley's situation is not unique, for traditional neighborhoods are increasingly giving way to gated communities and suburban sprawl. With this and other trends in the postmodern world, fewer individuals are likely to achieve the union between art and life that Holley has mastered. Whether it addresses the mentors from his childhood, the city's industrial heritage, or the environmental problems faced by Airport Hills and other neighborhoods, Holley's work resonates with the themes from his life. It transcends, however, the geographical boundaries of his immediate surroundings in that it also offers lessons relevant to people everywhere. Thus, the reflection in Holley's artistic mirror beckons as it compels us to reexamine our lives and the world community in which we all live.

KEN GRIMES

(b. 1947)
BORN NEW YORK CITY
WORKS CHESHIRE, CONNECTICUT

BY JOACHIM NEUGROSCHEL

As we approach the end of the twentieth century, books have largely forfeited their status as visual artworks in their own right; few publications today are artist's books, much less illuminated manuscripts, while book design generally aims at clarity rather than beauty. Furthermore, increasing numbers of people now limit their reading to a computer screen, thereby making the book even more of a cybernetic tool than an aesthetic medium.

By incorporating script into his usually black-and-white acrylic paintings, Ken Grimes brings the verbal back to the visual, without deserting the latter as some "literary" painters do. His oeuvre is a huge, continuously growing Book about visitors from outer space; each individual work is a self-contained "page" that can be understood on its own, yet in style, look, and subject matter relates to every other "page." Similarly, each new piece not only adds, but also revises, even redefines, the overall project as an endless serial. In this way, the artist challenges traditional ideas of narrative structure in both art and literature.

A novel, claims the nineteenth-century French writer Stendhal, in *The Red and the Black*, is a mirror drawn along a road. I would suggest that modernism splintered this mirror and zigzagged every which way on the road by shattering the linearity of the plot. Yet even if a modern plot is shredded into a nonlinear patchwork, Stendhal's metaphor might still apply—because no matter how nonlinear a plot, the action remains unilinear. After all, however much Marcel Proust and Kurt Vonnegut keep time-tripping, we are not supposed to leaf around in their fiction; we normally follow the numerical sequence of pages and chapters.

But for Ken Grimes, the order of the *viewed* pages is not only random and haphazard (despite the indication of the year in which he painted each piece), but also entirely at the mercy of galleries and museums. And even if an organization were to arrange all of Grimes' canvas pages in the linear or nonlinear sequence of his choosing or in a chronological string, any spectator could wander back and forth at will.

UNTITLED (CHESHIRE JODRELL BANK RADIO TELESCOPE BERNARD LOVELL COINCIDENCES) / 1993 / Acrylic on canvas / 48 x 96" /
Courtesy Ricco/Maresca Gallery, New York

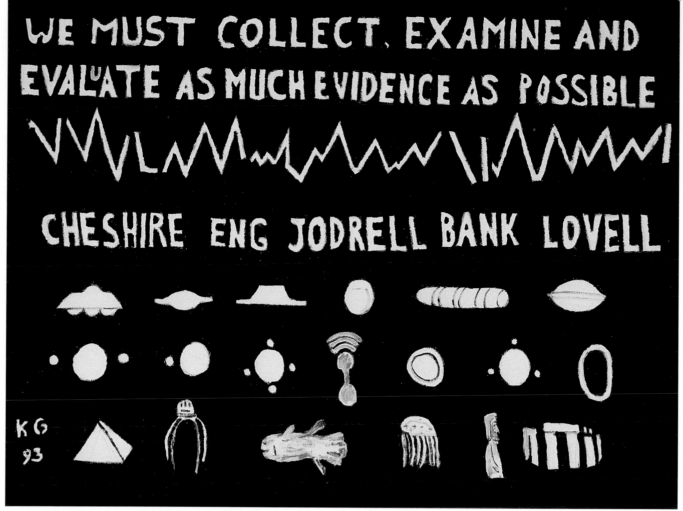

UNTITLED (WE MUST COLLECT, EXAMINE, AND EVALUATE AS MUCH EVIDENCE AS POSSIBLE) / 1993 / Acrylic on canvas / 48 × 66" / Collection of Margaret and John Robson

Further conceptualizing occurs in Grimes' works because viewers normally see only a few of the pages in a selective exhibition and therefore must somehow recall the various other pages that they may have seen elsewhere (originals or photographs); thus the map in the viewer's mind relies on the subjective nature of a less than perfect memory. This experience mimics our reading of newspapers—a messy, scattered procedure that loosely ties disparate items together in both space and time.

Of course, each of Grimes' texts is linear, following normal English usage and syntax; even when he organizes a diptych or "multi-tych," we read the pages from left to right as we habitually do with any book or painting. But then Grimes' linearity is disrupted by the sometimes more, sometimes less hieroglyphic renderings of certain objects—like spaceships and crop circles. Historically, such ideograms were an intermediary stage between images and alphabets, and Grimes, inadvertently perhaps, reminds us of these various transitions as human literacy evolved from recognizable pictures and objects to the symbols of hieroglyphs, and finally to the multi-phonetic letters, whose ideograms faded thousands of years ago.

The graphic, that is linear, stylization employed by Ken Grimes shifts from representation to abstraction, as in *Untitled (Saucer with Waves)*, yet even the most stylized is, in a sense, "realistic" as a projected possibility. In visualizing the waves in this latter picture, for instance, Grimes actually reverses the passage of concrete to nonconcrete, making unseen waves seeable; the abstract thereby becomes representational as the labyrinthine stripes form a creature-feature face, outlining the monster's gaping maw and curling up into his gawking eyes.

"After 1989, crop circles get weird," says Grimes, "is this a warning?" A sense of menace is what commonly spawns and imbues the xenophobic and jingoistic books and movies about cosmic intruders (don't "guest" and "hostile" go back to the same Indo-European word?). With a few exceptions, like *Superman* or *The Day the Earth Stood Still*, the aliens generally come to enslave or destroy and, as if helping to demonstrate American might, they usually land in the most powerful country on Earth, rather than starting with small nations, as Nazi Germany did, and conquering their way up. (Evidently, the Martians learned nothing from the German invasion of the Soviet Union.)

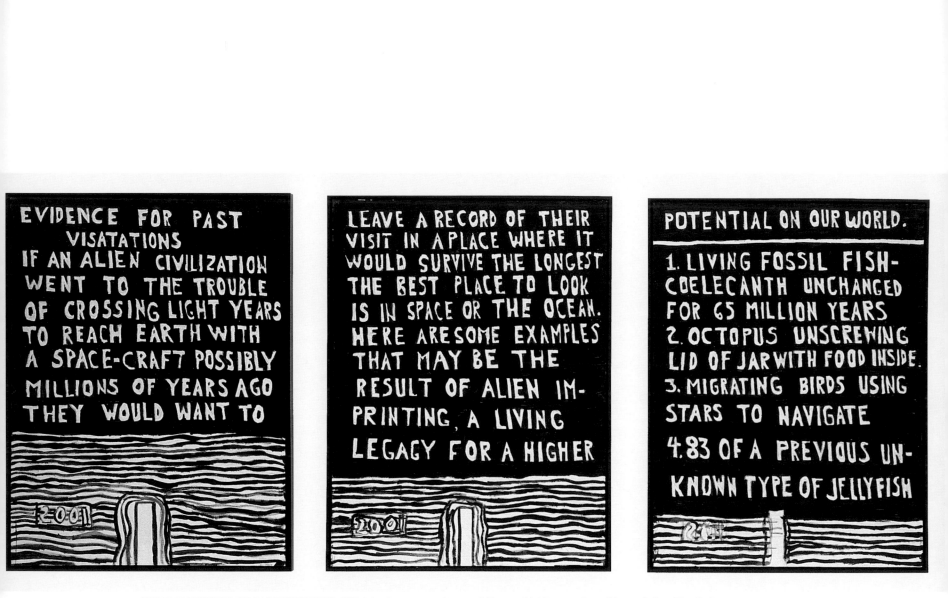

EVIDENCE FOR PAST
VISATATIONS
IF AN ALIEN CIVILIZATION
WENT TO THE TROUBLE
OF CROSSING LIGHT YEARS
TO REACH EARTH WITH
A SPACE-CRAFT POSSIBLY
MILLIONS OF YEARS AGO
THEY WOULD WANT TO

LEAVE A RECORD OF THEIR
VISIT IN A PLACE WHERE IT
WOULD SURVIVE THE LONGEST
THE BEST PLACE TO LOOK
IS IN SPACE OR THE OCEAN.
HERE ARE SOME EXAMPLES
THAT MAY BE THE
RESULT OF ALIEN IM-
PRINTING, A LIVING
LEGACY FOR A HIGHER

POTENTIAL ON OUR WORLD.
1. LIVING FOSSIL FISH-
COELECANTH UNCHANGED
FOR 65 MILLION YEARS
2. OCTOPUS UNSCREWING
LID OF JAR WITH FOOD INSIDE.
3. MIGRATING BIRDS USING
STARS TO NAVIGATE
4. 83 OF A PREVIOUS UN-
KNOWN TYPE OF JELLYFISH

UNTITLED (EVIDENCE FOR PAST VISITATIONS) / 1992 / Acrylic on canvas / 40 × 150" (five panels) / Courtesy Ricco/Maresca Gallery, New York

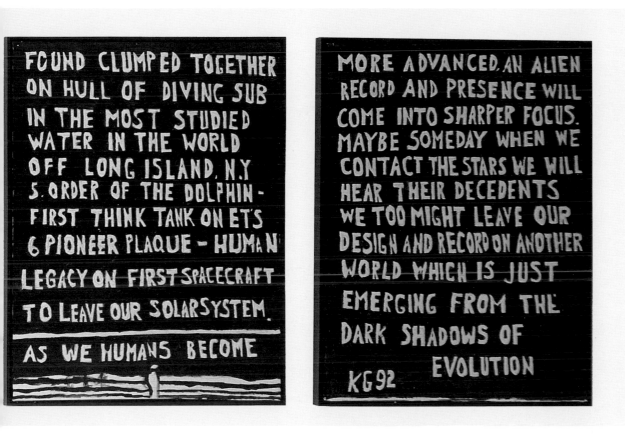

FOUND CLUMPED TOGETHER
ON HULL OF DIVING SUB
IN THE MOST STUDIED
WATER IN THE WORLD
OFF LONG ISLAND, N.Y.
5. ORDER OF THE DOLPHIN -
FIRST THINK TANK ON ETS
6 PIONEER PLAQUE - HUMAN
LEGACY ON FIRST SPACECRAFT
TO LEAVE OUR SOLAR SYSTEM.

AS WE HUMANS BECOME

MORE ADVANCED, AN ALIEN
RECORD AND PRESENCE WILL
COME INTO SHARPER FOCUS.
MAYBE SOMEDAY WHEN WE
CONTACT THE STARS WE WILL
HEAR THEIR DECEDENTS
WE TOO MIGHT LEAVE OUR
DESIGN AND RECORD ON ANOTHER
WORLD WHICH IS JUST
EMERGING FROM THE
DARK SHADOWS OF
 EVOLUTION
KG 92

Overall, however, Grimes does not necessarily share this angst. He is more concerned with communication: "If these crop circles are alien symbols—could they also know human symbols words signals [sic]?" In asking about the means and methods of interplanetary dialogue, Grimes is also posing an aesthetic and cybernetic question: how can visual art communicate the concerns of communication? Grimes zeros in on his issues by resorting to and mingling "symbols words signals," that is, depicting, presenting, and commenting in words and pictures. He experiments with all these approaches, weaving them into a network of the verbal and the visual.

By restricting his palette to black and white, Grimes evokes the usual colors of printed materials—and the idiom about having something in "black and white" as a claim to fact and truth.

However, he turns the process inside out by making the words and objects white against a black background—like photographic negatives—a device utilized by some photographers, painters, and filmmakers (check passages in Jean Cocteau's film *Orpheus*). Moreover, Grimes' nuanced grays not only provide a delicate gamut between dark and light, but also hint at "gray areas" in our understanding and communication. And etymologically, we come full circle, since "black" and "blank" derive from a common Indo-European root (meaning "colorless"). In this chromatic synthesis, the stark demands of black and white are tremulously linked by the subtleties of gray. That is what helps to produce the visual and mental intricacies of Ken Grimes' unsettling Book.

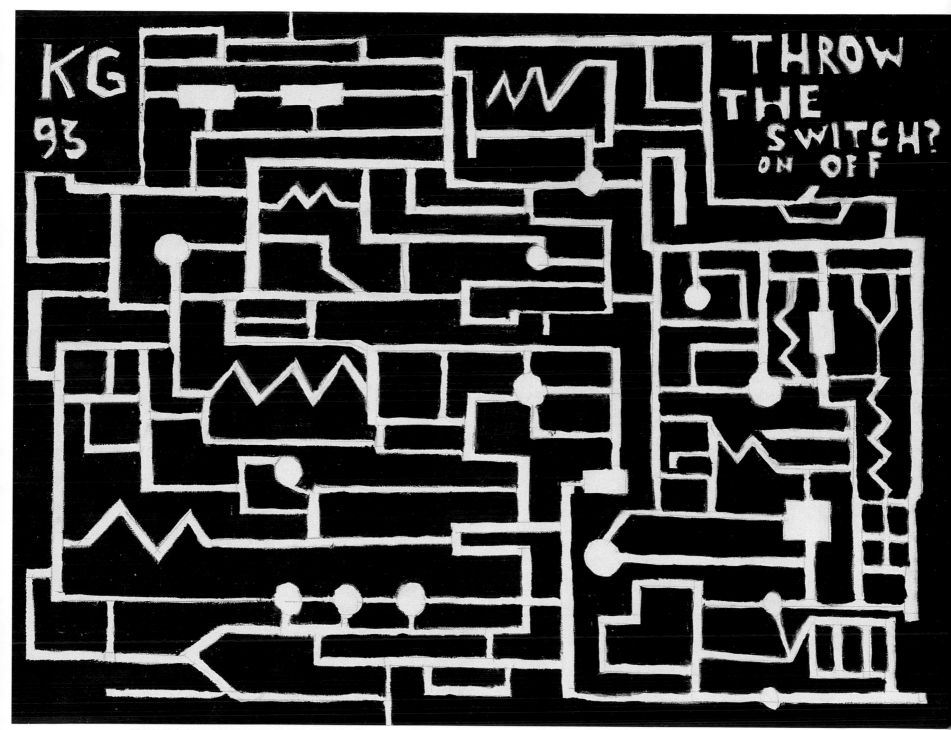

UNTITLED (THROW THE SWITCH? ON OFF) / 1993 / Acrylic on canvas / 30 x 40" / Courtesy Ricco/Maresca Gallery, New York

ENDNOTES

MAURICE BERGER

1 Judith Wilson, "The Myth of the Black Aesthetic," in *Next Generation: Southern Black Aesthetic* (Winston-Salem, N.C.: Southeastern Center for Contemporary Art, 1990), p. 26.

2 An excellent catalog, *Black Art—Ancestral Legacy: The African Impulse in African-American Art* (Dallas: Dallas Museum of Art, 1989), accompanied this exhibition.

3 David C. Driskell, "Introduction," in *Black Art—Ancestral Legacy*, p. 15.

4 Ibid., p. 16.

5 Ibid.

6 For more on these issues, see the following essays in ibid.: Edmund Barry Gaither, "Heritage Reclaimed: An Historical Perspective and Chronology," pp. 17–34; Regenia A. Perry, "African Art and African-American Folk Art: A Stylistic and Spiritual Kinship," pp. 35–52; Alvia J. Wardlaw, "A Spiritual Libation: Promoting an African Heritage in the Black College," pp. 53–74; William Ferris, "Black Art: Making the Picture from Memory," pp. 75–86; Robert Farris Thompson, "The Song that Named the Land: The Visionary Presence of African-American Art," pp. 97–141. See also the excellent annotated checklist of the works in the exhibition, pp. 143–258, and the detailed biographical profiles of participating artists, pp. 259–298.

7 This show was organized by Livingston and John Beardsley for the Corcoran Gallery of Art in Washington, D.C., in 1982. See Livingston and Beardsley, *Black Folk Art in America 1930–1980* (Jackson, Miss.: University Press of Mississippi and the Center for the Study of Southern Culture for the Corcoran Gallery of Art, 1982).

8 For an important analysis of Livingston's title and her general methodology, see Lynda Roscoe Hartigan, "Recent Challenges in the Study of African American Folk Art," *International Review of African American Art*, vol. 11, no. 3, 1993, p. 28.

9 Livingston, "What it is," in *Black Folk Art in America 1930–1980*, p. 13.

10 Ibid.

11 Ibid., p. 23.

12 The work creates "a truth we need to acknowledge," Livingston concludes. "[It] expresses a sensibility to which every one of us can relate on some level, whether out of the most basic or the most specialized capacity to create visual form" (p. 23).

13 Ibid., p. 13.

14 Livingston makes only passing reference, for example, to the "political" content of some of the work. Livingston reduced the importance of this ideological content to the fact that it lends the work a greater degree of recognizability, thus widening its message and appeal. She makes no effort to explain why such figures as Martin Luther King Jr., Abraham Lincoln, and John F. Kennedy "appear again and again" in this work or to explore the social implications of the "spirit of didacticism [that] pervades this art" (p. 19).

15 She also ignores the question of art history's racist past. She acknowledges, for example, that this African American artistic style—though it speaks in a powerful, "universal" voice that has influenced white mainstream artists—has not achieved the same level of "classicism or overtly influential nature of Jazz" (p. 13). Yet while she argues that this "truly formed American style requires analysis and authentication as such," she never asks a far more basic and obvious question: why has this respectful analysis or an understanding of the importance of African American art of any kind never been forthcoming in the world of art history and the museum.

16 While a number of formalist art historians have over the past two decades been interested in validating the importance or beauty of so-called folk or outsider culture, their desire to view the work through the mainstream/outsider perspective unwittingly echoes the foundational formalist (and racist and classist) distinction between folk and "high" culture: "There has always been on the one side the minority of the powerful and therefore the cultivated—and on the other the great mass of the exploited and the poor—and therefore the ignorant," Clement Greenberg wrote in 1939. "Formal culture has always belonged to the first, while the last have had to content themselves with folk or rudimentary culture, or kitsch" ("Avant-Garde and Kitsch," in *Art and Culture*, Boston: Beacon Press, 1961, p. 16).

17 *Black Folk Art in America*, pp. 14–16.

18 For more on this subject, see Daniel Robbins, "Folk Sculpture without Folk," in Michael D. Hall and Eugene W. Metcalf Jr., eds., *The Artist Outsider: Creativity and the Boundaries of Culture* (Washington, D.C.: Smithsonian Institution Press, 1994), pp. 45–46.

19 The formalist biases and assumptions that drove Livingston to some of her more problematic conclusions in 1982 continued to plague her work throughout the decade. In an essay on the methods she and co-curator John Beardsley employed in an exhibition on the "poetics and politics of Hispanic art," Livingston and Beardsley wrote: "we knew we wanted the underlying spirit of this exhibition to be artistic, not sociological, though of course we knew that, especially in this case, art and social context are inseparable. . . . However, the art museum is still widely defined in our society as the arena for more purely artistic and poetic impulses of the individual. We largely concur with this definition, and we saw no reason not to conform to the usual museum practice of concentrating on painting and sculpture" (Livingston and Beardsley, "The Politics and Poetics of Hispanic Art: A New Perspective," in Ivan Karp and Steven D. Lavine, eds., *Exhibiting Cultures: The Poetics and Politics of Museum*

Display, Washington, D.C.: Smithsonian Institution Press, 1991, p. 108).

20 Kenneth L. Ames, "Outside Outsider Art," in *The Artist Outsider*, pp. 258–259.

21 The former quote comes from Roger Manley, *Signs and Wonders: Outsider Art Inside North Carolina* (Raleigh, N.C.: North Carolina Museum of Art, 1989, p. ix), the latter from Paolo Bianchi, "Bild und Seele," *Kunstforum*, no. 101 (June 1989), pp. 71–72. For another, particularly disturbing, example of this kind of overdetermined thinking, see Martin Friedman, "Introduction," in *Naives and Visionaries* (New York: E.P. Dutton in association with the Walker Art Center, 1974), p. 74.

22 Livingston, "What it is," p. 16.

23 Many defenders of the outsider concept, such as the art historian Roger Cardinal, continue to argue that such "extra-aesthetic" considerations as biographical information and national and cultural differences "undermine [outsider art's] plausibility as being at least to some degree an *aesthetic* category and, as is now beginning to occur in the practical field, make it possible for a work to be credited with a low or high rating in the art market on biographical evidence alone" ("Towards an Outsider Aesthetic," in *The Artist Outsider*, p. 29). The urgency to establish such a unified aesthetic category—and the concomitant market-driven imperative to render alien cultures accessible and comprehensible to the artworld's white, upper-class consumers—is, to some extent, touristic and exploitive. Roger Manley has observed that the so-called outsider art industry is, by nature, exploitive in relationship to its cultural providers: "When representatives from the art market make contact with artists they label Outsiders, all too often these dealers and collectors are only acting out of a sense of what will sell well or increase in value. The term 'Outsider' itself sets up an imaginary category which seeks to make acceptable a range of exploitative properties" ("Separating the Folk from Their Art," *New Art Examiner*, September 1991, vol. 19, no. 1, pp. 25–28). The artists themselves are fre-

quently aware that these practices are unethical. Manley quotes folk artist Bessie Harvey: "We just take the waste that nobody don't want . . . and we see beauty in it. And we bring out the beauty we find in this junk (as they call it). Then we bring it out—Oh boy—it is something big and new then, and we don't get credit for what we've done. Except they take our name and put it out and make it big so that they can buy the work from us for nothing and sell it for something. And they keep the something and we still gets the nothing" (Bessie Harvey, in *Boneshop of the Heart*, a film by Scott Crocker and Toshiaki Ozawa, 1990, quoted in Manley, p. 25).

24 Marianna Torgovnick, *Gone Primitive: Savage Intellects, Modern Lives* (Chicago: University of Chicago Press, 1990), quoted in Eugene W. Metcalf Jr., "From Domination to Desire: Insiders and Outsider Art," in *The Artist Outsider*, p. 225. For a groundbreaking analysis of the machinations of power and control in the art-historical construction of outsider art, see Metcalf, "Black Art, Folk Art, and Social Control," *Winterthur Portfolio*, vol. 18, no. 4 (Winter 1983), pp. 271–289.

25 While most art-historical and critical methodologies sanction the construction of periodized, totalized, or historicized movements, such repressiveness is no more insidious than in the formalist ethos: "Formalism is least offensive when it is applied to the work of elite culture artists who share formalist values. But when this modern sensibility is superimposed on things created in entirely different contexts by people apart from, ignorant of, or indifferent to formalism, the ugly specter of cultural arrogance appears. Anything with the right formal properties may be wrenched out of context and appropriated as outsider art to merit the dominant culture's insatiable demand for formal novelty. . . . Even allowing for the value of formalism within current Western high art, which is dubious, its application to random bits of the humanly made universe shows ethnocentrism at its worst, cavalierly revaluing and reinterpreting things made by known and knowable people living in other

circumstances" (Ames, "Outside Outsider Art," in *The Artist Outsider*, p. 268).

26 Eugenio Donato, "The Museum's Furnace: Notes Toward a Contextual Reading of *Bouvard and Pécuchet*," in Josué V. Harari, ed., *Textual Strategies: Perspectives in Post-Structuralist Criticism* (Ithaca, N.Y.: Cornell University Press, 1979), p. 223.

27 Ibid.

28 For more on the need for this epistemological shift, see Cornel West, "The New Cultural Politics of Difference," in Russell Ferguson, et al., eds., *Out There: Marginalization and Contemporary Cultures* (Cambridge, Mass.: MIT Press in association with The New Museum of Contemporary Art, 1990), pp. 19–36.

29 Steven D. Lavine, "Art Museums, National Identity, and the Status of Minority Cultures: The Case of Hispanic Art in the United States," in Karp and Lavine, *Exhibiting Cultures*, p. 83.

30 bell hooks, "Postmodern Blackness," in *Yearning, Race, Gender, and Cultural Politics* (Boston: South End Press, 1990), p. 28.

31 Eugene W. Metcalf Jr., "From Domination to Desire: Insiders and Outsider Art," in *The Artist Outsider*, p. 215.

32 Stephen Greenblatt, "Resonance and Wonder," in *Exhibiting Cultures*, p. 45.

33 Ibid.

34 Gerald L. Davis, "Elijah Pierce, Woodcarver: Doves and Pain in Life Fulfilled," in *The Artist Outsider*, p. 293.

35 Ibid., p. 294.

36 Ibid., p. 296.

37 Pierce, quoted in ibid., p. 299.

38 Ibid., p. 301.

39 Roger Cardinal, "The Self in Self-Taught Art," *Art Papers* (September/October 1994), p. 23.

40 Cardinal, despite his call for a more individualistic understanding of the self in self-taught art, tends to fetishize and overdetermine the art object as the personification of the artist's "selfhood"—a complex convergence of emotions, ideas, and physicalities that is far too complex for any art object to embody, no less represent: "One might say that self-taught artists have graduated in Selfhood *magna cum laude*, and that what they construct as creators comes to embody the plenitude of what they are and what they stand for as individuals" (ibid.). Cardinal also makes an unintended Freudian slip: by using the word *magna*, or "second best," and not the more laudatory *summa*, he still manages to relegate the artist-outsider to less than first-class status.

41 Greenblatt, "Resonance and Wonder," in *Exhibiting Cultures*, p. 47.

42 Lowery S. Sims, "On Notions of the Decade, African-Americans and the Art World," in *Next Generation: Southern Black Aesthetic* (Winston-Salem, N.C.: Southeastern Center for Contemporary Art, 1990), p. 13.

GERALD L. DAVIS

43 Part of a comment made by an apparent arts patron actually overheard during my visit to the Museum of International Folk Art shortly after the opening of the exhibition.

44 See my use of the "esthetic community" concept in *"I Got the Word in Me and I Can Sing It, You Know": A Study of the Performed African-American Sermon* (Philadelphia: University of Pennsylvania Press, 1985), p. 31.

45 David Steinberg, "Santeros Fear for Tradition's Soul" in *The Albuquerque Journal*, 9 June 1996, section A, pp. 1, 10.

46 It probably need not be stated that contemporary, philosophically rationalized Western aesthetics historically owe a great debt to the aesthetic systems of traditional European, African, Asian, etc., communities.

47 Lonnie Holley, autobiographical essay in *Souls Grown Deep, African American Vernacular Art of the South* (forthcoming), manuscript courtesy of William Arnett.

48 Ibid.

49 See Gerald L. Davis, "What Are African American Folk Arts? The Importance of Presenting, Preserving, and Promoting African American Aesthetic Traditions," in Deirdre L. Bibby and Diana Baird N'Diaye, *The Arts of Black Folk* (New York: The Schomburg Center for Research in Black Culture, The New York Public Library/Astor, Lenox and Tilden Foundations, 1991), p. 23.

50 Roger D. Abrahams, "Can You Dig It? Aspects of the African Esthetic in Afro-America," paper presented at the African Folklore Institute, Indiana University, Bloomington, July 16–18, 1970.

51 Gerald L. Davis, *"I Got the Word in Me . . . ,"* pp. 36-37.

52 Talley was a chemist who taught at Fisk University. However, he held a lifelong interest in African American narrative and published, in 1926, his immensely influential *American Negro Folk Rhymes Wise and Otherwise, with a Study*, a pioneering work I continue to regard as one of the first works in American structuralism.

CAROL MILLSOM STUDER AND VICTOR STUDER ON HENRY CHURCH JR.

53 Jane E. Babinsky and Miriam C. Stem, *The Life and Work of Henry Church Jr.* (Chagrin Falls, Ohio: privately published, 1987). The authors, Church's great-great-granddaughter and granddaughter, respectively, drew on a number of family documents in preparing this account of their ancestor. Information about the early days on the frontier and the family's abolitionist activities are drawn from diaries kept by

Henry's younger brother, Austin, born in 1838.

54 Ray Turk, "Lifts Mystery Veil from Squaw Rock: Daughter of Smithy Who Made Carving Tells of His Work," *Cleveland News*, 7 August 1932, magazine sec., p. 4.

55 Stonehouse, "A Genius Near Home," *Cleveland Plain Dealer*, 12 July 1891, p. 12.

56 C.T. Blakeslee, *History of Chagrin and Vicinity* (Chagrin Falls, Ohio: Chagrin Falls Library, 1969), p. 12. Transcription of original manuscript written in 1872.

57 Stonehouse, op. cit., p. 12.

58 Ibid.

59 Turk, op. cit., p. 4.

60 Blakeslee, op. cit., p. 12.

61 Henry Murray, *The Art of Portrait Painting in Oil Colors with Observations on Setting and Painting the Figure*, 19th ed. (London: Winsor and Newton, 1874).

62 *Williams' Ohio State Directory* (Cincinnati: Williams and Co., 1884), p. 5. Also Church's business cards, now in possession of his descendants.

63 "Smith-Sculptor Is Dead at 72," *Cleveland Plain Dealer*, 19 April 1908, p. 18; "Unique Character," *Chagrin Falls Exponent*, 23 April 1908, p. 4.

64 Babinsky and Stem, op. cit., p. 37.

65 See the following exhibition catalogs: Lynette I. Rhodes, *American Folk Art from the Traditional to the Naive* (Cleveland: The Cleveland Museum of Art, 1978); Jean Lipman and Tom Armstrong, eds., *American Folk Painters of Three Centuries* (New York: Hudson Hills Press, 1980); and William H. Robinson and David Steinberg, *Transformations in Cleveland Art 1796–1946* (Cleveland: The Cleveland Museum of Art, 1996).

JUDITH E. STEIN ON JOHN KANE

66 This designation is reflected in the subtitle of Jane Kallir's catalog, *John Kane: Modern America's First Folk Painter* (New York: The Galerie St. Etienne, 1984).

67 Frank Crowningshield, "Foreword," in John Kane, *Sky Hooks: The Autobiography of John Kane* (Philadelphia: J.B. Lippincott Company, 1938), p. 9.

68 Kane, *Sky Hooks*, p. 178.

69 Ibid., p. 121.

70 Ibid., p. 111.

71 Ibid., p. 181.

72 For a reproduction of this work, see Leon Anthony Arkus, *John Kane, Painter* (Pittsburgh: University of Pittsburgh Press, 1971), p. 246.

73 See Racksdraw Downes, "The Meaning of Landscape," *Parenthèse* (Spring 1975), p. 36, for a short discussion of the possible affinities between these two Scotsmen, both of whom disliked strikes and never lost faith in capitalism. Downes insightfully comments on Kane's "immigrant's uprootedness," which "may give a special urgency to his attachment to places."

74 See Arkus, op. cit., for a catalogue raisonné, and Kallir, op. cit., n.p., n. 15.

75 Kane, op. cit., p. 112.

76 Ibid., p. 130.

77 This and the following quotes in this and the next paragraph are from Crowningshield, op. cit., p. 16.

78 Frank Crowningshield (op. cit., p. 17) gives this work the title *John Kane Looking in the Looking Glass*, and notes that it was Kane's habit, after returning from work in Pittsburgh, to strip himself to the waist and wash himself at a basin, over which there hung a mirror. But this is clearly not the image of a man casually cleansing himself of the day's grime.

JACK L. LINDSEY ON EDGAR ALEXANDER MCKILLOP

79 The pioneering and most comprehensive research and documentation of McKillop's life and work was compiled by Dr. Charles G. Zug III and serves as the basis for this essay. His field research, interviews, and documentation are contained in the exhibition catalog *Five North Carolina Artists* (Chapel Hill, N.C.: Ackland Art Museum, The University of North Carolina, 1986), pp. 61–72.

80 Zug, *Five North Carolina Artists*, p. 66.

81 Pat H. Johnston, "E.A. McKillop and His Fabulous Woodcarvings," *The Antiques Journal* vol. 33, no. 11 (1978, p. 17).

82 Zug, op. cit., p. 68.

83 Research file, "Southern Carved Folk Motif Sources," Collections of American Art Department, Philadelphia Museum of Art.

ROBERT STORR ON WILLIAM EDMONDSON

84 Charles Baudelaire, "The Painter of Modern Life," *Baudelaire: Selected Writings on Art & Artists*, trans. P.E. Charvet (Cambridge: Cambridge University Press, 1972), p. 398.

85 Louise LeQuire, "Nashville and Will Edmondson: A Tribute," in *William Edmondson: A Retrospective* (Nashville: Tennessee Arts Commission, 1981), p. 47.

86 Jack L. Lindsey, "William Edmondson," *Folk Art*, vol. 20, no. 1 (Spring 1995), p. 44.

87 Romare Bearden and Harry Henderson, *A History of African-American Artists* (New York: Pantheon Books, 1993), p. 353.

88 *Will Edmondson's Mirkels* (Nashville: Tennessee Fine Arts Center at Cheekwood, 1964), n.p.

89 Bearden and Henderson, op. cit., p. 354.

90 Edmund L. Fuller, *Visions in Stone: The Sculpture of William Edmondson* (Pittsburgh: University of Pittsburgh Press, 1973), p. 6.

91 William H. Wiggins Jr., in *William Edmondson: A Retrospective*, op. cit., p. 32.

92 Louise LeQuire, "Edmondson's Art Reflect His Faith Strong and Pure," *Smithsonian*, vol. 12, no. 5 (August 1981), p. 55.

93 Lindsey, op. cit., p. 45.

94 John Michael Vlach, *By the Work of Their Hands: Studies in Afro-American Folklife* (Ann Arbor, Mich.: UMI Research Press, 1991), p. 124.

95 Lindsey, op. cit., p. 46.

96 Bearden and Henderson, op. cit., p. 353.

97 Puryear Mims, in a tribute to Edmondson, quoted by Louise LeQuire in *William Edmondson: A Retrospective*, p. 45.

98 Bearden and Henderson, op. cit.

99 Fuller, op. cit., p. 12.

CARTER RATCLIFF ON MORRIS HIRSHFIELD

100 Sidney Janis, *They Taught Themselves: American Primitive Painters of the 20th Century* (New York: The Dial Press, 1942), p. 20.

101 William Saroyan, *Morris Hirshfield* (Parma: Franco Maria Ricci, 1976), p. 20.

JOHN W. ROBERTS ON HORACE PIPPIN

102 Bearden and Henderson, op. cit., p. 356.

103 See Bearden and Henderson, op. cit.; Selden Rodman, *Horace Pippin: A Negro Painter in America* (New York: Quadrangle Press, 1947); Judith E. Stein, ed., *I Tell My Heart: The Art of Horace Pippin* (New York: Universe Publishing in association with the Pennsylvania Academy of the Fine Arts, 1993); and "Brushing With Greatness: The Search for Horace Pippin's Paintings," in *The Philadelphia Inquirer Magazine*, January 16, 1994. This observation applies not only to extended biographical discussions, but also to the numerous brief

notices concerning his work and exhibitions found in various short newspaper and magazine accounts.

[104] Rodman, op. cit., p. 14; Stein, *I Tell My Heart*, p. 8.

[105] See Roger D. Abrahams, "Phantoms of Romantic Nationalism in Folkloristics," in *Journal of American Folklore* 106 (Winter 1993), pp. 3–37; Gerald L. Davis, "Elijah Pierce, Woodcarver: Doves and Pain in Life Fulfilled," in *The Artist Outsider*; and Johannes Fabian, *Time and the Other: How Anthropology Makes Its Object* (New York: Columbia University Press, 1983).

[106] Fabian, *Time and the Other*; Jack Goody, *The Domestication of the Savage Mind* (New York: Cambridge University Press, 1977), pp. 25–35; John W. Roberts, "African American Diversity and the Study of Folklore," in *Western Folklore* 52 (1993), pp. 157–172.

[107] Houston A. Baker Jr., *Blues, Ideology, and Afro-American Literature: A Vernacular Theory* (Chicago: University of Chicago Press, 1984); Davis, op. cit.; Roberts, op. cit.

[108] Stein, op. cit., p. 2.

[109] Cornel West, "Horace Pippin's Challenge to Art Criticism," in Stein, op. cit., p. 46.

[110] David C. Driskell, "Introduction," in Stein, op. cit., p. xii.

[111] Baker, op. cit.; Henry Louis Gates Jr., *The Signifying Monkey: A Theory of Afro-American Literary Criticism* (New York: Oxford University Press, 1988).

[112] Stein, op. cit., p. 16.

[113] Fabian, "Keep Listening: Ethnography of Reading," in *The Ethnography of Reading*, ed. Jonathan Bayarin (Berkeley, Calif.: University of California Press, 1992), p. 86.

[114] Ibid.

JANE KALLIR ON GRANDMA MOSES

[115] For a detailed analysis of Grandma Moses' rise to fame and the attendant critical response, see Jane Kallir, *Grandma Moses: The Artist Behind the Myth* (New York: Clarkson N. Potter in association with The Galerie St. Etienne, 1982).

[116] The folk art boom of the 1930s was inspired by a desire to connect with European modernism at a time when America had not yet developed a native avant-garde. As is revealed in numerous contemporary press accounts, American-trained artists were indignant when they were passed over in favor of their European colleagues or self-taught (hence allegedly inferior) countrymen. This animosity ultimately caused The Museum of Modern Art, and with it other members of the artworld establishment, to abandon their support of folk art in favor of the rising abstract expressionist school.

[117] Whereas trained artists are generally judged in part on the basis of their influence on colleagues, this is one of the many areas in which the folk art field reverses standard academic practice. Since a folk painter is supposed to be unique, influence on other artists is not considered a sign of merit.

NORMAN BROSTERMAN ON A.G. RIZZOLI

[118] Hernandez, Jo Farb, et al., *A.G. Rizzoli: Architect of Magnificent Visions* (New York: Harry N. Abrams in association with the San Diego Museum of Art, 1997). Anyone interested in Rizzoli can hardly miss this extensive treatment of his life and work.

LEE KOGAN ON PETER CHARLIE BESHARO

[119] Philip M. Kayal and Joseph M. Kayal, *Syrian Lebanese in America: A Study in Religion and Assimilation* (Boston: Twayne, 1975), p. 91.

[120] Ibid.

DERREL DE PASSE ON JOSEPH YOAKUM

[121] The major body of Yoakum's work was devoted to landscape. Portraits, usually of African American subjects (such as the drawing *This is of Chick Beaman, 1st End man with Williams & Walkers Minstrell Show in Years 1916 to 1930,* n.d.), constitute less than five percent of his output.

[122] Elihu Vedder, *The Digressions of V. Written for His Own Fun and That of His Friends* (Boston: Houghton Mifflin, 1910), p. 312.

[123] Interview with the artist's second cousin, Lora Rice Brewer, May 1994.

[124] As was typical of the period, Yoakum's birth was never recorded with the state of Missouri. His Social Security and Veterans Administration records, as well as his son Peter's 1912 birth certificate, indicate that the artist was born in 1890. The Federal Censuses for 1900 and 1910 list the year of his birth as 1891, however. Unfortunately, the Federal Census for 1890 was destroyed by fire. While Peter's birth certificate states that the artist was born in Ash Grove, Missouri, Yoakum's Veterans Administration file, dated October 4, 1946, indicates that Yoakum's birthplace was Springfield, Missouri.

[125] Interview with Jane Allen and Derek Guthrie, July 1994.

[126] The date of Joseph Yoakum's first marriage is recorded in Greene County, Missouri, Marriage Abstracts, Book D, p. 68.

[127] Interview with the artist's son Peter Yolkum, March 1994.

[128] Quoted in Jane Allen and Derek Guthrie, "Portrait of a Luckless Old Man: The Hard Times and Artistic Genius of Joseph E. Yoakum," in *Chicago Tribune Magazine* (10 December 1972), p. 33.

[129] Mary Baker Eddy, *Science and Health with Key to the Scriptures* (Boston: Allison V. Stewart, 1912).

[130] Lee Irwin, "Dreams, Theory, and Culture: The Plains Vision Quest Paradigm," in *American Indian Quarterly*, vol. 18, no. 2 (Spring 1994), p. 236.

[131] Quoted in Jared Flagg, *Washington Allston: Life and Letters* (New York: Charles Scribner's Sons, 1892), p. 198.

[132] Cottie Burland, *North American Indian Mythology* (London and New York: Hamilyn Publishing Group, 1965), p. 114.

[133] Quoted in Frederick E. Shearer, ed., *The Pacific Tourist* (New York: Adams & Bishop, Publishers, 1884).

WILLIAM A. FAGALY ON SISTER GERTRUDE MORGAN

[134] Interview with Regenia A. Perry, July 10, 1996. Perry, a friend and three-year correspondent of Sister Morgan, remembers Morgan telling her she had been married to a man, possibly named John, before she moved to New Orleans.

[135] Sister Gertrude Morgan, letter to Regenia A. Perry, December 4, 1972.

NAN BRESS ON EDDIE ARNING

[136] Although Arning lived in institutional settings for many years, it should be noted that schizophrenia, or dementia praecox, as it was formerly termed, was poorly understood at that time and often resulted in misdiagnosis.

[137] These efforts have no doubt been aided by Arning's habit of frequently attaching the original print source images to the back of his drawings.

[138] Arning's *Madonna with Child* was based on a color reproduction of a French painting, c. 1415–1420, in *Art News*, February 1966, p. 40. The cover story of this issue also features the pop artist Claes Oldenburg.

[139] Alexander Sackton, "Eddie Arning: The Man," in *Eddie Arning: Selected Drawings, 1964–1973*

(Williamsburg, Va.: The Colonial Williamsburg Foundation, 1985), p. 10.

KENNETH J. GERGEN ON EMERY BLAGDON
140 Dan Dryden and Don Christensen, "Grassroots Artist: Emery Blagdon," in *KGAA News*, vol. 8, no. 2 (1988), pp. 1–2.

141 David E. Nye, *The American Technological Sublime* (Cambridge: MIT Press, 1994).

NORMAN J. GIRARDOT ON HOWARD FINSTER
142 For the past several years, Finster has publicly talked about his plans to be "criminated." However, he has most recently (as of June 1997) capitulated to his wife's wishes that he receive a more conventional, and traditional, Christian burial in God's Good Earth. The "anticipatin' coffin" and full-length mirror remain as described.

ROBERT HOBBS ON THORNTON DIAL SR.
143 Thornton Dial, conversation with the author, September 2, 1995.

144 Fortunately, this proposal was refused because it was felt that underground water channels would soon spread the pollution throughout the area.

145 Thornton Dial, conversation with the author, April 20, 1996.

146 Sterling Brown, in James H. Cone, *The Spirituals and the Blues: An Interpretation* (New York: Orbis Books, 1991, reprint of The Seabury Press Edition, 1972), p. 98.

147 Richard J. Powell, *The Blues Aesthetic: Black Culture and Modernism* (Washington, D.C.: Washington Project for the Arts, 1989), p. 19.

148 William Ferris, *Blues from the Delta* (New York: Anchor Press/Doubleday, 1978), p. 31.

149 Ibid., p. 26.

150 Cornel West, *Prophesy Deliverance! An Afro-American Revolutionary Christianity* (Philadelphia: The Westminster Press, 1982), pp. 85ff.

151 Jeffrey Stewart, "Given the Blues," in Powell, op. cit., pp. 89ff.

152 Ferris, op. cit., p. 45.

153 Cone, op. cit., pp. 102ff.

154 Ibid., p. 104.

WENDY STEINER ON PURVIS YOUNG
155 Paula Harper, "Art as a Matter of Life and Death," in *Purvis Young* (Miami: Joy Moos Gallery, 1992), n.p.

156 Maria Elena Fernandez, "Hard Palette," *Miami Sun Sentinel*, 7 April 1993, p. 1E.

157 Ibid.

158 Ibid., p. 6E.

159 Ibid., p. 1E.

160 Elisa Turner, "Anguished Vision of Street Life Empowers Purvis Young Exhibition," *Miami Herald*, May 2, 1993.

161 Fernandez, op. cit., p. 6E.

TERESA PARKER ON LONNIE HOLLEY

[162] All Lonnie Holley quotes in this essay are from conversations with the artist, April 1997.

[163] Leah Atkins, *The Valley and the Hills: An Illustrated History of Birmingham and Jefferson County* (Woodland Hills, Ala.: Windsore Publications, 1981), p. 164.

[164] Loosely translated, *nkisi* (pl. *minkisi*) are "things that do things." The BaKongo of West Africa used these magic-filled, figurative and nonfigurative objects to effect change in their own and others' lives. In short, *minkisi* are "fabricated things, yet they can be invoked to produce desired effects, they have a will of their own, and they may willfully command the behavior of human beings" (Wyatt MacGaffey, "The Personhood of Ritual Objects: Kongo Minkisi," *Etnofoor*, vol. 3, no. 1 [1990], p. 45).

[165] Robert Farris Thompson, "Circle and the Branch: Renascent Kongo-American Art," in *Another Face of the Diamond: Pathways Through the Black Atlantic South* (New York: INTAR Latin American Gallery, Atlanta: New Visions Gallery, 1989), pp. 40–41. Italics mine.

CONTRIBUTORS

EMILY BARTON holds degrees in English from Harvard University and the Iowa Writers' Workshop. She is a frequent contributor to *The New York Times Book Review* and *Time Out New York*. Her work has appeared in *American Short Fiction*, and she recently received a grant from the Vogelstein Foundation to complete work on a novel.

MAURICE BERGER is a senior fellow at the Vera List Center for Art and Politics of the New School for Social Research in New York. He has taught, lectured, and written numerous articles on contemporary art, culture, and politics, and has contributed catalog essays to such institutions as the Solomon R. Guggenheim Museum, the Whitney Museum of American Art, and the Yale University Art Gallery. He is the author of *White Lies: Race and the Myths of Whiteness* (Farrar, Strauss & Giroux, 1998) and *How Art Becomes History* (HarperCollins, 1992), as well as editor of *The Crisis of Criticism* (The New Press, 1998) and co-editor of *Constructing Masculinity* (Routledge, 1995).

NAN BRESS has an M.A. in social sciences from the University of Chicago. She has worked at the Minnesota Humanities Commission and the Philadelphia Museum of Art, and has produced and directed several short films.

NORMAN BROSTERMAN is an architect, woodcarver, and collector, and the author of *Inventing Kindergarten* (Harry N. Abrams, 1997). In 1996 he co-curated and wrote the catalog essay for the traveling exhibition "Drawing the Future: Design Drawings for the 1939 New York World's Fair," organized for the Museum of the City of New York.

MARSHALL CURRY works in New York for a multimedia company that produces CD-ROMs, web pages, and computerized museum exhibits. He is currently designing a series of interactive documentaries on Native American history and culture for the Mashantucket Pequot Museum and Research Center, now under construction in Connecticut. He holds a degree in comparative religion from Swarthmore College.

ARTHUR C. DANTO is art critic for *The Nation* and Johnsonian Professor Emeritus of Philosophy at Columbia University. His most recent book is *After the End of Art* (Princeton University Press, 1996).

GERALD L. DAVIS, who died while this book was in production, was Professor of American Studies at the University of New Mexico and Rutgers University Professor Emeritus of Africana Studies. A folklorist, Davis wrote frequently on folk art topics, including African American expressive language performance and the African American in the American Southwest. Davis contributed essays to *Elijah Pierce: Woodcarver* (Columbus Museum of Art, 1993) and *The Artist Outsider: Creativity and the Boundaries of Culture* (Smithsonian Institution Press, 1994).

DERREL DE PASSE is a vice president of Varian Associates in Palo Alto, California. She previously served on the board of trustees of the San Jose Museum of Art. De Passe is the author of a forthcoming book on the life and art of Joseph Yoakum.

WILLIAM A. FAGALY is the assistant director for art at the New Orleans Museum of Art, with curatorial responsibilities for ethnographic art, contemporary art, and American self-taught art. During thirty years with NOMA, Fagaly has organized more than sixty exhibitions and has also served as guest curator at The Corcoran Gallery of Art in Washington, D.C., the Museum of American Folk Art in New York, and the Portland Art Museum in Oregon. He has written for many periodicals and journals, including *Art in America*, *Folk Art*, and *African Arts*.

KENNETH J. GERGEN is the Gil and Frank Mustin Professor of Psychology at Swarthmore College. He is the associate editor for both *Theory and Psychology* and *American Psychologist*. Among his many books on aspects of social psychology and cultural life are *Realities and Relationships* (Harvard University Press, 1995) and *The Saturated Self* (Basic Books, 1991).

NORMAN J. GIRARDOT is a professor of comparative religions in the Religion Studies Department at Lehigh University. He is a scholar of Taoism and Chinese religions and has published numerous books, essays, articles, and reviews on these subjects. He has also written on the cult phenomenon associated with Elvis Presley and has written extensively on American visionary folk art. He is the author and co-editor of *Natural Scriptures: Visions of Nature and the Bible in the Work of Hugo Sperger, Minnie and Garland Adkins, Jessie and Ronald Cooper, and Howard Finster* (Lehigh University Art Galleries, 1990).

MICHAEL D. HALL is an artist, critic, collector, and educator. From 1970 to 1990, he served as artist-in-residence/head of sculpture at the Cranbrook Academy of Art in Bloomfield Hills, Michigan. A distinguished scholar of contemporary folk art, Hall is the co-editor with Eugene W. Metcalf Jr. of *The Artist Outsider: Creativity and the Boundaries of Culture* (Smithsonian Institution Press, 1994) and the author of *Stereoscopic Perspective: Reflections on American Fine and Folk Art* (UMI Research Press, 1988). With Julie Hall, he assembled The Michael and Julie Hall Collection of American Folk Art, now in the collections of the Milwaukee Art Museum.

MARVIN HEIFERMAN is a partner in Lookout, a New York–based company that organizes exhibitions, produces illustrated books, and develops publications in collaboration with artists and cultural institutions. He has written extensively on photography and art issues for museums (including The Museum of Modern Art, the Whitney Museum of American Art, and the Stedelijk Museum) and various publications, including *Artforum* and *BOMB*.

ROBERT HOBBS has held the Rhoda Thalhimer Endowed Chair in American Art History at Virginia Commonwealth University since 1991. He is the author of numerous books, museum catalogs, and essays, including *Earl Cunningham: Painting an American Eden* (Harry N. Abrams, 1994). He is a contributor to the forthcoming publication *Souls Grown Deep: African American Vernacular Art of the South*. For the Michael C. Carlos Museum at Emory University

in Atlanta, he was the curator of "Thornton Dial: Remembering the Road."

JON IPPOLITO is an artist, curator, and writer with a particular interest in the way technology—whether traditional or cutting edge—affects the practice of art. Since 1991 he has served as an exhibition coordinator at the Solomon R. Guggenheim Museum, where he organized "Virtual Reality: An Emerging Medium" (1993) and events for "Rolywholyover A Circus" by John Cage (1994). He is the author of various exhibition catalog texts and a frequent contributor to such journals as *Flash Art International*, *art/text*, and *Guggenheim Magazine*.

JANE KALLIR is co-director of The Galerie St. Etienne in New York. She is the curator of many exhibitions for museums in the United States and abroad, including "Egon Schiele" (1994) at the National Gallery of Art and "Masters of Naive Art" (1989), which traveled to four museums in Japan. Kallir is a frequent lecturer and the author of numerous books, including *Egon Schiele: The Complete Works* (Harry N. Abrams, 1990), *Grandma Moses: The Artist Behind the Myth* (Clarkson N. Potter, 1982), and *The Folk Art Tradition: Naive Painting in Europe and the United States* (The Viking Press, 1982).

MASON KLEIN is an art historian and critic who lives in New York. He has taught and lectured at numerous institutions, including Hunter College, Brooklyn College, the New School for Social Research, and the School of Visual Arts. He is a frequent contributor to *Artforum*, *frieze*, *Arts Magazine*, and *World Art*. He has contributed a major essay, "Embodying Sexuality: Marcel Duchamp in the Realm of Surrealism," to *Modern Art and Society: An Anthology of Social and Multicultural Readings* (HarperCollins, 1994) and is currently completing a book on Duchamp.

LEE KOGAN is project coordinator of the exhibition "Self-Taught Artists of the 20th Century: An American Anthology" and the accompanying catalog. She is director of the Folk Art Institute at the Museum of American Folk Art in New York and an adjunct professor of art and art education at New York University. Kogan is

the author of several books and essays, and frequently lectures on folk art subjects.

JACK L. LINDSEY is curator of American Decorative Arts at the Philadelphia Museum of Art. He has organized many exhibitions, including "Selected Works by African American Artists" (1992) and "Community Fabric: African American Quilts and Folk Art" (1994). Lindsey has published essays on William Edmondson and African American folk art, and is a frequent contributor to *The Magazine Antiques* and *Folk Art*.

ELSA LONGHAUSER is co-curator of "Self-Taught Artists of the 20th Century: An American Anthology" and director of both the Goldie Paley Gallery and the Levy Gallery for the Arts in Philadelphia, at Moore College of Art and Design. Over the past sixteen years, she has organized exhibitions of such artists as Matt Mullican, Ray Johnson, Josef Hoffmann, Hanne Darboven, Terry Fox, Dan Graham, Marlene Dumas, Jean-Frédéric Schnyder, Martin Ramirez, and Adolf Wölfli.

JOHN L. MOORE has been senior visiting artist/associate professor in the Department of Art and Art History at Skidmore College since 1994. As an acclaimed artist, he has been the subject of numerous essays, articles, and exhibition catalogs. Moore has curated several exhibitions and has written many exhibition catalog essays.

JOACHIM NEUGROSCHEL has translated 160 books from French, German, Italian, Russian, and Yiddish, including works by Franz Kafka, Thomas Mann, and Sholem Aleichem. His reviews have appeared in *Artforum* and *Arts*, among others. In 1996 he was made a chevalier in France's Order of Arts and Letters.

TERESA PARKER is pursuing a master's degree in southern studies at the University of Mississippi's Center for the Study of Southern Culture. Specializing in southern folk art, she has done extensive fieldwork on artists living in the region. She holds a degree in English from Haverford College.

CARTER RATCLIFF is a contributing editor for *Art in America* and serves on the editorial advisory committee of *Sculpture*. He is the author of many

books, essays, and reviews—the most recent being *The Fate of a Gesture: Jackson Pollock and Postwar American Art* (Farrar, Straus & Giroux, 1996)—and a frequent contributor to *Art in America*, *Artforum*, and *Flash Art*. Ratcliff has also published two books of poetry, *Fever Coast* (Kulchur Press, 1973) and *Give Me Tomorrow* (Vehicle Editions, 1983), which was illustrated by Alex Katz.

JOHN W. ROBERTS is a professor of English at The Ohio State University in Columbus. He is a specialist in African American folklore whose writings include *From Trickster to Badman: The Black Folk Hero in Slavery and Freedom* (University of Pennsylvania Press, 1989); "African American Folklore," in the *Encyclopedia of African American Culture and History* (Macmillan, 1995); and "Representation of the Folk Hero in African American Vernacular Art," in the forthcoming publication *Souls Grown Deep: African American Vernacular Art of the South*. Roberts is president of the American Folklore Society.

PHILIP W. SCHER received his doctorate in anthropology and folklore from the University of Pennsylvania. He has conducted research and published on the Carnival in Trinidad and on West Indian culture in the diaspora.

ELLEN HANDLER SPITZ is currently Lecturer in the Department of Art at Stanford University. The author of many books on aesthetics and psychoanalysis, Spitz is currently writing on the psychological impact of images on young children. She has held major fellowships at the Getty Center, the Bunting Institute, and the Center for Advanced Study in the Behavioral Sciences.

JUDITH E. STEIN is a curator and critic with a Ph.D. in art history from the University of Pennsylvania. In 1994 she organized the exhibition "I Tell My Heart: The Art of Horace Pippin" for the Pennsylvania Academy of the Fine Arts. She is a frequent contributor to *Art in America*, *Art News*, and *The Philadelphia Inquirer*, and has written numerous catalog essays, including "Collaboration," in *The Power of Feminist Art* (Harry N. Abrams, 1994). In 1994 Stein received the Pew Fellowship in the Arts for writings on art.

WENDY STEINER is Richard L. Fisher Professor of English and chair of the English Department at the University of Pennsylvania. She is the author of many books, including *The Scandal of Pleasure: Art in an Age of Fundamentalism* (University of Chicago Press, 1995), and is a frequent contributor to *The New York Times, The London Independent, London Review of Books,* and *Art in America.*

ROBERT STORR is curator, Department of Painting and Sculpture, at The Museum of Modern Art. His exhibitions include "Dislocations" (1991) at The Museum of Modern Art, and "Robert Ryman: A Retrospective," co-curated with Nicholas Serota (1993) at The Museum of Modern Art and the Tate Gallery, London. He has written extensively on artists and art issues and is a frequent contributor to *Art in America, Artforum,* and *Art Journal.* Storr is the author of many books and exhibition catalogs and is currently preparing a monograph on Louise Bourgeois.

CAROL MILLSOM STUDER, who holds a Ph.D. in child development from Cornell University, recently retired as professor of education at New York University and is currently a graduate student at the Museum of American Folk Art's Folk Art Institute.

VICTOR STUDER recently retired from the Thomas J. Lipton Company, where he was director of tea research. He is currently enrolled in New York University's master's degree program in folk art studies and is writing his thesis on the Ohio folk artist Henry Church Jr. Studer serves on the advisory board of the Folk Art Society of America.

HARALD SZEEMANN is co-curator of "Self-Taught Artists of the 20th Century: An American Anthology." Since 1981 he has been an independent curator at Kunsthaus Zurich and a freelance curator for international museums. Szeemann organized documenta 5 (1972) and most recently the "4th Biennale de Lyon: 'L'Autre'" (1997). In 1989 he received the Prize of Art Cologne.

ANN TEMKIN is The Muriel and Philip Berman Curator of 20th Century Art at the Philadelphia Museum of Art. She co-curated the exhibitions "Constantin Brancusi" (1995) for the Philadelphia Museum of Art and the Musée national d'art moderne, Centre Georges Pompidou, in Paris, and "Thinking Is Form: The Drawings of Joseph Beuys" (1993) for the Philadelphia Museum of Art and The Museum of Modern Art.

JAY TOBLER lives and works in New York. He is a director at Barbara Gladstone Gallery and has written for *Flash Art, Art Issues,* and *frieze* magazines. He has been a collector and scholar of American folk art for the past ten years.

GERARD C. WERTKIN is director of the Museum of American Folk Art and an adjunct associate professor of art and art education at New York University. Wertkin has contributed essays to many exhibition catalogs and is an authority on the art, culture, and history of the Shakers and other religious communities.

LENDERS

Ackland Art Museum, The University of
North Carolina at Chapel Hill
Judith Alexander, Atlanta and New York
The Ames Gallery, Berkeley, California
Judith Mary Anderson, New York
The William S. Arnett Collection, Atlanta
Frances O. Babinsky, Chagrin Falls, Ohio
Didi and David Barrett, New York
Helen and Jack Bershad, Philadelphia
Edward V. Blanchard and M. Anne Hill, New York
Jill and Sheldon Bonovitz, Philadelphia
Lucinda W. Bunnen, Atlanta
John M. Cain, Crown Point, Indiana
Carnegie Museum of Art, Pittsburgh
Janice and Mickey Cartin, West Hartford,
Connecticut
Cheekwood Nashville's Home of Art and Gardens
Don Christensen, New York
Mr. and Mrs. J.M.O. Colton, Nashville
Columbus Museum of Art, Ohio
Deborah and Robert Cummins, Evanston, Illinois
Mr. and Mrs. Daniel W. Dietrich II,
Chester Springs, Pennsylvania
Dan Dryden, New York
Ralph O. Esmerian, New York
Sam and Betsey Farber, New York
Josh Feldstein, Gainesville, Florida
Fine Arts Museums of San Francisco
Fleisher/Ollman Gallery, Philadelphia
Henry Ford Museum & Greenfield Village,
Dearborn, Michigan
John and Sarah Freeman, Portland, Maine
Estelle E. Friedman, Washington, D.C.
Norbert and Gabrielle Gleicher, Chicago
Robert M. Greenberg, New York
Michael D. Hall, Hamtramck, Michigan
Carl Hammer Gallery, Chicago
Alvina and Paul Haverkamp, New Orleans
High Museum of Art, Atlanta
Hill Gallery, Birmingham, Michigan
Sandra Jaffe, New Orleans
Sidney Janis Gallery, New York
George Jevremovic, Philadelphia
Jane Kallir, New York
Kansas City Art Institute, Kansas City, Missouri
Phyllis Kind Gallery, New York and Chicago
John Michael Kohler Arts Center,
Sheboygan, Wisconsin

Kiyoko Lerner, Chicago
Nathan Lerner Living Trust, Chicago
Richard Levine, Miami
Jack L. Lindsey, Philadelphia
The Robert Lynch Collection of The Daisy Thorpe
Gallery at North Carolina Wesleyan College
Frank Maresca, New York
The Metropolitan Museum of Art, New York
Milwaukee Art Museum, Wisconsin
Mrs. Alexis Pierce Moore, Florissant, Missouri
Matt Mullican and Valerie Smith, New York
Museum of American Folk Art, New York
The Museum of Modern Art, New York
National Museum of American Art, Smithsonian
Institution, Washington, D.C.
Jim Nutt and Gladys Nilsson, Wilmette, Illinois
David T. Owsley, New York
The Anthony Petullo Collection of Self-Taught &
Outsider Art, Milwaukee, Wisconsin
Philadelphia Museum of Art
Patrice I. Pluto, New York
Ricco/Maresca Gallery, New York
Lisa Roberts and David Seltzer, Philadelphia
Margaret and John Robson, San Francisco
Abby Aldrich Rockefeller Folk Art Center at
Colonial Williamsburg
Trace Rosel, New York
Luise Ross Gallery, New York
Robert A. Roth, Chicago
Selig D. Sacks, New York
San Francisco Museum of Modern Art
Eleanor Sandresky, New York
Judy A. Saslow, Chicago
Amr Shaker, Geneva, Switzerland
Joseph D. and Janet M. Shein, Merion, Pennsylvania
Myron Shure Collection, Chicago
Linda and Ray Simon, New York
Dr. Siri von Reis, New York
Joan T. Washburn Gallery, New York
Westmoreland Museum of Art, Greensburg,
Pennsylvania
Whitney Museum of American Art, New York
John Wieland Homes, Atlanta
Jeffrey Wolf and Jeany Nisenholz-Wolf, New York
Private collections: New York, New Jersey,
Ohio, Pennsylvania

TIMELINE

COMPILED BY LEE KOGAN AND PHILIP W. SCHER

This timeline—consisting of two components, *Art and Artists*, and *History, Literature, and Popular Culture*—serves as an aid in contextualizing the works of the artists presented in this volume and in the exhibition that it documents.

Items in bold cite events important to the various art fields in the twentieth-century. The rest of the timeline is meant to evoke the eras in which the artists produced their works and to indicate some of their influences. The decision as to which events and moments to include is necessarily subjective. Moments cited are intended to suggest important periods and are not in themselves necessarily events of isolated importance. For instance, the successful atomic tests at Alamogordo are symbolic of the birth of the atomic era. Other important dates from that time would equally invoke the atomic era. But what is vital here is the inauguration of an era significant in the history of the United States, an era that figures prominently in the works of several of the exhibition's artists. It is the aim of the compilers to provide some sense of the momentous events to which the artists and their catalog biographers refer, either implicitly or explicitly.

The larger component, *Art and Artists*, focuses on the artists' lives and the important events happening concurrently in the world of art, especially in the rebellious enclaves of the avant-garde. The development of a field centered on the works of self-taught artists cannot be understood apart from consideration of the political and artistic agendas of progressive "mainstream" artists. Thus to extract the history of self-taught artists from the broader art-historical canon would obscure some of the most important relationships occurring in the American artistic communities of the twentieth century. In keeping with the spirit of both the exhibition and the catalog, this timeline provides a skeleton form that is intended to be provocative, open-ended, and multidisciplinary. The possibilities for discovering fruitful parallels, new relationships, and fresh perspectives from and for these artists' works are expanded by such a format. The timeline is an open invitation to read these works in a multiplicity of contexts.

Art and Artists
History, Literature, and Popular Culture

1829	T.D. Rice begins performing his "Jump Jim Crow," leading to the great success of the entertainment form known as minstrelsy, which was also perhaps the most popular music of the mid-nineteenth century
1830	First U.S. Railroad, the Baltimore & Ohio, established
1836	**Henry Church Jr. born, Chagrin Falls, Ohio**
1842	P.T. Barnum opens Barnum's American Museum in New York City, beginning a long tradition of sideshows and circus "freaks"
1848	Elizabeth Cady Stanton and Lucretia Mott organize first women's rights convention in the United States at Seneca Falls, New York
	The Fox sisters, Kate and Margaret, hear tapping noises in their home in Hydesville, New York; interest in the phenomenon grows, and American Spiritualism is born
1851	Herman Melville's *Moby Dick* published
1853	New York Crystal Palace holds the first American World's Fair

1854 Henry David Thoreau's *Walden, or Life in the Woods* published

1855 Walt Whitman's *Leaves of Grass* published

1856 **Bill Traylor born, near Benton, Alabama**

1857 *Banner of Light*, the major Spiritualist publication, publishes first issue
Dred-Scott Case, in which the Supreme Court rules that an African American cannot sue his owner because he is not a citizen and that the Missouri Compromise was unconstitutional, makes the Civil War all but inevitable

1860 **Grandma Moses born, Greenwich, New York**
John Kane born, West Calder, Scotland

1863 Lincoln issues Emancipation Proclamation during the Civil War, freeing the slaves in the "rebel" states

1865 Lee surrenders at Appomattox Court House, ending the Civil War

1866 13th Amendment passed, abolishing slavery in America
Ku Klux Klan founded

c. 1870 **William Edmondson born, Davidson County, near Nashville, Tennessee**

1872 **Morris Hirshfield born, Russia Poland**

1876 Alexander Graham Bell invents the telephone

1878 Thomas Edison patents his phonograph

1879 Church of Christ, Scientist, founded in Boston by Mary Baker Eddy

 Edgar Alexander McKillop born, Cooper's Gap Township, Polk County, North Carolina

1883 Brooklyn Bridge completed after fourteen years of construction

1884 Ringling Brothers open their first show, which becomes the largest and most successful circus in America
Mark Twain's *The Adventures of Huckleberry Finn* published

1885 **Jesse Howard born, Shamrock, Missouri**

1886 Statue of Liberty installed in New York Harbor

1888 **Henry Church Jr. opens Church's Art Museum at Geauga Lake Park, near Chagrin Falls, Ohio**
Horace Pippin born, West Chester, Pennsylvania
American Folklore Society, Boston, founded

1889 Photography becomes a popular hobby after the Eastman Company markets its new "roll" film

1890 **Joseph Yoakum born, Ash Grove, Missouri**

1891	Massacre of more than 250 Sioux at Wounded Knee, South Dakota; U.S. Census Bureau announces that the frontier has ceased to exist
1892	**Elijah Pierce born, Baldwyn, Mississippi** **Henry Darger born, Chicago** **Justin McCarthy born, Weatherly, Pennsylvania**
1893	First U.S. automobile built by the Duryea brothers Popular magazines, the only medium capable of reaching a national audience, begin to revolutionize mass communications; *McClure's* magazine established, *Munsey's* begins to rely heavily on advertising revenue as opposed to subscription fees Chicago hosts the World's Columbian Exposition
1894	**Alois Riegl, Viennese art historian, writes short thesis on the characteristics of folk art defined as "the sum total of the traditional art forms common to a particular group"**
1895	**Martin Ramirez born, Jalisco, Mexico** **William L. Hawkins born, Union City, near Lexington, Kentucky** Richard Felton Outcault produces *The Yellow Kid* comic strip for the *New York World*, essentially defining the newspaper comic strip
1896	**Andrew Carnegie helps to found the Carnegie International, an annual exhibition of contemporary painting** **A.G. Rizzoli born, Port Reyes, Marin County, California** **William Morris, the initiator of the arts and crafts movement, dies** Billy Sunday begins massive evangelical crusade, which sweeps the nation Plessy v. Ferguson, in which the Supreme Court rules that separate but equal accommodations are constitutional, supports segregation
1898	**Peter Charlie Besharo born, Syria (Lebanon)** **Eddie Arning born, Germania, Texas**
1899	**New York State Historical Association, Cooperstown, New York, founded**
1900	**Sister Gertrude Morgan born, Lafayette, Alabama** **Nellie Mae Rowe born, Fayetteville, Georgia**
c. 1900	Initial appearance of music called the blues, which in the 1920s made its way through the Mississippi Delta region
1903	**Stewart Culin, curator of ethnology at Brooklyn Institute Museum, organizes several exhibitions that look at folk art aesthetically and contextually** Wright Brothers' first successful flight at Kitty Hawk, North Carolina
1904	**Edgar Tolson born, Lee City, Kentucky** **Steve Ashby born, Delaplane, Virginia** **Several young German artists calling themselves *der Brücke* ("the Bridge") break with the academy and are among the first to appreciate aboriginal art**

1905 Buddy Boldon, considered by many to be the first jazz musician, is at height of popularity in New Orleans

1906 **Henri Rousseau becomes acquainted with Delauney, Picasso, and Apollinaire**

1907 **Emery Blagdon born, Callaway, Nebraska**
Picasso sees African sculpture for the first time at the Ethnographic Museum at the Palais du Trocodero; his artistic vision is altered (reflected in *Les demoiselles d'Avignon*)
Leroy Person born, Occhineechee Neck, North Carolina
Electra Havemeyer Webb, daughter of Henry O. and Louisine Havemeyer, collectors of European art, purchases a carved cigar store Indian for $15

1908 **Henry Church Jr. dies**

Christian Science Monitor begins publication

1909 **The Newark Museum, Newark, New Jersey, founded by John Cotton Dana**

Sigmund Freud lectures on psychoanalysis in the United States

1910 **Walpole Society, for collectors interested in the decorative arts, organized**
Eugene Von Bruenchenhein born, Marinette, Wisconsin

c. 1910 **Charles Sheeler begins to study Pennsylvania folk art and architecture and Shaker design, which influence his work**
Henry Darger begins his 15,000-page epic, *The Story of the Vivian Girls in What is Known as the Realms of the Unreal or the Glandelinian War Storm or the Glandico-Abbienian Wars as Caused by the Child Slave Rebellion*

1911 **Wassily Kandinsky, Franz Marc, and others combine their interest in folk and ethnographic art with their own art in the journal *Der Blaue Reiter* ("The Blue Rider") in Munich**

1912 **Kandinsky, in "On the Spiritual in Art," looks to the "primitives" for the expression of internal truths**

1913 **Marcel Duchamp creates his first ready-made, *The Bicycle Wheel***
"International Exhibition of Modern Art" at the 69th Regiment Armory in New York introduces modern art to the American public
Ogunquit School of Painting and Sculpture, Ogunquit, Maine, organized by Hamilton Easter Field, writer and painter; participants include Marsden Hartley, Bernard Karfiol, Yasuo Kuniyoshi, Gaston Lachaise, Robert Laurent, and Niles Spencer

Henry Ford introduces the moving assembly line in automobile production

1914 **Alfred Stieglitz's Gallery 291 exhibits so-called Negro art, emphasizing objects' aesthetic characteristics**

1915 *Birth of a Nation* released

1916 **Howard Finster born, Valley Head, Alabama**
Henry Chapman Mercer, curator of American and prehistoric archaeology at the University of Pennsylvania, builds and endows a museum in Doylestown to preserve and house a collection of 24,000 utensils and implements illustrating the industrial history of America

1917 **William A. Blayney born, Claysville, Pennsylvania**

United States, under President Wilson, enters World War I
The Original Dixieland Jazz Band makes first recordings for Victor

1919 **Allen H. Eaton, field secretary of the American Federation of Arts, directs "Art and Crafts of the Homelands" in Buffalo, New York, the first of several dozen exhibitions focusing on ethnic and regional traditions**

c. 1919 **Sculptor Elie Nadelman and his wife, Viola, begin to collect European and American folk objects and by 1926, open a museum on their Riverdale-on-Hudson estate**

1920 **Hamilton Easter Field organizes *Arts* magazine**
Roger Fry, art critic, writes of the form and techniques of "Negro sculpture" in an essay of the same name, and forms a basis for a general modern aesthetic

19th Amendment ratified, granting women the right to vote
First radio station opens in Pittsburgh
Carl Sandburg's *Smoke and Steel* published
Langston Hughes' first published poem, "The Negro Speaks of Rivers," appears in *The Crisis*, the NAACP journal edited by W.E.B. DuBois
Mamie Smith is first black jazz/blues singer to be featured on a record

1921 **The first *Oxford English Dictionary* citation of the term "folk art"**

1922 **Hans Prinzhorn, psychotherapist and art historian, gathers approximately 5,000 drawings that become the basis of his book, *Die Bildnerei der Geisteskranken* ("Creative Imagery of the Mentally Ill")**

First recording by Louis Armstrong with the King Oliver Orchestra in Chicago

1924 **Folk art selected by Henry Schnakenberg, painter, first seen publicly at the Whitney Studio Club in "Early American Art"**
"Early American Portraits and Landscapes" at Valentine Dudensing's New York gallery

MID-1920s **The Harlem Renaissance, an African American cultural regeneration noted in literary, dramatic, musical, and visual arts in northern urban centers**

George Gershwin's *Rhapsody in Blue* performed
Vladimir Kosma Zworykin patents a basic model television

c. 1925 **Simon Rodia, an Italian immigrant, begins building his Watts Towers in Los Angeles**

1927 **Paintings by John Kane debut in the annual juried Carnegie International Exhibition**

Charles Lindbergh makes first solo transatlantic flight
The Jazz Singer, starring Al Jolson, first motion picture with sound

1928 **Thornton Dial Sr. born, Emelle, Alabama**

Steamboat Willie, the first Mickey Mouse animated short, opens at the Colony Theater in New York City to sensational success
Jimmie Rodgers, considered by many to be the father of country music, records for RCA

1929 **The Museum of Modern Art, New York, opens**

Edith Gregor Halpert begins to sell folk art at the Downtown Gallery; among her early clients is Abby Aldrich Rockefeller

Stock market crashes, plunging America into the Great Depression

1930 The Whitney Museum of American Art, New York, founded
"Exhibition of American Folk Painting in Connection with the Massachusetts Tercentenary" (with accompanying catalog) organized by Lincoln Kirstein, John Walker, and Edward M. Warburg, three undergraduate members of the Harvard Society for Contemporary Art
"American Primitives: An Exhibit of the Paintings of Nineteenth Century Folk Artists" organized by Holger Cahill, at The Newark Museum

1931 "American Folk Sculpture: The Work of Eighteenth and Nineteenth Century Craftsmen," organized by Holger Cahill, at The Newark Museum

Empire State Building completed

1932 "Art of the Common Man in America 1750–1900," which includes paintings and sculptures borrowed from the collection of Abby Aldrich Rockefeller, organized by Holger Cahill, acting director, at The Museum of Modern Art

Franklin Delano Roosevelt elected President, promises recovery

1934 John Kane dies

1935 Holger Cahill appointed national director of the Federal Art Project, a New Deal program to support artists during the Depression; part of the program is *The Index of American Design*, containing thousands of watercolor paintings of popular objects made before 1890

Five-billion-dollar Emergency Relief Appropriation helps to establish the Works Progress Administration and Social Security, among other programs
George Gershwin's opera *Porgy and Bess* is heard in New York
Woody Guthrie, considered one of the fathers of folk music, composes "So Long, It's Been Good to Know Yah," a song about leaving the Dust Bowl

1936 Joseph Cornell's work included in "Fantastic Art, Dada, Surrealism" at The Museum of Modern Art

Modern Times, starring Charlie Chaplin, released

1937 National Gallery of Art, Washington, D.C., founded
George H. Straley, reporter for West Chester, Pennsylvania's *Daily Local News*, sees two paintings by Horace Pippin in a store window and calls them to the attention of Christian Brinton, president of the Chester County Art Association, and illustrator N.C. Wyeth
Louise Dahl-Wolfe, photographer, "discovers" William Edmondson's carvings and brings them to the attention of Alfred H. Barr Jr., director of The Museum of Modern Art
Twelve works by William Edmondson exhibited at The Museum of Modern Art, marking the first one-man museum exhibition by an African American artist

Golden Gate Bridge, San Francisco, completed

1938 Grandma Moses' paintings consigned to a "women's exchange" in Hoosick Falls, New York, where they attract the attention of Louis Caldor, an engineer and collector who then gathers support for the artist and her work from Otto Kallir, a New York gallery owner

"Masters of Popular Painting: Modern Primitives of Europe and America," organized by Holger Cahill, at The Museum of Modern Art

Superman, created by Jerry Siegel and Joe Shuster, makes first appearance

1939 Charles Shannon and other idealistic young artists in Montgomery, Alabama, form the New South Art Center to promote the contemporary visual arts, theater, and literature

Charles Shannon meets Bill Traylor on Monroe Street in Montgomery only a few weeks after Traylor begins to draw regularly

Abby Aldrich Rockefeller presents a portion of her extensive folk art collection to the Colonial Williamsburg Foundation

"Contemporary Unknown American Painters," featuring works by Morris Hirshfield and Grandma Moses, organized by Sidney Janis, at The Museum of Modern Art

World War II begins in Europe

Wizard of Oz released

Marian Anderson, a Philadelphia-born African American opera singer, is barred from singing at Constitution Hall, instead gives historic concert at the Lincoln Memorial

1940 Alain Locke, African American author, addresses the issue of race and its importance in culture in his book *The Negro Art: A Pictorial Record of the Negro Artist and of the Negro Theme in Art*, which includes four works by Horace Pippin

Bill Traylor has his first one-person exhibition, at the New South Art Center in Montgomery, Alabama

Grandma Moses has her first one-woman exhibition, "What a Farm Wife Painted," at The Galerie St. Etienne, New York

1940-1941 Jacob Lawrence, classically trained African American artist, paints sixty panels entitled *The Migration of the Negro*, detailing the migration of African Americans to northern industrial centers before World War II

1941 Japanese attack Pearl Harbor, United States enters World War II

1942 *They Taught Themselves*, a book developed by Sidney Janis as an extension of an exhibition held in 1939 in which sixteen new talents were introduced, published

Enrico Fermi builds first nuclear reactor

The first electronic brain, or automatic computer, developed in the United States

1943 Jackson Pollock has his first one-person show at Peggy Guggenheim's New York gallery

Purvis Young born, Liberty section of Miami, Florida

1945 War in Europe ends at Reims, France

Successful test of atomic bomb at Alamogordo, New Mexico

Atomic bombs dropped on Hiroshima and Nagasaki, killing more than 100,000 people

1945-1950 Paintings by Grandma Moses exhibited in the annual juried Carnegie International Exhibition

1946 Horace Pippin dies

Old Sturbridge Village, a historic village museum, founded in Sturbridge, Massachusetts

Morris Hirshfield dies

Allen Rankin, reporter, writes about Bill Traylor's art and life in *Collier's Magazine*

Winston Churchill delivers "Iron Curtain" speech in Fulton, Missouri, helping to define the Cold War

1947 **Ken Grimes born, New York City**
Martin Ramirez shows his drawings to psychotherapist Tarmo Pasto, DeWitt State Hospital, Auburn, California

Jackie Robinson joins the Brooklyn Dodgers, becoming the first black baseball player in the major leagues

1948 **Jean Dubuffet defines the concept of "art brut" as spontaneous, highly inventive art by "obscure people outside professional artistic circles" and organizes the Compagnie de l'Art Brut to seek out and document artworks that meet his stringent criteria**
Seminars on American culture launched at the New York State Historical Association, Cooperstown, under the leadership of Louis Jones, specialist in folk culture and director of the association

1949 **Grandma Moses awarded Women's National Press Club Award "For Outstanding Accomplishments in the Arts" by President Harry S Truman**
Grandma Moses receives honorary doctorate from Russell Sage College in Troy, New York
Bill Traylor dies

1950 **"What is American Folk Art? A Symposium" published in the May issue of *Antiques* magazine**
Edgar Alexander McKillop dies
Lonnie Holley born, Birmingham, Alabama

The Weavers score a number-one hit with their rendition of "Goodnight Irene"; the folk music revival hits its stride

1951 **William Edmondson dies**
Dubuffet delivers a long-remembered "anti-cultural" lecture at the Arts Club in Chicago

1952 **Grandma Moses' autobiography *My Life's History* published**

Ralph Ellison's *Invisible Man* published

1953 **Edgar William and Bernice Chrysler Garbisch initiate their gift, which, by 1980, includes more than 300 American naive paintings and approximately 100 works on paper, to the National Gallery of Art**
The Museum of International Folk Art, Santa Fe, New Mexico, founded

1954 In Brown v. Board of Education of Topeka, U.S. Supreme Court overturns Plessy v. Ferguson in a historic strike against Jim Crow laws

1955 Martin Luther King Jr. leads boycott of Montgomery, Alabama, transit company to protest segregation on buses
Sun Records releases Elvis Presley's "That's All Right, Mama," which some call the first rock and roll record, to overwhelming response in Memphis
Disneyland opens to the public in Anaheim, California

1956 Allen Ginsberg's poem "Howl" published

1957	**The Abby Aldrich Rockefeller Folk Art Center opens in Williamsburg, Virginia**
	Leonard Bernstein composes *West Side Story*, an American musical based on Shakespeare's *Romeo and Juliet* that focuses on the challenges of contemporary urban daily life
1958	**Edward Duff Balken, curator of prints at the Carnegie Institute, donates 565 folk paintings to his alma mater, Princeton University**
	Stephen Clark, Chairman of the Board of the New York State Historical Association, purchases 175 pictures for that organization from the estate of collector Mrs. William J. Gunn
1959	**The Solomon R. Guggenheim Museum, New York, founded in 1937, opens in a building designed by Frank Lloyd Wright**
1960s	**A group of experimental young artists called both The Hairy Who and the Chicago Imagists becomes interested in twentieth-century self-taught artists**
1960	**Grandma Moses' 100th birthday declared "Grandma Moses Day" by New York Governor Nelson Rockefeller**
	Peter Charlie Besharo dies
1961	**Grandma Moses dies**
	Artists Sterling and Dorothy Strauser begin to collect paintings by Justin McCarthy, whose work they saw a year earlier at the annual Outdoor Art Fair in Stroudsburg, Pennsylvania
	"The Art of Assemblage," exhibition of found objects, opens at The Museum of Modern Art
	Museum of American Folk Art (formerly Museum of Early American Folk Art) founded in New York; its first curator, Herbert Waide Hemphill Jr., plays a major role in fostering appreciation for contemporary folk art using an aesthetic approach
	Telstar, first private communications satellite, launched
1962	Death of Marilyn Monroe propels her from actress to twentieth-century icon
	Cuban Missile Crisis
1963	**Martin Ramirez dies**
	Henry Darger begins to compose his 2,600-page autobiography, *The History of My Life*
	John F. Kennedy assassinated
	Betty Friedan's *The Feminine Mystique* published
1964	Congress passes Civil Rights Act, banning racial discrimination, especially in employment and public accommodations
	The Beatles conquer America with "I Want to Hold Your Hand"
1965	**The Graduate Program in American Folklore and Folklife begins at the New York State Historical Association**
1967	**The Studio Museum in Harlem founded**
	Woody Guthrie dies
	Jack Kerouac's *On the Road* published
1968	**Whitney Halstead, teacher at the Art Institute of Chicago, begins to collect the work of Joseph Yoakum**
	Jim Nutt, a Chicago artist teaching at Sacramento State College, finds reproductions and actual drawings made by patients in psychiatric institutions

Martin Luther King Jr. and Robert F. Kennedy assassinated
2001: A Space Odyssey released

1969 **Paintings by Justin McCarthy in "American Naive Painting: Twentieth Century" at Zabriskie Gallery, New York**

Apollo II lands on the moon, Neil Armstrong becomes first man to walk on its surface
The three-day Woodstock Music and Art Fair in Bethel, New York
Easy Rider released

1970 **"Twentieth-Century Folk Art and Artists," organized by Herbert Waide Hemphill Jr., at the Museum of American Folk Art**

1971 **Boris Gruenwald, student in sculpture at Ohio University, "discovers" Elijah Pierce; later that year arranges an exhibition of Pierce's work at the Krannert Art Museum of the University of Illinois, Urbana-Champaign**

1972 **Roger Cardinal, in the book *Outsider Art*, uses Jean Dubuffet's definition of art brut and expands the meaning**
 Joseph Yoakum dies

1973 **Henry Darger dies**
 Carvings by Edgar Tolson are shown in the Whitney Biennial

Vietnam War cease-fire signed

1974 **"Naives and Visionaries" at the Walker Art Center, Minneapolis, Minnesota, examines folk art environments**
 "The Flowering of American Folk Art" (with accompanying catalog) at the Whitney Museum of American Art, focuses on folk art from an aesthetic point of view
 Kansas Grassroots Art Association organized to document grassroots art
 Herbert Waide Hemphill Jr. and Julia Weissman publish *Twentieth-Century American Folk Art and Artists*, in which they discuss 145 identified and 59 anonymous artists

President Richard M. Nixon resigns his presidency after Watergate scandal
Alex Haley's *Roots* airs on national television

1976 **_Art Brut_, by Michel Thévoz, published**
 "200 Years of American Sculpture" (with accompanying catalog) celebrates the nation's bicentennial at the Whitney Museum of American Art

1977 **After more than a decade, Robert Bishop, director of the Museum of American Folk Art, succeeds in building a collection of twentieth-century paintings and sculpture**
 Justin McCarthy dies
 Kenneth Ames, cultural historian, organizes "Beyond Necessity: Art in the Folk Tradition" at the Brandywine River Museum, Chadds Ford, Pennsylvania, arguing for consideration of art as a social activity
 "Perspectives on American Folk Art," a three-day conference held at The Henry Francis duPont Winterthur Museum, extends the parameters of folk art scholarship

Star Wars released

LATE 1970S **Graffiti influences American artists such as Jean-Michel Basquiat and Keith Haring**

1980 **"American Folk Painters of Three Centuries," at the Whitney Museum of American Art, includes works by Henry Church Jr., Morris Hirshfield, and Horace Pippin**

Elijah Pierce receives honorary doctorate in fine arts from Franklin University in Columbus, Ohio
Sister Gertrude Morgan dies
Steve Ashby dies
Artist Lee Garrett recognizes the talent of William L. Hawkins and brings his artwork to the attention of knowledgeable dealers and museum professionals
Folk Art Finder newsletter publishes first issue

1981 A.G. Rizzoli dies
"Transmitters: The Isolate Artist in America," organized by Elsa S. Wiener [Longhauser], at the Philadelphia College of Art

MTV goes on the air

1982 Nellie Mae Rowe dies
"Black Folk Art in America 1930–1980," at the Corcoran Gallery of Art, Washington, D.C., examines work of twenty African American artists
Saving and Preserving Arts and Cultural Environments (SPACES) issues first newsletter

1983 "American Folk Art: Expressions of a New Spirit" at the Museum of American Folk Art and international tour
Jesse Howard dies
Eugene Von Bruenchenhein dies
Howard Finster appears on *The Tonight Show*, hosted by Johnny Carson

1984 Edgar Tolson dies
Elijah Pierce dies
"'Primitivism' in 20th Century Art: Affinity of the Tribal and the Modern" at The Museum of Modern Art, juxtaposes tribal and modern art

Apple's Macintosh computer introduced, transforming digital culture and heralding the information age

1985 William A. Blayney dies
Leroy Person dies
"A Time to Reap: Late Blooming Folk Artists," at Seton Hall University, features works by fifty elderly self-taught artists
"Ape to Zebra: A Menagerie of New Mexican Woodcarvings/The Animal Carnival Collection of the Museum of American Folk Art" features a portion of Elizabeth Wecter's gift to the museum of contemporary animal carvings, including the works of many southwestern masters

1986 Emery Blagdon dies
National Museum of American Art, Smithsonian Institution, acquires, by gift and purchase, 378 objects from the collection of Herbert Waide Hemphill Jr.
"Muffled Voices: Folk Artists in Contemporary America," organized by Didi Barrett for the Museum of American Folk Art at the PaineWebber Art Gallery, New York, focuses on 28 twentieth-century American self-taught artists
The Names Memorial Project, organized as an advocacy group to help raise funds for research in the fight against AIDS, incorporates the quilt in its program as a symbol of healing and remembrance

1987 First issue of *Folk Art Messenger* published by the newly organized Folk Art Society of America

1989 The inaugural exhibition "Five Star Folk Art" heralds the opening of the newly constructed Eva and Morris Feld Gallery of the Museum of American Folk Art and includes work of twentieth-century self-taught artists

Raw Vision, an international journal, publishes first issue

The Milwaukee Art Museum acquires, by gift and purchase, 273 objects from the Michael and Julie Hall Collection of American Folk Art

1990 "The Cutting Edge: Folk Art from the Rosenak Collection," including works by contemporary self-taught artists, opens at the Museum of American Folk Art, accompanied by Chuck and Jan Rosenak's *Museum of American Folk Art Encyclopedia of Twentieth-Century American Folk Art and Artists*, featuring entries for 244 artists

William L. Hawkins dies

The Contemporary Arts Center, Cincinnati, Ohio, and its director, Dennis Barry, are indicted for obscenity, but later found not guilty, for exhibiting 175 photographs by Robert Mapplethorpe

"Made with Passion: The Hemphill Folk Art Collection in the National Museum of American Art" at the National Museum of American Art, Smithsonian Institution

Vincent van Gogh's *Portrait of Dr. Gachet* sells at auction for $82.5 million, the most money paid at auction for a painting

1991 Intuit: The Center for Intuitive and Outsider Art (formerly Society for Outsider, Intuitive, and Visionary Art) formed in Chicago

1992 "Parallel Visions: Modern Artists and Outsider Art," at the Los Angeles County Museum of Art, examines the influence of visionary artists on a number of trained artists

"Free Within Ourselves," a traveling exhibition, features the works of thirty-one African American artists from the collection of the National Museum of American Art

1993 Eddie Arning dies

"Passionate Visions of the American South: Self-Taught Artists from 1940 to the Present" at the New Orleans Museum of Art

Outsider Art Fair presented for the first time, by Sanford L. Smith and Associates, at the Puck Building in New York

"Uncommon Artists," an annual symposium sponsored by the Museum of American Folk Art and held in conjunction with the Outsider Art Fair, presented for the first time

"Thornton Dial: Image of the Tiger," a one-person exhibition, at the Museum of American Folk Art and The New Museum of Contemporary Art, New York

The World Wide Web, a graphics-intensive application of the Internet—a global network of computers communicating in a common language—takes off

1995 American Visionary Art Museum, Baltimore, Maryland, opens

"A World of Their Own: Twentieth-Century American Folk Art," organized by Joseph Jacobs, at The Newark Museum

Lonnie Holley's sculpture *Leverage* presented in an exhibition at the White House garden, at the invitation of Hillary Clinton

Philip Glass' *The Voyage*, an opera exploring space travel, time, and science, at the Metropolitan Opera, New York

1996 "Souls Grown Deep: African American Vernacular Art of the South" at City Hall East, Atlanta

1997 National Museum of American Art, Smithsonian Institution, acquires, by gift and purchase, 220 objects from the collection of Chuck and Jan Rosenak

1998 "Self-Taught Artists of the 20th Century: An American Anthology," organized by Elsa Longhauser and Harald Szeemann for the Museum of American Folk Art, opens at the Philadelphia Museum of Art

CHECKLIST OF THE EXHIBITION

Height precedes width precedes depth.
Artists' spellings are retained in titles.

HENRY CHURCH JR.
Still Life [p. 45]
 c. 1895–1900
 Oil on canvas
 26 × 38"
 Collection of Frances O. Babinsky

A Friend in Need Is a Friend Indeed [p. 9]
 1885
 Stone and iron
 Approx. 40 × 84 × 16"
 Collection of Frances O. Babinsky

The Monkey Picture [p. 46]
 c. 1895–1900
 Oil on canvas
 28 × 44"
 Abby Aldrich Rockefeller Folk Art Center,
 Williamsburg, Virginia, 1981.103.1

Self-Portrait with Five Muses [p. 47]
 c. 1880
 Oil on composition board
 29 3/4 × 23 1/2" oval
 Courtesy Joan T. Washburn Gallery,
 New York

Angel of Night [p. 44]
 n.d.
 Stone
 18 × 11 × 12"
 Collection of Frances O. Babinsky

JOHN KANE
Self-Portrait [p. 51]
 1929
 Oil on canvas over composition board
 36 1/8 × 27 1/8"
 The Museum of Modern Art, New York
 Abby Aldrich Rockefeller Fund

Seen in the Mirror [p. 49]
 1928
 Oil on canvas
 8 1/2 × 6 3/4"
 Collection of Janice and Mickey Cartin

The Girl I Left Behind [p. 50]
 1920
 Oil on board
 15 3/8 × 11 1/8"
 Collection of Janice and Mickey Cartin

Highland Hollow [p. 48]
 c. 1930–1935
 Oil on canvas
 26 1/2 × 36 1/2"
 Carnegie Museum of Art, Pittsburgh
 Gift of Mary and Leland Hazard, 1961
 61.2.1

Monongahela River Valley [pp. 52–53]
 1931
 Oil on canvas
 28 × 38"
 The Metropolitan Museum of Art
 Bequest of Miss Adelaide Milton
 de Groot (1876–1967), 1967,
 67.187.164

EDGAR ALEXANDER McKILLOP
Hippoceros [p. 24]
 c. 1928–1929
 Black walnut, glass eyes, leather tongue,
 bone teeth, tusks, plastic nostrils, and
 Victrola works
 58 1/4" wide
 Abby Aldrich Rockefeller Folk Art Center,
 Williamsburg, Virginia, 61.701.15

Mountain Lion [p. 54]
 c. 1940s
 Black walnut, bone, and glass eyes
 9 5/8 × 7 × 24 1/4"
 Milwaukee Art Museum
 Gift of Mr. and Mrs. Robert Beal and
 Isabelle Polacheck

Man Holding an Eagle [p. 55]
 c. 1928–1929
 Black walnut, bone, and glass eyes
 52 × 13 × 18"
 From the Collections of Henry Ford Museum
 & Greenfield Village

Man with a Snake [p. 56]
 c. 1926–1933
 Black walnut, glass eyes, bone teeth, and
 painted bone fang
 22 × 10 1/4 × 15 1/8"
 Ackland Art Museum, The University
 of North Carolina at Chapel Hill,
 Ackland Fund

Cane
 c. 1930
 Black walnut with tack eyes and burnt wood
 decoration
 43"
 Private collection

BILL TRAYLOR
Untitled *(Two Dogs)*
 1939–1942
 Poster paint on paper
 21 1/2 × 22"
 Collection of Judy A. Saslow

Untitled *(Man and Large Dog)* double-sided [p. 59]
 1939–1942
 Pencil and poster paint on cardboard
 28 × 22"
 Courtesy Luise Ross Gallery, New York

Untitled *(Running Rabbit)*
 1939–1942
 Poster paint on cardboard
 12 3/4 × 21 1/4"
 Collection of Edward V. Blanchard and
 M. Anne Hill

Untitled *(Black Jesus)* [p. 17]
 1939–1942
 Gouache and pencil on cardboard
 13 3/4 × 10"
 The Metropolitan Museum of Art
 Promised gift of Charles E. and Eugenia
 C. Shannon, 1995, L.1995.38.10

Untitled *(Black Seated Figure)* [p. 61]
 1939–1942
 Pencil and poster paint on cardboard
 14 1/2 × 8"
 Courtesy Luise Ross Gallery, New York

Untitled *(Geometric Pot)*
 1939–1942
 Poster paint on paper
 22 1/2 × 22 1/2"
 Collection of Jill and Sheldon Bonovitz

Untitled *(Two Animals)*
 1939–1942
 Poster paint on paper
 15 × 26"
 Collection of Judy A. Saslow

Untitled *(Boxers)*
 1939–1942
 Poster paint on paper
 20 1/2 × 22"
 Collection of Judy A. Saslow

Untitled *(Radio)* [p. 60]
 1939–1942
 Poster paint and pencil on cardboard with
 gold paint
 32 × 24 1/2"
 Collection of Judy A. Saslow

Untitled *(Ross the Undertaker)*
 1939–1942
 Pencil and poster paint on cardboard
 14 × 14 1/2"
 Private collection

Untitled *(Man with Cat)*
 1939–1942
 Pencil and colored pencil on paper
 15 1/2 × 12"
 Private collection

Untitled *(Fighting Dogs)* [p. 58]
 1939–1942
 Poster paint and pencil on cardboard
 27 1/2 × 22"
 Collection of Patrice I. Pluto

Untitled (Black Elephant with a Brown Ear)
1939–1942
Poster paint and pencil on paper
14 5/8 × 25 3/4"
High Museum of Art, Atlanta
T. Marshall Hahn Jr. Collection, 1997.113

Untitled (Figures with Pitchfork)
1939–1942
Crayon on cardboard
12 1/2 × 15 1/2"
Private collection, New York

Untitled (Lamps on Mantelpiece)
1939–1942
Poster paint on cardboard
10 3/4 × 7 1/2"
Courtesy Luise Ross Gallery, New York

Untitled (Blue Spotted Cat)
1939–1942
Poster paint and pencil on cardboard with
string
13 1/2 × 12 1/4"
Private collection

Untitled (Runaway Goat Cart)
1939–1942
Poster paint and pencil on cardboard
14 1/8 × 22 1/4"
Collection of Jill and Sheldon Bonovitz

WILLIAM EDMONDSON
Untitled (Noah's Ark) [p. 64]
c. 1930
Limestone
22 1/4 × 16 1/4 × 14 3/4"
Collection of Robert M. Greenberg

Untitled (Seated Girl with Cap) [p. 65]
c. 1935
Limestone
21 × 7 × 10 1/2"
Collection of Mr. and Mrs. J.M.O. Colton

Untitled (Crucifix) [p. 66]
c. 1940
Limestone
20 1/2 × 14 3/4 × 14 1/2"
Collection of Robert M. Greenberg

Untitled (Bess and Joe)
c. 1940
Limestone
17 × 20 1/8 × 10 1/2"
Cheekwood Nashville's Home of Art
and Gardens
Museum purchase through the bequest of
Anita Bevill McMichael Stallworth and gift
of Salvatore J. Formosa Sr., Mrs. Pete A.
Formosa Sr., Angelo Formosa Jr., and Mrs.
Rose M. Formosa Bromley in loving memory
of Angelo Formosa Sr. and wife Mrs.
Katherine St. Charles Formosa, and Pete A.
Formosa Sr.

Untitled (Woman with Muff)
c. 1940
Limestone
15 1/2 × 6 1/2 × 6 3/4"
Private collection

Untitled (Bird)
1934–1941
Limestone
7 1/4 × 7 1/2 × 4 3/4"
San Francisco Museum of Modern Art
Albert M. Bender Collection
Bequest of Albert M. Bender

Untitled (Three Doves) [p. 62]
c. 1935–1940
Limestone
7 1/4 × 10 1/4 × 6"
Collection of Jill and Sheldon Bonovitz

Untitled (Talking Owl)
1937
Limestone
22 3/4 × 8 × 20"
Collection of Estelle E. Friedman

MORRIS HIRSHFIELD
Beach Girl [p. 69]
1937–1939; dated 1937
Oil on canvas
36 1/4 × 22 1/4"
The Museum of Modern Art, New York
The Sidney and Harriet Janis Collection

Waterfalls [p. 68]
 1940
 Oil on canvas
 20 × 28"
 Private collection

Girl with Angora Cat [p. 71]
 1944
 Oil on canvas
 36 × 28"
 Private collection

HORACE PIPPIN
The Buffalo Hunt [p. 76]
 1933
 Oil on canvas
 21 ¼ × 31"
 Whitney Museum of American Art,
 New York. Purchase, 41.27

Christ Before Pilate [p. 72]
 1941
 Oil on fabric
 20 × 24"
 Collection of Joseph D. and Janet M. Shein

Birmingham Meeting House III
 1941
 Oil on fabric
 15 × 20"
 Private collection

The Trial of John Brown [pp. 74–75]
 1942
 Oil on canvas
 16 ⅛ × 20 ⅛"
 Fine Arts Museums of San Francisco
 Gift of Mr. and Mrs. John D. Rockefeller 3rd
 1979.7.82

Abe Lincoln, The Great Emancipator [p. 36]
 1942
 Oil on canvas
 24 × 30"
 The Museum of Modern Art, New York
 Gift of Helen Hooker Roelofs

Mr. Prejudice [p. 73]
 1943
 Oil on canvas
 18 × 14"
 Philadelphia Museum of Art
 Gift of Dr. and Mrs. Matthew T. Moore
 1984.108.1

GRANDMA MOSES
The Burning of Troy [p. 78]
 c. 1939
 Oil on Masonite
 9 × 11 ¼"
 Private collection
 Courtesy The Galerie St. Etienne, New York

The Thunderstorm [p. 80]
 1948
 Oil on Masonite
 20 ¾ × 23 ¾"
 Private collection
 Courtesy The Galerie St. Etienne, New York

The Quilting Bee [p. 82]
 1950
 Oil on Masonite
 20 × 24"
 Private collection
 Courtesy The Galerie St. Etienne, New York

Halloween [p. 81]
 1955
 Oil on Masonite
 18 × 24"
 Private collection
 Courtesy The Galerie St. Etienne, New York

Old Times [p. 83]
 1957
 Oil on Masonite
 16 × 24"
 Private collection
 Courtesy The Galerie St. Etienne, New York

A.G. RIZZOLI

Mother Symbolically Recaptured/The Kathredal [p. 85]
 1937
 Colored inks on rag paper
 30 1/8 × 50 1/4"
 Courtesy The Ames Gallery, Berkeley,
 California

The Ornament [p. 85]
 1936
 Colored inks on rag paper
 17 7/8 × 8 7/8"
 Private collection

The Y.T.T.E. Plot Plan—
Fourth Preliminary Study [p. 84]
 1938
 Colored inks on rag paper
 38 1/4 × 24 1/4"
 Courtesy The Ames Gallery, Berkeley,
 California

The Primalglimse at Forty [p. 86]
 1938
 Colored inks on rag paper
 54 × 26 5/8"
 Courtesy The Ames Gallery, Berkeley,
 California

Shirley Jean Bersie Symbolically Sketched/
Shirley's Temple [p. 87]
 1939
 Colored inks on rag paper
 37 3/4 × 23 7/8"
 Courtesy The Ames Gallery, Berkeley,
 California

A.T.E. Contents
 1935–1943
 Colored inks on rag paper
 19 × 14 11/16"
 Courtesy The Ames Gallery, Berkeley,
 California

Mr. O.A. Deichmann's Mother Symbolically
Sketched/Toure D'Longevity
 1938
 Colored inks on rag paper
 59 × 29"
 Courtesy The Ames Gallery, Berkeley,
 California

The Shaft of Ascension
 1939
 Colored inks on rag paper
 21 1/16 × 13"
 Courtesy The Ames Gallery, Berkeley,
 California

Brother Lou and Sister Palmira Lievre Symbolically
Sketched/Palais Pallou
 1941
 Colored inks on rag paper
 25 3/4 × 35 3/4"
 Courtesy The Ames Gallery, Berkeley,
 California

Emma Rizzoli, the artist's mother
 1934
 Black-and-white photograph
 3 × 5"
 Courtesy The Ames Gallery, Berkeley,
 California

JUSTIN McCARTHY

Miss Margaret Porter of New York Wearing a
Simply Designed Bathing Suit at Palm Beach [p. 89]
 1921
 Watercolor and graphite on newsprint
 11 15/16 × 9"
 Private collection

Worker Bee
 c. 1923
 Pen and ink, graphite, and watercolor on
 paper
 8 7/8 × 11 5/8"
 Private collection

Queen Elizabeth [p. 89]
 c. 1960
 Oil on Masonite
 21 1/2 × 28 1/2"
 Collection of Norbert and Gabrielle Gleicher

Clothes Make the Woman [pp. 90–91]
 c. 1963
 Oil on Masonite
 24 1/2 × 36 1/2"
 Collection of Linda and Ray Simon

Washington Stadium (Umpire's View)
1963
Oil on Masonite
24 × 32 ¼"
Collection of Edward V. Blanchard and
M. Anne Hill

Candlelight in Acapulco Ice Follies 1964 [pp. 92–93]
n.d.
Oil on Masonite
32 × 35 ¾"
Museum of American Folk Art, New York
Gift of Elias Getz, 1981.7.4

Spanky and Dave Pitts Ice Capades 1964
1965
Oil on Masonite
24 ½ × 16"
Collection of George Jevremovic

Rio de Janeiro [p. 88]
n.d.
Gouache and ink on brown paper
21 × 27"
Collection of Didi and David Barrett

ELIJAH PIERCE
Crucifixion [p. 97]
Mid-1930s
Carved and painted wood with glitter;
mounted on wood panel
47 ½ × 30 ½"
Columbus Museum of Art, Ohio
Museum purchase

Louis vs. Braddock [p. 96]
n.d.
Carved and painted wood relief with glitter;
mounted on painted corrugated cardboard
21 ½ × 23"
Collection of Jeffrey Wolf and Jeany
Nisenholz-Wolf

The Wise and Foolish Virgins and Four Other Scenes
Before 1971
Carved and painted wood relief with glitter
39⅜ × 29¾
Akron Art Museum, Akron ,Ohio
Museum Acquisition Fund and funds donated
by Beatrice K. McDowell and The Graves
Foundation

My Sayings
n.d.
Carved wood relief with paint, marking pen,
and graphite; on plywood back
25 ⅞ × 40 ⅞"
Columbus Museum of Art, Ohio
Museum purchase

Archie Griffin [p. 95]
1976
Carved and painted wood with glitter
16 ⅛ × 14 ⅛ × 3 ⅝"
Columbus Museum of Art, Ohio
Museum purchase

Music Box [p. 94]
n.d.
Carved and painted figures inside commercial
wood box
9 ¼ × 15 ¼ × 7"
Collection of John and Sarah Freeman

Preaching Stick
1950
Carved and painted wood with rhinestones
36 × 1 ⅜" diameter
Collection of Mrs. Alexis Pierce Moore

Father Time Racing
1959
Carved and painted wood relief with glitter
13 × 29"
Private collection
Courtesy Keny Galleries, Columbus, Ohio

Horse and Rider
n.d.
Carved and painted wood with chain
and thumbtacks
13 × 16 ⅞ × 3"
Columbus Museum of Art, Ohio
Museum purchase

MARTIN RAMIREZ
Untitled [frontispiece]
c. 1950
Graphite, tempera, and crayon on paper
110 × 51"
Collection of Jim Nutt and Gladys Nilsson

Untitled [p. 98]
c. 1953
Graphite, tempera, crayon, and collage on
paper
36 × 90 1/4"
Collection of Jim Nutt and Gladys Nilsson

Untitled [p. 100]
c. 1950
Graphite, tempera, crayon, and collage on
paper
32 × 60 1/2"
Collection of Jim Nutt and Gladys Nilsson

Untitled [p. 101]
c. 1950
Graphite, tempera, and crayon on paper
46 × 36"
Collection of Jim Nutt and Gladys Nilsson

Untitled [p. 99]
c. 1950
Graphite and tempera on paper
27 3/4 × 23 7/8"
Collection of Jim Nutt and Gladys Nilsson

Untitled
c. 1950
Graphite and tempera on paper
30 × 24"
Collection of Jim Nutt and Gladys Nilsson

Untitled
c. 1950
Graphite and tempera on paper
34 × 24"
Collection of Jim Nutt and Gladys Nilsson

Untitled
c. 1950
Graphite and tempera on paper
24 1/2 × 24"
Collection of Jim Nutt and Gladys Nilsson

Untitled
c. 1950
Graphite and tempera on paper
24 5/8 × 24"
Collection of Jim Nutt and Gladys Nilsson

Untitled
c. 1950
Graphite and tempera on paper
35 1/8 × 24"
Collection of Jim Nutt and Gladys Nilsson

Untitled
c. 1950
Graphite and tempera on paper
28 1/2 × 23 3/4"
Collection of Jim Nutt and Gladys Nilsson

Untitled
c. 1950
Graphite and tempera on paper
29 3/4 × 23 3/4"
Collection of Jim Nutt and Gladys Nilsson

Untitled
c. 1950
Graphite, tempera, crayon, and collage on
paper
65 × 38 1/2"
Collection of Jim Nutt and Gladys Nilsson

Untitled
c. 1950
Graphite, tempera, and crayon on paper
77 × 25 1/2"
Collection of Jim Nutt and Gladys Nilsson

Untitled
c. 1953
Graphite and tempera on paper
86 × 36"
Collection of Jim Nutt and Gladys Nilsson

HENRY DARGER
Untitled (*The Way Out*)
n.d.
Mixed media on pieced paper
24 × 110"
Collection of Kiyoko Lerner, 2 E

Untitled (*Out of the Cave/Pursued by Forest Fires/
Fear of Rats and Mice*) [pp. 104–105]
n.d.
Mixed media on pieced paper
19 × 70"
Collection of Kiyoko Lerner, 62

Untitled (*At Sunbeam Creek/Two Adventures at Torrington*) [pp. 104–105]
 n.d.
 Mixed media on pieced paper
 19 × 71"
 Collection of Kiyoko Lerner, 106

Untitled (*2000 Feet Below; 22 at Jennie Richee at Hard Fury*) [p. 21]
 double-sided, recto/verso
 n.d.
 Watercolor, pencil, and carbon tracing on pieced paper
 17 3/4 × 47 1/4"
 Collection of Robert M. Greenberg

Untitled (*At Jennie Richee the Blunder of One of the Glandelinian Rug Carriers*)
 n.d.
 Mixed media on pieced paper
 19 × 71"
 Collection of Robert M. Greenberg

Untitled (*Watching the Storm through Windows*) [p. 104]
 n.d.
 Mixed media on pieced paper
 19 × 70"
 Collection of Dr. Siri von Reis

Untitled (*Two Spangled Blengins*)
 n.d.
 Mixed media on paper
 14 × 17"
 Collection of Kiyoko Lerner, 523 B

Untitled (*Sacred Heart Explosion*)
 n.d.
 Mixed media on pieced paper
 19 × 49"
 Collection of Kiyoko Lerner, 129

Untitled (*Young Tuskerhorian*)
 n.d.
 Mixed media on paper
 14 × 17"
 Collection of Nathan Lerner Living Trust, 542 B-F

Untitled (*After M Whirther Run/ At 5 Norma Catherine*)
 n.d.
 Mixed media on pieced paper
 23 × 36 1/2" sight
 Collection of Sam and Betsey Farber

Untitled (*Calverinia*) [p. 102]
 n.d.
 Watercolor and collage on paper
 7 × 8"
 Collection of Nathan Lerner Living Trust, 14 F-B

Untitled (*Almost Murdered Themselves/After the Massacre/Witness Frightful Massacre; Vivian Girls and Glandelinian Tent*) double-sided, recto/verso
 n.d.
 Mixed media on pieced paper
 22 × 89"
 Collection of Kiyoko Lerner, 6 E

Untitled (*The Main National Flag of Abbieannia*)
 n.d.
 14 × 17"
 Watercolor and collage on paper
 Collection of Nathan Lerner Living Trust, 14 F-O

Untitled (*Untill Rescued by Angelinians*)
 n.d.
 Mixed media on pieced paper
 19 × 34 1/2"
 Collection of Nathan Lerner Living Trust, 126

Untitled (*At Phelantonberg. What They Saw; Scare Glandelinian Soldiers by Making Peculiar Cries*) double-sided, recto/verso
 n.d.
 Mixed media on pieced paper
 19 × 48"
 Collection of Nathan Lerner Living Trust, 127

Untitled (At Jennie Richee They Allow Themselves
to be Captured; At Norma Catherine They Are
Recaptured) double-sided, recto/verso
n.d.
Mixed media on pieced paper
22 × 86"
Collection of Nathan Lerner Living
Trust, 202

Untitled (They Try to Get Away with the Enemy
Plans/Kids on Horseback)
n.d.
22 × 42"
Mixed media on pieced paper
Collection of Nathan Lerner Living
Trust, 334

Untitled (Map of Angelinia Ayathas Battlefield)
n.d.
Mixed media on kraft paper
24 × 69"
Collection of Nathan Lerner Living
Trust, 600 G

PETER CHARLIE BESHARO

Untitled (Eve with Spirits) [p. 107]
n.d.
Oil on paper
23 × 29"
Collection of Janice and Mickey Cartin

Untitled (Nome Sone)
n.d.
Oil on paper
23 × 29"
Private collection

Untitled (Mary Power Hibernated) [p. 108]
n.d.
Oil on canvas
17 × 24 1/4"
Collection of Helen and Jack Bershad

Untitled (Infant & Children)
n.d.
Paint on paper
22 1/16 × 28 1/16"
Courtesy Phyllis Kind Gallery, New York
and Chicago

Untitled (Atomic Power) [p. 106]
n.d.
Mixed media on board
15 × 27"
Collection of Robert M. Greenberg

Untitled (Wars)
n.d.
Oil on paper
22 × 28 1/2"
Courtesy Phyllis Kind Gallery, New York
and Chicago

Untitled (All-Seeing Eye) [p. 109]
n.d.
Oil on canvas
28 1/2 × 53"
Collection of Josh Feldstein

Untitled (Hounted Rosery 100/100)
n.d.
Oil on canvas
23 × 29"
Collection of Janice and Mickey Cartin

JOSEPH YOAKUM

e.s. Valentin Crater [p. 114]
1964
Crayon, pen, and watercolor on paper
19 × 24"
Collection of Sam and Betsey Farber

Idaho Falls Braintree Pass [p. 113]
n.d.
Ballpoint pen and watercolor on paper
8 × 10"
Collection of Jim Nutt and Gladys Nilsson

Mt Horeb of Mt Sini Range of Canaan Asia
on palestine [p. 111]
c. 1966
Crayon, pen, and watercolor on paper
12 × 18"
Collection of Amr Shaker
Courtesy Fleisher/Ollman Gallery,
Philadelphia

The Three Great Falls in Missouri River near Great Falls Montana [p. 110]
n.d.
Colored pencil and pen on paper
19 × 12"
Collection of Edward V. Blanchard and
M. Anne Hill

This is of Chick Beaman, 1st End man with Williams & Walkers Minstrell Show in Years 1916 to 1930 [p. 112]
1968
Ballpoint pen, graphite, and colored pencil
on paper
15 1/2 × 11 3/4"
Collection of Jim Nutt and Gladys Nilsson

Assie De La Hotte
1960
Pencil on paper
11 7/8 × 11 7/8"
Courtesy Fleisher/Ollman Gallery,
Philadelphia

Trinita Valley Between Texas and Arizona
1964
Ballpoint pen and pencil on paper
12 × 18"
Collection of Jim Nutt and Gladys Nilsson

Mt. Kheio 4,167 ft Near Bangkok Thailand of asia
1965
Ballpoint pen and colored pencil on paper
12 × 18"
Collection of Jim Nutt and Gladys Nilsson

Lake Maude in North Center of Lakeland Florida
1965
Ballpoint pen, fountain pen, and colored
pencil on paper
12 1/8 × 19 1/16"
Collection of Jim Nutt and Gladys Nilsson

Los Osos. Valley Baywood Park San Luis Obispo County California
c. 1968
Ballpoint pen and watercolor on paper
8 × 10"
Collection of Jim Nutt and Gladys Nilsson

Central Portion of Grand Canyons Ground Floor Space in Arizona Section
1968
Ballpoint pen and colored pencil on paper
12 1/4 × 19 1/16"
Collection of Jim Nutt and Gladys Nilsson

The Cyclone that Struck Susanville California in Year of 1903
1970
Felt-tip pen, ballpoint pen, and colored pencil
on paper
12 1/8 × 19 1/16"
Collection of Jim Nutt and Gladys Nilsson

Movie Actress and Actor Lucille Haggerman Died in air Crash with Rudolph Valentina Near Hollywood California in 1920
n.d.
Ballpoint pen and colored pencil on paper
15 1/2 × 11 13/16"
Collection of Jim Nutt and Gladys Nilsson

Crater Head Mtn, in Andes Mtn Range Near Santiag Chile, South America
n.d.
Ballpoint pen, pencil, and colored pencil
on paper
17 15/16 × 23 15/16"
Collection of Jim Nutt and Gladys Nilsson

P.M. WENTWORTH
Untitled (*Rays of White on the/Cross*) [p. 119]
1951
Pastel, pencil, charcoal, and mixed media on
paper
17 × 22"
Collection of Robert M. Greenberg

Untitled (*11/22/53 / 6 PM*) [p. 118]
1953
Charcoal, gouache, and pastel on paper
14 1/2 × 22"
Collection of Robert M. Greenberg

Untitled (*Sea of Galilee*)
c. 1955
Pencil, crayon, and tempera on paperboard
29 3/4 × 25 1/4"
Collection of Jim Nutt and Gladys Nilsson

Untitled (Moses—Tabernacle—Foot of Mount Sinia)
[p. 116]
 c. late 1950s
 Pencil, crayon, and tempera on paper
 17 × 22"
 Collection of Jim Nutt and Gladys Nilsson

Untitled (Body and Messages in the Clouds,
and on Earth)
 c. late 1950s
 Pencil on paperboard
 30 × 25 1/2"
 Collection of Jim Nutt and Gladys Nilsson

Untitled (Planets)
 c. late 1950s
 Pencil and crayon on paperboard
 30 × 25 1/2"
 Collection of Jim Nutt and Gladys Nilsson

Untitled ([Crucifixion] Mt. Calvary)
 c. late 1950s
 Pencil, crayon, and tempera on paperboard
 30 × 25 1/2"
 Collection of Jim Nutt and Gladys Nilsson

Untitled (Lazarus/Tomb/Bethany)
 n.d.
 Mixed media on paper
 18 × 24"
 Courtesy Phyllis Kind Gallery, New York
 and Chicago

Untitled (Imagination/Creation of the/World)
[p. 117]
 n.d.
 Mixed media on paper
 30 × 25 1/2"
 Collection of Matt Mullican and
 Valerie Smith

EUGENE VON BRUENCHENHEIN

PHOTOGRAPHS, 1940S

Portrait of the Artist's Wife, Marie (Reclining)
 Gelatin-silver print, hand-tinted
 6 1/4 × 9 3/4"
 Milwaukee Art Museum
 Gift of Christopher Goldsmith

Composite Portrait of the Artist's Wife, Marie
 Gelatin-silver print
 9 7/8 × 7 3/8"
 Milwaukee Art Museum
 Gift of Christopher Goldsmith

Untitled [p. 124]
 Gelatin-silver print
 10 × 8" (image: 9 3/8 × 7 1/4")
 John Michael Kohler Arts Center,
 Sheboygan, Wisconsin
 1984.10.278

Untitled
 Gelatin-silver print, hand-tinted
 10 × 8" (image: 10 × 6 7/8")
 John Michael Kohler Arts Center,
 Sheboygan, Wisconsin
 1984.10.276m

Untitled
 Gelatin-silver print, hand-tinted
 10 × 8" (image: 9 1/8 × 7 1/8")
 John Michael Kohler Arts Center,
 Sheboygan, Wisconsin
 1984.10.275d

Eugene Thinks of Marie: Montage by Eugene [p. 123]
 Gelatin-silver print from multiple negatives;
 handwritten text
 10 × 8" (image: 10 × 5 5/8")
 John Michael Kohler Arts Center,
 Sheboygan, Wisconsin
 1984.10.276b

Untitled
 Gelatin-silver print, hand-tinted
 10 × 8" (image: 7 × 6 1/4")
 John Michael Kohler Arts Center,
 Sheboygan, Wisconsin
 1984.10.274k

Untitled (Marie Montage, Gazing upward, Imposed
upon Clouded Sky)
 Montage photograph
 8 × 10"
 Myron Shure Collection

Untitled (*Marie Leaning Right, Long Pearls around Neck and Midriff, Floral Set*)
Cyantone photograph
2 ³/₄ × 4"
Courtesy Carl Hammer Gallery, Chicago

Untitled (*Marie Seated, Gazing upward, Long Pearls and Panties, Floral Set*)
Black-and-white photograph
2 ³/₄ × 4 ¹/₂"
Courtesy Carl Hammer Gallery, Chicago

Untitled (*Marie Standing, Hands on Hips, Side View, Nude, Striped Set*)
Gelatin-silver print
8 × 10"
Courtesy Carl Hammer Gallery, Chicago

Marie
Gelatin-silver print
2 ¹/₂ × 3"
Courtesy Carl Hammer Gallery, Chicago

Marie
Gelatin-silver print
10 × 8"
Courtesy Carl Hammer Gallery, Chicago

PAINTINGS

To Marie
1977
Oil on wood panel
37 ³/₄ × 23 ⁵/₈"
John Michael Kohler Arts Center,
Sheboygan, Wisconsin

Untitled (*H Bomb*) [p. 31]
1954
Oil on paperboard
21 × 26"
Milwaukee Art Museum
Gift of Friends of Art

Untitled (*Stone and Steel/A Vast Construction/Rainbow Complex*)
1978
Oil on cardboard
39 × 39"
Milwaukee Art Museum
Gift of Friends of Art

BONE CHAIRS, LATE 1960s

Untitled
Chicken and turkey bones, glued and painted
8 ³/₈ × 5 × 4 ³/₄"
John Michael Kohler Arts Center,
Sheboygan, Wisconsin
1984.10.291

Untitled
Chicken and turkey bones, glued and painted
5 ⁵/₈ × 3 ³/₈ × 3 ¹/₄"
John Michael Kohler Arts Center,
Sheboygan, Wisconsin
1984.10.290

Untitled
Chicken and turkey bones, glued and painted
7 ¹/₄ × 3 ⁵/₈ × 3 ³/₄"
John Michael Kohler Arts Center,
Sheboygan, Wisconsin
1984.10.289

Untitled
Chicken and turkey bones, glued and painted
7 ⁵/₈ × 4 ³/₄ × 4 ¹/₂"
John Michael Kohler Arts Center,
Sheboygan, Wisconsin
1984.10.287

Untitled
Chicken and turkey bones, glued and painted
6 ⁷/₈ × 3 ⁷/₈ × 4 ³/₄"
John Michael Kohler Arts Center,
Sheboygan, Wisconsin
1984.10.288

Untitled [p. 125]
Chicken and turkey bones, glued and painted
8 ⁷/₈ × 4 ¹/₂ × 4 ¹/₂"
John Michael Kohler Arts Center,
Sheboygan, Wisconsin
1984.10.4

BONE TOWERS, 1970s

Untitled [p. 121]
Chicken and turkey bones, glued and painted
33 ¹/₂ × 10 ¹/₂ × 10 ¹/₂"
Collection of Jill and Sheldon Bonovitz

CERAMIC CROWNS, LATE 1960s AND 1970s

Untitled
Paint on clay
8 ½ × 7 ¼" diameter
Collection of Jill and Sheldon Bonovitz

CERAMIC VESSELS, 1960s–1980s

Untitled [p. 120]
Paint on clay
13 × 6 × 6"
Collection of Jill and Sheldon Bonovitz

Untitled
Paint on clay
11¾ × 6½" diameter
Collection of Jill and Sheldon Bonovitz

Untitled
Paint on clay; metal jar lid base
12 × 5" diameter
Collection of Jill and Sheldon Bonovitz

Untitled
1963
Paint on clay; metal jar lid base
12 × 5 ½" diameter
Collection of Jill and Sheldon Bonovitz

CONCRETE MASKS, 1960s

Untitled (Blue Headdress Surrounding Golden Face)
[p. 122]
1960
Painted concrete relief
35 × 22 × 7"
Courtesy Carl Hammer Gallery, Chicago

Untitled (Headdress Design—Corinthian Pattern)
1960
Concrete relief
32 ½ × 24 × 4"
Courtesy Carl Hammer Gallery, Chicago

Untitled (White and Red Headdress Surrounding
Small Male Face with Goatee)
1960–1962
Painted concrete relief
31 × 19 ½ × 7"
Courtesy Carl Hammer Gallery, Chicago

Untitled (Headdress Surrounding Large Male Face
with Pronounced Nose "Ugloos")
1960
Painted concrete
41 × 29 ¾ × 7"
Courtesy Carl Hammer Gallery, Chicago

JESSE HOWARD
Untitled (The Patience of Job) [p. 128]
1953
Mixed media
64 × 57 × 19"
Kansas City Art Institute, Kansas City,
Missouri

Untitled (The Voice of the Bird) [p. 129]
1955
Painted wood and metal corn planter
37 × 56 × 18"
Kansas City Art Institute, Kansas City,
Missouri

Untitled (The Lord Saith Vengeance) [p. 127]
1960
Paint on metal drum lid
22 ¼" diameter
Kansas City Art Institute, Kansas City,
Missouri

Untitled (Eisenhower Says Peace) [p. 126]
1953–1960
Paint on Masonite
20 × 48"
Kansas City Art Institute, Kansas City,
Missouri

Untitled (Walther Funk)
c. 1953–1974
Painted wood
21 × 29"
Kansas City Art Institute, Kansas City,
Missouri

Untitled (What Is Truth?)
1960
Paint on metal drum lid
22" diameter
Kansas City Art Institute, Kansas City,
Missouri

Untitled *(Religious Scroll)*
1977
Oil on window shade
42 ½ × 38"
Milwaukee Art Museum
Gift of Robert Bishop

Untitled *(This Is the Grave)*
n.d.
Oil on wood
16 ½ × 48"
Kansas City Art Institute, Kansas City,
Missouri

Untitled *(Vengeance Is Mine)*
n.d.
Painted metal
10 × 40"
Kansas City Art Institute, Kansas City,
Missouri

Untitled *(John F. Kennedy)*
n.d.
Oil on wood
8 ½ × 119 ¼"
Kansas City Art Institute, Kansas City,
Missouri

Untitled *(The 79 Year Old Jurist)*
n.d.
Paint on Masonite
21 ¼ × 48"
Kansas City Art Institute, Kansas City,
Missouri

Untitled *(000.000 Nothing)*
n.d.
Paint on metal
16" diameter
Kansas City Art Institute, Kansas City,
Missouri

Untitled *(Joshua's Death and Burial)*
n.d.
Paint on wood
21 × 29 ¼"
Kansas City Art Institute, Kansas City,
Missouri

Untitled *(Boycott to Combine)* double-sided
n.d.
Paint on metal and wood
33 × 47"
Kansas City Art Institute, Kansas City,
Missouri

EDGAR TOLSON
Man with Pony [p. 131]
1958
Carved and assembled painted wood
23 × 11 ¼ × 32"
Milwaukee Art Museum
The Michael and Julie Hall Collection of
American Folk Art, M1989.314

Adam and Eve [p. 130]
1979
Carved and painted wood, and pencil
10 ¼ × 10 ¾ × 7 ¼"
National Museum of American Art,
Smithsonian Institution
Gift of Herbert Waide Hemphill Jr. and
Museum purchase made possible by Ralph
Cross Johnson, 1986.65.269

GROUP OF SIX FIGURES [p. 132]:

Untitled *(The Hippie)*
1971
Carved wood
13 ½" high
Private collection

Untitled *(Man with Red Shoes)*
1968
Carved and stained wood
12 ¾" high
Private collection

Untitled *(The Daughter)*
1966
Carved wood
12 ¾" high
Private collection

Untitled *(Library Doll)*
1967
Carved wood
11 ½" high
Private collection

Untitled *(Farmer)*
 1970
 Carved wood
 12 ¾" high
 Private collection

Untitled *(Picasso Doll)*
 1968
 Carved wood
 13" high
 Private collection

SISTER GERTRUDE MORGAN

Christ Coming in His Glory [pp. 138–139]
 1965–1970
 Crayon and acrylic on hard board
 6 × 9 ¼"
 Collection of Sandra Jaffe

Paradise
 c. 1970
 Tempera and pen on cardboard
 11 ⅜ × 9 ¾ × ⅛"
 Collection of Robert A. Roth

Charity Hospital 523,2311 [p. 136]
 c. 1970
 Acrylic and ink on cardboard
 13 × 16"
 Collection of Alvina and Paul Haverkamp

Jesus Is My Co-Pilot [p. 135]
 c. 1970
 Watercolor on paper
 17 × 4 × 4"
 Collection of Deborah and Robert Cummins

Sister Gertrude Morgan with Allan Jaffe,
New Orleans Jazz & Heritage Festival
 Michael P. Smith, photographer
 1973
 Black-and-white photograph
 8 ¼ × 12 ¼"
 Collection of Robert A. Roth

God's Greatest Hits
 1978
 Tempera and pen on book pages
 7 ⅞ × 9 ⅝ × ½" (open)
 Collection of Robert A. Roth

The Lamb Standing on Mt. Zion with His Company
[p. 137]
 n.d.
 Pencil and acrylic on Masonite
 23 ¾ × 23 ¾" (without post)
 Collection of Sandra Jaffe

Untitled *(Do You Thank God)* [p. 134]
 n.d.
 Paint on paper
 12 ½ × 19"
 Collection of Jill and Sheldon Bonovitz

Prayer Fan
 n.d.
 Paint on wooden crate slats
 14 × 12 ½"
 Collection of Lisa Roberts and David Seltzer

NELLIE MAE ROWE

The Day People Voted at the Voting Poll [p. 140]
 1978
 Felt-tip pen, pencil, and hand-colored
 photograph
 20 × 30"
 Collection of Lucinda W. Bunnen

Untitled *(Nellie in Her Yard)* [p. 141]
 1978
 Felt-tip marker and pencil on Foamcore
 17 ½ × 20"
 Museum of American Folk Art, New York
 Gift of Judith Alexander, 1997.5.1

Untitled *(Two Figures and Animal)* [p. 141]
 c. 1979–1980
 Crayon, marker, and oil pastel on paper
 15 ¼ × 11 ⅛"
 Museum of American Folk Art, New York
 Gift of Judith Alexander, 1997.1.16

Untitled *(Woman and Plaid Background)* [p. 143]
 1950s
 Crayon and pencil on vinyl wallcovering
 display card
 15 ¼ × 10 ¾"
 Museum of American Folk Art, New York
 Gift of Judith Alexander, 1997.1.3

Nellie on Blue [p. 142]
n.d.
Paint on photograph and paper; mounted
on cardboard
10 × 8"
Private collection, New York

God Loves Us All
1978
Hand-colored photograph
17 ½ × 14 ½"
Private collection, New York

Untitled *(Girl on Orange Chair)*
1950s
Crayon, pencil, and paint on cardboard
12 ¼ × 8 ¼"
Museum of American Folk Art, New York
Gift of Judith Alexander, 1997.1.20

Untitled *(Woman with Orange Hat)*
1960s
Crayon and pencil on paper
11 ½ × 8 ¾"
Museum of American Folk Art, New York
Gift of Judith Alexander, 1997.1.14

Yellow Boots
1977–1981
Crayon on board
13 ¼ × 10 ¼"
Collection of Judith Alexander

Nellie Going to the Moon
1978
Gouache, crayon, and pen on canvas board
23 ½ × 19 ½"
Collection of Judith Alexander

Strutting
1978
Crayon and pen on paper
17 × 14"
Collection of Judith Mary Anderson

Untitled *(Nellie with Plant)*
1978
Hand-colored photograph
14 × 14 ¾"
The William S. Arnett Collection

Untitled *(Portrait of a Woman)*
Late 1940s
Crayon, pencil, and chalk on paper
12 ¼ × 8 ½"
Museum of American Folk Art, New York
Gift of Judith Alexander, 1997.1.6

STEVE ASHBY
Untitled
n.d.
Wood, cloth, collage, metal, wire, and acorns
24 × 22 × 5"
Courtesy Phyllis Kind Gallery, New York
and Chicago

Untitled
n.d.
Oil and latex house paint on wood with
photo collage, fabric, wire, tin, and nails
19 ½ × 15 ½ × 12 ⅝"
Collection of Robert A. Roth

Untitled
n.d.
Oil house paint on carved quarter-plywood
with string and thumbtack
8 × 9 ¼ × ½"
Collection of Robert A. Roth

Untitled
n.d.
Oil house paint on carved quarter-plywood
with wire hinge
2 ⅝ × 1 ½ × ½"
Collection of Robert A. Roth

Untitled
n.d.
Oil house paint on wood with photo collage,
fabric, hair, tin, wire, rod, hinges, and nails
19 ¾ × 19 × 20"
Collection of Robert A. Roth

Untitled [p. 144]
n.d.
Latex and oil house paint on wood with
fabric, fur, straw hat, metal rod, wire, nuts,
tin, and nails
12 ½ × 22 ¾ × 23"
Collection of Robert A. Roth

Untitled [p. 10]
n.d.
Oil house paint on wood with hinges,
serrated rubber pad, upholstery tacks, picture
frame, magazine photo collage, glass, ribbon,
human hair, hook, ceramic knob, and metal
rod with wooden washers
23 ³/₄ × 14 ¹/₄ × 13"
Collection of Robert A. Roth

Untitled
n.d.
Oil house paint on wood with yarn, string,
fabric, tacks, nails, and screws
11 ¹/₂ × 13 ¹/₄ × 11 ¹/₄"
Collection of Robert A. Roth

Untitled [p. 147]
n.d.
Latex and oil house paint, dolls' eyes, fabric,
and feathers on carved wood; plastic pill
container as matchholder on reverse
11 ¹/₂ × 8 ³/₁₆ × 3 ³/₄"
Collection of Robert A. Roth

Untitled [p. 146]
n.d.
Fabric, lace, metal, thumbtacks, wire, human
hair, and acorn with magazine photo collage
on carved wood
8 × 6 ¹/₂ × 5 ¹/₂"
Collection of Robert A. Roth

Untitled
n.d.
Oil house paint, enamel, and yarn on wood
construction
5 ¹/₂ × 7 ¹/₄ × 7 ¹/₂"
Collection of Robert A. Roth

EDDIE ARNING
Untitled (Colored Balls) [p. 151]
c. 1965
Crayon on paper
18 × 24"
Courtesy Hill Gallery, Birmingham, Michigan

Untitled (Child in Cradle) [p. 149]
c. 1965
Crayon on paper
15 × 23"
Courtesy Fleisher/Ollman Gallery,
Philadelphia

Untitled (Man Sitting on Post) [p. 150]
1968
Crayon and oil pastel on paper
22 × 28"
The Anthony Petullo Collection of
Self-Taught & Outsider Art

Banana Baron [p. 148]
1970
Oil pastel on paper
25 ⁵/₈ × 19 ³/₄"
National Museum of American Art,
Smithsonian Institution
Gift of Mr. and Mrs. Alexander Sackton
1987.51.10

Untitled (Nativity) [p. 149]
n.d.
Crayon and oil pastel on paper
21 ¹/₂ × 31 ¹/₂"
Collection of Edward V. Blanchard and
M. Anne Hill

Untitled (Baseball Diamond)
c. 1964
Crayon and oil pastel on paper
18 × 24"
Courtesy Ricco/Maresca Gallery, New York

Untitled (Flagless Ship)
c. 1968
Crayon on paper
18 × 24"
Courtesy Hill Gallery, Birmingham, Michigan

Untitled (Two Figures)
n.d.
Crayon and oil pastel on paper
38 ³/₄ × 28 ¹/₂"
Private collection

Untitled *(Yellow Man with Cross)*
 n.d.
 Crayon and oil pastel on paper
 24 × 18 ¼"
 Private collection

EMERY BLAGDON

Healing Machines [pp. 152–155]
 1956–1984
 Metal, wood, and aluminum foil
 environmental installation
 Approx. 12'3" × 26' × 20'
 Collection of Dan Dryden, Don Christensen,
 Trace Rosel, and Eleanor Sandresky

LEROY PERSON

Untitled *(Hen and Chicks with Rooster)* [p. 159]
 1970–1985
 Paint and crayon on wood
 Hen and chicks: 13 × 15 ⅜ × 8 ½"
 Rooster: 5 ¹³⁄₁₆ × 7 ⅝ × 2 ¹¹⁄₁₆"
 Museum of American Folk Art, New York
 Gift of Roger Cardinal in memory of
 Timothy Grutzius, 1995.14.1

Untitled *(Table)* [p. 156]
 1975–1980
 Wax crayon, spray paint, aluminum, and nails
 on wood
 27 × 19 × 12"
 The Robert Lynch Collection of The
 Daisy Thorpe Gallery at North Carolina
 Wesleyan College

Untitled *(African Throne)* [p. 14]
 n.d.
 Carved and assembled wood
 35 × 26 ½ × 23"
 The Robert Lynch Collection of The
 Daisy Thorpe Gallery at North Carolina
 Wesleyan College

Untitled *(Armchair)* [p. 158]
 1979
 Enamel on wood
 39 × 26 × 28"
 Collection of Frank Maresca

Untitled *(Peacock)*
 1975–1980
 Wax crayon, paint, and tar on wood
 6 ½ × 4 × 1 ¼"
 The Robert Lynch Collection of The
 Daisy Thorpe Gallery at North Carolina
 Wesleyan College

Untitled *(Peacock)*
 1975–1980
 Wood, tar, and paint
 4 ½ × 3 ½ × 1"
 The Robert Lynch Collection of The
 Daisy Thorpe Gallery at North Carolina
 Wesleyan College

Untitled *(Silver Peacock)*
 1975–1980
 Paint on wood
 5 × 4 ¼ × 1 ¼"
 The Robert Lynch Collection of The
 Daisy Thorpe Gallery at North Carolina
 Wesleyan College

Untitled *(Peacock)*
 1975–1980
 Wax crayon on wood
 5 × 3 ¼ × 1 ¼"
 The Robert Lynch Collection of The
 Daisy Thorpe Gallery at North Carolina
 Wesleyan College

Untitled *(Blue Bird or Figure)*
 c. 1980
 Enamel paint on tree wood
 5 ½ × 1 ¼ × 2"
 The Robert Lynch Collection of The
 Daisy Thorpe Gallery at North Carolina
 Wesleyan College

Untitled *(Gold Chair)*
 c. 1980
 Gold paint on tree wood
 5 × 1 ½ × 1 ¼"
 The Robert Lynch Collection of The
 Daisy Thorpe Gallery at North Carolina
 Wesleyan College

Untitled *(Gold Figure on Yellow Base)*
 c. 1980
 Wax crayon on tree wood
 6 ½ × 2 × 2 ½"
 The Robert Lynch Collection of The
 Daisy Thorpe Gallery at North Carolina
 Wesleyan College

Rosemary Person
 c. 1982
 Black-and-white photograph; plywood, wax
 crayon, nails, and staples
 17 ¼ × 13 × ⅞"
 The Robert Lynch Collection of The
 Daisy Thorpe Gallery at North Carolina
 Wesleyan College

Untitled *(Peacock)*
 Early 1980s
 Latex paint on twig
 2 × 4 × ¾"
 The Robert Lynch Collection of The
 Daisy Thorpe Gallery at North Carolina
 Wesleyan College

Untitled *(Peacock)*
 Early 1980s
 Tree branch, wood, stain or paint, and
 thumbtack
 12 ½ × 9 ½ × 2"
 The Robert Lynch Collection of The
 Daisy Thorpe Gallery at North Carolina
 Wesleyan College

Untitled *(Bird)*
 n.d.
 Paint and crayon on carved wood
 5 ¾ × 13 ½"
 Collection of Didi and David Barrett

Untitled *(Three Figures)*
 n.d.
 Paint, nails, and glazing putty on wood
 7 × 12 × 7"
 The Robert Lynch Collection of The
 Daisy Thorpe Gallery at North Carolina
 Wesleyan College

Side Chair
 n.d.
 Painted wood and metal
 33 ½ × 17 × 18 ½"
 The Robert Lynch Collection of The
 Daisy Thorpe Gallery at North Carolina
 Wesleyan College

Side Chair
 n.d.
 Painted wood and metal
 33 × 16 ½ × 18"
 The Robert Lynch Collection of The
 Daisy Thorpe Gallery at North Carolina
 Wesleyan College

WILLIAM A. BLAYNEY
Diptych: *Anti-Christ and Reign of the Gentile*
Kingdoms (recto) [p. 161]
The Sealed Book of the Revelation of Jesus Christ
(verso) [p. 162]
 c. 1960
 Oil on board
 47 × 67 ½"
 Collection of David T. Owsley

The First and Second Wonders
 1962
 Oil on canvas board
 27 ¾ × 21 ¾"
 Westmoreland Museum of Art, Greensburg,
 Pennsylvania
 Gift of Mr. David Owsley

HOWARD FINSTER
Brower Root Hotel [p. 167]
 1979
 Glass, enamel paint, brower roots, and
 wooden coins
 25 × 8 × 9"
 Courtesy Fleisher/Ollman Gallery,
 Philadelphia

Sights Appear on My Mountains, Sighns of the Times
[p. 166]
 1978
 Enamel on Masonite or plywood
 26 ½ × 16 ¾"
 Collection of Didi and David Barrett

The Weight of the World [p. 165]
1982
Enamel on wood
20 ¼ × 48"
Collection of Robert M. Greenberg

In My Father's House [p. 168]
1977–1979
Mixed media
78 × 24" diameter
Collection of John Wieland Homes

History of Plant Farm Museum [p. 164]
1982
Enamel on plywood
46 ½ × 55"
Collection of Robert M. Greenberg

Green Gourd
n.d.
Painted gourd
26" long
Collection of Edward V. Blanchard and
M. Anne Hill

WILLIAM L. HAWKINS
Willard Hotel [p. 172]
c. 1987
Enamel on Masonite
48 × 60"
Collection of Robert M. Greenberg

Last Supper #6 [p. 173]
1986
Latex and oil house paint on quarter-plywood
with magazine photo collage
23 ¹⁵⁄₁₆ × 48 × ¼"
Collection of Robert A. Roth

Collage with Steeples [p. 171]
1988
Enamel and collage on Masonite
48 × 60"
Courtesy Ricco/Maresca Gallery, New York

Tiger and Bear [p. 170]
1989
Enamel, paper, duct tape, and sand on board
42 × 48"
High Museum of Art, Atlanta
T. Marshall Hahn Jr. Collection
1997.84

THORNTON DIAL SR.
Diana's Castle
1997
House paint on plywood, stuffed animals,
blankets, artificial flowers, and various found
objects
83 × 86 × 105"
The William S. Arnett Collection

The Power of the Seat: You Can't Do without Us
1997
Iron bench, house paint, dolls, brooms, tools,
and hat
48 × 104 × 40"
The William S. Arnett Collection

Running for Cover
1997
House paint on plywood, fabric, artificial
flowers, corrugated tin, stuffed animals,
and screening
64 × 130"
The William S. Arnett Collection

PURVIS YOUNG
Locked Up Their Minds [p. 181]
1972
House paint and wood on plywood
84 × 84"
The William S. Arnett Collection

Boat People [p. 184]
1990
House paint on found wood
49 × 14"
Collection of Mr. and Mrs. Daniel
W. Dietrich II

Untitled (*Black Jesus*)
1973
House paint on plywood
96 × 48"
Collection of Richard Levine

Untitled *(Angel Portrait #1)*
 1973
 House paint on plywood
 17 3/4 × 18 3/4"
 Collection of Richard Levine

Untitled *(Angel Portrait #2)*
 1973
 House paint on plywood
 16 1/2 × 19 1/2"
 Collection of Richard Levine

Untitled *(Jesus with Halo)*
 1972
 House paint on plywood
 23 1/2 × 43"
 The William S. Arnett Collection

LONNIE HOLLEY
Environmental site-specific installation
 Mixed media
 The William S. Arnett Collection

KEN GRIMES
Untitled *(Evidence for Past Visitations)*
[pp. 192–193]
 1992
 Acrylic on canvas
 40 × 150" (five panels)
 Courtesy Ricco/Maresca Gallery, New York

Untitled *(Cheshire Jodrell Bank Radio Telescope
Bernard Lovell Coincidences)* [p. 190]
 1993
 Acrylic on canvas
 48 × 96"
 Courtesy Ricco/Maresca Gallery, New York

Untitled *(Throw the Switch? On Off)* [p. 195]
 1993
 Acrylic on canvas
 30 × 40"
 Courtesy Ricco/Maresca Gallery, New York

Untitled *(We Must Collect, Examine, and Evaluate
as Much Evidence as Possible)* [p. 191]
 1993
 Acrylic on canvas
 48 × 66"
 Collection of Margaret and John Robson

SELECTED READINGS

Adele, Lynne. *Black History/Black Vision: The Visionary Image in Texas.* Austin, Tex.: Archer M. Huntington Art Gallery, University of Texas, 1989.

American Folk Art: Expressions of a New Spirit. New York: Museum of American Folk Art, 1983.

Ames, Kenneth L. *Beyond Necessity: Art in the Folk Tradition.* Wilmington, Del.: Winterthur Museum, 1977.

Another Face of the Diamond: Pathways Through the Black Atlantic South. New York: INTAR Latin American Gallery, 1989.

Ardery, Julia Spencer. "The Temptation: Edgar Tolson and the Sociology of Twentieth Century Folk Art." Ph.D. dissertation, University of Kentucky, 1995.

Arkus, Leon Anthony. *John Kane, Painter.* Pittsburgh: University of Pittsburgh Press, 1971.

Armstrong, Tom, et al. *200 Years of American Sculpture.* New York: David R. Godine, Publisher, in association with the Whitney Museum of American Art, 1976.

Atkins, Jacqueline M. "Joseph E. Yoakum: Visionary Traveler." *The Clarion,* vol. 15, no. 1 (Winter 1990), pp. 50–57.

Babinsky, Jane E., and Miriam C. Stem. *The Life and Work of Henry Church, Jr.* Chagrin Falls, Ohio: privately published, 1987.

Baker, Houston A. Jr. *Blues, Ideology, and Afro-American Literature: A Vernacular Theory.* Chicago: University of Chicago Press, 1984.

Baking in the Sun: Visionary Images from the South, Selections from the Collection of Sylvia and Warren Lowe. Lafayette, La.: University Art Museum, University of Southwestern Louisiana, 1987.

Barrett, Didi. *Muffled Voices: Folk Artists in Contemporary America.* New York: Museum of American Folk Art, 1986.

Bearden, Romare, and Harry Henderson. *A History of African-American Artists.* New York: Pantheon Books, 1993.

Beardsley, John. *Gardens of Revelation: Environments by Visionary Artists.* New York: Abbeville Press, 1995.

————, and Jane Livingston. *Hispanic Art in the United States: Thirty Contemporary Painters and Sculptors.* New York: Abbeville Press, 1987.

Becker, Jane S., and Barbara Franco. *Folk Roots, New Roots: Folklore in American Life.* Lexington, Mass.: Museum of Our National Heritage, 1988.

Berger, Maurice. *How Art Becomes History: Essays on Art, Society, and Culture in Post–New Deal America.* New York: HarperCollins, 1992.

————. "The Delicate Quest: Paradox in Contemporary African-American Art." In *No Doubt African-American Art of the 90s.* Ridgefield, Conn.: The Aldrich Museum of Contemporary Art, 1996.

————. *White Lies: Race and the Myths of Whiteness.* New York: Farrar, Straus & Giroux, 1998.

————, and Johnetta Cole. *Race and Representation: Art, Film, Video.* New York: Hunter College Art Gallery, 1987.

Beyond Reason, Art and Psychosis: Works from the Prinzhorn Collection. London: Hayward Gallery, 1996.

Bihalji-Merin, Oto. *Modern Primitives: Naive Painting from the Late Seventeenth Century Until the Present Day.* New York: Gallery Books, 1971.

————, and Nebojsa-Bato Tomasevic, eds. *World Encyclopedia of Naive Art: A Hundred Years of Naive Art.* Secaucus, N.J.: Chartwell Books, 1984.

Bishop, Robert. *American Folk Sculpture.* New York: E.P. Dutton, 1974.

_____. *Folk Painters of America.* New York: E.P. Dutton, 1979.

Black Art—Ancestral Legacy: The African Impulse in African-American Art. Dallas: Dallas Museum of Art, 1989.

Bluestein, Gene. *Poplore: Folk and Pop in American Culture.* Amherst, Mass.: University of Massachusetts Press, 1994.

Bonesteel, Michael. "Chicago Originals." *Art in America,* vol. 73, no. 2 (February 1985), pp. 128–135.

Borum, Jenifer P. "Strategy of the Tiger: The World of Thornton Dial." *Folk Art,* vol. 18, no. 4 (Winter 1993/94), pp. 34–40.

Bowman, Russell, and Roger Cardinal. *Driven to Create: The Anthony Petullo Collection of Self-Taught and Outsider Art.* Milwaukee: Milwaukee Museum of Art, 1993.

Bronner, Simon J. *American Folk Art: A Guide to Sources.* New York. Garland Publishing, 1984.

Cahill, Holger. *American Folk Art: The Art of the Common Man in America, 1750–1900.* New York: The Museum of Modern Art, 1932.

_____. *American Folk Sculpture.* Newark, N.J.: The Newark Museum, 1931.

_____. *American Primitives.* Newark, N.J.: The Newark Museum, 1930.

_____, et al. *Masters of Popular Painting: Modern Primitives of Europe and America.* New York: The Museum of Modern Art, 1938.

Cardinal, Roger R. *Outsider Art.* New York: Praeger Publishers, 1972.

_____, "The Self in Self-Taught Art." *Art Papers,* vol. 18, no. 5 (September/October 1994), pp. 23–33.

Cerny, Charlene, and Suzanne Seriff, eds. *Recycled, Re-Seen: Folk Art from the Global Scrap Heap.* New York: Harry N. Abrams in association with the Museum of International Folk Art, 1996.

Chalmers, F. Graeme. "The Study of Art in a Cultural Context." *Journal of Aesthetics and Art Criticism,* vol. 32 (Winter 1973), pp. 249–255.

Clifford, James. *The Predicament of Culture: Twentieth Century Ethnography, Literature, and Art.* Cambridge, Mass.: Harvard University Press, 1988.

Cone, James H. *The Spirituals and the Blues: An Interpretation.* New York: Orbis Books, 1991.

Conwill, Kinshasha Holman. "In Search of An 'Authentic Vision.'" *American Art,* vol. 5, no. 4 (Fall 1991), pp. 2–9.

Cubbs, Joanne. *Eugene Von Bruenchenhein: Obsessive Visionary.* Sheboygan, Wis.: John Michael Kohler Arts Center, 1988.

Danto, Arthur. *After the End of Art.* Princeton, N.J.: Princeton University Press, 1996.

_____, et al. *Art/Artifact: African Art in Anthropology Collections.* New York: The Center for African Art, 1988.

_____. *Beyond the Brillo Box.* New York: Farrar, Straus & Giroux, 1992.

_____. "Outsider Art." *The Nation,* March 10, 1997, pp. 33–36.

_____. *The Transfiguration of the Common Place.* Cambridge, Mass.: Harvard University Press, 1981.

Davis, Gerald L. *"I Got the Word in Me and I Can Sing It, You Know": A Study of the Performed African-American Sermon.* Philadelphia: University of Pennsylvania Press, 1985.

_____. "What Are African American Folk Arts? The Importance of Presenting, Preserving, and Promoting African American Aesthetic Traditions." In Deirdre L. Bibby and Diana Baird N'Diaye, *The Arts of Black Folk*. New York: The Schomburg Center for Research in Black Culture, The New York Public Library/Astor, Lenox, and Tilden Foundations, 1991.

Dream-Singers, Story Tellers: An African-American Presence. Tokyo: New Jersey State Museum, Fukui Fine Arts Museum, and Jane Voorhees Zimmerli Art Museum, Rutgers, The State University of New Jersey, 1992.

Driskell, David C., ed. *African American Visual Aesthetics: A Postmodernist View*. Washington, D.C.: Smithsonian Institution Press, 1995.

Eaton, Allen H. *Handicrafts of the Southern Highlands*. 1937. Reprint. New York: Dover Publications, 1973.

_____. *Immigrant Gifts to American Life: Some Experiments in Appreciation of the Contribution of Our Foreign-Born Citizens to American Culture*. New York: Russell Sage Foundation, 1932.

Edgar Tolson: Kentucky Gothic. Lexington, Ky.: University of Kentucky Art Museum, 1981.

Elijah Pierce, Woodcarver. Columbus, Ohio: Columbus Museum of Art, 1992.

Fagaly, William A. "Sister Gertrude Morgan." In *Louisiana Folk Paintings*. New York: Museum of American Folk Art, 1973.

Farber, Sam, Simon Carr, and Allen S. Weiss. *Portraits from the Outside: Figurative Expression in Outsider Art*. New York: Grœgfeax Publishing in association with Parsons School of Design Gallery, 1990.

Ferguson, Russell, et. al, eds. *Out There: Marginalization and Contemporary Cultures*. Cambridge, Mass.: MIT Press in association with The New Museum of Contemporary Art, 1990.

Ferris, William. *Blues from the Delta*. New York: Anchor Press/Doubleday, 1978.

_____. *Local Color: A Sense of Place in Folk Art*. New York: McGraw-Hill Book Company, 1982.

Fuller, Edmund L. *Visions in Stone: The Sculpture of William Edmondson*. Pittsburgh: University of Pittsburgh Press, 1973.

Gates, Henry Louis Jr. *The Signifying Monkey: A Theory of Afro-American Literary Criticism*. New York: Oxford University Press, 1988.

Gilman, Sander. *Madness and Representation: Hans Prinzhorn's Study of Madness and Art in Its Historical Context*. Urbana, Ill.: University of Illinois Press, 1984.

Girardot, Norman. *The Finsters at Lehigh*. Bethlehem, Pa.: LUAG, 1986.

_____. *Natural Scriptures: Visions of Nature and the Bible in the Work of Hugo Sperger, Minnie and Garland Adkins, Jessie and Ronald Cooper, and Howard Finster*. Bethlehem, Pa.: LUAG, 1990.

Glassie, Henry H. *Pattern in Material Folk Culture of the Eastern United States*. Philadelphia: University of Pennsylvania Press, 1968.

_____. *The Spirit of Folk Art: The Girard Collection of the Museum of International Folk Art*. New York: Harry N. Abrams in association with the Museum of New Mexico, 1989.

Goldin, Amy. "Problems in Folk Art." *Artforum*, vol. 14, no. 10 (June 1976), pp. 48–52.

Griffith, Benjamin. "Howard Finster, Visionary Painter: God's Second Noah and Last Red Light." *The Gettysburg Review*, vol. 3, no. 2 (Spring 1990), pp. 305–320.

Hall, Michael D. "The Problem of Martin Ramirez: Folk Art Criticism as Cosmologies of Coercion." *The Clarion*, vol. 11 (Winter 1986), pp. 56–61.

_____. *Stereoscopic Perspective: Reflections on American Fine Art and Folk Art.* Ann Arbor, Mich.: UMI Research Press, 1988.

_____. "You Make It with your Mind: The Art of Edgar Tolson." *The Clarion,* vol. 12, no. 2/3 (Spring/Summer 1987), pp. 36–43.

_____, and Eugene W. Metcalf Jr., eds. *The Artist Outsider: Creativity and the Boundaries of Culture.* Washington, D.C.: Smithsonian Institution Press, 1994.

Halstead, Whitney. *Joseph E. Yoakum: Drawings.* New York: Whitney Museum of American Art, 1972.

Hancock, Butler. "The Designation of Indifference." *New Art Examiner,* vol. 20, no. 2 (October 1992), pp. 21–25.

Harper, Paula. *Purvis Young.* Miami: Joy Moos Gallery, 1993.

Hartigan, Lynda Roscoe. *Made with Passion: The Hemphill Folk Art Collection in the National Museum of American Art.* Washington, D.C.: Smithsonian Institution Press, 1990.

_____. "Recent Challenges in the Study of African-American Folk Art." *The International Review of African-American Art,* vol. II, no. 3 (1993), pp. 27–29, 60–63.

Hemphill, Herbert W. Jr., ed. *Folk Sculpture USA.* New York: The Brooklyn Museum, 1976.

_____, and Julia Weissman. *Twentieth-Century American Folk Art and Artists.* New York: E.P. Dutton, 1974.

Hernandez, Jo Farb, et al. *A.G. Rizzoli: Architect of Magnificent Visions.* New York: Harry N. Abrams in association with the San Diego Museum of Art, 1997.

Holstein, Jonathan. *The Pieced Quilt: An American Design Tradition.* Greenwich, Conn.: New York Graphic Society, 1973.

hooks, bell. "Postmodern Blackness." In *Yearning, Race, Gender, and Cultural Politics.* Boston: South End Press, 1990.

Horwitz, Elinor Lander. *Contemporary American Folk Artists.* Philadelphia: J.B. Lippincott, 1975.

Hufford, Mary, et al. *The Grand Generation: Memory, Mastery, Legacy.* Seattle: University of Washington Press in association with the Smithsonian Institution Traveling Exhibition Service and Office of Folklife Programs, 1987.

Jacobs, Joseph. *A World of Their Own: Twentieth-Century American Folk Art.* Newark, N.J.: The Newark Museum, 1995.

Janis, Sidney. *They Taught Themselves: American Primitive Painters of the 20th Century.* New York: The Dial Press, 1942.

Johnson, Jay, and William C. Ketchum Jr. *American Folk Art of the Twentieth Century.* New York: Rizzoli Press, 1983.

Johnston, Pat H. "E.A. McKillop and His Fabulous Woodcarvings." *The Antiques Journal,* vol. 33, no. 11 (1978), p. 17.

Jones, Michael Owen. *The Hand Made Object and Its Makers.* Berkeley, Calif.: University of California, 1975.

Kallir, Jane. *The Folk Art Tradition: Naive Painting in Europe and the United States.* New York: The Viking Press, 1982.

_____. *Grandma Moses: The Artist Behind the Myth.* New York: Clarkson N. Potter in association with The Galerie St. Etienne, 1982.

_____. *John Kane: Modern America's First Folk Painter.* New York: Galerie St. Etienne, 1984.

_____. *The World of Grandma Moses.* Washington, D.C.: International Exhibitions Foundation, 1984.

Kallir, Otto. *Grandma Moses.* New York: Harry N. Abrams, 1973.

Karlins-Thoman, Nancy. *Justin McCarthy.* Ph.D. dissertation, New York University, 1986.

Karp, Ivan, and Steven D. Lavine, eds. *Exhibiting Cultures: The Poetics and Politics of Museum Display.* Washington, D.C.: Smithsonian Institution Press, 1991.

Kaufman, Barbara Wahl, and Didi Barrett. *A Time to Reap: Late Blooming Folk Artists.* South Orange, N.J.: Seton Hall University in association with the Museum of American Folk Art, 1985.

Kogan, Lee. "New Museum Encyclopedia Shatters Myths." *The Clarion,* vol. 15, no. 5 (Winter 1990/1991), pp. 53–56.

Kornfeld, Phyllis. *Cellblock Visions: Prison Art in America.* Princeton, N.J.: Princeton University Press, 1996.

Kraskin, Sandra. *Black History and Artistry: Works by Self-Taught Painters and Sculptors from the Blanchard-Hill Collection.* New York: Baruch College, City University of New York, 1993.

Kuspit, Donald B. "The Appropriation of Marginal Art in the 1980s." *American Art* (Winter/Spring 1991), p. 134.

Larsen-Martin, Susan, and Lauri Martin. *Pioneers in Paradise: Folk and Outsider Artists of the West Coast.* Long Beach, Calif.: Long Beach Museum of Art, 1985.

Lindsey, Jack L. *"Miracles": The Sculptures of William Edmondson.* Philadelphia: Janet Fleisher Gallery, 1994.

Lipman, Jean. *Provocative Parallels: Naive Early Americans/International Sophisticates.* New York: E.P. Dutton, 1975.

_____, and Tom Armstrong, eds. *American Folk Painters of Three Centuries.* New York: Hudson Hills Press, 1980.

_____, Robert Bishop, Elizabeth V. Warren, and Sharon L. Eisenstat. *Five Star Folk Art: One Hundred American Masterpieces.* New York: Harry N. Abrams in association with the Museum of American Folk Art, 1990.

_____, Elizabeth V. Warren, and Robert Bishop. *Young America: A Folk Art History.* New York: Hudson Hills Press in association with the Museum of American Folk Art, 1986.

_____, and Alice Winchester. *The Flowering of American Folk Art (1776–1876).* New York: Penguin Books in cooperation with the Whitney Museum of American Art, 1974.

Lippard, Lucy R. *Mixed Blessings: New Art in a Multicultural America.* New York: Pantheon Books, 1990.

Livingston, Jane, and John Beardsley. *Black Folk Art in America 1930–1980.* Jackson, Miss.: University Press of Mississippi and the Center for the Study of Southern Culture for The Corcoran Gallery of Art, 1982.

Locke, Alain. "Horace Pippin, 1888–1947." In *Horace Pippin Memorial Exhibition.* Philadelphia: The Art Alliance, 1947.

Longhauser, Elsa Weiner. *The Heart of Creation: The Art of Martin Ramirez.* Philadelphia: Goldie Paley Gallery, Moore College of Art, 1985.

Longhauser, Elsa, with Elka Spoerri. *The Other Side of the Moon: The World of Adolf Wölfli.* Philadelphia: Goldie Paley Gallery, Moore College of Art, 1988.

[Longhauser], Elsa S. Weiner. *Transmitters: The Isolate Artist in America.* Philadelphia: Philadelphia College of Art, 1981.

Lowry, Bates. *Looking for Leonardo: Naive and Folk Art Objects Found in America by Bates and Isabel Lowry.* Iowa City: University of Iowa Press, 1993.

Luck, Barbara R., and Alexander Sackton. *Eddie Arning: Selected Drawings, 1964–1973.* Williamsburg, Va.: The Colonial Williamsburg Foundation, 1985.

MacGregor, John M. *The Discovery of the Art of the Insane.* Princeton, N.J.: Princeton University Press, 1989.

_____. *Henry J. Darger: Dans les Royaumes de l'Irréel.* Lausanne, Switzerland: Collection de l'art brut, 1996.

Maizels, John. *Raw Creation: Outsider Art and Beyond.* London: Phaidon Press, 1996.

Manley, Roger. "Separating the Folk from Their Art." *New Art Examiner,* vol. 19, no. 1 (September 1991), pp. 25–28.

_____. *Signs and Wonders: Outsider Art Inside North Carolina.* Raleigh, N.C.: North Carolina Museum of Art, 1989.

Maresca, Frank, and Roger Ricco. *American Self-Taught: Paintings and Drawings by Outsider Artists.* New York: Alfred A. Knopf, 1993.

_____. *Bill Traylor: His Art—His Life.* New York: Alfred A. Knopf, 1991.

Martin Ramirez: Pintor Mexicano (1885–1960). Mexico City: Centro Cultural/Arte Contemporaneo A.C., 1989.

McElroy, Guy C., et al. *African-American Artists 1880–1987; Selections from the Evans-Tibbs Collection.* Seattle: University of Washington Press in association with the Smithsonian Institution Traveling Exhibition Service, 1989.

McEvilley, Thomas. "The Missing Tradition." *Art in America* (May 1997), pp. 78–85, 137.

Metcalf, Eugene W. "Black Art, Folk Art, and Social Control." *Winterthur Portfolio,* vol. 18, no. 4 (Winter 1983), pp. 271–289.

_____. "Modernism, Edith Halpert, Holger Cahill, and the Fine Art Meaning of American Folk Art." In *Folk Roots, New Roots: Folklore in American Life.* Edited by Jane S. Becker and Barbara Franco. Lexington, Mass.: Museum of Our National Heritage, 1988.

Meyer, George H., ed. *Folk Artists Biographical Index.* Detroit: Sandringham Press in association with the Museum of American Folk Art, 1987.

Miele, Frank J., ed. "Folk or Art?: A Symposium." *Antiques,* vol. 135, no. 1 (1989), pp. 272–287.

Morris, Randall Seth. "Good vs. Evil in the World of Henry Darger." *The Clarion,* vol. 11, no. 4 (Fall 1986), pp. 30–35.

_____. "Martin Ramirez." *Folk Art,* vol. 20, no. 4 (Winter 1995/96), pp. 36–45.

Moses, Grandma. *My Life's History.* Edited by Otto Kallir. New York: Harper & Brothers, 1952.

Naives and Visionaries. New York: E.P. Dutton in association with the Walker Art Center, 1974.

Nellie Mae Rowe, Visionary Artist. Judith Alexander, organizer. Atlanta: Southern Arts Federation, 1983.

Next Generation: Southern Black Aesthetic. Winston-Salem, N.C.: Southeastern Center for Contemporary Art, 1990.

Ollman, John. "Foreword." In *Animistic Landscapes: Joseph Yoakum Drawings.* Philadelphia: Janet Fleisher Gallery, 1989.

Patterson, Tom. *Howard Finster: Stranger from Another World, Man of Visions Now on This Earth.* New York: Abbeville Press, 1989.

Patton, Phil. *Bill Traylor: High Singing Blue.* New York: Hirschl & Adler Modern; Chicago: Carl Hammer Gallery, 1997.

Paulsen, Barbara. "Eddie Arning: The Unsettling World of a Texas Folk Artist." *Texas Journal,* vol. 8 (Fall–Winter, 1985–1986).

Peacock, Robert, with Annibel Jenkins. *Paradise Garden: A Trip through Howard Finster's Visionary World.* San Francisco: Chronicle Books, 1996.

Perry, Regenia A. *Free Within Ourselves: African American Artists in the Collection of the National Museum of American Art.* Washington, D.C.: National Museum of American Art, Smithsonian Institution, in association with Pomegranate Artbooks, San Francisco, 1992.

Powell, Richard J. *Black Art and Culture in the 20th Century.* London: Thames & Hudson, 1997.

_____. *The Blues Aesthetic: Black Culture and Modernism.* Washington, D.C.: Washington Project for the Arts, 1989.

Price, Sally. *Primitive Art in Civilized Places.* Chicago: University of Chicago Press, 1989.

Prinzhorn, Hans. *Artistry of the Mentally Ill: A Contribution to the Psychology of Configuration.* Translated by Eric von Brockdorff. Berlin: Springer-Verlag, 1972.

Prokopoff, Stephen, ed. *Henry Darger: The Unreality of Being.* Iowa City: University of Iowa Press, 1996.

Quimby, Ian M.G., and Scott T. Swank, eds. *Perspectives on American Folk Art.* New York: W.W. Norton, 1980.

Rankin, Allen. "He Lost 10,000 Years." *Colliers* (June 22, 1946), p. 67.

Rhodes, Lynette I. *American Folk Art from the Traditional to the Naive.* Cleveland: The Cleveland Museum of Art, 1978.

Roberts, John W. *From Trickster to Badman: The Black Folk Hero in Slavery and Freedom.* Philadelphia: University of Pennsylvania Press, 1989.

Robinson, William H., and David Steinberg. *Transformations in Cleveland Art 1796–1946.* Cleveland: The Cleveland Museum of Art, 1996.

Rodman, Selden. *Horace Pippin: A Negro Painter in America.* New York: Quadrangle Press, 1947.

Rosen, Seymour. *In Celebration of Ourselves.* San Francisco: California Living Books in association with the San Francisco Museum of Modern Art, 1979.

Rosenak, Chuck and Jan. *Museum of American Folk Art Encyclopedia of Twentieth-Century American Folk Art and Artists.* New York: Abbeville Press, 1990.

Rumford, Beatrix T., and Carolyn J. Weekley. *Treasures of American Folk Art from the Abby Aldrich Rockefeller Folk Art Center.* Boston: Little, Brown in association with the Colonial Williamsburg Foundation, 1989.

Saroyan, William. *Morris Hirshfield.* Parma, Italy: Franco Maria Ricci, 1976.

Sass, Louis A. *Madness and Modernism: Insanity in the Light of Modern Art, Literature, and Thought.* Cambridge, Mass.: Harvard University Press, 1994.

Schlereth, Thomas J., ed. *Material Culture Studies in America.* Nashville: American Association for State and Local History, 1982.

Schwindler, Gary J. *William L. Hawkins: Transformations.* Charleston, Ill: Tarble Arts Center, Eastern Illinois University, 1989.

Sellen, Betty-Carol, with Cynthia J. Johanson. *20th Century American Folk, Self Taught, and Outsider Art.* New York: Neal-Schuman Publishers, 1993.

Shannon, Charles. "Bill Traylor's Triumph." *Art & Antiques* (February 1988), pp. 61–64, 95.

_____. "Introduction." In *Bill Traylor.* New York: Hirschl & Adler Modern, 1985.

Source and Inspiration: A Continuing Tradition. New York: Hirschl & Adler Folk, 1988.

Stebich, Ute. *Justin McCarthy*. Allentown, Pa.: Allentown Art Museum, 1984.

Stein, Judith E. "Brushing With Greatness: The Search for Horace Pippin's Paintings." *The Philadelphia Inquirer Magazine*, (January 16, 1994), pp. 16–22.

————. *I Tell My Heart: The Art of Horace Pippin*. New York: Universe Publishing in association with the Pennsylvania Academy of the Fine Arts, 1993.

Szeemann, Harald. *Bachelor Machines*. New York: Rizzoli, 1975.

————. *documenta 5*. Kassel: Verlag Bertelsman, 1972.

————. *Der Hang Zum Gesamtkunstwerk: Europäische Utopien Seit 1800*. Aarau, Switzerland: Sauerländer, 1983.

————. *Visionäre Schweiz*. Aarau, Switzerland: Sauerländer, 1991.

Thévoz, Michel. *Art Brut*. New York: Rizzoli, 1976.

Thompson, Robert Farris. *Flash of the Spirit: African and Afro-American Art and Philosophy*. New York: Random House, 1983.

Torgovnick, Marianna. *Gone Primitive: Savage Intellects, Modern Lives*. Chicago: University of Chicago Press, 1990.

Tuchman, Maurice, and Carol S. Eliel. *Parallel Visions: Modern Artists and Outsider Art*. Princeton, N.J.: Princeton University Press in association with the Los Angeles County Museum of Art, 1992.

Turner, John F. "Howard Finster: Man of Visions." *Folklife Annual 1985*, pp. 158–173.

Uncommon Ground: American Folk Art from the Michael and Julie Hall Collection. Milwaukee: Milwaukee Art Museum, 1993.

Vlach, John Michael. *The Afro-American Tradition in Decorative Arts*. Cleveland: The Cleveland Museum of Art, 1978.

————. *By the Work of Their Hands: Studies in Afro-American Folklife*. Ann Arbor, Mich.: UMI Research Press, 1991.

————. "Holger Cahill as Folklorist." *Journal of American Folklore*, vol. 98, no. 388 (April–June 1985), pp. 148–162.

————, and Simon J. Bronner, eds. *Folk Art and Art Worlds: Essays Drawn from the Washington Meeting on Folk Art Organized by the American Folk Life Center at the Library of Congress*. Logan, Utah: Utah State University Press, 1997.

Wadsworth, Anna, et al. *Missing Pieces: Georgia Folk Art, 1770–1976*. Atlanta: Georgia Council for the Arts and Humanities, 1976.

Ward, Daniel Franklin, ed. *Personal Places: Perspectives on Informal Art Environments*. Bowling Green, Ohio: Bowling Green State University Popular Press, 1984.

West, Cornel. *Prophesy Deliverance! An Afro-American Revolutionary Christianity*. Philadelphia: The Westminster Press, 1982.

Winchester, Alice, ed. "What is American Folk? A Symposium," *Antiques*, vol. 57, no. 5 (May 1950), pp. 355–362.

Yelen, Alice Rae. *Passionate Visions of the American South: Self-Taught Artists from 1940 to the Present*. New Orleans: New Orleans Museum of Art, 1993.

Zed, Xenia. *Nellie Mae Rowe*. Augusta, Ga.: Morris Museum of Art, 1996.

Zug, Charles G. III. *Five North Carolina Folk Artists*. Chapel Hill, N.C.: Ackland Art Museum, The University of North Carolina, 1986.

PHOTOGRAPHERS

Howard T. Agriesti: 9, 44, 45
William S. Arnett: 41, 186
Gavin Ashworth: 88, 89 left, 96, 106, 114, 118,
 119, 141, 143, 149 bottom, 159, 161,
 162, 166
Charles Bechtold: front cover right, 109, 170,
 171, 172, 173, 182–183, 190, 191,
 192–193, 195
William Bengtson: frontispiece
Ben Blackwell: 84, 85, 86, 87
Jon Blumb: 155
Harry Butler, Nashville: 65
Bernard Cohen: 176
Charles Cloud III: 132
Liz Deschenes: 71
Robert Eagles Photography: 14, 156
Rick Echelmeyer: 72
Jeff Ellis: 10, 144, 146, 147
Alan Finkelman: front cover left, 68
Gamma One Conversions: 108, 174, 175
Ron Lee/The Silver Factory: 187, 188
Matt McFarland: 126, 127, 128, 129
Owen Murphey: 136
Joseph Painter: 62, 111, 120, 121, 134, 149 top,
 167, 180, 184
James Prinz: 21, 102, 104–105, back cover right
Trace Rosell: 152, 153, 154 top
Larry Sanders: 98, 150
Tom Van Eynde: 99, 100, 101, 112, 113, 135
Chris Verene: 168
Jean Vong: 154 bottom
Ellen Page Wilson: 110
Graydon Wood: 73, 178

We would like to thank the following private collectors, public collections, publishers, and galleries for providing images for this publication:

Abby Aldrich Rockefeller Folk Art Center,
 Williamsburg, Virginia: 24, 46, back cover
 center
The Ames Gallery, Berkeley, California: 84, 85,
 86, 87
Fleisher/Ollman Gallery, Philadelphia: 62, 111,
 120, 121, 134, 149 top, 167, 180, 184
Carl Hammer Gallery, Chicago: 104 center, 122
Hill Gallery, Birmingham, Michigan: 151
Sidney Janis Gallery, New York: 68, 70, 71
Phyllis Kind Gallery, Chicago and New York:
 89 right, 107, 108
Kiyoko Lerner: 102, 104–105 top and bottom,
 back cover right
Copyright © 1997 The Metropolitan Museum of
 Art, New York: 17, 52–53
Milwaukee Art Museum: 31, 54, 98, 131, 150
Copyright © 1995 Grandma Moses Properties, Co.,
 New York: 78, 83
Copyright © 1996 Grandma Moses Properties, Co.,
 New York: 80, 81, 82
© 1997 The Museum of Modern Art, New York:
 36, 51, 69
New Orleans Museum of Art: 136
Ricco/Maresca Gallery, New York: front cover
 right, 109, 170, 171, 172, 173, 182–183,
 190, 191, 192–193, 195
Luise Ross Gallery, New York: 59, 61
Judy A. Saslow Gallery, Chicago: 60
Judith E. Stein: 72
Joan T. Washburn Gallery, New York: 47
© 1997 Whitney Museum of American Art: 76

INDEX